LATE NINETEENTH CENTURY ART

EDITED BY

Hans Jürgen Hansen

With contributions by
Hanns Theodor Flemming, Hans Lehmbruch,
Manfred Meinz, Barbara J. Morris,
Nancy Halverson Schless, Jean Selz, Heinz Spielmann
and Hugh Wakefield

Translated by Marcus Bullock

LATE NINETEENTH CENTURY ART

THE ART, ARCHITECTURE, AND APPLIED ART OF THE "POMPOUS AGE"

McGraw-Hill

Contents

Translated by Marcus Bullock from the German DAS POMPÖSE ZEITALTER
© 1970 Gerhard Stalling Verlag, Oldenburg and Hamburg
First published in English by McGraw-Hill Book Company, a division of McGraw-Hill, Inc.,
New York, London, Toronto, 1972.
All Rights Reserved
Library of Congress Catalog Card Number: 72-148989
SBN 07-026053-2 Printed in West Germany

Introduction

Hardly anyone a decade or more ago would have predicted the sudden and vigorous renaissance of Art Nouveau. Actually, after the lengthy period of enthusiasm for the Biedermeier style, rediscovered shortly before the First World War, it was rather the second half of the nineteenth century, which follows it chronologically, that should have been due for a rebirth. It seems, however, that this period is making its appearance only now after Nouveau Art Nouveau, which charged into preeminence with so much bravura, has gradually begun to decay into the style of mail-order goods and living-room wallpaper designs. If indications are to be believed—and the trend in the art trade can hardly be overlooked (for example, at Christie's in London a recent auction of quite average Victorian paintings brought sensational prices)—we appear to be witnessing the rehabilitation of the post-Biedermeier pre-Art Nouveau period. This was a period of Historicism which was until recently reviled and presumptuously derided: that of the Victorian Age in England, the Second Empire and *Fin de siècle* in France, and the *Gründerjahre* in Germany, the main distinguishing feature of which was the use of just about every element of style from the past, generally employed in the most grandiose manner. And it is clear that the time has come for us to rediscover the delights of overrefined delicacy, of sentimentally (not to mention erotically) elaborated painting and sculpture, and the splendidly florid architecture, as well as the bizarre design of pioneering industrial products from the second half of the nineteenth century, a period that reveled in pomp and (even false) magnificence.

This period can very aptly be termed the Age of Pomp. Of course, pomp existed prior to those times, but for the most part it belonged to the court and was restricted to the trappings of the Church or State. Now, however, made cheap and plentiful by industrial mass production, it permeated every level of society. Great industrialists, bankers, and businessmen expected as much from the architects of their buildings as the highest nobility. The Second Rococo of the Second Empire, as the wit of Egon Friedell had it, was the Rococo of the Third Estate. And it was not only the drawing rooms of the rich which were pompous, with their heavy carpets and por-

tieres whose tufts and tassels justly earned the name *Klunkertid*, "the Age of Tassels," for this period in Denmark. It was also characteristic of the cozy rooms of lower middle-class homes with their plush sofas and cabinets laden with fancy knickknacks.

The great events described in history books—the wars in the United States, Schleswig, Bohemia, France, the Balkans, and Korea—were just the accidents of the age: its high moments of triumph and glory, in no way less important or decisive in their influence on the future than its catastrophes, were such happenings as the spectacular opening of the Suez Canal, the completion of the Trans-American Railroad, the Transatlantic telegraph cables and—the great international exhibitions. These, above all, best typified the second half of the nineteenth century. Here the nations would compete together with what they considered to be their country's highest achievements in the fields both of art and industry. Today, these two branches of achievement seem to be opposed to one another, yet in those times men were so inspired by the amazing, ever-increasing potentialities of technology that they strove for a meaningful symbiotic relationship between them, which was called the industrial arts in some countries and known in Germany as *Kunstgewerbe*.

The Crystal Palace of London dating from 1851, which was destroyed by fire in 1936, and the Eiffel Tower of Paris dating from 1889 were probably the most spectacular, and in the longer term impressive, results of this showing-off that the nations carried on with one another. The success and popularity of the gigantic exhibitions, however, was chiefly due to the continually quickening pace of technological advance. Telegraph communication made it possible as early as the famous London Exhibition of 1851 for daily reports to be sent out to European newspapers, and the construction of railroads had progressed to such an extent that it was now possible to make the whole journey from Basel or Bordeaux to Calais via Paris by train, take a steamer across the Channel, and then travel on to London from Dover by rail once again. There was also a recently completed line from Warsaw and Cracow via Berlin and Cologne to the Channel port of Ostende which linked up in Magdeburg with a connection from Budapest, Vienna, Prague, and Dresden. It

suddenly became possible to travel long distances by rail, and such journeys took only a fraction of the time they had taken by mail coach only a short while before. The short amount of time needed, which would previously have been quite unimaginable, was a significant factor in making a trip to the international exhibitions worthwhile. This was also the time when Thomas Cook founded his travel agency, ushering in the age of mass tourism.

While steam power was more important in the earlier stages, electricity began to play an ever more fascinating and revolutionary role toward the end of the century. There was quite a sensation caused by the great Electricity Building at the World's Columbian Exposition of 1893 in Chicago and finally by the Salon d'Électricité of 1900 in Paris where, alongside generators and motors, telegraphs and telephones, there were also many prototypes of modern household appliances: electric cooking pots, frying pans, irons—to say nothing of electric lighting. Electric arc lights played a prominent part in the fantastic mixed-media productions which Ludwig II of Bavaria had put on. In 1865, after Richard Wagner's visit to Hohenschwangau, an artificial swan drew the royal adjutant Prince Paul von Thurn und Taxis, dressed as Lohengrin, "most magnificently illuminated by means of an electric light," across the alpine lake during a colossal fireworks display. The famous Venus Grotto of the Linderhof Park glowed in 1877 with electric illuminations in five different colors. The current was supplied by Bavaria's first generating station, built there expressly for the purpose, using twenty-five of Werner von Siemens' newly invented dynamos. In every other area, too, artists and craftsmen made similarly enthusiastic use of the possibilities which technology was opening up to them. For example, the first photographers had almost all been portrait painters who now exploited the techniques of Daguerre and Maddox in their studios. However, the pictures produced by these means were not yet in color. One result is that today we are strangely unable to imagine those times, and especially the people of those times, as having any color other than the sepia brown tones of those old pictures. In fact it was really the age of the brightest, most brilliant, fluorescent colorfulness; our grandparents loved the glowing colors of Italian majolica, shimmering lusterware, and glittering brocades. Electrotyping offered gold- and silversmiths new production techniques, making possible such wonderful and worthwhile achievements as the electrochemical copying and mass production of exquisite antique utensils.

We have seen far too much of the comical side of this age and also its kitsch. We look down on it just as the Romantic Age looked down on the Rococo Period, forgetting the simple fact that in every age, the second half of the nineteenth century included, there was bad as well as good architecture, painting, and sculpture. To take a more recent example, even with the brilliant paint-daubing of the now more or less vanished Tachist movement, the most important thing was *who* was doing the daubing—in other words, what kind of a genius it was who let the paint dribble onto the canvas. And we may also ask just what we have gained from the bare fronts along the streets of our cities and their ill-placed and badly proportioned window-spaces where the *Gründerjahre* stucco work has recently been battered away? It is simply a demonstration of misunderstood Bauhaus ideas and a puerile lack of imagination. Our modern apartment blocks, now called housing complexes, are generally not the slightest bit more aesthetic or even better proportioned than their ornamented predecessors of 1880, for all that they are now often set in a more spacious landscape and even those for the lower social classes have baths and toilets. Compared to them the façade of many an elegant tenement building in the West End of Berlin or Frankfurt, or a noble apartment block on the Champs Élysées, is much more a work of art—to say nothing of those grand hotel façades, still magnificent even today, such as what is now the Magasin du Nord in Copenhagen, the colossal Russell Hotel in London, or the Casino at Monte Carlo.

What is more, historicism, the imitation of the styles of the past, has existed in almost every age. Rome indulged in Greek historicism, Charlemagne in Roman, the Jesuits of the sixteenth century and the Romantics of the nineteenth century in Gothic, the Empire in Egyptian, Art Nouveau in Japanese, and the Cubists and Expressionists in black African imitations. And it is beginning once again as the Renaissance is followed by the Neo-Renaissance. It can hardly be denied that in art as in fashion, innovations are all too often just a return to something old. Even the one thing that the present day has to offer as something supposedly never before experienced was not really unknown before our own time. The mixed media of the Baroque opera, using elaborate stage machinery which was in fact even built into the altar fronts of Rococo churches, presented a subject such as the miracle of the Resurrection with moving figures, drums, trumpets, organ music, displays of flowers, the smell of incense, and rockets, all combined to produce

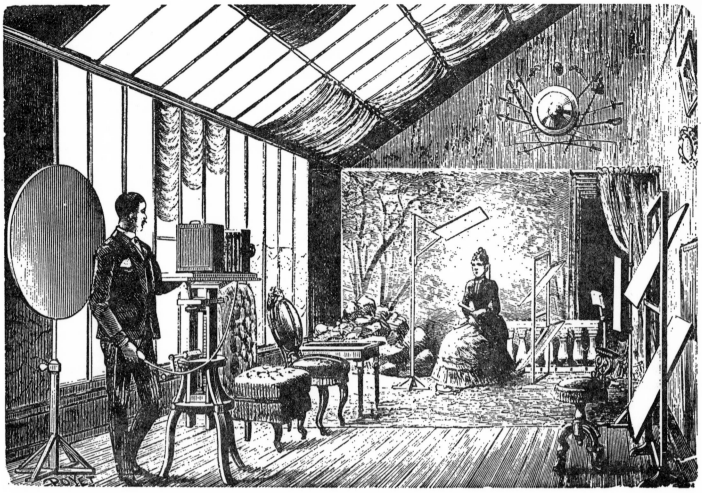

In the Photographer's Studio, wood-engraving by Poyet, Paris, about 1880.

something in every way equivalent to a happening in its effect. The fireworks and complicated automata produced for courtly celebrations of the past, the swinging, spinning, noise- and music-making carousels, ferris wheels, and other huge machines which have been offered to the crowds at amusement parks and funfairs for many years are actually nothing more than extremely lively examples of a very popular art form: pop art and kinetic art combined.

Thus, more or less the entire history of art shows itself to be Historicism *en permanence* or even *en rotation*. The change of styles from one period to the next is like the phoenix (or rather several of them) perpetually rising again from the ashes of iconoclasm, though the cycle is irregular. What right then do we have to despise the Age of Pomp? It was more varied and productive than other periods in art—more productive in imitations due to its technological achievements, and due also to its greater degree of knowledge.

So let us not be embarrassed to see beauty in eclectic splendor once again! The few surviving Victorian pubs and restaurants in England and elsewhere are now fashionable, and others are being refurbished with minute attention to accuracy with those items which not so long ago were used for firewood. Mahogany paneling with machine-carved ornamentation of the Second Rococo is there again in all its richness, set off with plenty of decoratively ground mirrors. Not long ago a Texas millionaire had a Victorian gentlemen's toilet from a street in the City of London transported out to him, and gas street lamps and fireplaces from Victorian houses have become popular embellishments to the country houses of wealthy people.

To be fair, however, the present revival of the Age of Pomp does not depend solely on snobs and the profits of keen-nosed art dealers. The most staid museums have begun to dust off their modern collections of one hundred years ago and bring them out of the storehouses where they have lain for so long, and research and specialist literature are becoming increasingly concerned with works produced by this period.

For this reason it was by no means difficult at the present time to realize the project of putting together a first specialized international survey of Historicism, now that it has found its rightful place in history. Experts were quickly found who were willing and able to provide material from their knowledge and ideas in their special fields. Their contributions, together with a large number and variety of illustrations, have gone to make up this book. Even a preliminary glance through it will prove what has often been doubted—though a few informed people have known better for some time—namely, that even this "styleless" second half of the last century had its own completely individual and unmistakable style. And it seems very much as though we are about to become very familiar with it.

September 1970, Insel Amrum

Hans Jürgen Hansen

Right: *Opening of the London World Exhibition at the Crystal Palace in 1851*, painting by Henry C. Selous, Lv.
Page 10: Castle Theater, Gottfried Semper, 1874—88 (above) and City Hall,
Friedrich von Schmidt, 1872—1883 (below) on Vienna's Ringstrasse.

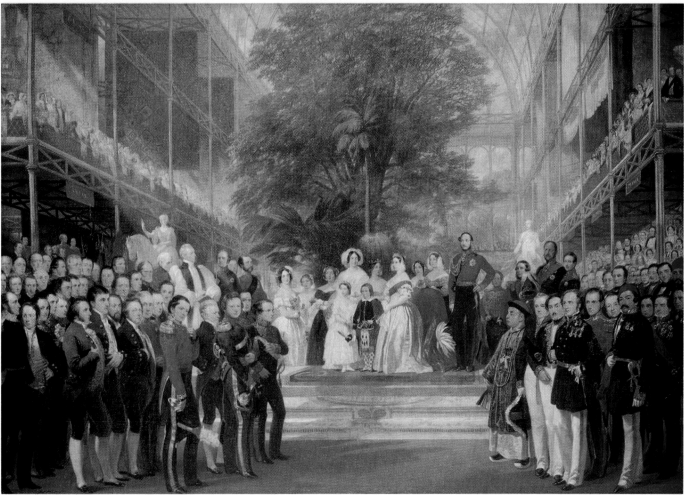

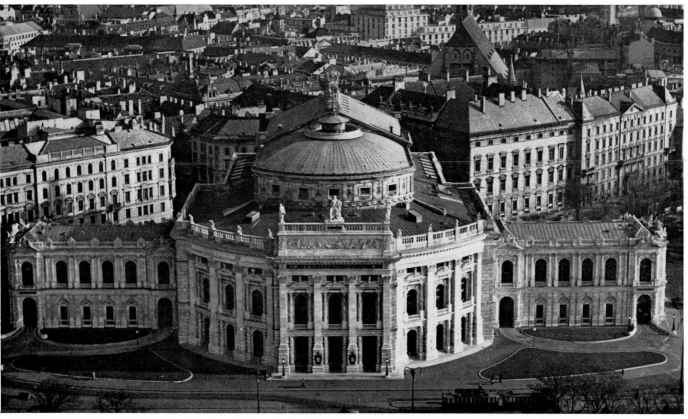
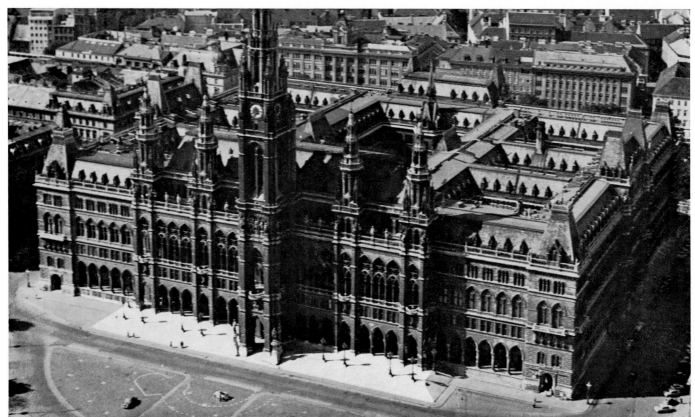

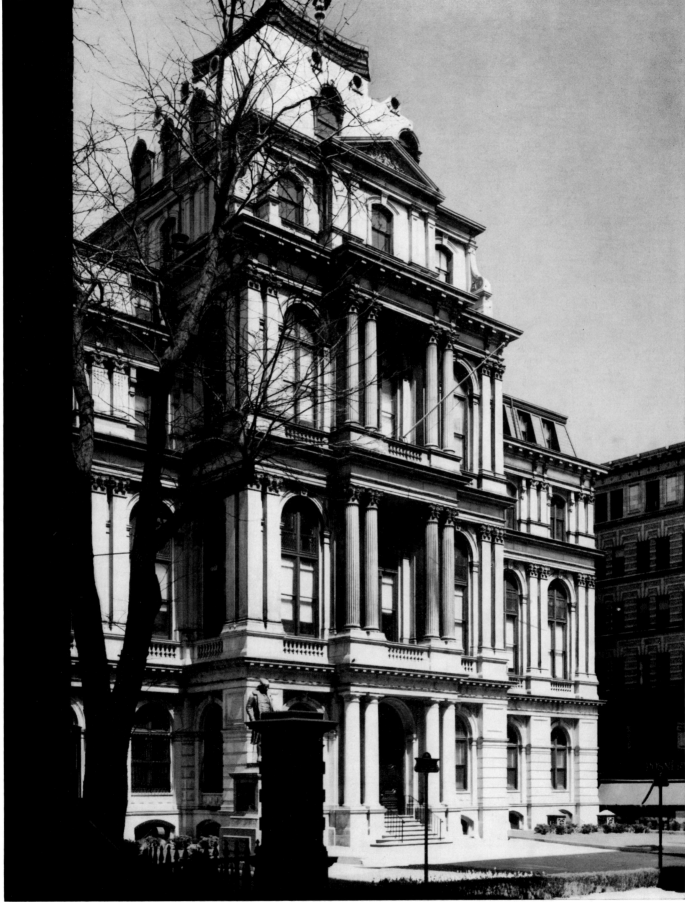

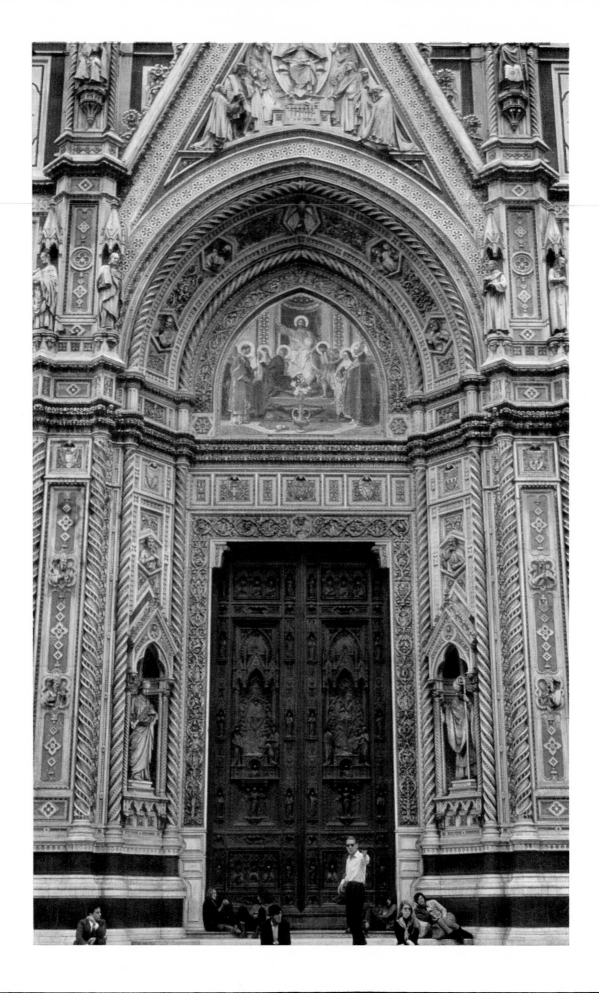

Architecture

The architecture of the period dealt with in this book begins with a fairy-tale castle. It was a miraculous building which grew up almost overnight in a spacious park, a palace of vast dimensions. No wall subdivided it so that it was like a single hall, so large that one could scarcely see from one end of it to the other, and so high that the ancient trees of the park could hold up their heads in it without hindrance. Nothing interfered with their growth, and even the sunshine could reach them unimpeded because the palace was built of nothing but light. There was no stone or wall around it; the walls were of pure, transparent crystal supported only by a thin iron filigree. The builder of this palace, the prince, filled it with all the wealth of his kingdom and precious things from every part of the world, and every subject of his country, and every foreigner too, could come and admire the treasures to his heart's content.

It is also possible to give a more sober account of the building: around the middle of the nineteenth century the capacity of British industry had grown to the point where the domestic market was no longer sufficient for it if it was to expand further, and new markets had to be secured overseas. A great exhibition of English products in London would demonstrate to the world the power and skill of the country's industry by an international comparison. Every nation in the world would be invited to put their products on show too. This Great Exhibition was the first international exhibition of its kind, the first world's fair, and had a tremendous impact, particularly in Europe. The building in which the Great Exhibition was housed was a masterly feat of civil engineering and so was in itself a very effective demonstration of the efficiency of British industry and the inventive genius of English engineers. It was a pure glass and iron construction on a scale which had never before been achieved: some 600 yards long, 140 yards wide, and more than 40 yards high. It was erected in Hyde Park, an extended hall with galleries at the sides down the length of it so that its cross-section was like a basilica with a high nave and low aisles. Everywhere the right angle and straight line dominated, except in the long axis where it was broken by a kind of transept over which the glass roof arched up. Here, in the center of the exhibition, stood a row of old trees which they had not wanted to cut down for the show. As though in a gigantic winter garden, they continued to flourish in the glass house. Winter gardens and greenhouses were also the direct technical antecedents to the London structure. Its creator, Joseph Paxton, was a gardener by profession. His idea had put every other competitor completely out of the running because no other project could offer the same abundance of light as this glass house. One should not forget how limited the capacity of artificial lighting was at that time and how especially important adequate lighting is for an exhibition. In this hall, whose walls were completely transparent, daylight could stream in freely from every side, making artificial lighting quite unnecessary.

But there was more to recommend his idea than this alone, for it could be put up with a minimum of expense and in the shortest possible time. Paxton had worked out a procedure whereby prefabricated, standardized cast-iron sections simply had to be fixed into position at the building site. These not only had the advantage that they could be used at every stage of the construction from the roof to the fence, but they also came equipped with all the necessary installations, such as channels to carry away water from condensation. The hall was erected in the amazingly short time of just over six months and excited as much wonder on the part of visitors as the exhibits themselves.

The building is no longer in existence, and all that we have left of it are plans, pictures, and descriptions.

Page 11: City Hall, Bryant and Gilman, 1862—65, Boston, Massachusetts
Left: Portal of the Cathedral, colored marble and mosaic, Emilio de Fabris, 1875—87, Florence

Nevertheless it still earns the same admiration from architectural historians today as it ever did from visitors in its own day. With it began an age of exhibitions and related buildings which either copied the hall—such as the Munich Glass Palace in 1854—or developed the principles of its construction further as technology progressed. There are, or were, countless examples of this in Europe and America. This was the first time in the modern age that the purpose of a building, the characteristics of a new building material, and the possibilities offered by industrial mass production caused a method of construction and a style to develop which purely and directly expressed the function and construction of the building. It was a forerunner to modern functionalistic building. In histories of recent architecture, this exhibition hall is always described as the point from which a direct line of development can supposedly be traced right down to the twentieth century.

However, architecture certainly did not follow this direct line. A statement by Lothar Bucher, a political refugee and correspondent of a German newspaper in London, is extremely significant for the following decades. He concluded an enthusiastic description of the building with the following lines: "The much-disputed beauty of the building...depends, in my view, on the fact that it is not possible to use the given materials, iron and glass, to achieve the given purpose better than Paxton has done. In future the same technique will be used to roof over large rooms, courtyards, railroad stations, hothouses and suchlike, but I cannot persuade myself that those people who claim that a new style in building, a revolution in architecture, will have begun with the glass palace have really given the question sufficient thought." The German architect, Gottfried Semper, had similarly interesting reservations concerning a structure of the same type in Paris two years earlier. It was the winter garden on the Champs Élysées, whose great hall of glass and iron planted with tropical species, along with the cafés and restaurants there, was, for a while, the meeting place of Parisian fashionable society. Semper said of the building: "I did not like the fact that the whole thing really did not consist of anything more than an enormous glass box...and that architectural considerations had played too small a part in its creation." To this he added some thoughts of a more general kind: "I have not yet come across one single example of an artistically satisfying exposed iron construction on a monumental structure. Only on structures with a distinctly

practical purpose such as roof-shelters with a large span...did it have a pleasing effect. Wherever else it is used it is reminiscent, often very disturbingly so, of cold and drafty railroad stations, making any cozy or cheerful atmosphere quite impossible."

The history of architecture in the second half of the nineteenth century is not the history of the new building materials (iron and steel, glass, and later concrete), and neither is it the history of civil engineering, the great railroad stations, bridges, and similar works. Not that the possibilities which technological progress brought to the building industry were neglected. On the contrary, they were completely ready to use every means by which the construction could be done quicker and cheaper, and the buildings themselves made more practical and comfortable. At times they were quite radical and uncompromising about the exploitation of new materials and techniques when putting up purely utilitarian structures. Yet it was rare for them to be regarded as anything more than expedients and designs which actually had nothing to do with architecture as an art.

"Ever since his earliest days man has never remained satisfied to build only according to utilitarian considerations. He was guided by higher ideas than the thought of his immediate need. Ideas like the fear of God, love of country, a belief in morality and law, and the joyful awareness of culture work together with that artistic instinct, which is an essential part of Man's nature, to go beyond the requirements of a building's function alone, and generate the impulse to add something to it which can exist quite independently of the function." What the nineteenth century expected from architecture could hardly be better expressed than in these words by Christian Öser in 1874 from his *Letters to a Maiden on the Main Points of Aesthetics*. (This is an abbreviated quotation from letter 19).

When Öser wrote this letter the attitude which he puts forward was, however, already beginning to lose its credibility. Architects' sketches still showed that their pens were reflecting "a joyful awareness of culture," but this was less to give expression to ideas of fear of God and love of country, or a belief in morality and law for that matter, than to show the self-confidence and wealth of an established society, a society no longer troubled by the disorders of those political and social changes which had still dominated the scene in the middle of the century and had their influence on architecture. At that time the major concern was still with overcoming the revolutionary

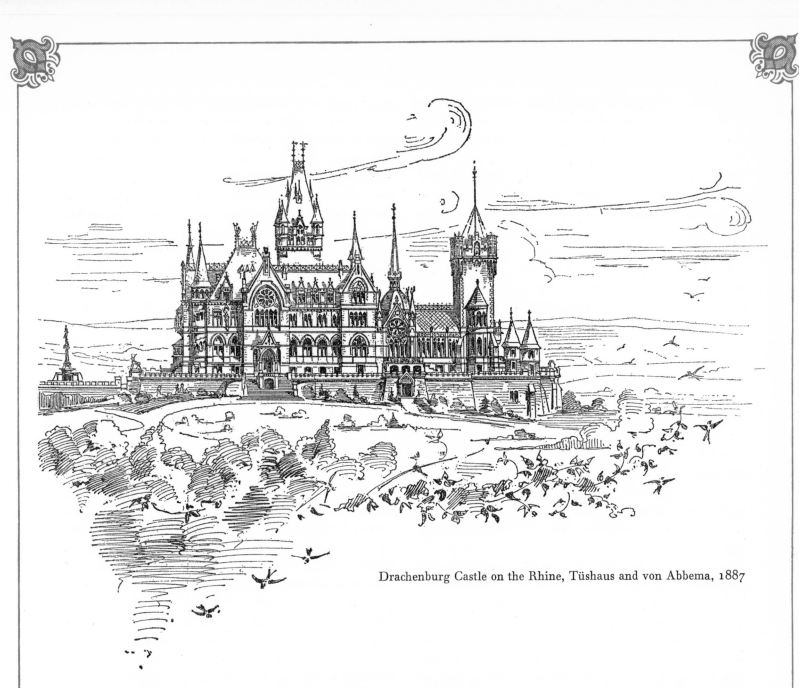

Drachenburg Castle on the Rhine, Tüshaus and von Abbema, 1887

movements which had begun in the late eighteenth century and did not end until the (temporary) restabilization in the second half of the nineteenth century. The collapse of the old political and social order and the struggle to establish new ones, the accelerated pace of technological development and the rise of an industry organized for mass production, and finally the population growth that rose by leaps and bounds and resulted in the increased size of cities presented builders with a new set of problems that were not always easily dealt with.

Never before in the history of the West had there been so much building as in the nineteenth century. It may be no exaggeration to say that more buildings were put up in this one century than in all preceding centuries of Western history combined. In spite of this, the main problem was not how to raise the output of buildings sufficiently to meet the increased demand. There was no lack of available labor, technology provided new methods and materials, and the new means of transport, the railroad, made it possible to deliver building materials to any place they were wanted. There was no technical problem about constructing ever more and ever larger buildings in ever shorter spaces of time. The question of land for building on seemed to present no problem either. The cities, which in some cases were still held in and constricted by the ancient ring of fortifications up until the middle of the century, burst their bounds and used the surrounding country as a reservoir of building sites which at that time appeared inexhaustible. While on the one hand industry provided the means for coping with the situation facing builders, many problems which architects had to solve during this period arose directly out of

the effects of industrialization. Not least among these was the concentration of the population in cities, so that almost all the construction done was concentrated at these main points. What took place in the countryside far from the cities in the second half of the nineteenth century is almost completely without importance for architectural history.

Industrialization was also the driving force behind changes in social stratification and a redistribution of political power which was reflected in architecture and posed problems that were more difficult to solve than the purely quantitative satisfaction of demand. New forms of state—or even municipal—and private images had to be found; new kinds of buildings appeared which demanded new artistic solutions.

With private houses it was possible to go back to older forms. Although the old ordering of social class structure was breaking down and changes in the distribution of wealth led to changed positions on the social ladder, people were still willing to go back to the forms of the old order to find a social image. The big industrialist, the banker, the successful businessman, or whoever could afford it would build himself a manor house or possibly a castle in medieval style, and even for those with lesser fortunes there were garden cities and residential suburbs where they could build homes which had the general appearance of a manor or castle, though on a rather smaller scale. Then there were various kinds of apartment houses in the center of the city itself—and these were not exclusively for the poorer section of the population—in which, since the house was shared with several other families, social rank or pretension was expressed in the way the rooms were furnished.

It was more difficult and problematical to go back to old ideas for buildings which had a public role to fill. In these cases requirements had to be met for which earlier times had either had no solution at all or one which applied to a set of circumstances no longer relevant to the new situation. In the first half of the century, for example, a large number of theater and museum buildings were put up to fulfill a function which had formerly been restricted to the setting of a castle, but now had to serve a broader public. In the second half of the century the new disposition of power in the state gave rise to new needs for the accommodation of the administration, the legislative and the executive bodies for which new types of buildings were developed. In the capital cities of every state great parliamentary buildings, ministries, and, not least, courthouses appeared whose size and massiveness were often quite awe-inspiring and accurately reflected the authoritarian character of these societies. We can see this in such examples as the Palace of Justice in Brussels erected in 1866—83 by J. Poelaert, which towers menacingly above its surroundings like a mountain range in stone.

New kinds of building also arose as a result of the new developments in production, trade, and transportation, including the need to supply the wants of large concentrations of people in the cities. Factories, railroad stations, banks, department stores, and hotels are just some of these new tasks architects were faced with.

It might have seemed the obvious course to base the design solely on the purpose of such structures, to find a functional form which would insure the greatest possible practical advantages as the hall for the London international exhibition had done in 1851; yet it rarely happened that way. People were not generally prepared to allow a building's purpose and the materials employed to determine its form. Though its function was the essential reason why a building was erected, it was still regarded as a base consideration, and they shrank from expressing it unless it was ennobled by some higher idea. Architecture had to give expression to this higher idea rather than the practical aspect.

Perhaps ideas from an earlier time were still having their effect. Ideas may have persisted from the time of absolute monarchy when the king was still the embodiment of the state and the palace was also the seat of government, when the pomp and circumstance surrounding the monarch and the wealth expended on him—and his buildings too, of course—were an important element of political life and part of the business of state.

Right: Pavillon Richelieu of the Palais du Louvre, 1852—80, Paris
Page 18: Palace of Justice, Poelaert, 1866—83, Brussels (above); Gare du Nord, Hittorf, 1861—63, Paris (below)

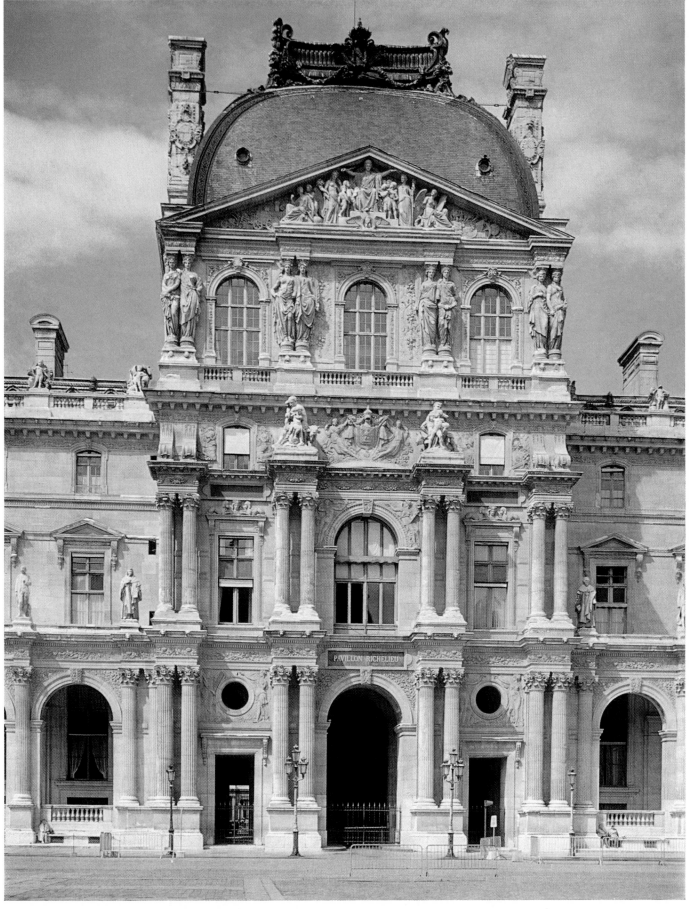

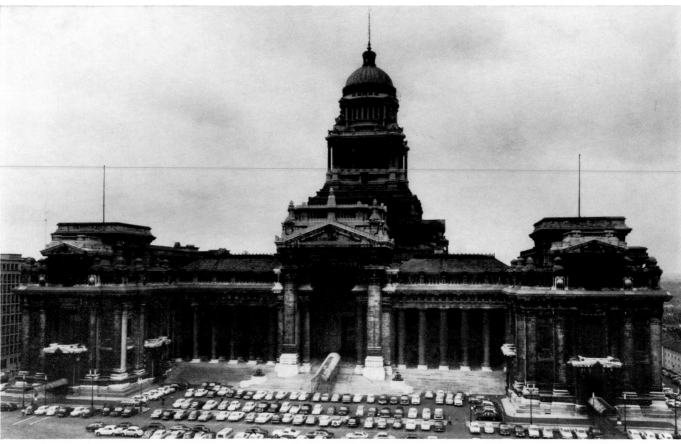

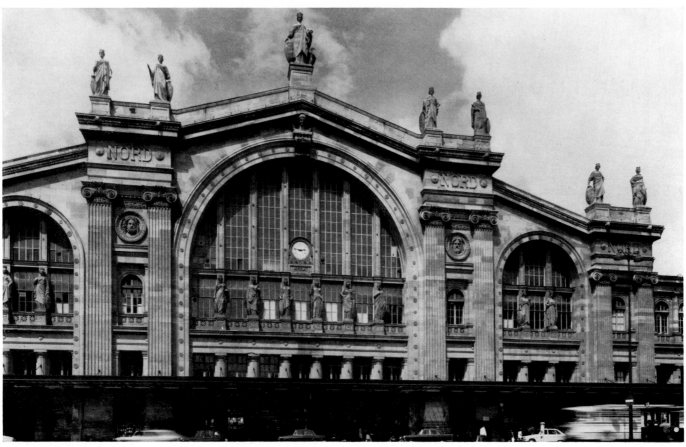

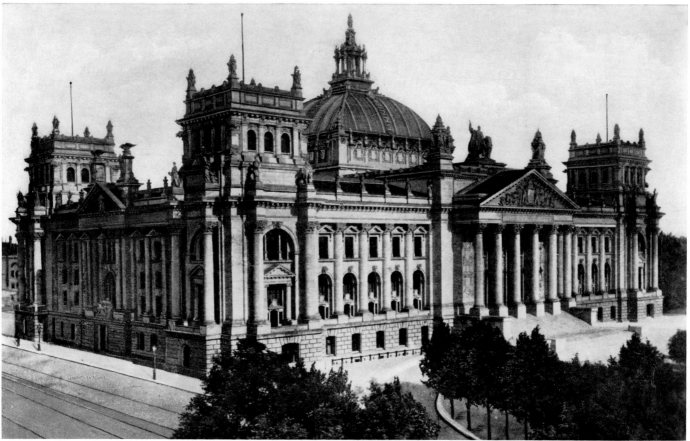
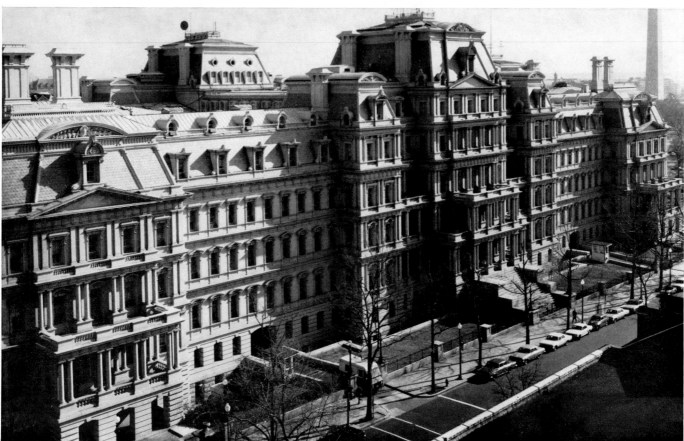

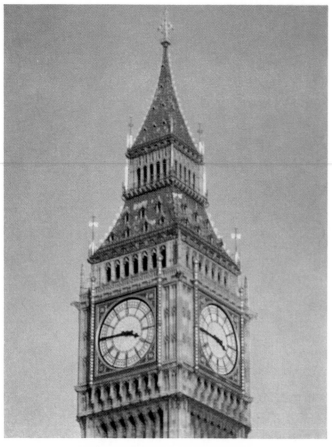
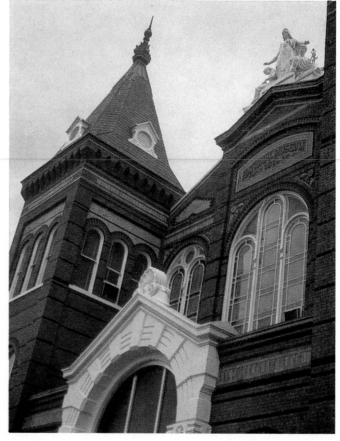
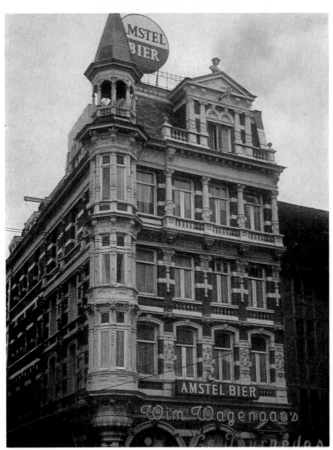
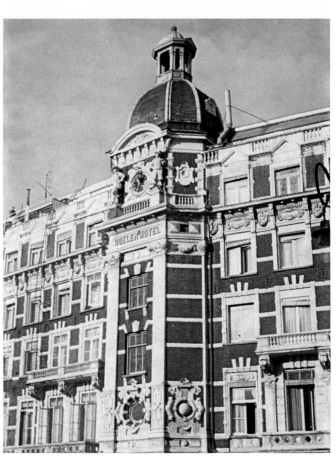

In the second half of the nineteenth century, beauty in architecture was based on artistic ornamentation which was added on to the functional structure and very rarely developed out of it. Factories and warehouses might be allowed their purely functional form, yet even such purely engineering structures as rail- or road-bridges were often enough dressed up in a costume borrowed from the Middle Ages. In doing this they deliberately ignored the fact that, while the new bridges were supposed to represent the smoothest and most convenient possible link in communications, in medieval times they had been frontier posts and intended for defense, serving to interrupt as well as facilitate traffic. Even the glass palace in London was not conceived as a purely functional structure. It may not be a very important point, but the plan was not completely free of any symbolic meaning, as it was made exactly 1851 feet long, to represent the year the exibition was opened.

Just how unready the public was to see this exhibition hall as a purely utilitarian building can be gauged from the name that was bestowed on it quite spontaneously and under which it has gone down in architectural history: The Crystal Palace. And the first commentators to inspect the exhibition extolled it as the Temple of Industry or Aladdin's Palace.

Temple and palace—the century always took old types of buildings as models when new architectural forms had to be found to answer new requirements. In order to fully realize them the forms of earlier European and, less often, foreign artistic styles were used. This procedure is not particularly remarkable in itself, however. Since the Renaissance at the latest it has been a completely normal practice to go back to past stylistic periods for the enrichment of one's own modern artistic expression. What made this approach seem so awkward in the nineteenth century and has caused the almost universal rejection of art from the period of Historicism was the

apparently arbitrary way completely different and contradictory styles would be used together.

It was not unusual either to hope for more than just a revival of art by such a return to historical forms. A renewed sense of the thought and ideas of the age concerned was supposed to be linked with it, art being only the outward expression of its revitalization. The Renaissance, by adopting one single historical epoch and evolving a unified conception of style—that of Greco-Roman antiquity—developed an ideal which for a long time had a quasinormative standing. Even when this ideal was departed from it still served as a stable yardstick against which practicing artists could measure their achievements. In the nineteenth century, especially the second half, there was no particular stylistic ideal with normative standing. Every imaginable period in which art was produced could now serve as an inspiration. There was agreement only on the basic principle of borrowing from historical models.

This does not mean that the aesthetic outlook of this age was as varied as the models it adopted. It is too often assumed that the revival of stylistic forms is identical with reviving the style itself. Actually, terms like Neo-Gothic, Neo-Renaissance, or Neo-Baroque do not mean three distinct styles, but rather three possibilities of decorative form within a unified conception of art which, like any other stylistic period, naturally developed through a slow process of evolution. The changing preference for particular historical models could be, at the most, a reflection of this evolution. But essentially the adoption of any stylistic model was possible during every phase of Historicism.

Until the beginning of the nineteenth century the decorative principle of architecture had always been identical with the style to which it belonged. When foreign decorative motifs became incorporated with it they were generally so altered that sometimes their

Page 19: Reichstag Building, Paul Wallot, 1884—94, Berlin (above); State, War, and Navy Department Building, Arthur B. Mullet, 1871—75, Washington (below)

Page 20: Clock tower of the Houses of Parliament, Sir Charles Barry, 1840—60, London (above left); Smithsonian Institution, Arts and Industries Building, Cluss and Schulze, 1880, Washington (above right); Apartment and business building, about 1890, Amsterdam (below left); Doelens Hotel, about 1890, Amsterdam (below right)

foreign origin could hardly be recognized. From that time, however, in the same way as the purely functional structure became separated from architecture as an art, decorative form became separated from the style and could be employed in any way desired or else—as in the case of utilitarian buildings—given up completely.

Although the ways in which decorative form could be used had become so much freer, this did not mean that in every case it was exploited completely arbitrarily. As a rule it was there to represent an idea and was handled with a great deal of deliberate care in order to express and propagate this idea. Thoughts of patriotism, political ideas, civil virtues, or religious ideals were associated with particular stylistic models, determining the way they were used and frequently giving the architecture of this age an allegorical character which is hardly ever immediately clear to us today. "My endeavor," wrote Georg von Hauberrisser, builder of the Neo-Gothic city hall in Munich, in his autobiography, "is to create works—as a good German—'In the German spirit'!" And so his buildings were erected in "German" styles, i. e., borrowings from the Gothic (which at that time was considered a national style in both Germany and England as well as the country where it originated, France) or the German Renaissance. And in planning or building city halls with a high tower wherever it could be arranged, he was, of course, also reflecting the aesthetic outlook of his time; Hauberrisser himself justified these towers—on the model of Gothic, and in particular Flemish, city halls—as symbols of civic freedom.

With church buildings, similarly, the return to a medieval form was not primarily based on aesthetic considerations, but rather on the idea that it "best reflects our religious outlook and is an expression of our prayers." This was the way Prelate Johannes Graus expressed it when appealing to the public for donations for a project to build a Neo-Gothic church.

On the other hand the sacramental origins of the Gothic and the favor it found in the nineteenth century among clerics led to the condemnation of this style in liberal circles. They saw the Neo-Gothic as nothing but "reactionary folly," a relapse into Papism and the "dark days" of the Middle Ages. The same mistrust was felt towards the Baroque as being the style of absolute monarchy. Instead of these, especially among German liberals, imitations of the Renaissance were favored as being art of the middle class. Buildings by the German architect Gottfried Semper are a notable example of this.

These are just a few random examples, which could be multiplied indefinitely, demonstrating the "allegorical" background of architectural Historicism. They occur throughout the entire period, though less frequently after about 1870. Architecture of the last third of the century largely dispensed with such "literary" associations and appeals to the senses much more directly—while still using historical forms as before—by its magnificence and lavishness.

The aesthetic view that lies behind the historically oriented decorative forms of Historicism brought about a collapse of the Neo-Classical aesthetic of the first half of the century at the beginning of the period. People were certainly correct in regarding the glass palace of London in 1851 as an example of a functionalistic way of building which was indicative of what lay in the future. And yet its style is really backward for its time. The predominance of horizontals and smooth surfaces, of the right angle and the straight line, the regularity of its ground-plan and the way similar forms were repeated one beside the other in endless rows are all elements which it shared with buildings dating from the thirties and forties of that century. This can be seen in the buildings of Munich's Ludwigstrasse or even the Houses of Parliament in London (though there are some characteristics of anticlassical architecture as well). These are buildings from the second phase of Neo-Classicism whose forms were lighter, more elegant, and less dramatic than the first phase. Its main characteristics were the plainly delimited firm outline, the blocks generously spaced on the ground, and the surfaces of the façade arranged at right angles to one another.

Though this kind of building continued long after mid-century, by the time the glass palace was erected opposition to it had already grown up. An alternative conception of architecture was offered which the age itself termed "Picturesque." Whereas the outline had previously been developed working from the outside to the inside on the basis of a regular rectangle which was divided up in the most rational way to provide the individual rooms, this closed form was now abandoned and loosened up. The outline was arrived at by putting individual rooms together in a loose arrangement where particular parts might project or recede. The rooms themselves were often irregularly shaped. They could be round, polygonal, or have oblique walls, and sometimes they incorporated smaller alcoves, bays, and similar added structures. The outline of the building becomes irregular and broken up vertically into various steps and levels by

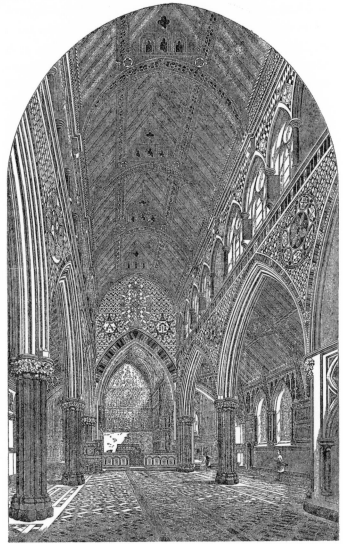
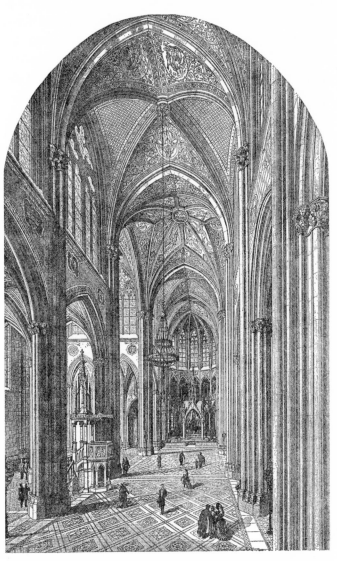

Left: Interior of All Saints' Church, London;
Right: Interior of the Votive Church, begun 1856, Vienna

parts of the building of differing heights, by towers and gables and roofs which project into the air. The firm, clear line has been abandoned, and the upper limit of the building seems like a fringe of pinnacles, uneven roof structures, and other forms which break up the vertical line. "Secondary" parts of the building, such as the roof for example—until now generally concealed—were developed and extended often to an astonishing size. A compact block was no longer desired, and instead various structures were grouped together and balanced against one another. The building takes on a multiple form derived from the way its various individual parts and sections interlock and interrelate. Symmetry and the hierarchy of forms is abandoned in favor of contrasts, horizontality in favor of verticality, and instead of the building's resting firmly on the ground "flying" structures are introduced: bays, loggias, balconies, and smaller towers built on at the upper floors. Asymmetry and groupings of separate forms were also predominant in decoration. The overall effect achieved is the result of the combination of all its often very different individual parts, instead of a rhythmic repetition of the same form.

Just as each part of a particular building is stressed as an independent entity and not absorbed into a dominating overall form, each building stresses its own individuality, its own special character, with regard to its surroundings, which means above all its neighboring buildings. It seems that the architecure of this age wanted to lay particular stress on the personality of the individual against the rising tide of state bureaucracy and the mass society. And indeed the idea of the Picturesque and the ability to employ freely many different stylistic forms opened up the possibilities for builders to express their individuality as almost never before. It was like a costume ball at which you could have your architect make up any kind of dress to suit your ambitions, character, or social standing.

The idea of Picturesque building could be realized most easily where there was no need to make any allowance for the size and cost of the site, neighboring buildings, the purpose of the building, or any considerable

legal restrictions: That is, for the construction of private houses some distance from the city or else in the more spacious countryside areas surrounding it. The more elaborately conceived the ground plan was, the more space would naturally be required for it, and it could therefore be achieved most fully where land was plentiful and freely available. Consequently, Picturesque form first reached its full development in great country houses. This happened before mid-century even, in the late thirties and the forties. It found particular favor in England among the aristocracy, who often expanded their country mansions into complex arrangements where individual tracts of land with an elaborate ground plan were set together to make a loose grouping, generally around a courtyard. It is also a significant factor that these country seats included stables, farm buildings and so on, which, unlike buildings in the city, had many different functions to fulfill.

Nevertheless, richness of form in buildings also had its success in the city. For this, private builders were able to profit from the way towns were growing by breaking out of their old boundaries and steadily absorbing the surrounding countryside areas. Cities were expanding continuously, often covering several times their former area, and to do this they took over what seemed then to be virtually unlimited building land. It was used for a more spread-out style of building which made it possible to put up houses in the middle of an area of garden, so separating it from the neighboring houses. It so fully reflected the tendency towards "individualization" of buildings that, all round the tightly packed centers of cities, garden suburbs grew up whose villas—though more compact in ground plan—were in no way behind country houses in their richness of form. It sometimes seems amazing what a variety of different forms architects managed to find a place for even on relatively small houses. There were towers and turrets, gables and pinnacles, bays, garrets and loggias, terraces and balconies, and roofs that interlocked together and were overlooked at some points by the tips of towers or the domelike structures built on them.

Right: Garden front of the Victoria and Albert Museum, London.
Page 26: Old Corcoran Gallery, James Renwick, 1859, Washington

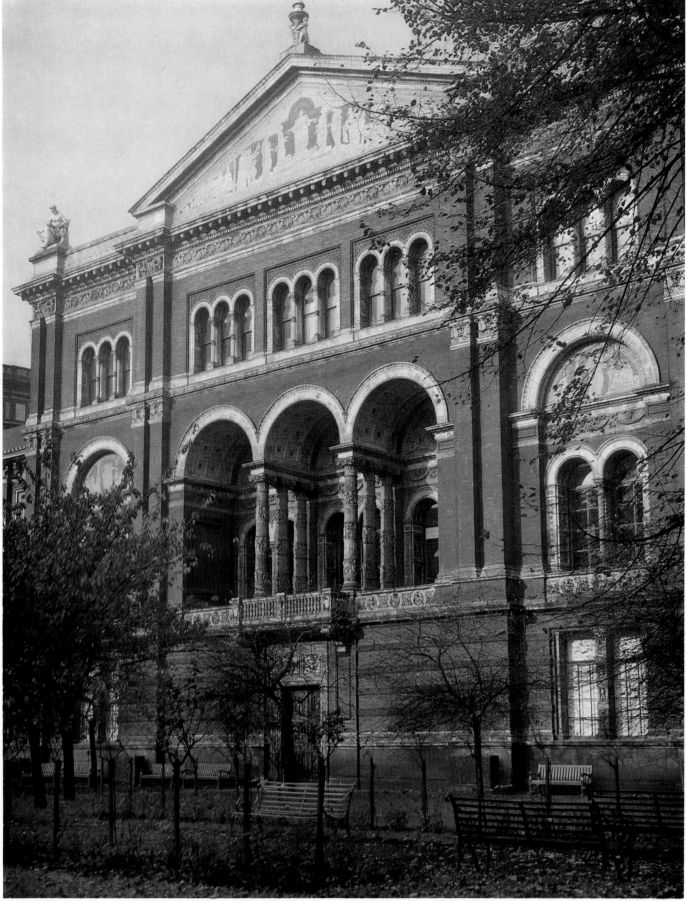

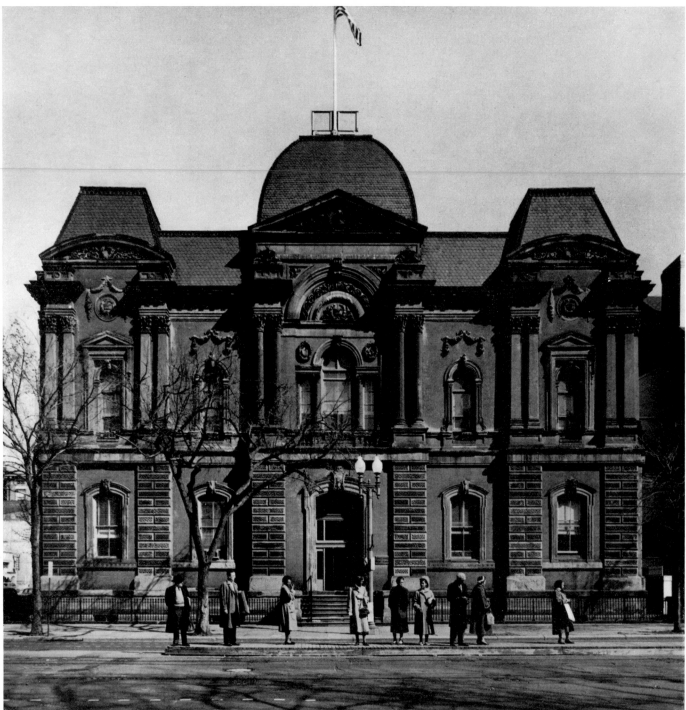

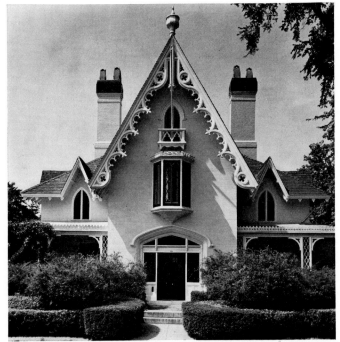
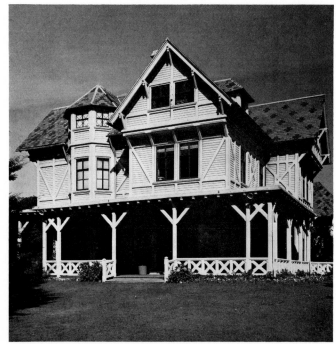
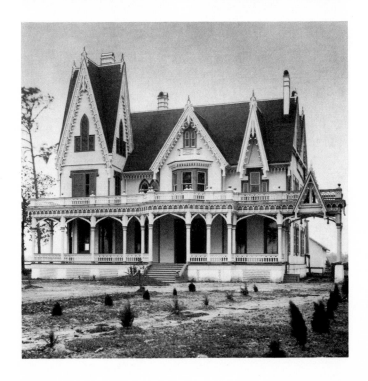
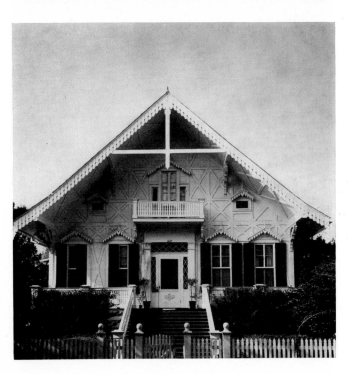

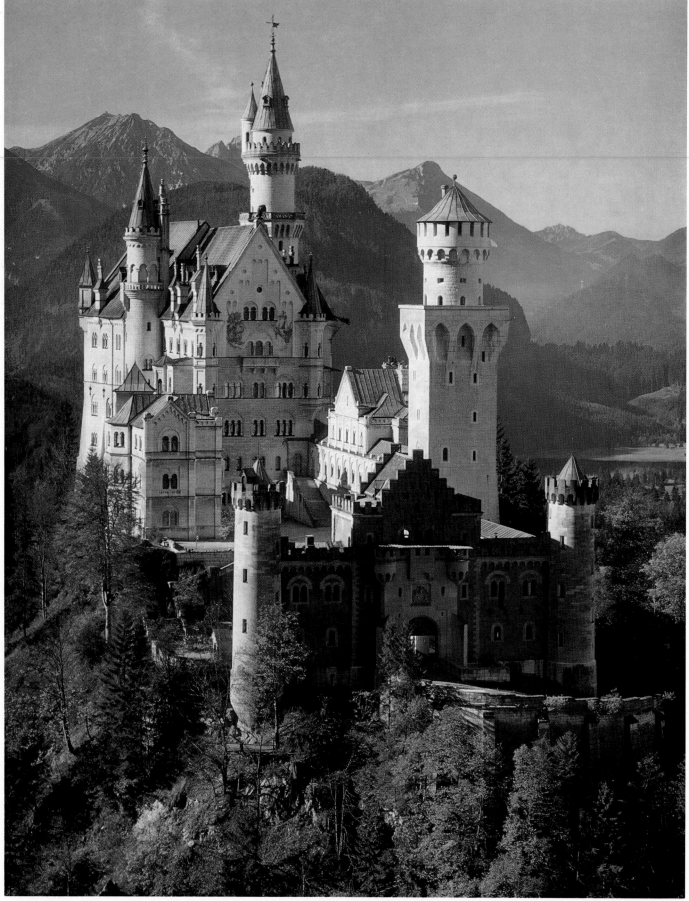

It was more difficult for the architect in the central areas of the city where houses had to be built in serried ranks, wall to wall with neighboring buildings. Very extensive legal restrictions sometimes set close limits on the freedom of the architect's imagination, but the need to make the most economical use of the expensive sites was almost worse. The builder could not afford to waste any of the area, or even the air space, that was allowed him by the regulations either on the ground plan or the elevation. The most economical form for these structures was a block with identical floors arranged one on top of the other without any break in the alignment, based on a regular rectangular ground plan. Countless buildings—particularly tenements built on high-interest capital—were erected on this pattern, and only the stucco covering of the façade is there to provide any enrichment of their appearance.

On the other hand there were still many luxurious buildings which even though in a row of houses did not spare the expense of rich forms. They were, however, tied to the general alignment and roof level, so that the variations in form available were restricted to the surfaces. In spite of this, by calculated asymmetries of the façade; differences in the size and shape of window spaces and the way these were set in groups rather than in regular rows; high gables which interrupt the gutter line and whose edges could be curved, in steps or serrated; and smaller added structures such as bays, balconies, and many other devices, it was possible to escape the monotony of row housing and stress the house's own unmistakable individuality. Architects evolved a high degree of inventiveness in doing this. Corner sites were the most popular since they presented an asymmetrical form, and, using a tower set on the corner—this would generally be a bay tower which began at the second floor—the character of the façade as simply a surface could be overcome and the building made meaningful as a three-dimensional shape.

It has already been stated that when the architecture of Historicism borrowed formal motifs from historical styles it did not take over their aesthetic principles too. And it was therefore possible to create this essentially anticlassical architecture using motifs of every style, even those styles based on orderliness and classicism. This possibility was made full use of, and there was no style without its enthusiast. However, the beginning of Picturesque architecture is associated with the revival of one style in particular—the Gothic. And not without reason: Since they were turning against an aesthetic idea which for preference adopted the garb of antiquity, along with the governing principle they also rejected the specific form of Classicism. The Gothic, on the other hand, was a model which not only offered an untapped supply of forms for the external design of an architecture striving for a new mode of expression, but, more than that, it was also much closer in spirit to the structure of buildings they were striving for. The medieval castles and churches must have seemed precursors of their own efforts from the way that they too showed similarly contrasting groups of buildings arranged to make up a richly balanced whole. One could, of course, also use forms belonging to antiquity—employing asymmetries, the addition of towers, and so on—to create these complex arrangements, and it did happen, but the affinity with Gothic structures made it particularly attractive to take buildings from this period as a model.

The Gothic revival goes back to the eighteenth century, but hardly affected the plastic arts during its early stages. In the beginning, the movement found its main response in literature. Goethe's essay "On German Architecture," which he wrote after being completely overwhelmed by the Gothic architecture of Strassburg Cathedral, Walter Scott's romances of chivalry, and the novel *Notre Dame de Paris* by Victor Hugo, are just three facets of this literary aspect. When Gothic motifs were taken up and used in the decorative system of the late,

Page 27: Rotch House, Alexander Jackson Davis, 1846, New Bedford, Massachusetts (above left);
Griswold House, Richard Morris Hunt, 1862—63, Newport, Rhode Island (above right);
Ardoyne Plantation, C. Mile Williams and William C. Williams, 1894, Terrebone Parish, Louisiana (below left);
Bullit-Jones House, Cuthbert Bullit, 1869, New Orleans, Louisiana (below right)
Left: Neuschwanstein Castle, 1869—1886, near Füssen in Allgäu

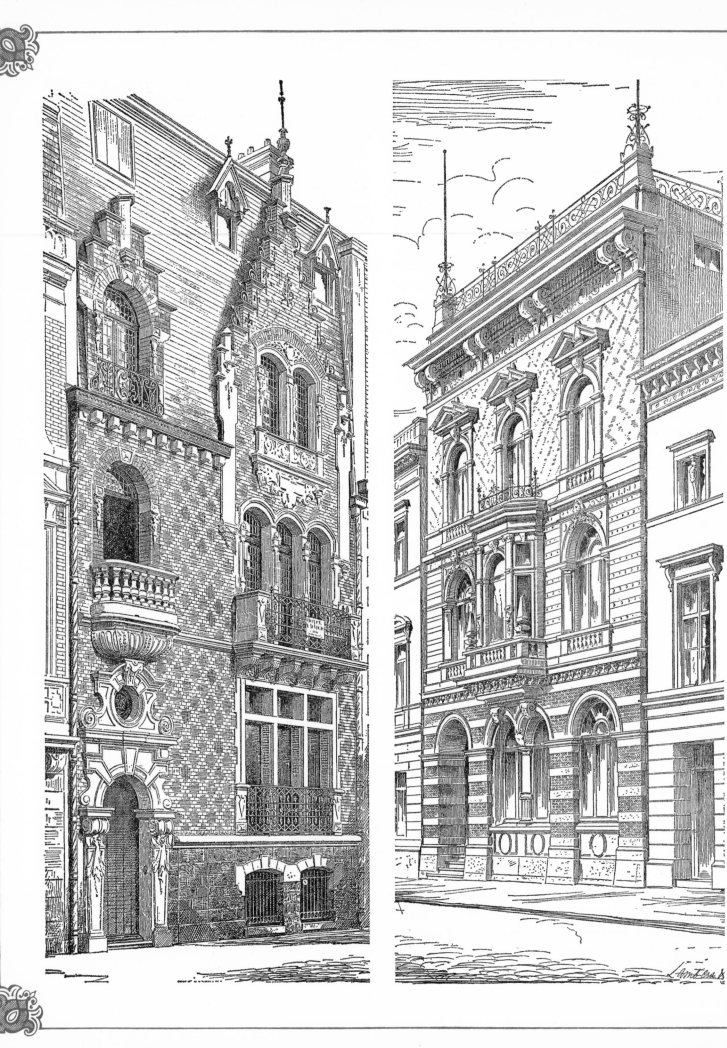

romantic, phase of Neo-Classicism they had to conform with the pattern of the clearly delineated surface as an endless repetition of identical formal elements. It was not until the Picturesque houses, in which the plain overall outline was abandoned, that the Gothic emerged as the predominant stylistic model. Not just churches and castle-like dwelling houses, but also large administrative buildings, business premises, and even railroad stations, were built according to the medieval mode.

Neo-Gothic architecture lasted right up until the first decade of the twentieth century, yet very soon, as early as 1850 in fact, a powerful rival to it appeared in the Neo-Renaissance. The reasons for this are many. They are, as mentioned earlier, partly political in origin. Enlightened liberalism condemned the Gothic revival as a relapse into clericalism and irrationalism, choosing instead the example of the Renaissance as an epoch of the sciences and of open-mindedness in which the middle class emancipated itself and set its stamp on society. The architecture of the Renaissance was praised for its rational and urbane character. For this reason, it was seen as better suited to the middle class than the medieval style. A Classicist undercurrent made its appearance once again as a result and was only temporarily masked by the Neo-Gothic. In fact the model of Italian Renaissance façades was very helpful to an architecture which had to deal with the problems of a straight line of row houses and the continuous surface of a common street front. In addition, with this style a more rational use of the area of the site and the air space is possible, and this was an important factor for larger buildings too. There is certainly no doubt that a design in the manner of Picturesque, and especially Gothic, architecture always ran into difficulties where long sections of building had to be laid out with an endless series of rooms of the same size repeated behind the façade, such as was needed for administrative buildings. There was then a considerable danger that for the sake of an elaborate structure the building would be broken up into a complex of many different parts, becoming nonfunctional, impractical, and unsatisfactory for its intended purpose. The London law courts by

G. E. Street, which even when they were opened in 1882 were called "the grave of Neo-Gothic," are an example of this. Alternatively the architect could preserve the regularity of the ground plan and the arrangement of the rooms, but try to offset the repetitive lines by putting a façade on the building which bore no relation to what was inside. Balconies, bays, turrets, and gables could be used to produce as irregular and asymmetrical an effect as possible. This approach can be observed on the side face of the Munich City Hall by Georg von Hauberrisser, which was not completed until 1908.

Similar problems were also involved with larger buildings such as department stores which did not contain many identical rooms, but just a few big ones. Here again, a unified and regular type of façade would seem better suited to the purpose of the building than one where the architecture uses arrangements in groups and contrasts.

However, such functionalistic arguments carried no power to resist the creative urge. Quite a few buildings did appear which were constructed on the pattern of the Italian Renaissance, such as tenement blocks divided up into many different apartments, but their monotonous façades were expressive of the impersonal relationship of both the builder and the occupants to the building. It was more common for the owner and the architect to try and raise even a large building above the anonymity of the mass of housing in the city by giving it various particular touches and designing a very rich and "personal" façade. This did not mean that building in the Renaissance style necessarily had to be avoided. Instead of borrowing from Italian Renaissance models they went north of the Alps to find the far more colorful formal language of the native variants of this style, at the same time bringing in the idea of the Renaissance as middle-class architecture and the argument for a national style, which was a particularly important concept for the nineteenth century. Even the supporters of Neo-Gothic had used this argument. By about 1860—1870 the national variants of Neo-Renaissance had become predominant almost everywhere in Europe.

Page 30: Dwelling house on the Boulevard Pereire, Brisson, 1887, Paris (left);
Residence of Senator Mann (parental home of Heinrich and Thomas Mann), Julius Grube, 1887, Lübeck (right)

Even at this time, however, yet another phase of architecture was beginning which dominated the last decade of the century and represented the high point of the Pompous Age. It did not carry with it any particular association and developed mainly out of the desire to achieve the greatest possible sumptuousness. The political situation had become settled, the class structure of society was (for the moment) stable; it was no longer necessary to expect architecture to propagate ideas. People had grown rich and were proud to show it. They built themselves palaces whose stone masses of stifling weight must have had a really intimidating effect on passers-by. This applied to every kind of building whether it might be a private house, business premise, store, bank, or insurance building, and it also applied to buildings belonging to the state. The architecture of these years neither had much affection for the confused structure of the first stage of Historicism nor did it particularly prize the plain surfaces of Neo-Renaissance façades. The ground plan was actually similarly regular and used the site up to the last inch, but above it towered a massive block of stone, a structure of massively rich plastic form with an array of ornamentation of an equal heavy plasticity, most of whose elements were borrowed from the Baroque. They loved, as Johann Jahn said, "what was gushing, pompous, with mighty rhythms, not lightness and delicacy but something ponderous and heavy; not the harmony of beautifully proportioned surfaces, but the massive effect of plasticity in projecting areas." State buildings preferred regular and symmetrical forms, going back to classical formal ideas with the use of columns and triangular gables. However, the columns are used less for a rhythmical division of the surface than to give plastic depth to the façade. Frequently the wall is pierced with deeply shadowed openings between which the heavy columns are situated for plastic emphasis. The center of the building and sometimes the corners too are accentuated with added structures. A favorite motif is a dome, or something shaped like a dome, which rises above the center point like a crown. Private and business architecture follows the same principle of plastic modeling of the entire structure. With them, too, the middle, or even more often a corner, is given emphasis by the use of an added structure in the form of a dome. In these cases there is less concern with symmetry and regularity than in state buildings, and even more stress laid on the greatest possible amount of decorative forms and on "the massive effect of plasticity in projecting areas." The buildings of this period frequently seem disproportionately large relative to their surroundings and are quite intimidatingly massive.

The high point of pomposity had been reached. The reaction against it was quick to follow, and before the century was ended voices were raised which pronounced their condemnation of the preceding five decades. At the same time the first buildings appeared which tried to break out of the principle of stylistic imitation and so point the way into the architectural history of the twentieth century.

Rejection of the architecture of Historicism for many years has had the result that this period, though very close to our own, is almost unknown today. Apart from work done in England, art historians have hardly bothered with this period. Many architects who were famous and widely employed in their own time are now forgotten and their buildings have become anonymous. Only the few names which are associated with the great public works of the age now remain. Often it is just their names and nothing more, for few people still remember anything of their lives or work. Many important buildings have been destroyed, not only by the war but also because they have been torn down as not being worth preserving. The knowledge that we have of the architecture of the second half of the nineteenth century is therefore often only accidental and fragmentary.

While the development of architecture followed by

Right: Linderhof Castle, 1874–78, near Garmisch in Upper Bavaria
Page 34: Gallatin House, Nathaniel Goodell, 1877–78, Sacramento, California (above left);
Morse-Libby House, Henry Austin, 1859, Portland, Maine (above right);
Olana, Frederick E. Church, 1870, near Hudson, New York (below left);
Villa by the Wannsee, end of 1877, Berlin (below right)

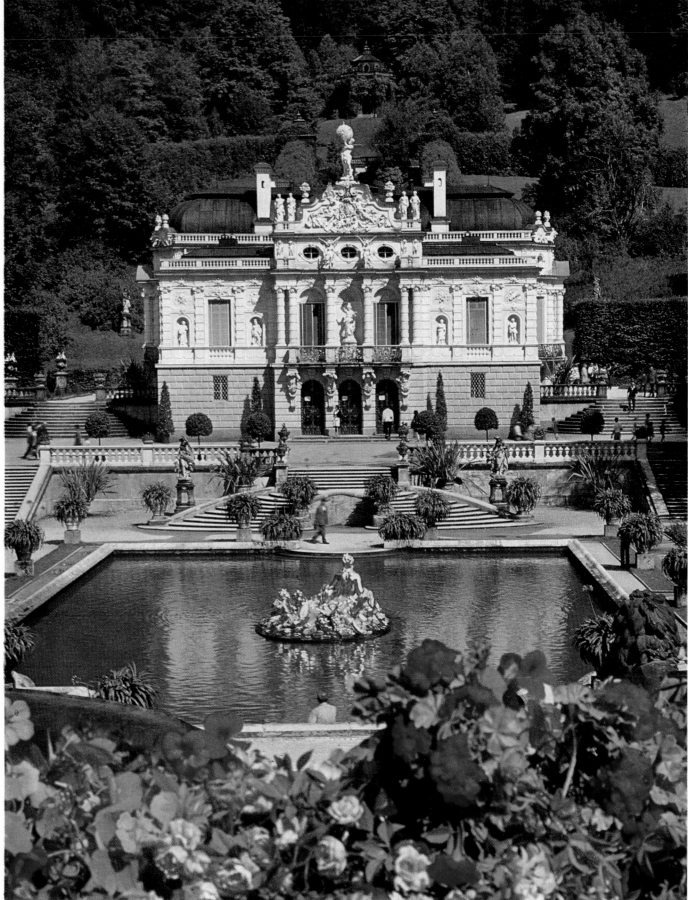

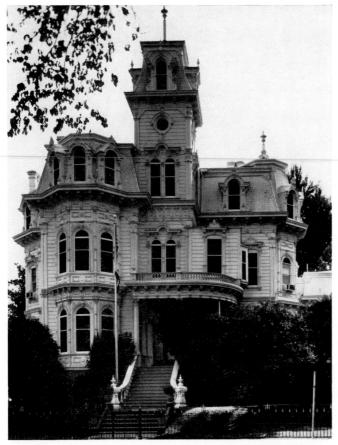
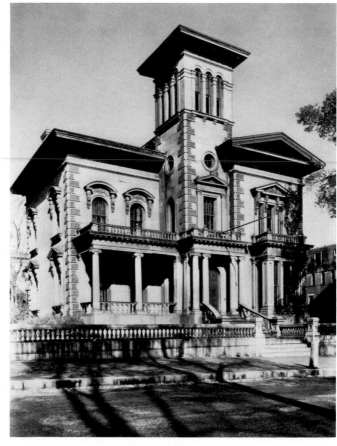

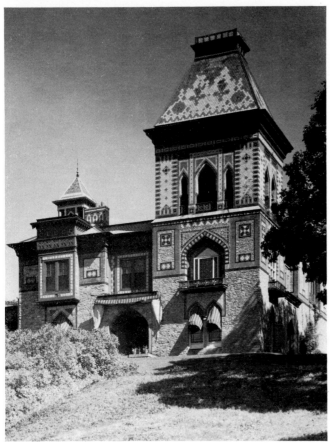
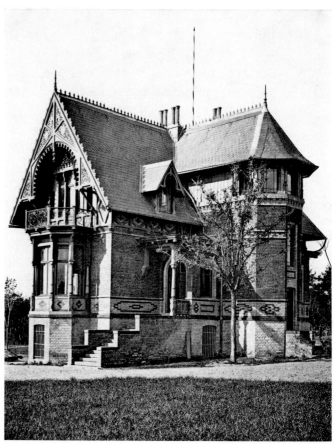

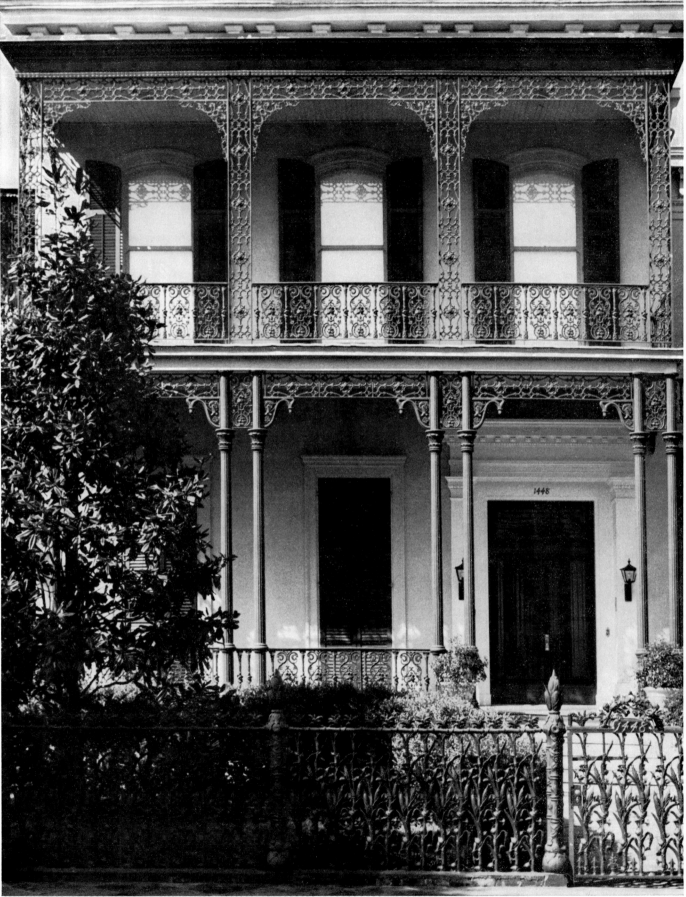

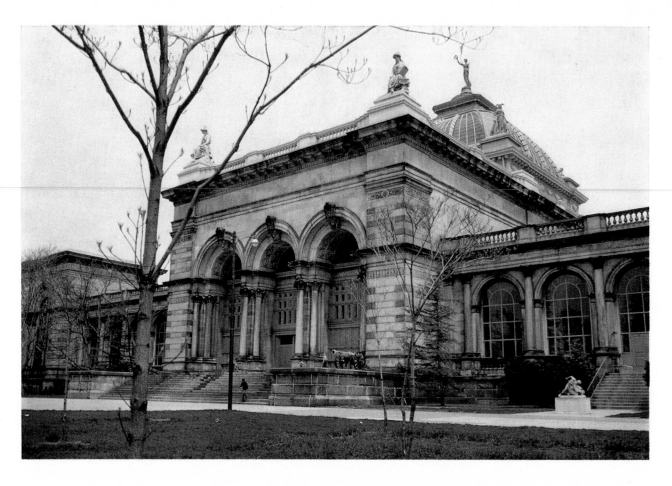

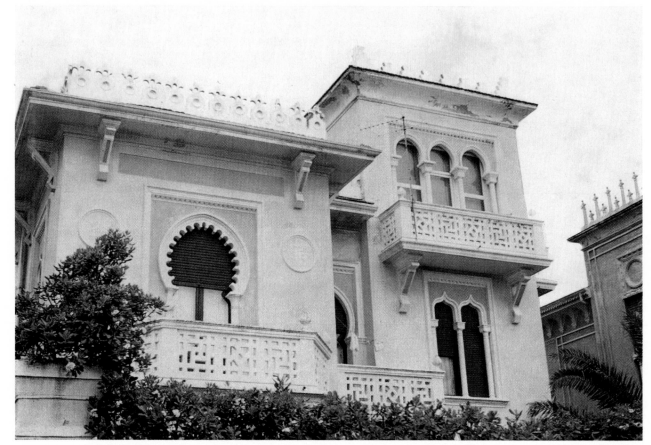

and large the same course throughout Europe, there are individual features in every country which are the result, to some degree at least, of the stress laid on the national character of building styles. In this century the conception of the nation-state arose or gained strength, and in this century, too, architecture was often enough used as a propaganda instrument for political ideas, so it is not surprising that it should also serve the principle of nationalism. They studied the building traditions of their own countries and drew on the store of national forms (or rather what they regarded as such). Because of this and in spite of all the similarity in the style and structure of buildings, in the choice of historical models, the degree of their influence, and the length of time they were used, there were still differences in the architectural history of every country.

The tone was set by the politically and economically strong nations. England and France especially not only produced a rich architecture of their own, but also influenced the development in other countries. England's influence can be discerned very early on the Continent, extending back to the eighteenth century and the fashion of the English garden. It is particularly strong at the beginning and at the end of the period of Historicism—at the beginning with the Gothic revival and at the end with the search for a simpler, less ornamented style.

The English Neo-Gothic was a vigorous movement even before the middle of the century, and it received official sanction with the erection of the Parliament Building from 1840 to 1860, with Charles Barry as the architect and A. W. N. Pugin as the interior designer. This building actually still belongs to the aesthetic approach of Neo-Classicism even though the asymmetrically positioned masses of the towers do break up the regularity and horizontality of the main block. Other great Neo-Gothic works, such as the railroad station of St. Pancras in London built by Gilbert Scott in 1867–74 and the law courts mentioned earlier (G. E. Street, 1871–82), belong to the new architecture not only because of their Neo-Gothic decoration, but above all for their complex,

"picturesque" structure. The Neo-Gothic movement was most productive of all in the area of church building. Both in the country and in the cities, hundreds of churches were built which followed the medieval pattern.

The influence of English Neo-Gothic on the Continent was considerable and is illustrated by, among other things, the commission given to Gilbert Scott to supply plans for the Nikolai Church destroyed in 1842 in the great Hamburg fire. England then went its own way, which led to the revival of national styles, but very soon it also found an approach that at the end of the century served as a model for the architects of continental Europe in their search for an alternative to the florid, pompous architecture of stylistic imitation.

As the leading industrial nation, England had early developed the use of new materials and new manufacturing and assembly techniques for the erection of purely utilitarian structures, such as bridges and railroad stations, to a high degree of perfection. It is not at all surprising that opposition to the overly elaborate forms of historicist architecture developed early on in England too—by about 1860—and individual architects tried to achieve a restrained building style which would be practical rather than extravagant. These efforts were joined in 1890 by similar endeavors on the Continent—Belgium and Austria were especially important at this point—and an artistic outlook developed which saw itself as representing a radical break with the preceding period and led finally to the end of the Pompous Age. The center of gravity of the Pompous style had moved considerably before this to the Continent and to France. Interest in the Gothic revival was very strong there also. It was led by the architect Viollet-le-Duc. He distinguished himself particularly by his work in restoring old buildings, but he made an even more important contribution to the architectural history of the period by the research work that he published, including a comprehensive dictionary of medieval architecture which appeared in 1867. His intention was to derive the basis for a modern architecture from the principles of medieval architecture, and then

Page 35: Short-Moran House, Henry Howard and Albert Diettel, 1859, New Orleans, Louisiana
Page 36: Memorial Hall, Herman J. Schwarzman, 1875–76, Philadelphia (above);
Villa, about 1890, Livorno (below)

with the use of modern materials it was to achieve its own forms which would no longer imitate the historical model. The revival of Gothic ideas was to him just a stage on the way to a new style.

Viollet-le-Duc's influence on the revival of Gothic ideas reached every country in Europe through his writings and had a lasting effect. Yet when they appeared, Neo-Gothic was already past its highest point. A more permanent and important role was played by the works produced in France with the encouragement and under the protection of Louis Napoléon. They made France the leading nation in Europe for several decades in the area of stylistic development in architecture. There are two building projects which were the primary trail blazers here: the extension of the Louvre and the construction of the Opéra in Paris. Both of these were undertaken as part of the plan to modernize the capital, which the emperor had the prefect Haussmann carry out. Broad swaths were cut through the city's masses of housing, old districts were torn down, and new ones put up. Avenues, squares, and parks appeared, making Paris a modern city.

This work, though probably the largest and most important building project undertaken in the second half of the nineteenth century, cannot really be considered part of the *pompous* aspect of the age. It depended on perfectly rational considerations, not least among which were military and tactical factors, and to a large extent followed purely functional lines. Even the architecture along the new boulevards and avenues was designed with noticeably little display of artistic imagination and with the main emphasis on economy. Representative buildings were put up only at the nodal points of the new districts, and the outstanding achievement of them all was the Opéra.

If the architecture of this age created its own style anywhere, it was in the Paris Opéra. In spite of all the borrowing from historical models, in spite of the use of traditional forms, it is still an original creation of its own time. The brief, often-quoted scene between its creator, Charles Garnier, and the Empress Eugénie is very significant on this point. The empress, disappointed that her protégé Viollet-le-Duc had not been awarded the com-

mission for the building, asked Garnier somewhat scornfully what style—meaning historical style as employed in Historicism—this building was in. It is not certain that she understood the architect when he tried to explain to her that it had been designed wholly in the style of its own time, in the style of Napoléon III. The empress herself preferred stylistic imitation, and during these years she had her chambers in the Tuileries furnished with copies of antique furniture.

Garnier received the commission for building the Opéra as the result of a competition which he won by a unanimous vote of the jury. It was begun in 1861 and inaugurated in 1875. It is a massive, compact block which makes use of symmetries and analogies, yet avoids the stiffness of Classicist buildings. The outside clearly shows the complexity of the layout because every part of the building grows out from the center of the whole and has its particular function plainly emphasized. The framework of the stage and wings rises high up as the broadest, though not entirely most important, part of the theater. Then the main façade, not from its size so much as the magnificence of its design, carries almost more impact. It celebrates the opera as a social event, and with its noble setting provides a splendid end for the monumental approach leading up to it: the Avenue and Place de l'Opéra. Above it the dome of the auditorium rises like a crown. Due to the foreshortening of perspective it seems to be situated directly on the edge of the façade when viewed from the Place de l'Opéra. One does not realize that in reality it is set far back against the structure containing the wings and above a tambour. Even the side entrances are developed as separate sections of the building emphasized with smaller domes. The one on the right served as a covered approach for the carriages, and the one on the left was for the imperial builder and protector. The most modest part is the stage entrance at the back of the building.

The ground plan is also arranged so as to allow sufficient space for both the artistic and the social aspects of a visit to the Opéra. In the center is the auditorium and the stage, the largest of its time. Behind that is the section of the layout where everything needed for the func-

Right: Villa, Grujon, 1887, St. Mandé near Paris

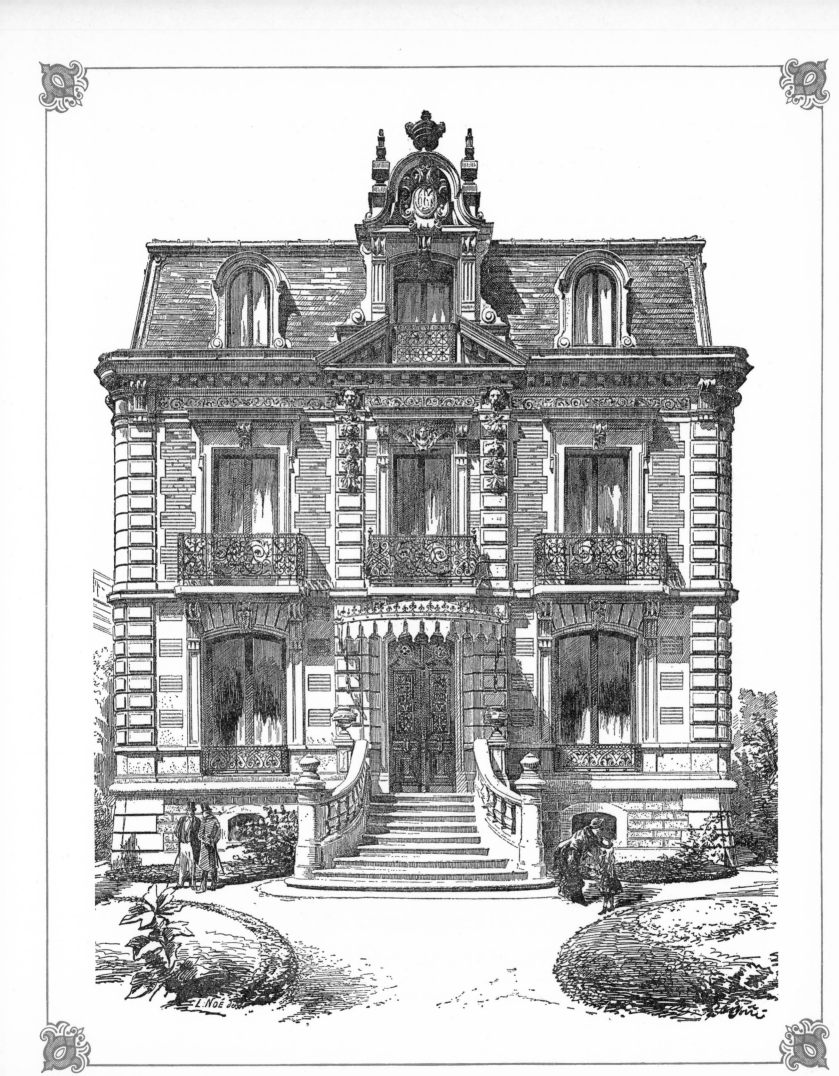

L.NOÉ del.

tioning of operatic productions is housed. In front of the auditorium, however, where the public makes its appearance, is the foyer and its great stairway. This is constructed like a ceremonial bridge, all around which, as in the auditorium of the theater itself, are placed rows of seats and boxes. And just as on the outside, architecture, plastic decoration, and colored types of stone alternate between wall and decoration, column and opening, to give the building that pompous and ceremonious feeling which the century so admired, so on the inside the harmony of colors, the priceless marble pillars, and the gilt together with the curved and rounded forms of the architecture in the glow of candelabras would have set an exuberant tone for the festive event of the musical drama.

The design of the Paris Opéra had a great impact which was not restricted just to the theaters of its time. It can also be seen in more "profane" buildings, including the courthouses of Rome built at the end of the century. It marks the beginning of the Neo-Baroque phase, the last high point and conclusion of the development of Historicism.

Another important French contribution to the history of the Pompous conception of architecture was the attempt made to find a form for iron construction which would replace the dryness of pure functionalism with something they could make "socially acceptable" as artistic. The first efforts still lay completely within the realm of conventional architecture with iron being used as a substitute for stone and taking on its formal attributes. Examples of this are the reading rooms in the Bibliothèque Ste. Geneviève and the Bibliothèque Nationale built by Henri Labrouste and opened in 1850 and 1868, or the interior of the Église St. Augustin erected by Victor Baltard in 1860—71. Even though it was still oriented toward the forms of stone construction, iron construction did develop its own aesthetic thanks to its smaller bulk and its gracefulness. Yet these attempts had no lasting effect on building with iron. It was rather the glass-iron constructions of exhibition palaces that became

the most important area of experimentation where the technical possibilities and the artistic potential of the material were tried out together. And indeed, along with the halls which were able to impress the visitor by masterly handling of the material and production techniques alone, there did develop representative forms which show the same Baroque traits as the stone structures of the last third of the century. The domed hall of the world exhibition of 1889 demonstrated that even a glass-iron framework structure could be made into a full-fledged Pompous building.

Although all the other countries of Europe were involved in the turbulent movements of the nineteenth century, their impact on the development of architecture and their influence on other countries was not comparable to that of England and France. Mostly the influence of a country's capital city would be felt only as far as its own provinces. The influence of Vienna hardly reached beyond the frontiers of the Austro-Hungarian Empire, although the buildings of the Ringstrasse represent one of the most beautiful and comprehensive city expansion projects of the nineteenth century. When Napoléon III had the old Paris reduced to rubble and rebuilt again along new lines, it was turned into a modern city by an act of violence. The equally necessary transformation of Vienna could be approached in a somewhat more leisurely way. In the middle of the century the city was still held in by the ring of its fortifications and had not grown into the sprawling monster which Paris had become to a certain extent before its renewal. When the fortifications around Vienna were knocked down in 1858 to make room for the expansion of the city, the new districts being built could be linked to the old city by a belt of parks and tree-lined avenues in which great public buildings are set like precious stones. In spite of all the magnificence of the layout and the sumptuousness of the buildings, the Vienna Ringstrasse still manages to preserve a hint of elegance and lightness which almost belongs to the late phase of Neo-Classicism. The buildings demonstrate the various historical styles like textbook examples.

Right: Eiffel Tower, Jean Eiffel, 1887—89, Paris
Page 42: Town-house façades, about 1880, Wiesbaden (above left and right); town-house façades on the Hertoginnelaan, about 1890, The Hague (below left); detail of the Schouwburg façade, about 1880, Amsterdam (below right)

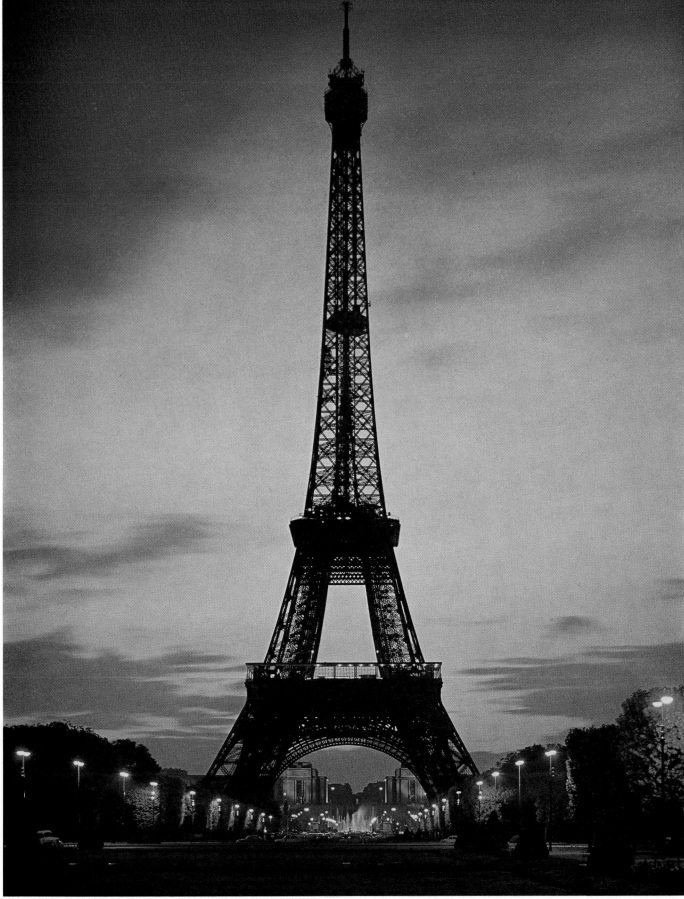

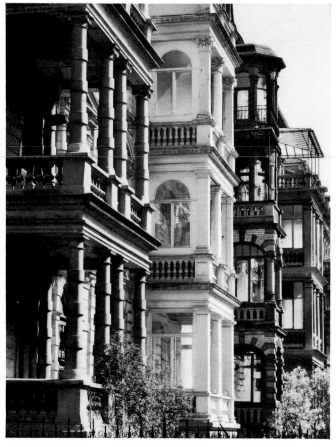
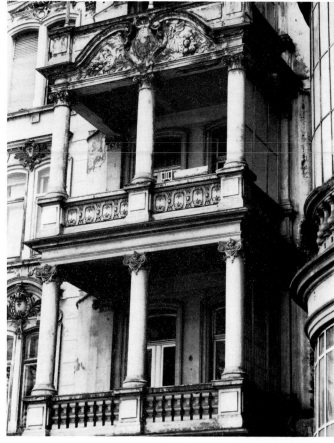
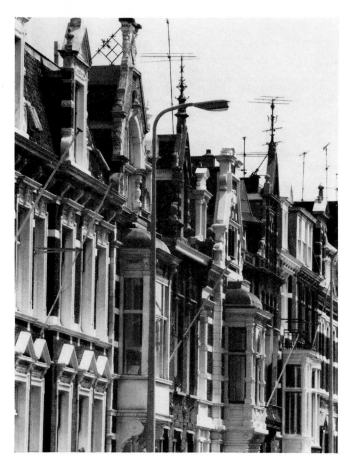
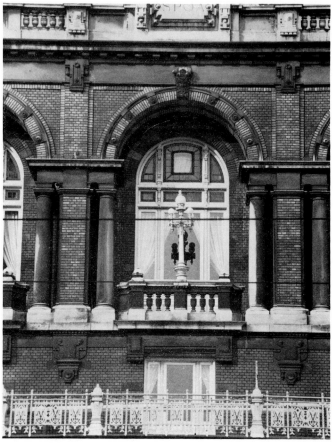
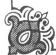

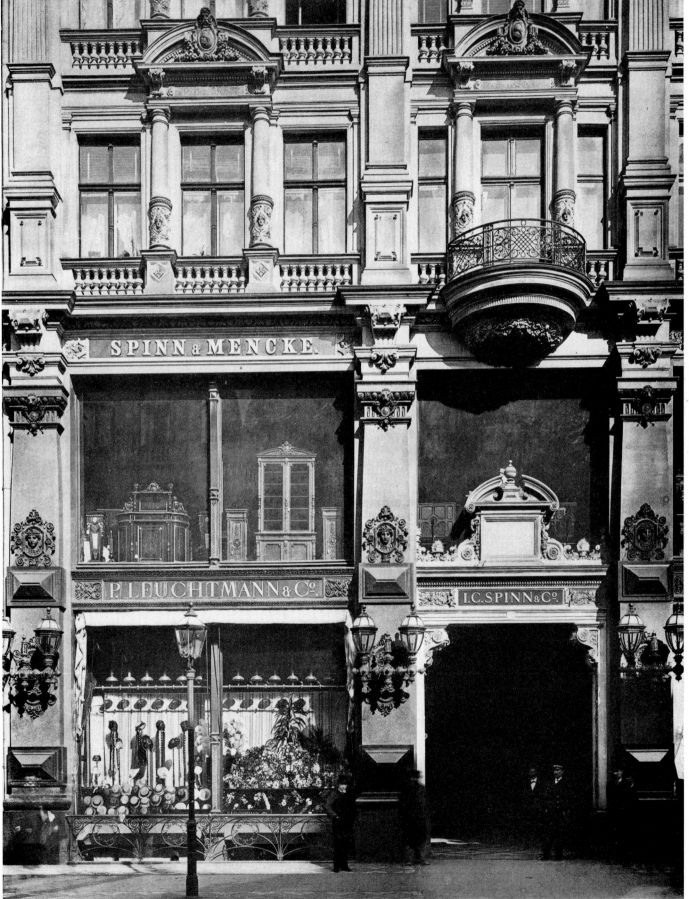

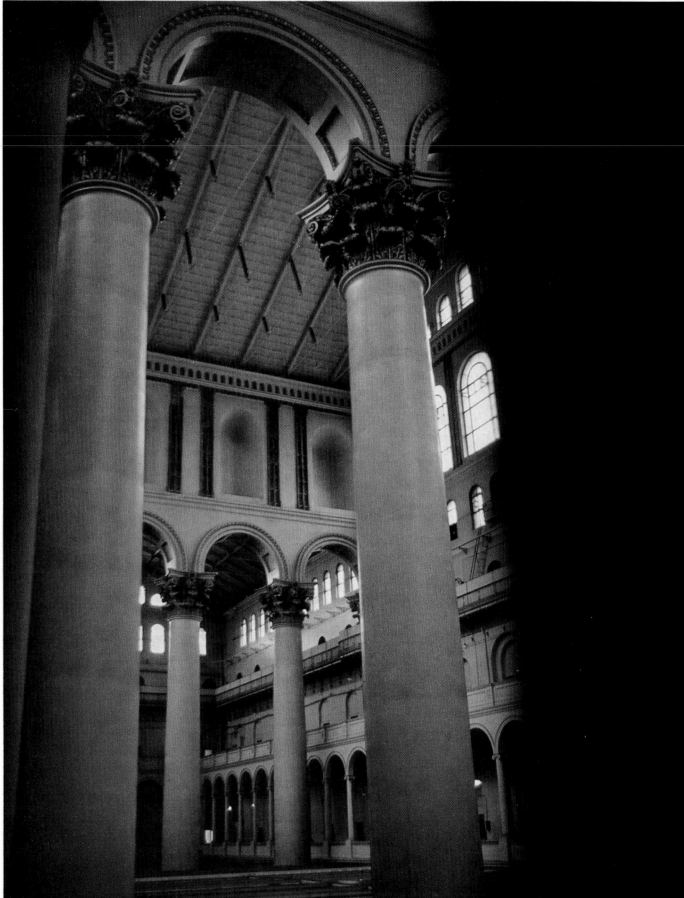

It is a real compendium of Historicism: the votive church in the style of French cathedral Gothic; the city hall based on middle-class architecture of the late Gothic in Flemish towns; the parliament building in the forms of classical antiquity; the schools as examples of the Neo-Renaissance....

Most of the buildings were put up in the years between 1870 and 1890. However, the votive church was begun as early as 1856, that is, before the city walls had been razed, and the new Imperial Palace was still being worked on in 1913 without ever being completed. Several generations of architects learned their art on the Ringstrasse and then went to work in the provinces.

The situation was different in Germany, where, until the various states of the Confederation joined together to form the German Empire, the absence of a common capital prevented the creation of a single architectural center. In the first half of the century architecture had two main centers in Berlin and Munich, where the strong will and protection of a monarch gave the art a particular direction, and this was further favored by the effects of strong architectural personalities. Schinkel and his school were working in Berlin, and Klenze and Gärtner were in Munich. The political unrest around the middle of the century had also contributed to the interruption of this development. The case of Gottfried Semper, who spans the middle years of the century as the outstanding architect of Germany, is very informative on this point. As an active supporter of the 1848 revolution he had to leave Dresden when his work was just showing its first fruits; then he had to leave Germany and began to lead a restless life. Paris, London, Munich, Vienna, and Zürich were all stops along the way in his wanderings. Zürich was the only place where he stayed for any length of time, and in 1879 he died in Rome. His teaching was heard all over Germany, but his architectonic work was much too dispersed for it to be lastingly effective.

Semper was the leading figure of that school of thought which regarded the Renaissance as the model for a middle-class architecture in which it would be possible to achieve a functionally oriented building style

developed from pure stereometrical basic structures. The ground plans of the theater and museum which he built in the first and planned in the second case in Dresden before the middle of the century are derived from the purpose of the building by an economic functionalism. In the main structure, too, the decorative work is based on the forms of the Italian Renaissance, subordinate to the overall form and figuring as an element of the wall rather than having any independent existence of its own.

The war which the states of Germany won against France in 1870—1871 and the proclamation of the German Empire under the leadership of Prussia that followed it were more important in the architectural history of Germany than any individual architect. This was primarily because of the billions paid by the French as reparations which boosted the German economy and brought about an upswing in the amount of building done such as the country had never known before. Countless private houses and business premises appeared in every city in Germany, and public building was every bit as active as that of the prospering middle class. City halls, courthouses, schools, and churches sprang up everywhere. Berlin, as the capital of the new empire, became the center of the building boom of the *Gründerzeit*. Thousands of cheap tenements were put up as a result of the rapid growth in numbers of inhabitants; their depressing poverty makes a gloomy background to the pompous buildings of the business districts and the wealthy luxury of the garden suburbs.

Finally, the state erected its monumental buildings in the new imperial capital. Among these, the Reichstag by Paul Wallot, from 1884 to 1894, and the cathedral by Julius Raschdorf, begun in 1894, in particular are not just typical official state monuments of the late nineteenth century. They belong—like the Paris Opéra—to those original buildings of this time which, in spite of all the borrowing from stylistic forms, have filled the old motifs with a new spirit and blended them into their own style.

This applies even more, perhaps, to a great building project in Italy: the Galleria Vittorio Emanuele II built

Page 43: Spinn, Kayser, and Grossheim, 1877—79, Berlin
Left: Old Pension Building, interior, Montgomery Meigs, 1883, Washington

by Giuseppe Mengoni in Milan from 1865 to 1877. It is probably the most important work of this period in Italy. The shopping arcade is a typical structure of the nineteenth century, though actually its roots go further back. It could only become an important element of town planning after the perfection of glass-iron construction and artificial lighting. The majority of these glass-covered shopping streets appeared in the second half of the nineteenth century, a compromise between a public street and an indoor area. The genre spread from Paris to all over Europe, but nowhere did it evolve to such monumental proportions as the one in Milan and the imitations of it in other Italian cities. The Milan arcade is a magnificent work which satisfies the requirement of the age—to combine splendor and practicality—so convincingly that even today we can move around it without any of that feeling of uneasiness we so often associate with the pompous architecture of the nineteenth century. It is laid out as a crossroads which broadens out to a square at the intersection with an octagonal dome of iron and glass rising above it, while the arms are covered over with barrel vaulting of the same material. The four stories of the side walls are divided up like street façades, with a continuous balcony at the level of the second floor. Pilasters and caryatids and the window frames provide rich, but not overdone, ornamentation. Together with the colored patterns of the mosaic floor and the polychromy of the mosaic pictures in the lunettes of the dome, the decoration gives the arcade a holiday atmosphere, which is also helped by the height and the width of the light-flooded hall. The façade onto the cathedral square was not added until later and has a high triumphal arch as a monument to King Victor Emmanuel.

Other Italian buildings should also be mentioned as great and especially typical achievements of this period. These are the courthouse in Rome by G. Calderini, begun in 1888 but not finished until the twentieth century, and finally the monument to Victor Emmanuel II in Rome which, since it was erected on the side of the Capitol Hill by Giuseppe Sacconi (from 1885) has given the historical center of Rome a completely new appearance.

Victorian Architecture in America: 1850—1900

American architecture of the last half of the nineteenth century was characterized by a new and complete freedom. For the first time since the settlement of the North American continent in the seventeenth century, architecture in the United States was not heavily dependent upon European—and especially English—precedent. The extraordinary range of new functions the architect now had to provide buildings for, coupled with the growing nineteenth century awareness of the multiplicity of architectural styles of the past, could only result in unparalleled variety. As the century drew to a close, greater effort was expended to reconstruct accurately the diverse worlds of previous civilizations, often with results reflecting the virtuosity and virility of American style.

American Victorian architecture is further distinguished by the fact that it is, predominantly, although not solely, a style noted for its achievements in the building of the single family residence. As American society, despite its mercantile and industrial expansion towards the Pacific Ocean, remained rural and agricultural for a relatively longer period of time than in Europe, domestic architecture could enjoy a vigorous florescence which was to continue even into the early years of the twentieth century. In addition, America never witnessed the great architectural competitions for major public, government, and industrial buildings comparable to those held abroad. Such exciting competitions as those promoted by the English government—the Houses of Parliament competition, 1835; the Royal Exchange competition, 1838; the Public Offices competition, 1856; the South Kensington Museum competition, 1864; the National Gallery competition, 1866—67; or the Royal Courts of Justice, also from 1866 to 1867—which were such features of the nineteenth century European architectural scene played but a minor role in the United States.

It is not surprising that the first revival style of any consequence in America at mid-century was the Gothic Revival and that its best examples are to be found in the Gothic Picturesque country house or cottage, the design of which is dependent on wooden frame construction. In fact, as at the Rotch House, New Bedford, Massachusetts, 1846 (p. 27, above left) the architect, Alexander Jackson Davis, uses the exposed frame of the dominant central gable as the chief element of architectural organization. The Davis type of Gothic country house, invariably identifiable by the front veranda and the elaborate traceried or "gingerbread" effect bargeboards, was to be popularized all over America through the media of his engraved designs which were published by his friend Andrew Jackson Downing in his book, *Cottage Residences,* 1842. This book was to go through twelve editions

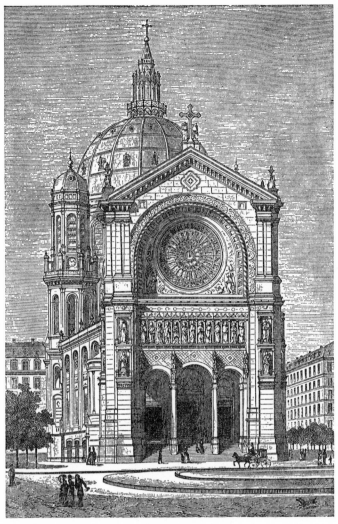
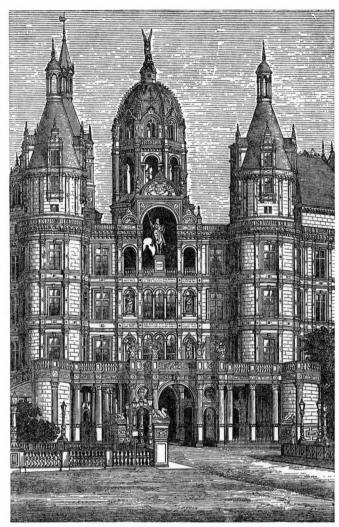

Left: Church of St. Augustine, Victor Baltard, 1860—71, Paris;
Right: Castle façade, Friedrich August Stüler, 1844—57, Schwerin
Page 48: Kaiser-Wilhelm-Passage, about 1880, Berlin
Page 49: Domed hall of the World Exhibition, 1889, Paris
Page 50: House façade, detail, Rond Point des Champs Elysées, Paris (above left);
Capitals in the treasury hall of the Musée du Louvre, Paris (above right);
Fontaine St. Michel, Davioud, 1858—60, Paris (below left);
Detail of the façade of the Opéra, Paris, Charles Garnier, 1860—75 (below right)

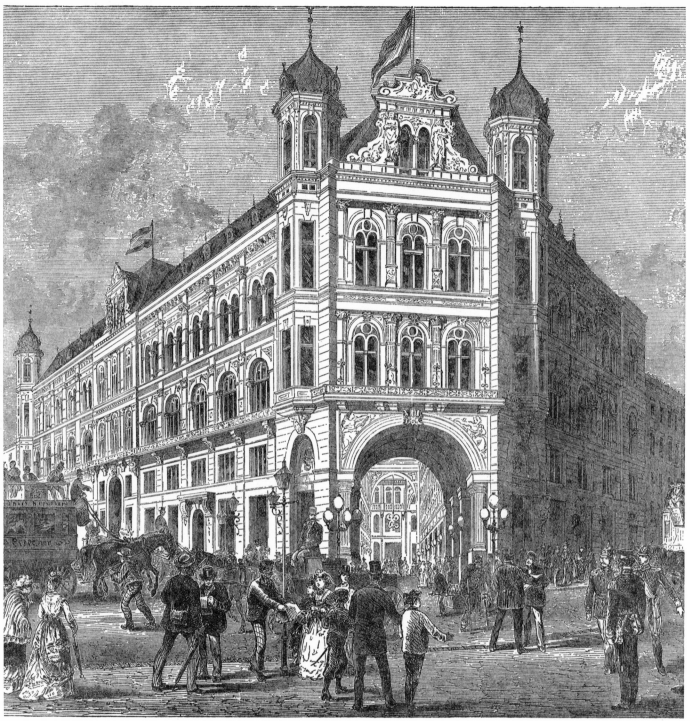

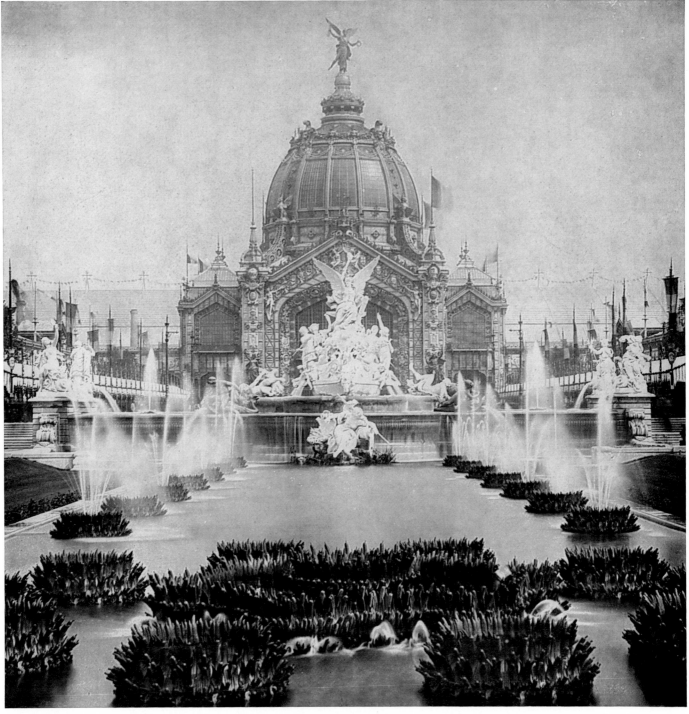

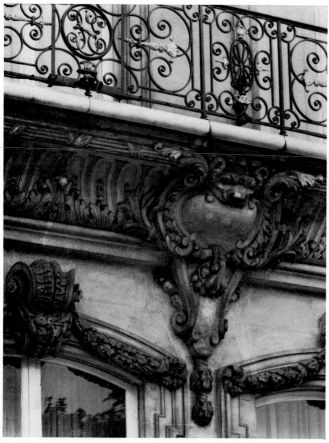
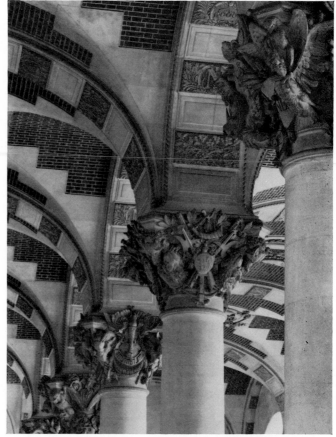
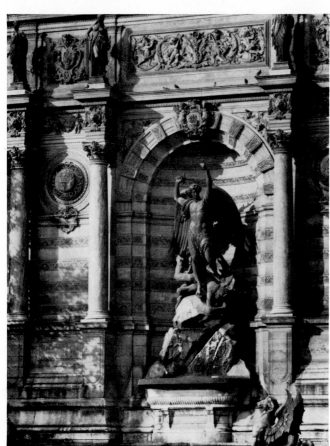
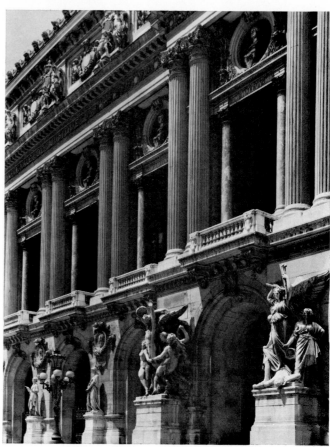

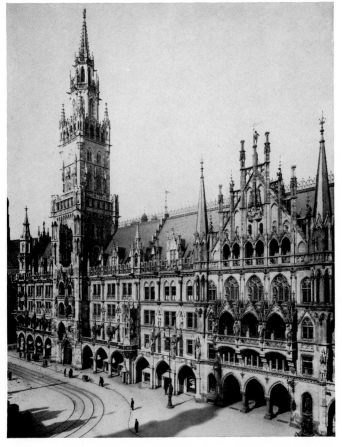
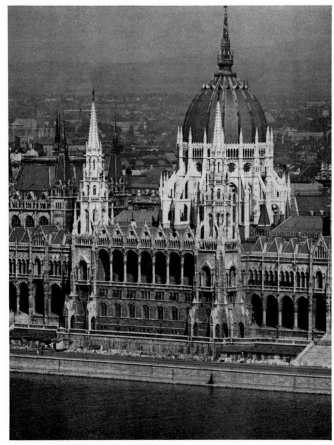

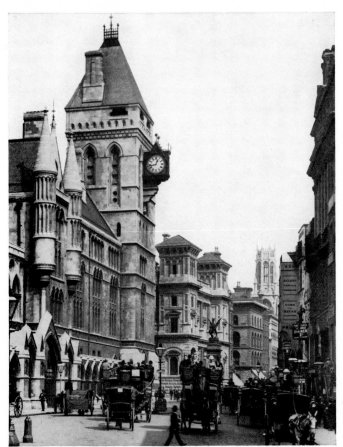
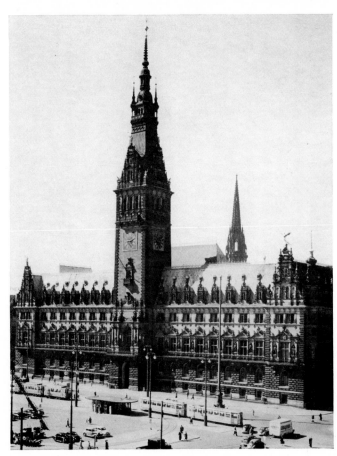

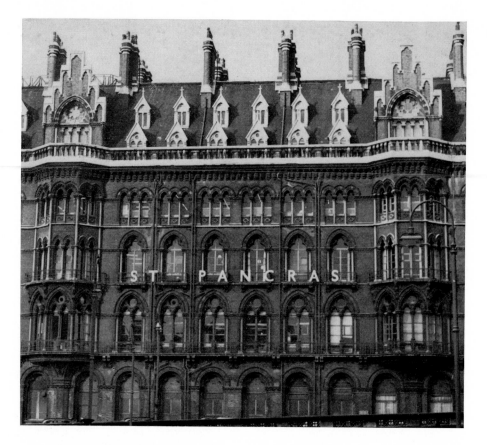

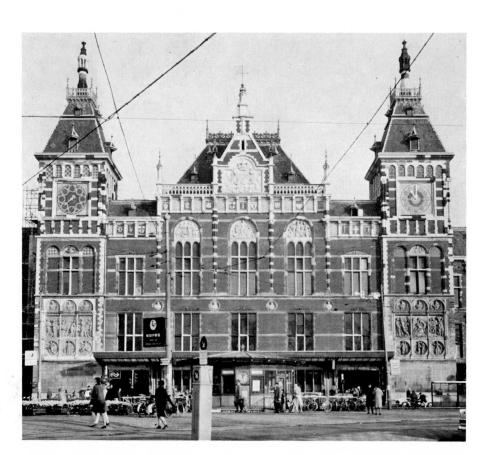

before 1888. The period from 1850 to 1860 witnessed the appearance of another version of the Picturesque viewpoint—the Swiss Chalet Revival, one of the more exotic modes, but essentially akin to the Gothic Revival in its use of intricate wooden tracery to express the stick character of American carpentry. In the Bullit-Jones House, New Orleans, 1869 (p. 27, below right), there is again the feeling for fragility, a sham, fairy-tale quality, an attitude which is to distinguish these buildings of the early Victorians from those of the High Victorian era.

The alternative revival style, also an outgrowth of the Picturesque attitude, was the vogue for the Italian villa. The great American exponent of the towered Villa style was Richard Upjohn, whose Utica (New York) City Hall of 1852—53 shows the sharply defined rectangular blocks of masonry, grouped in an asymmetric manner about the sheer height of the square tower with its characteristic ranges of round-headed windows. The Italian Villa style, however, found its most complete expression in the so-called "Tuscan" villa, an informal suburban dwelling dominated by one or more towers based on Italian Renaissance prototypes. The advantages of the style were many, the major one being the great freedom in planning it allowed. Picturesque principles are seen at the Morse-Libby House, Portland, Maine, 1859, by Henry Austin (p. 34, above right) with its emphasis on the loggia or veranda, the wide-spreading eaves capping the elevations of the individual blocks, and the variety of outline. Variations of Austin's and Upjohn's style were soon found as far South as New Orleans. The Short-Moran House, a Louisiana version of the Villa style, also of 1859 (p. 35), has the Southern features of the cast-iron balustraded balconies and the cast-iron fence of cornstalk pattern. The use of cast iron for this decorative detailing was a direct reflection of the current, consuming American interest in the technical and structural possibilities of ferrous metals, a development which had reached its peak in the 1850s.

As the century progressed, the Gothic, Swiss Chalet, and Italian Revival styles were to be gradually abandoned and replaced by the High Victorian buildings which reached their zenith of popularity during the 1860s, 1870s, and early part of the 1880s. Particularly after the Civil War, American architecture began to use consistently the materials of brownstone and red brick with a subsequent increase in variety of color and surface textures. The restlessness and often jarring effect of High Victorian style was a reaction against the monochromatic, quieter appearance of the very pale surfaces of the earlier revival styles of the middle of the century.

The Second Empire Style was one of the dominant modes of the High Victorian Period. Its origin was France and, more specifically, the greatest public work of Napoléon III: the extension of the Palace of the Louvre, 1852—57. The first reflection of the style of the New Louvre in America was James Renwick's design for the Old Corcoran Gallery, Washington, D. C., 1859 (p. 26). This is immediately recognizable as being Second Empire because of the visible, high mansard roofs, the projecting pavilions, both central or terminal, with each pavilion having its own roof (sometimes inscribing a convex shape), and the general air of grandeur.

Even more three-dimensional and emphatically modeled in effect is the Boston City Hall, by Bryant and Gilman, 1862 (p. 11), which was to be the immediate prototype for important public buildings throughout the country. It is rivaled both in the boldness of its modeling—created by contrasts in light and shade through the use of coupled columns of one storey—and in its great height, both actual and implied, by one of the most impressive American structures in the Second Empire Style, the Old State, War, and Navy Building, 1871—75, Washington, D. C., by Alfred B. Mullett (p. 19, below). Mullett's architectural office was responsible for the extension of the style to the Midwest of the country with such prominent buildings as the Old Post Office, St. Louis, Missouri,

Page 51: City Hall, Georg von Hauberrisser, 1867—1909, Munich (above left); Parliamentary Building, I. Steindl, 1883—1902, Budapest (above right); Law Courts, G. E. Street, 1871—82, London (below left); City Hall, Haller, Grotjahn, et al., 1886—97, Hamburg (below right)
Page 52: St. Pancras Railway Station, Gilbert Scott, 1867—74, London (above); Central Railway Station, P. J. H. Cuypers, 1881—85, Amsterdam (below)

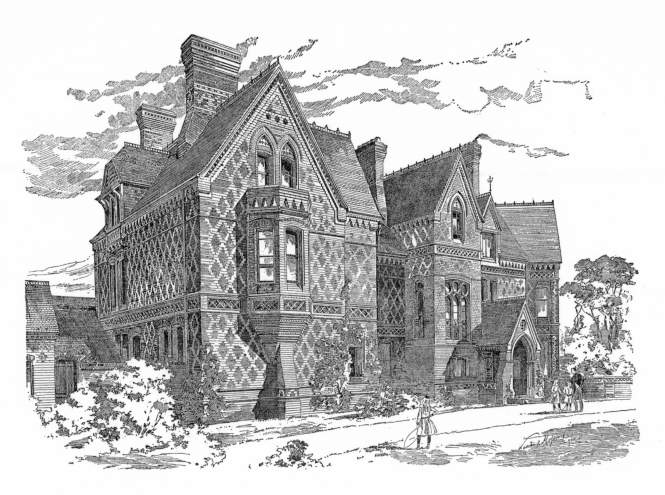

Fox Hill country house, Alfred Waterhouse, 1891

which again features the towering mansard roof and tier after tier of sculpturesque colonnades. The Second Empire Style was equally as popular for American domestic architecture, especially the free-standing houses built in the smaller towns, the suburbs, and the countryside. They were—as at the Gallatin House, Sacramento, California, 1877–78, by Nathaniel Goodell (p. 34, above left)—usually executed in wood painted pale gray to simulate stone and externally sculpturesque with bold detailing in the carved surrounds of all windows. In addition, a Second Empire house always featured a modeled roof with mansard outline and dormers and a jagged, asymmetrical silhouette.

The other conspicuous architectural style of the last third of the century—if only by sheer volume of productivity—was High Victorian Gothic and its many Neo-Gothic derivatives. Essentially the style of Anglican ecclestiastical architecture, it was inevitably employed for American churches (p. 58, below left—Episcopal Church of the Advent, Boston, Massachusetts, by John Sturgis, 1878) and retained this High Church flavor even when

used for other Victorian buildings such as the Pennsylvania Academy of the Fine Arts, Philadelphia, other Academies and museums, numerous banks and courthouses. All of European medieval architecture might be drawn upon as sources. The heavy, carved stone ornamental detail of the archivolts of the Church of the Advent, so reminiscent of both medieval France and Italy, has a certain solidity, which is reinforced by its contrast with the brickwork of the main fabric of the body of the church.

High Victorian buildings invariably gain their vigor from this very use of carved moldings, tracery, and many coloristic textures of material. The polychromy resulting from the use of many kinds of stone, brick, and patterns of tile is splendidly illustrated at the Smithsonian Institution (Arts and Industry Building), Washington, D. C., 1880, by Cluss and Schulze (p. 20, above right). The russet and orange tones are applied in a coarse manner, the contrasts in scale are quite jarring, and both details and wall are solidly, even insistently, stressed.

And often, in a quest for monumental grandeur, the American architect of the seventies and eighties brought

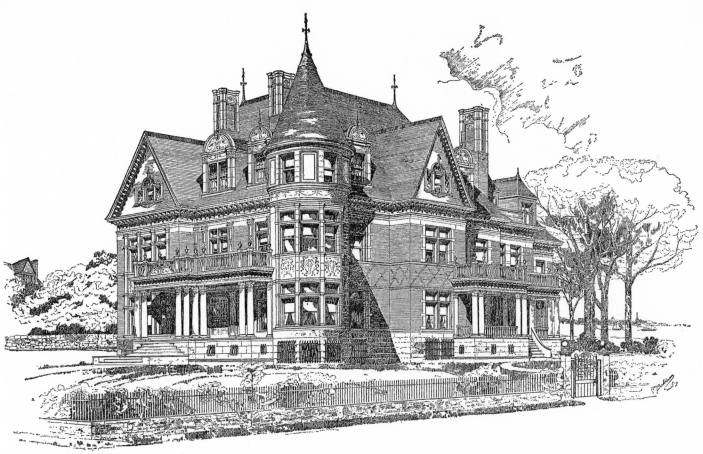

Country house, John Scott & Co., 1891, Detroit

together in one building such a wide range of styles that the result can only be termed "synthetic eclecticism." Such an example of High Victorian style is the Pension Building, Washington, D. C., 1883, by Montgomery Meigs whose exterior is in the Italian Renaissance mode, based on the Palazzo Farnese, Rome, but whose interior court (p. 44), the largest in Washington, is articulated by eight massive Roman Corinthian columns 89 feet high, dividing the spatial volume into three gigantic bays. The effect is not unlike that of the interior of an Early Christian church, but intensified and strengthened because of the dramatic emphasis on height and the grouping of the colossal order.

In addition to the two popular currents in late nineteenth century America (the Second Empire and High Victorian Gothic), there was a significant and pronounced attempt to create a domestic vernacular. This was the Stick style. Although a vein of the Picturesque and even a survival from the Gothic Revival runs through this, Stick style is, first and foremost, American in its quest for honesty in wooden construction. The most notable

feature is the diagonal "stickwork," since the walls are faced with clapboard with a geometrical patternization created by the vertical and horizontal boards as well as the diagonal ones which suggest the structural frame beneath. The Griswold House, Newport, Rhode Island, by Richard Morris Hunt, 1862—63, has the typical projecting eaves and spacious veranda carried on diagonally braced posts (p. 27, above right), while the interior staircase hall (p. 65, below left) is almost imitation Tudor, for the open stickwork of the porch seems to have been transferred to the well of the wall surface and gives the appearance that it is an actual and integral part of the structural support.

Popularized by Gervase Wheeler's book, *Rural Homes* (eight editions between 1851 and 1869), Stick style exhibition buildings were featured at the first major exposition staged by the United States: the Philadelphia Centennial Exposition of 1876. Most Centennial structures were temporary, except for the building to be known as Memorial Hall (erected to commemorate 100 years of American independence) whose purpose was

to house the art exhibition in 1876 and to be used thereafter as an art museum (p. 36, above). This differed dramatically from the Stick style buildings on the fair grounds in that it is almost a monumental piece of stage architecture, grandiose in concept, and descended from the competition projects created by the students at the École des Beaux-Arts, Paris, throughout the entire nineteenth century. The result of the influence of Beaux-Arts Classicism, Memorial Hall, with its insistence on symmetry, its combination of Greek and Roman structural systems, the clustered columns defining the tripartite archway, the monumental flight of stairs, and the Neo-Classic figure sculpture at the roofline, is the prototype of numerous public buildings, one of the most notable being the Grand Central Railroad Terminal, New York, 1903—13. It was also the ubiquitous style at every major American exposition until World War I.

Indeed the last few decades of the nineteenth century in American architecture may be characterized as years of uncertainty and doubt. Style might range from such pieces of pictorial Beaux-Arts Classicism as Memorial Hall to private houses recalling Saracenic or Arabic architecture. Frederick Church's Olana (p. 34, below left), sited high above the Hudson River, is an eclectic recreation of the artist's travels abroad and fondness for the exotic juxtaposition of both materials and motifs. Or such a Moorish element as the horseshoe arch might be adapted and domesticated as the hall or parlor archway, as seen in the interior of the DaPonte-Newman House, New Orleans, 1890 (p. 82, above). And, also, in and near New Orleans at the end of the century, some of the most fanciful offshoots of Victorian style were created when houses along the Mississippi River were erected in the "Steamboat Gothic." A house such as Ardoyne Plantation, Terrebonne Parish, Louisiana, 1894 (p. 27, below left), composed of many elements culled from the wooden Stick style and finding its origins in the many phases of the Gothic Revival, has pushed the vein of phantasy to its

limit, and the result can only be as substantial as confection.

At this same moment, there was a reaction in American architecture. This reaction was in favor of simple, large, clear-cut forms and an overall effect of quiet; it was opposed to the domination of the multiplicity of styles of the past and the consequent compilation of diverse elements. This is first intimated in the work of Henry Hobson Richardson, who was able to impose his own personality and feeling for homogeneous effects upon a revival style of the past: the Romanesque. Richardson's contribution lay in such a building as Emmanuel Episcopal Church, Pittsburgh, 1884—86, where the respect for weight and massiveness of material and the general simplicity of forms and planes was to foreshadow those American architects of the twentieth century who would pioneer the earliest styles of modernism.

It would be difficult within the format of this account to describe all the important Pompous buildings of the nineteenth century, but we should take a closer look at the buildings of King Ludwig II of Bavaria, which, while they do on the one hand represent phenomena completely typical of the age, are also a very special case within the total architectural history of this epoch. The King's chambers (destroyed in World War II) in the Munich Residence, and the Neuschwanstein, Linderhof, and Herrenchiemsee castles belong with the Paris Opéra and the Milan Galleria Vittorio Emanuele II as the most outstanding examples of architecture in the nineteenth century. Ludwig II was certainly the biggest builder of the Pompous Age, for though the transformation of Paris set in motion by Napoléon III was a far larger operation than any of the Bavarian king's undertakings, it was much too rational and functional to be counted part of the pompous aspect of the age. There is really nowhere else in Europe at this time, the last third of the century,

Right: Design sketch of the west face of the cathedral, J. C. Raschdorf, 1891, Berlin
Page 58: Portal of the Academy of Arts, Constantin Lipsius, 1886—94, Dresden (above left);
Entrance to a house on the Matthäiskirchstrasse, on the corner of Tiergartenstrasse, Cremer and Wolfenstein,
1895, Berlin (above right); Portal to the Church of the Advent, John Hubbard Sturgis, 1878, Boston, Massachusetts
(below left); Portal to the Hackley Public Library, Patton and Fischer, 1888, Muskegon, Michigan (below right)

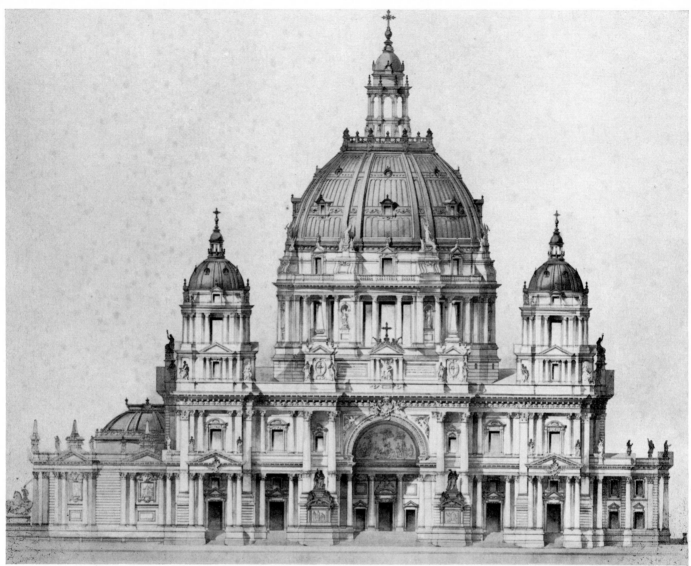

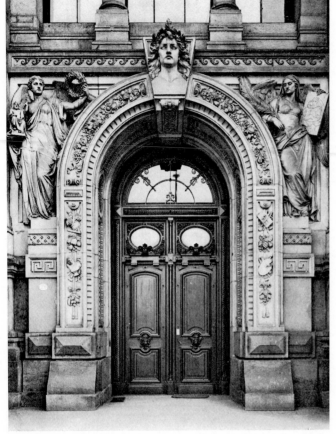
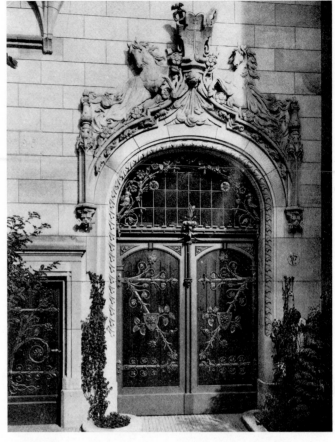
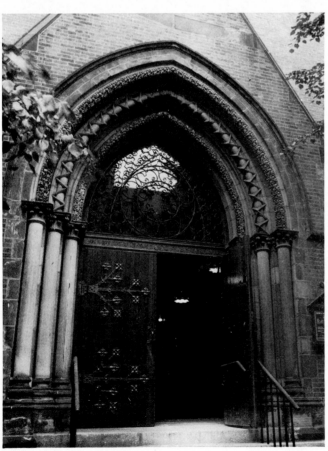
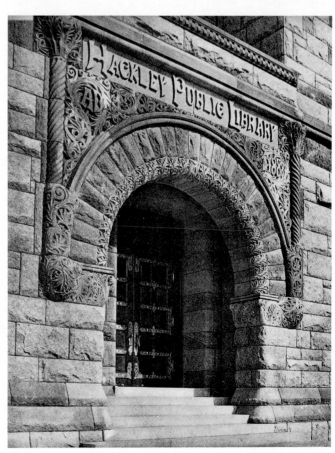

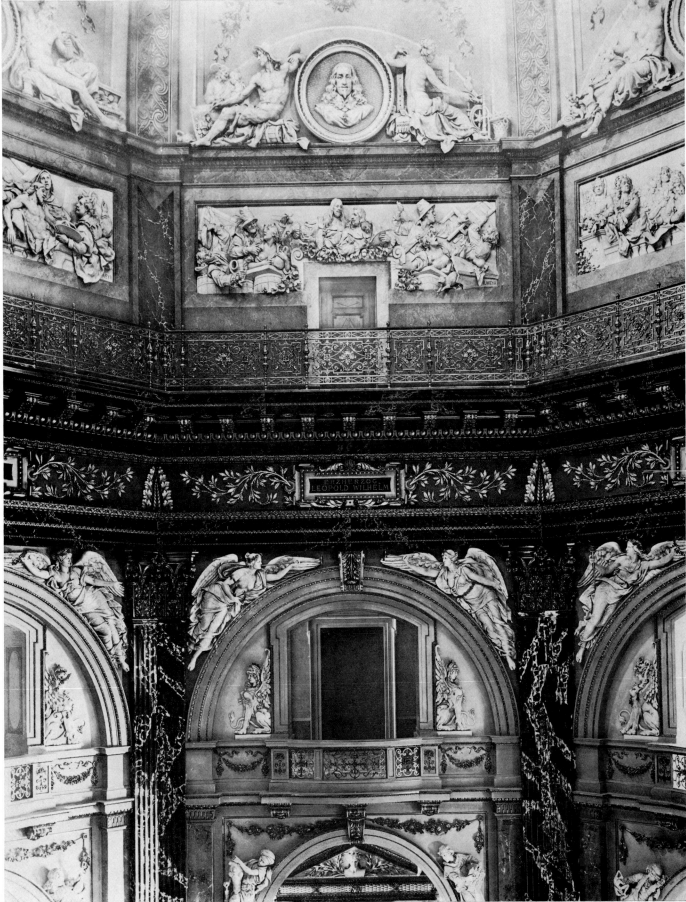

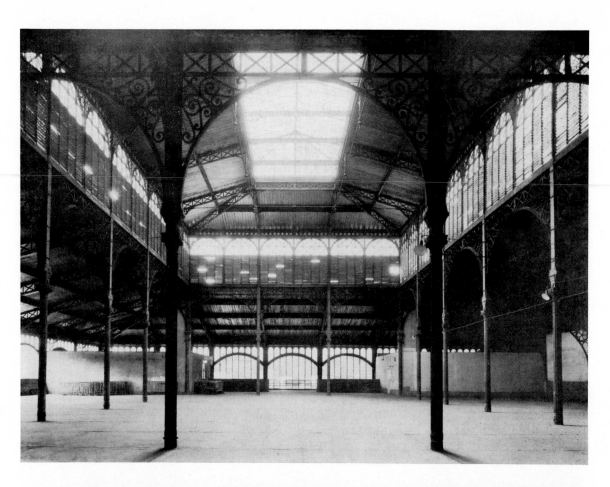
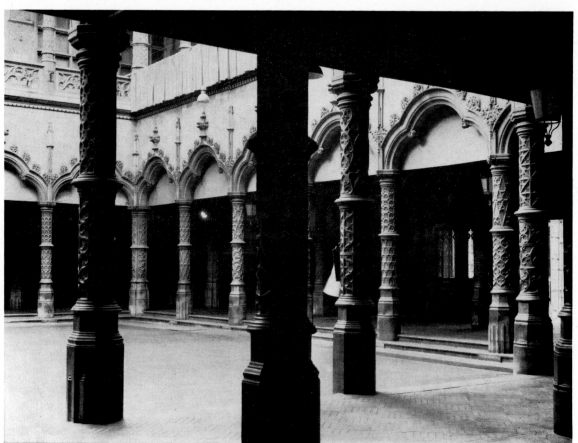

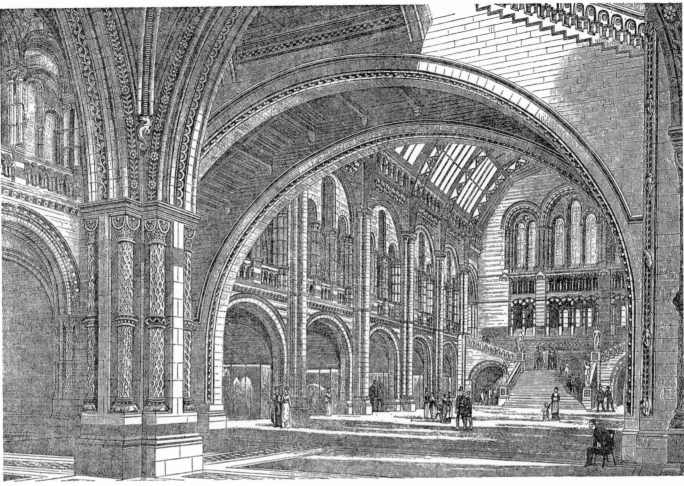

Page 59: Entrance hall to the Art-Historical Museum, Vienna
Page 60: Halles Centrales, interior view, Victor Baltard, Paris (above);
Exchange, inner court, Schadde, 1868—72, Antwerp (below)
Above: Hall of the Natural History Museum, London

that such an amount of building was done for one man and designed solely for his personal needs. The buildings that he had commissioned were quite different from the castles of previous ages for they were intended, not for the exercise of public power, the seat and center of a ruling authority, but for private use. Just like the villas of the prospering middle class, they were supposed to express the owner's claim to power and rank by their lavishness and their forms. They were accessible only to the king and his servants, and it was not until after his death that as museums, memorials, and tourist attractions they became public buildings. It was not only their pompous aspect that was typical of the age, nor the fact that this pomp made use of the forms of past eras, but that an idea was linked with the historical forms which they were supposed to evoke—in this case, the idea of absolute monarchy. They express a claim which had long ago lost any basis in reality for the young king. Because of this, these buildings also led to the king's ruin and finally to his early death.

Ludwig II had inherited his enthusiasm for building from his ancestors. The Munich of the nineteenth century was created by his father Maximilian II and even more by his grandfather Ludwig I of Bavaria. During their reigns, from the beginning of the century, monumental rows of streets, squares, and entire districts of the town had grown up, and the royal builder regarded it as a public duty to see that the planning came under his patronage. Through these buildings the authoritarian will of the monarchy once again gave the city a unified appearance. At the same time it had come up against the growing resistance of the citizens, and when Ludwig II assumed the throne in 1864 he left the further growth and development of the city in their hands. After the first, ill-fated attempt on the part of the king to introduce a new note into Munich with a festival theater designed by Semper for the performance of Wagner's operas, Ludwig turned his back on the city and retreated into the countryside with his building plans. While in his capital and residential city the first middle-class monumental building, the Neo-Gothic city hall, was being put up, the king had those castles built far away in the magnificent landscape of the Bavarian mountains and lakes where he could dream the dream of absolute monarchy. In Munich itself, on the other hand, he restricted himself to the refurnishing and decorating of a few rooms in the residence erected by his forefathers.

The first of the castles, Neuschwanstein, which was begun in 1869, still belongs to the period of "Picturesque" architecture of the second third of the century. It is a creation of Late Romanticism, and like many Romantic buildings owes its origins and its form to an inspiration from outside the plastic arts: Wagner's musical dramas *Tannhäuser* and *Lohengrin*. As a medieval castle, in a mixture of Romanesque and Gothic styles, the building has an irregular main structure, jutting towers, and the tall, harsh residential wing which echo the alpine peaks surrounding it. In the interior, rooms were built in the heavy, stark Romanesque, and to some extent also Gothic, style, with enormous, oppressively heavy wooden ceilings. They were just like stage sets for the Wagnerian operas, which were the direct source of the inspiration for them. The great choral hall, for example, was reminiscent of *Tannhäuser*.

In the two following castles, the builder turned from the world of Nordic sagas to one which lay closer to the present and one which he felt himself to be directly related to—the period of the French monarchy in the seventeenth and eighteenth centuries. In this he was in agreement with the general change in public taste which had evolved a preference for the showy forms of the French Baroque and Rococo. Yet while this stylistic period was imitated to a great extent because it enabled the middle class to make a pompous show of its wealth and, in addition to that, as the age of a highly developed and cultivated way of life, provided the model for every comfort and luxury that this age loved so well and above all could afford, there were deeper, personal reasons why Ludwig II turned to it. For him the historical form still had the allegorical, expressive character that for the most part had already been lost in this last phase of Historicism. Ludwig II felt himself allied to the French Bourbons not only because he regarded their regime as the ideal realization of monarchy, which he could never achieve himself in this century of the middle class which allowed him nothing beyond a representative role; he felt himself to be directly related to the French kings through his name, since the godfather of his own godfather, his grandfather Ludwig I, was none other than Louis XVI of France. Schloss Linderhof and its gardens were begun in 1870. It was a building in the Rococo manner whose architecture and furnishings, however, were also mixed with earlier stages of the French Baroque going back to the time of Louis XIII. Finally, in 1878, there followed the most magnificent evocation of absolute monarchy—Schloss Herrenchiemsee. It was conceived as

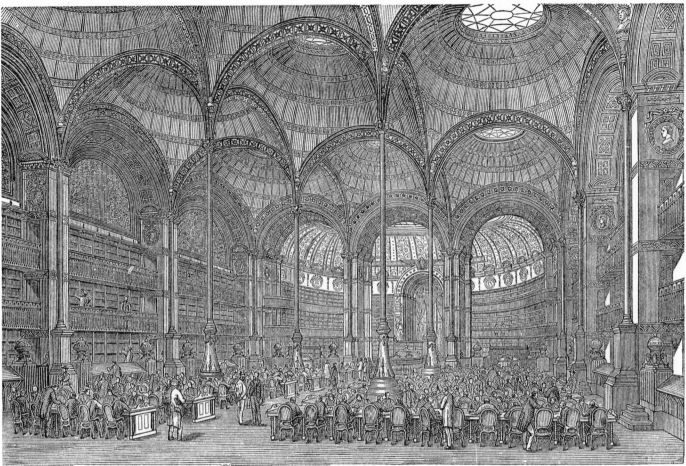

Above: Reading Room of the Bibliothèque Nationale, Henri Labrouste, 1868, Paris
Page 64: Room furnished in late Gothic style, Viollet-le-Duc, 1887 (above)
Hall of the Society of Friends, Cremer and Wolfenstein, 1891, Berlin (below)
Page 65: College of Technology, upper vestibule, Neureuther, 1866—70, Munich (above left);
Villa Bürklin, staircase, Durm, 1882, Karlsruhe (above right);
Griswold House, staircase, Richard Morris Hunt, 1867—68, Newport, Rhode Island (below left);
König-Karl-Bad, staircase, watering place in the Black Forest (below right);
Page 66: Galleria Umberto I, Ernesto di Mauro, 1887—91, Naples

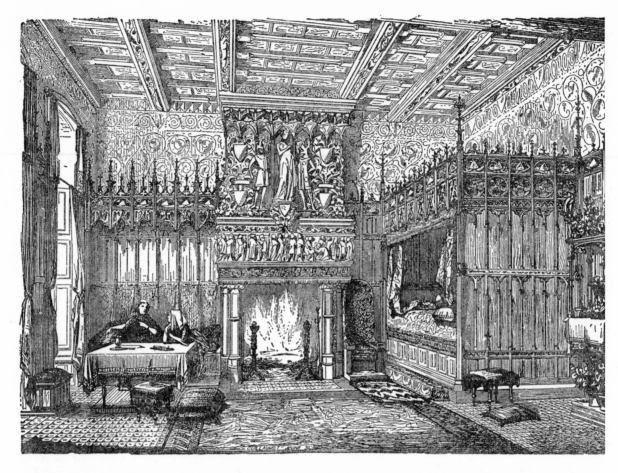

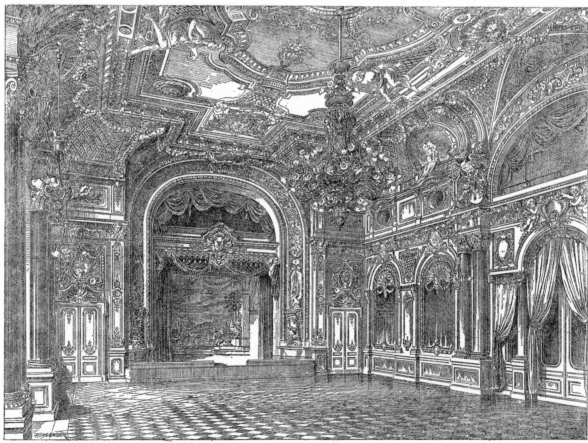

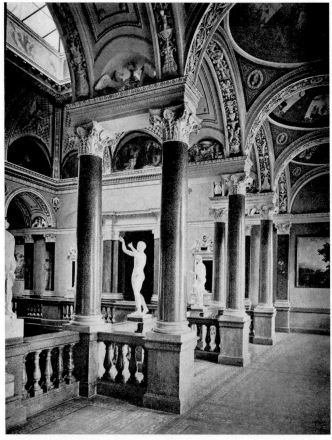

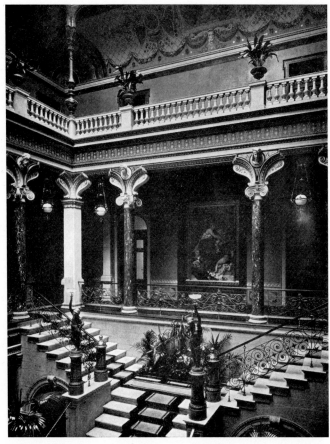

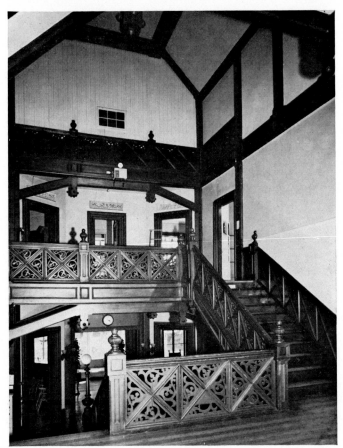

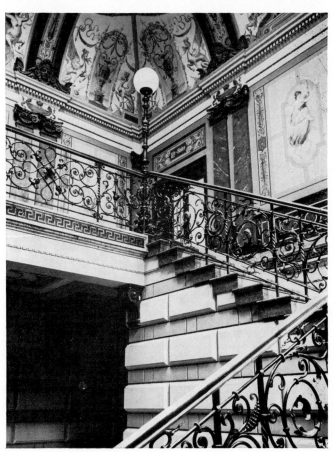

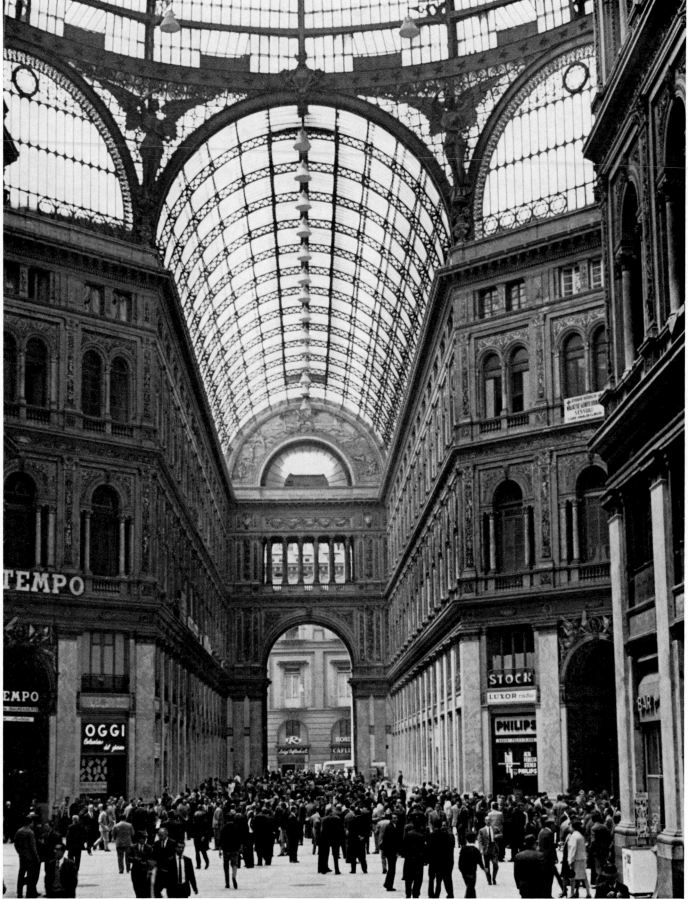

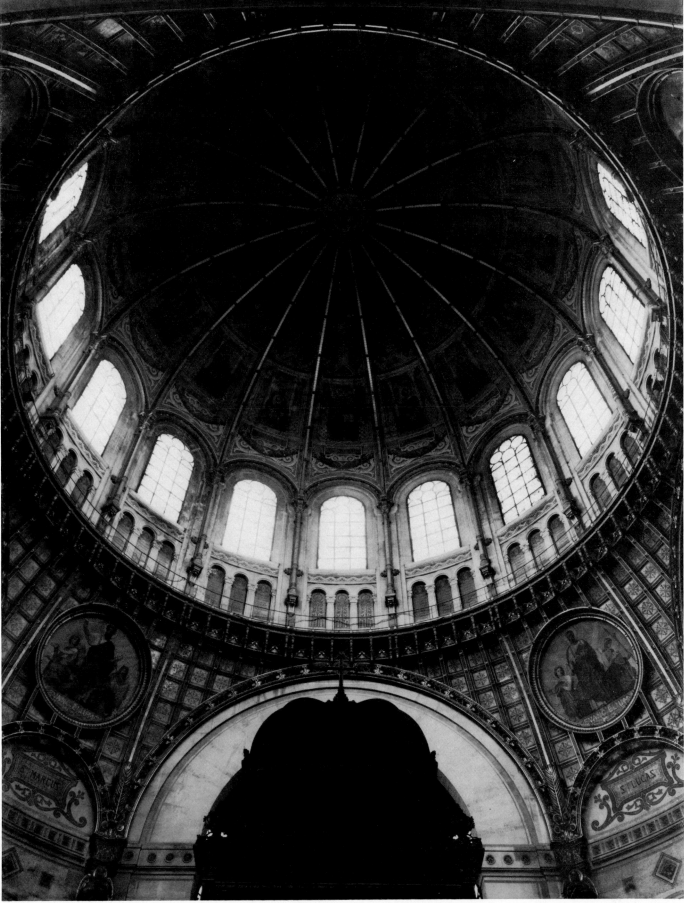

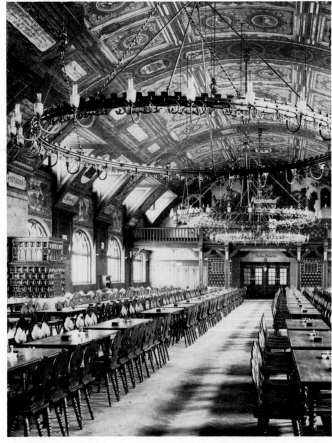

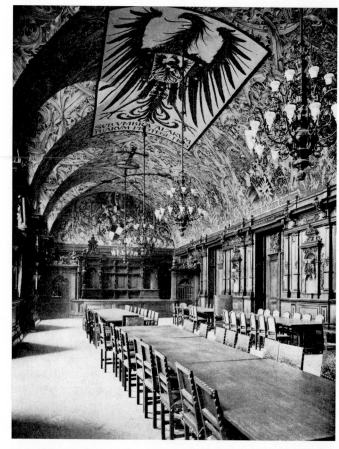

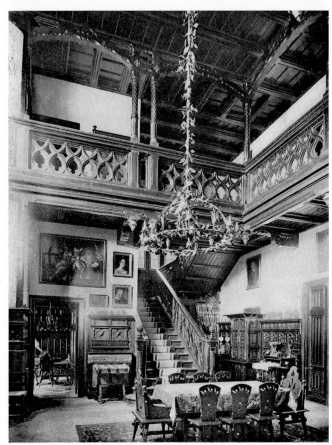

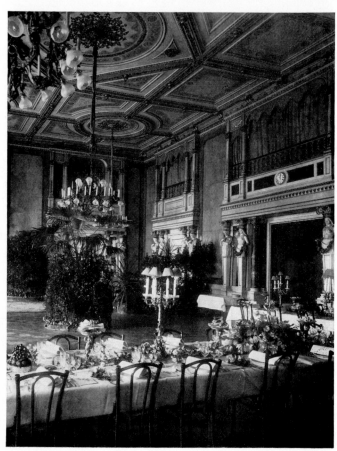

a copy of Versailles and was intended to reproduce not only the buildings, but also the gardens with groups of statues and fountains, borders of flowers, and the great canal. Ludwig II took no less care over the decoration of the interiors. In order to preserve the most faithful copy of the original possible, the king ordered a research program on a full-scale scholarly footing using old pictures, descriptions, and inventories to reconstruct in plans and drawings the way the palace had been before later alterations were made. He sent his artists to Paris and Versailles so that they could gather ideas and inspiration for their work, and finally he had the French model measured and individual parts such as the gigantic ceiling painting of the Hall of Mirrors painstakingly copied by a complete team of painters. And so that rare thing, an architectural copy, was accomplished, which, in contrast to copies of sculpture and painting, is something almost never found even in the nineteenth century when copying was so popular.

The king was often really petty about the exactness of details. He reprimanded his architect, for example, because in his plans he had changed the overall length of a group of rooms represented in Versailles by the sequence of the War Room, Hall of Mirrors, and Peace Room, by 8 feet. Considering the size of these rooms this is a truly insignificant difference. Nevertheless, Schloss Herrenchiemsee does depart from the original in some important respects, and in this sense it is completely a creation of the nineteenth century. This particular case illustrates something typical in general for this time and its relationship to the past—the model was not understood just as a formal design all of whose separate aspects seemed equally important and therefore had to be reproduced with the same faithfulness. Instead it was looked upon as the manifestation of an idea, the expression of a way of life and social order of which, in the view of the nineteenth century, it was the ideal embodiment. It was only as a manifestation of this idea that it was considered worthy of imitation. Any aspect or detail which seemed

to depart from the ideal embodiment, or possibly even contradict it, would therefore either be disregarded or else corrected so as to conform with the ideal conception. Since formal considerations were not the primary reason for the imitations, it was also possible to use modern materials and techniques and to adapt them to modern requirements of comfort and hygiene. A passage from a letter by the court secretary Düfflipp concerning the Schloss Neuschwanstein project illustrates this point: "It is His Majesty the King's most exalted wish that the new castle be built in the Romanesque style. Since we are now writing in the year 1871, we are several centuries beyond the period of time which saw the rise of the Romanesque style, and there can be no doubt whatsoever that we must take full advantage of the achievements made in the meantime in the realms of art and science... and similarly I cannot agree that we should retrogress completely into the former age and deny ourselves knowledge which would most certainly have been turned to account at that time had it but existed." (It is also interesting in this connection that Bavaria's first electrical generating plant was installed at Ludwig II's command for the Linderhof park illumination.) In these imitations there was no sense of the creation of lifeless museum pieces, but rather a reawakening of old forms and traditions for a very lively present.

The Palace of Versailles is something that grew with history; it includes parts in different architectural styles which even after its completion continued to change according to the needs of its occupants. Ludwig II of Bavaria, however, saw the palace as the embodiment of an abstract idea, the idea of absolutism, and in his reconstruction he not only undid everything added by later times, but also eliminated everything in Louis XIV's building that reflects the fact that it was a historically conditioned structure. The main change was that the court façade of Herrenchiemsee was erected along the lines of the gabled gardenfront and not in the style of the Louis XIII hunting lodge which today forms the

Page 67: Church of St. Augustine, view into the dome, Victor Baltard, 1860—71, Paris
Page 68: Banquet hall of the Hofbräuhaus, Munich (above left); Great refreshment room in the Reichstag Building,
Paul Wallot, 1884—94, Berlin (above right); entrance-hall of a dwelling house, Giese and Waldner, 1893—94,
Dresden-Blasewitz (below left); room in business premises, Munich (below right)

nucleus of the Versailles complex and provides the façade looking on to the Marble Court. In addition, the interior was also systematized and regularized according to a stricter conception. In this way Ludwig II not only—as would have followed from the original—had a ceremonial staircase to the upper floor built in the east wing, but also added a second one to the west wing to preserve a strict symmetry. Finally, the monarch's main attention was concentrated on the completion of the Hall of Mirrors and the state bedroom in the central axis of the palace as being the two rooms which embodied the idea of the French monarchy in the purest form. Most of the other rooms, even the state apartment, were neglected.

For his own use he had a few rooms furnished in the style of the French Rococo. In spite of extremely accurate imitations of particular details, however, these are adapted completely to the requirements of a man of the nineteenth century. This even included technical refinements like a mechanically retractable dining table, and, of course, the rooms were equipped with electrical lighting.

Schloss Herrenchiemsee remained just a torso. It showed as no other building did the potentialities and the limitations of Historicism. The copy of Versailles had no *point*. What had been built in France had been a seat of government and the center of a great empire, but here it served nothing but the private dreams of a monarch without constitutional power. If, as had been originally planned, the copy had been carried out in all its parts, it would have remained an empty shell just like the torso. Who would have ever occupied the countless rooms in the palace of this shy, retiring king?

The king was ruined by this work. He had neither the power nor the means to carry out such grandiose building projects. Nevertheless, it was not all in vain, for in these buildings he assumed—for the last time in Europe—the role of the king as patron to the arts. Through his will and so completely according to his own instructions that today we hardly bother about the architects, the castles of Ludwig II became buildings which we today must include among the most magnificent achievements of the nineteenth century.

Department of Electricity at the World's Columbian Exposition, van Brunt and Howe, 1893, Chicago

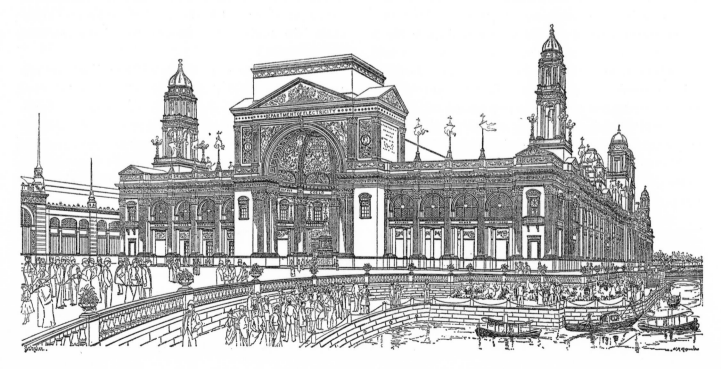

Furniture and Fittings

Nowhere did the second half of the nineteenth century show itself so much the "Pompous Age" as in the furniture and fittings of its homes. In architecture, there were some considerations which could set a limit to extravagance: there was the position and size of the site, official regulations, and not least the concern to make the most economical use of financing. When it came to furnishing the house, all this was insignificant or of just minor importance. Even the person who was unwilling or unable to afford a house of his own could still turn to the furnishing of a rented home for the perfect opportunity to express his own taste. With the help of furniture he could create the outward signs of social rank equivalent to his ambitions or his pretensions and display the pomp which might perhaps have been denied him elsewhere. In this period when the economic, social, and political upheavals that had got under way long before finally reached their peak, people searched in the private sphere just as much as in the public realm for new forms of social image. The question of what was the right style for furnishing a house (as with the kind of architecture) sometimes took on the overtones of a moral or philosophical dispute. Ideas and rival claims were often defended or brought forward against other theories with the fanaticism of religious zeal. The history of furniture in the second half of the nineteenth century is like a thicket through which explorers have not yet cut a trail and whose fauna until now has hardly been classified. Many different and, in part, contradictory ideas and tendencies overlapped or were superimposed on one another, and English researchers are the only ones who have until now tried to achieve a general understanding of their area in this epoch. For this reason we cannot so much give a history of the development of furniture in this period as merely an interim report.

Nevertheless, there are certain general tendencies which can be pointed out. Some developments, which had mostly begun as early as the eighteenth century and become predominant in the first half of the following century, reached their peak. In about 1850 the dominance of these was met by the stirrings of a reaction against them which was not merely seeking a new direction but a reversal of what had been established.

The decisive factor in the history of furniture is the process by which conditions of production were completely changed, and the development of its forms moved from the realm of aesthetics into that of technology. This depended mainly on the increasing pressure that was driving small craftsmen out of business and the introduction of mechanical techniques of manufacture, and also the introduction of new methods of marketing, such as sales from department and furniture stores.

During the Revolution in France at the end of the eighteenth century, the ancient craftsmen's guilds were dissolved by decree, and elsewhere in Europe there was a loosening of old traditional rules and privileges concerning craftsmanship. It became possible for people from outside to exert their influence on the craft and for the introduction of new methods and materials and experimentation with them and—to a lesser extent—with new forms in the production of furniture. For a long time mechanization was only available to large industrial manufacturers and not to the small craftsman's establishment because only a large concern could economically afford an expensive steam engine. It was not until the invention of the gas turbine and soon after the invention of Siemens's electrical generator that the extensive replacement of manual labor by machines became a possibility for smaller establishments too in the last third of the century.

It seems quite obvious to us today that new methods of manufacture and materials should also bring about new forms. When mechanization was extending its influence in many areas of production in the first half of the nineteenth century, however, and the introduction of new materials became possible, it was just seen as a replacement of the familiar processes. They were used to cheapen the old craftsman-made products and to boost the volume of their output while the forms and materials were mostly kept the same, or else they were copied and imitated with new materials. For example, the ability to cast iron in molds and to reproduce large numbers of identical pieces caused a wave of furniture of cast-iron to be made which not only tried to show the same forms as wooden furniture, but also the same appearance by the use of paint to imitate the color, and even the grain,

of wood. Of course such a heavy material could only be employed for furniture that would never or only very seldom have to be moved again after it was once put in place—a bed, perhaps, or the bench in the hallway. For movable pieces there was a lighter material available: papier-mâché. It had been known for a long time, but it now grew into a new importance in furniture manufacture. Light, cheap, easily worked into any form, it seemed an obvious choice for mass production. With glossy paints it could be made to look like expensive laquered work, and with inlays of precious or precious-looking materials this effect could be still further heightened. Mother-of-pearl or imitations of it in glass were particulary suitable for this.

Of course, a piece of furniture made out of papier-mâché was not very durable, it was true. However, did one really any longer want furniture that was made to last several generations? Instead of having their own houses, people lived in rented apartments, and they changed their furniture as often as they changed apartments. The ever greater amounts spent on furnishings were also meant to demonstrate the owner's growing wealth and rising social status. Naturally, wood continued to be the principal material used in the production of furniture. The new materials which appeared as surrogates for it enjoyed some fashionable popularity because of the charm of their novelty, but due to the general increase in wealth among the middle-class sections of society in the course of the century, they disappeared when their novelty faded, except for where their special properties could really compete with wood. Iron, for example, was favored for those items where great sturdiness was required from long and thin supports, such as movable clothes racks or simple washstands which were made either of cast-iron or cold-forged round bars. Iron was soon considered to have a slight hint of vulgarity about it. Wood kept its preeminence wherever the article of furniture consisted of large surfaces and also in cases

where the warmth of wood was regarded as an important factor in the comfort of the article.

Even wooden furniture could be produced cheaper, faster, and in larger numbers than ever before by means of extensive mechanization and mass production. Power saws and planes, milling machines and lathes not only lowered the costs of production, but also made it possible to use a greater wealth of machine-made ornamental forms to give the appearance of a more costly product.

Some of the machines used in this way had already been invented before the nineteenth century, but it was not until now that they could be fully exploited. The harnessing of steam power on a large scale was necessary for that. This required the massive working of coal mines and the new means of transport, the railroad, to carry the coal which fueled the steam engines to wherever it was needed. But it also required the removal of the old craft guilds, since this was the only way that furniture could be manufactured in factories instead of by highly trained specialist craftsmen in small workshops as in the past. In their place now stood the half-taught worker making the same movement over and over again at his machine. Instead of being paid a daily wage, he was paid a piecework rate. In this way the newly established furniture industry could not only produce more cheaply, but it was also able to satisfy the steadily rising demand caused by a rapid rise in the population, increasing urbanization, and the feverish building boom this brought with it.

There was boundless optimism about the progress of technology and industry, and its influence was also felt in the field of furniture manufacture. It did, after all, fit in with the political and social revolutions of the century which had resulted in an ever broader stratum attaining a position which had formerly been reserved for a comparatively small group. The new achievements of technology enabled more and more people to surround themselves with the luxury and comfort which until then had only been available to a few.

Page 73: Hall in the residence of George J. Baker, President of the First National Bank, New York (above);
Sitting room in Munich, about 1890, Ms (below)
Page 74: Great dining room of the Arkadenhausgruppe, Franz von Neumann, 1883, Vienna (above left);
Imperial Room in the central railway station, H. Stier, 1876—79, Hanover (above right);
Compartment in a sleeping car, about 1900 (below left); Arabian Room in the Glass Palace, Krecht, Munich (below right)

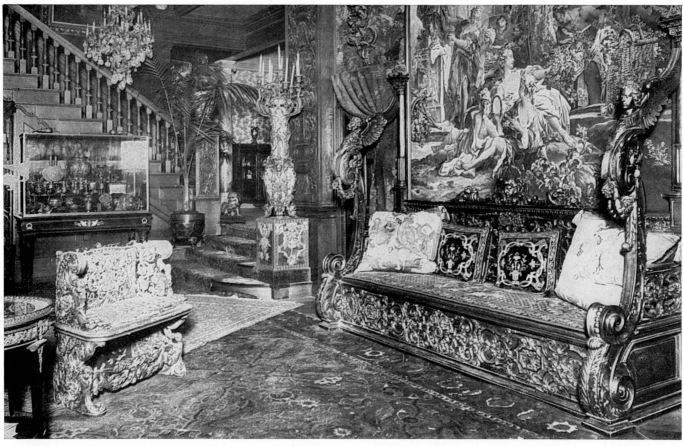
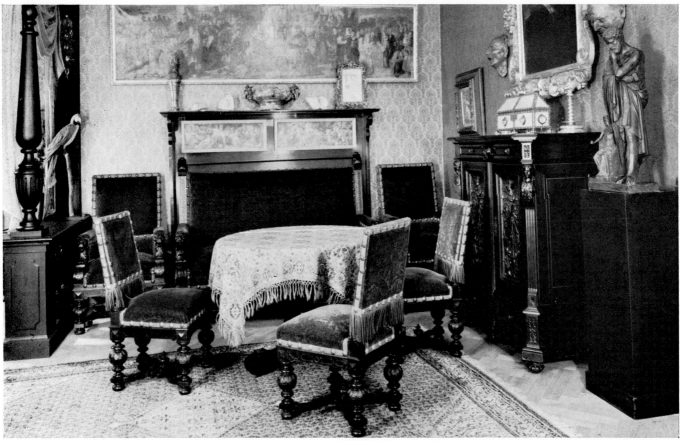

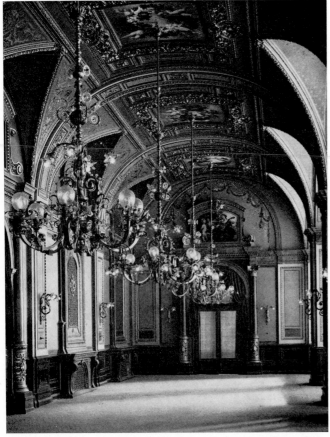
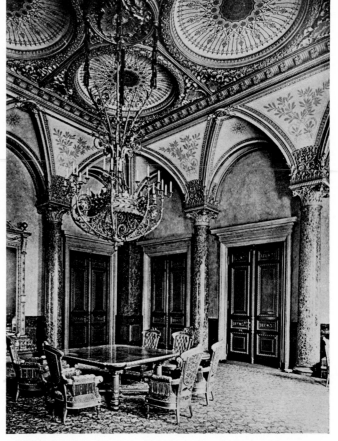
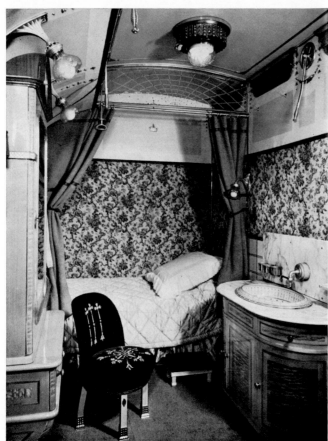
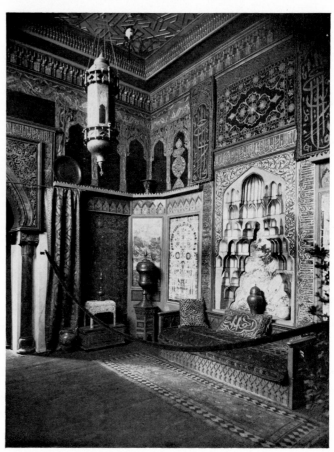

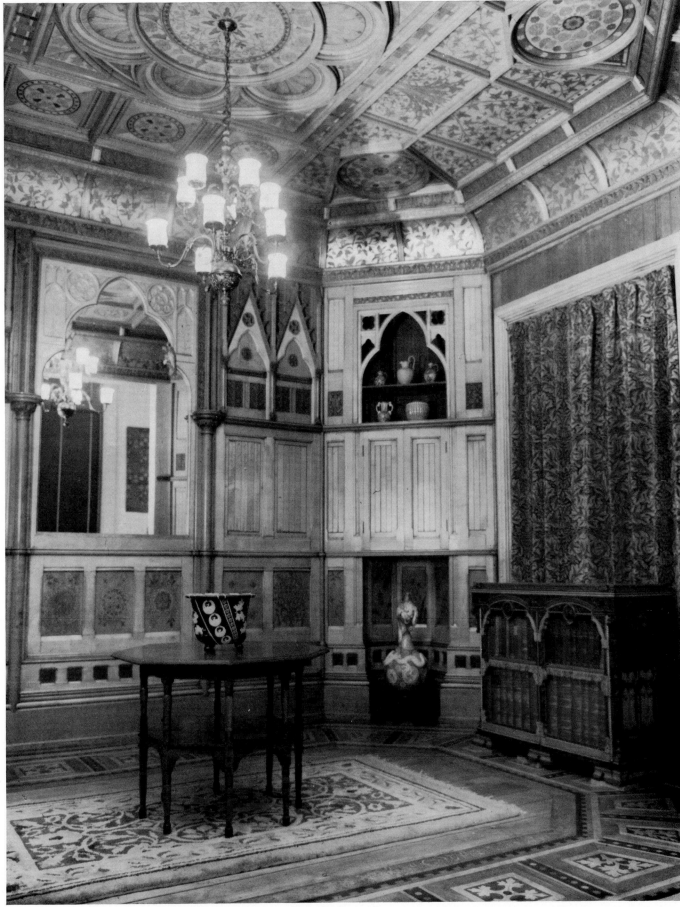

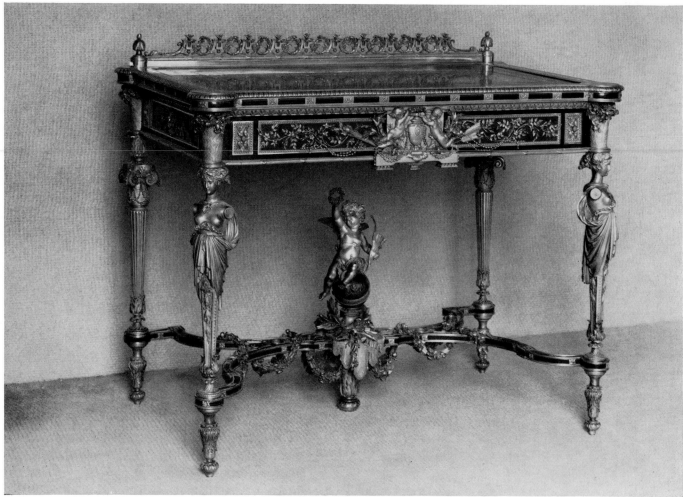

Even though the old aristocracy might have lost a good deal of its power and influence, people were still only too ready to imitate their way of life. In the course of generations pieces of furniture, household objects, and collectors' items of many ages, styles, and countries had often accumulated in the houses and castles of the nobility. They reflected the wealth and age of the house and the taste of its owner. With the help of the furnishing industry, however, there was no longer any necessity for a hereditary family home, for great riches, for travels to distant lands in order to create the same atmosphere of old established wealth and taste even in a rented apartment. The trade offered furniture of every period and style at reasonable prices, for if there was not quite enough money for old or exotic objects the industry always had a substitute ready which was hardly distinguishable from the real thing. People accumulated furniture and ornaments of the most varied kind and hung carpets and decorative objects on their walls, which, though not necessarily old, were convincing copies of old things. Georg Hirth, then an authority on German, and especially South German, industrial arts described one of these "quite lovely and cozy rooms" in 1885 as follows: "Next to the gorgeously shining ashwood cabinet stands the dark Italian chest—made into a comfortable sofa with a modern plush cover; there is a new imitation of a Spanish leather wall-hanging on the paneling next to a Flemish tapestry; on the cornice next to old pewter mugs . . . also French faience and Italian majolica; the enormous green stove rises above a magnificently colorful Armenian or Persian carpet; over the table with spiraling legs hangs a modern petroleum-burning chandelier; in the windows with bull's-eye panes and coats of arms stand English flowerpots, etc." In another passage he suggests the following "exquisite decorations" to the enthusiastic hunter for use on the walls: "Some living flowers and exotic plants, bunches of dried ears of wheat and grasses, stuffed birds: a hanging eagle, a black grouse in mating display or a peacock with its tail outspread, a large tiger- or bearskin, stag antlers, and so on." A real jungle of knickknacks! It was no mere chance that the winter garden, in which native and tropical plants made an artifical jungle, was one of the status symbols of wealthy people's houses.

Through his book *The German Room*, published in 1885, which contained a historical outline of the development of German domestic styles together with a theory of the creation of an environment with regard to the home and practical suggestions for furnishing, Georg Hirth had a tremendous influence in Germany for almost two decades, on German industrial arts and on a wide public following. He was just one representative of those theorists who had such a decisive effect on the form of furniture and the way in which homes were decorated both in Germany and the other European countries during the second half of the nineteenth century. Up until the close of the eighteenth century, styles in furnishings had been the result of the craftsman's mastery over his materials and the feeling for beauty of a highly cultured elite of clients. Since then this very fruitful contact between furniture producer and client lost more and more influence on the formation of style, and craftsmanly skill and knowledge of the materials played a smaller and smaller part in determining the development of form. This now became the task of the designer or draftsman or some other person who rarely had any experience in the practical side of the craftsman's work. Instead, he would produce his design on the drawing board and then hand it over to industry or possibly a craftsman to be made up in any material that was desired. In this respect, too, the eighteenth century had set the precedent for the nineteenth. The first time this happened was when the painter Jacques Louis David had furniture made to his own designs for his studio in the Louvre which would correspond to that in his pictures, whose style was inspired by classical antiquity. What appeared

Page 75: Reception room from the house called "The Grove," Harborne, Birmingham, paneling with wood tarsias,
J. H. Chamberlain, 1877; table in the middle: oak, English, about 1880; bookcase on the right: oak with bronze fittings,
glass doors, medallions painted on the sides, Hayward, about 1870, Lv
Left: Lady's writing desk, inscribed "P. Christofle et H. Bouilhet orfèvre. E. Reiber dessinateur, Paris 1867,
Carrier Beleuse et J. Chéret sculpteur," made for the Paris World Exhibition of 1867, Pd

in this case as the private initiative of an individual soon became the official practice with the designs made by the architects Percier and Fontaine for Napoléon I. On their drawing boards they developed a style using elements from Greco-Roman and Egyptian antiquity whose heavy forms, derived purely from the furniture's tectonics, were meant to embody the mode of government and authority of the emperor: the Empire style. As this spread to the other courts of Europe, certain principles were established for the construction of furniture which to some extent were to remain effective until the end of the century. Henceforth there was a division of labor between the designer and the producer. The *ébéniste*, both artist and craftsman at the same time, died out. Cases where this did not happen were exceptions. It was the learned theoretician who determined the form of furniture from that time, and he brought the whole store of his knowledge of art history to bear on his design. (Even the architect is a theoretician in the field of furniture making.) At the same time the individual article of furniture acquired an independence relative to the room, and a monumental character which it had previously not had. Until the late eighteenth century it was part of the overall decoration, dependent on the same formal idea as the enclosing surfaces of the room, the walls, and the ceiling, and only existed really in this complete context. After the beginning of the nineteenth century, however, the furniture became heavier and more massive, more independent of the room whose function was reduced to that of an empty stage or a neutral setting for furniture of a sometimes suffocating presence. The middle-class style which evolved from the courtly Empire in the 1830s—called Biedermeier in Germany—preferred lighter, less massive forms, arrived at by toning down the forms of the Empire. But furniture remained an independent entity, not absorbed into the design of the enclosing room, and it preserved this character until about the middle of the century when the taste of a public that had grown more prosperous began to change.

Around the year 1850 architecture was completely driven out of the room. The structure of the room, of the walls and floor, was only seen in the role of a clothes hanger, a "wardrobe hook" for the furnishings which alone determined the feeling and appearance of the room. The furniture of the Biedermeier Period still needed the structure of the room as a setting and emphasized it as a coherent three-dimensional continuum. Comparatively few pieces stood in the room, most of them being

placed up against the wall so that the middle of the room was clear. In addition, the furniture was generally set on such high legs that even under a chair or an armchair or even a table, the floor was always visible as a continuous surface. The walls, too, were always a continuous surface enclosing the room. The decoration of the walls was light and did not disturb this effect; it was the age of scissor cuts and miniatures. Even the individual pieces of furniture were made so that their decoration never disturbed the clarity of the overall form of the furniture, always appearing as a pattern on a neutral background. Bright, light woods and colors and plenty of daylight allowed this counterbalancing effect between furniture and room, between pattern and background to emerge clearly.

However, by the middle of the century people began to feel that these rooms were rather miserable and bare. They saw them as the result of hard times caused by war and political troubles and regarded them with contempt. "All their decorative work," wrote Georg Hirth in 1885, "was as hollow as the tinkling tin ornaments on their alabaster clocks and as dreary as the shriveled garlands on their stubby columns," and "Until then delicate shades of color had at least been preserved for the walls, but now the most insipid whiteness became mandatory, and where the gleam of gold was popular, it was used in boring broad areas, rough and unattractive. When we want to picture the heartless effect that the Empire or Napoleonic style had on middle-class homes we think of those terrible grandfather clocks with alabaster pillars and a head-piece like a frieze of thin brass sheeting with melancholic muses on it." The rooms of that period seemed to him "stultifying, chilling, dispiriting." They got rid of this coldness and dreariness and set up rooms for themselves which were filled with the treasures of every land and every age, like the fabulous caves in oriental fairy tales, lit with muted light that filtered through bull's-eye panes or through heavy curtains and portieres. Caves in which one could feel sheltered and secure from a modern world of technology and bureaucracy which one used, on the one hand, to increase his own prosperity, but which one feared when it penetrated into his private sphere. And, when it could not be avoided, it had to be concealed if possible. Those who could afford it found a refuge for their private lives in their own little castles, shielded from the banality of the everyday world by the trees and gardens of the suburb—but even in a rented apartment it was possible to create a

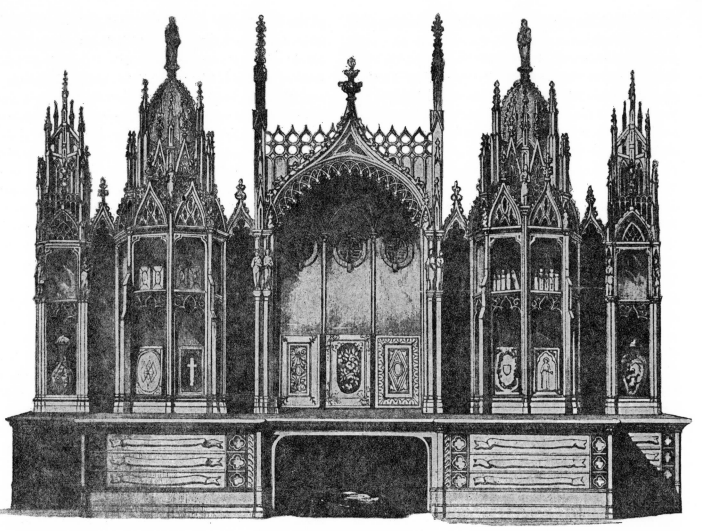

Above: Gothic bookcase, oak with carvings, gift from Emperor Franz Josef of Austria-Hungary to
Queen Victoria of England, design by B. Bernardis and J. Kremer, execution by Leistler and Son, Vienna, Lv

private retreat for oneself with the help of the right kind of furnishings.

The existence of the structure of a room, the architecture, seemed in itself to be too much a part of everyday reality and was largely denied and concealed. The relationship of the walls and floor disappeared under the great quantity of articles of furniture and furnishings: wall carpets, curtains, portieres, and other kinds of drapery which often had no "function," hanging in the room for no reason that we can discern today, obscured the relationship of the walls. The floor was "dismembered" and more or less disappeared as a unified surface. It was not just the quantity of furniture that disguised it, either. This furniture, particularly the seating, was also extremely low, and trimmings of all kinds—fringes, ruches, and tassels—hung down to conceal the floor under it and prevent it from being a part of the effect generated by the room. Wherever there were gaps left between the furniture and the drapery, they were filled with smaller objects like screens, stands, floor vases with dried or artificial flowers, and busts on columns. The room was created out of the furnishings, and the architecture played very minor role indeed.

The same abhorrence of empty space and the same concealment of structure can also be seen in individual articles of furniture. In chairs the upholstery and the frills are more important than the carpentry. The upholsterer made the soft seats and backs into something with a real plasticity, and the framework, which was often already very low, would be covered with trimmings and tassels right down to the floor. Even furniture in which wood was not just something added on, but a visible part of the structure—things like closets, writing desks, dressers, and so on—were turned by the use of lathes and woodcarving machines into objects whose structure, and even their purpose, was lost under the sheer weight of decoration. A typical example of this, perhaps, is to be found in the English sideboards which were shown in 1851 at the London international exhibition in the Crystal Palace. They were like carved altars

of the late Middle Ages, except that instead of legends from the lives of the saints they told the stories of Robinson Crusoe or Ivanhoe the knight. Did they serve any practical purpose? Looking at them, one forgets to ask.

The dim light, which was tolerated only in such rooms, and the colors both contributed to the obscuring of the room's structure and forms. "Insipid whiteness" was no longer "mandatory." Dark or dark-stained woods and cloths with heavy colors and thick, light-absorbing weaves soaked up the daylight. And when artificial lighting took its place in the evening, it glimmered and sparkled, broken up in many ways, scattered and reflected from the angular crystal of the chandelier, from the ground borders of many large and small mirrors and from the French polish of the furniture.

Not all the rooms of the house were overfilled like that. It was mainly the parlor, the "best room," which would not normally be used for everyday purposes. Lying embalmed in "cold magnificence" under dustsheets and protective covers, it would only be resurrected on days of particular celebration. Even then it was usually strictly forbidden to children because, in spite of the impression of great comfort made by the amount of upholstery and soft cloth, it was always necessary to maintain a very restrained and dignified standard of behavior there. Otherwise one risked damage either to oneself, on the many corners and edges, or else to the fragile ornamental objects, the knickknacks, which were an essential part of the decoration of such rooms. At the end of the century, Lichtwark, writing in Hamburg in 1892, expressed his contempt for rooms like this: "During the day one could only move around in these rooms with the greatest care, since they were quite dark and as crowded as a furniture storehouse. In addition, all the furniture had so many medieval corners and so many sharp bits of ornamentation in the most unlikely places that a visitor who was not familiar with it would go home with periostitis. People who really loved . . . their young children did not allow them in without supervision, as they tended to come out with crushed hands and cracked heads. It was a

Right: Great Stairway in the Opéra, Charles Garnier, 1860—75, Paris
Page 82: Front sitting room in the Daponte-Newman house, Thomas Sully and Toledane, 1890, New Orleans, Louisiana (above); entrance hall of the Porter house, Uhl und Schmidt, 1891, Chicago (below)

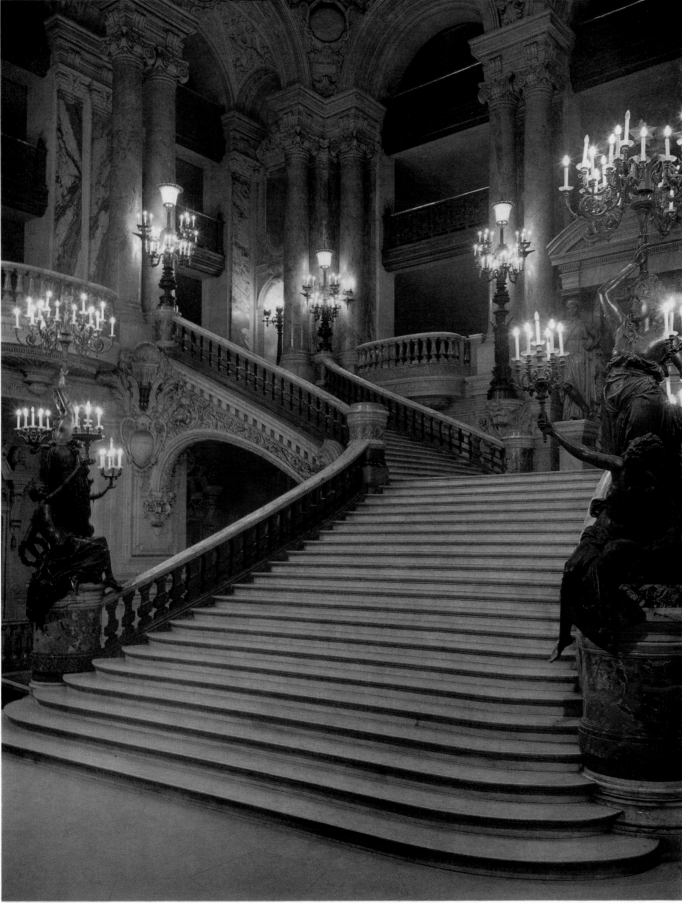

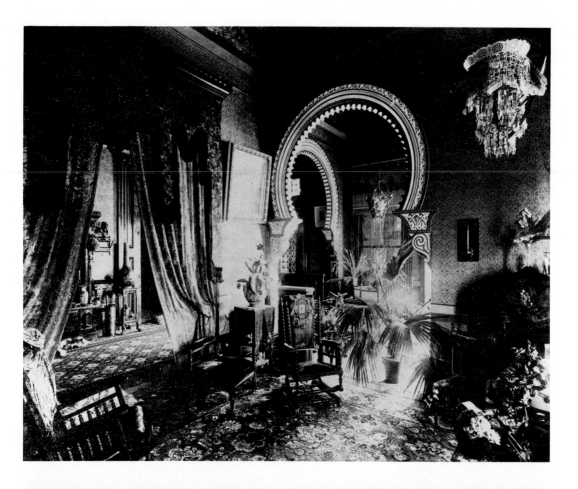
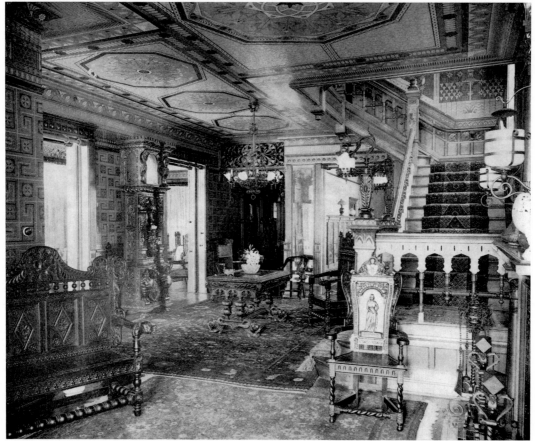

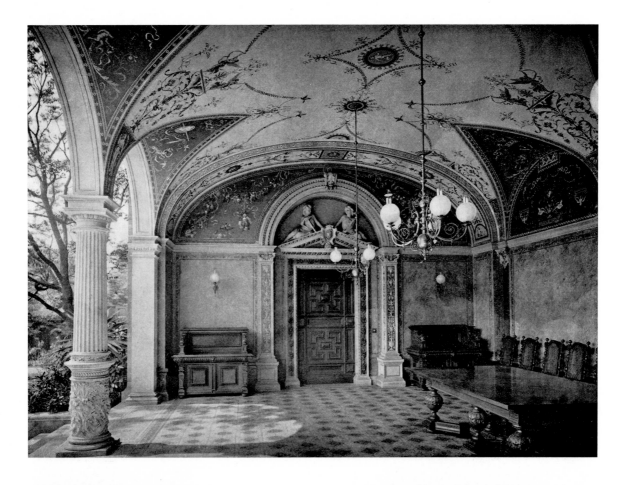
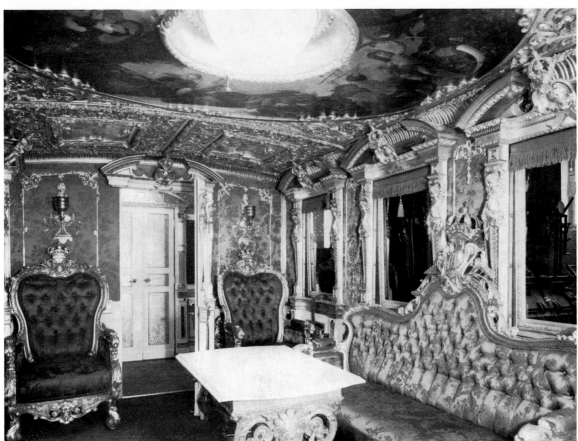

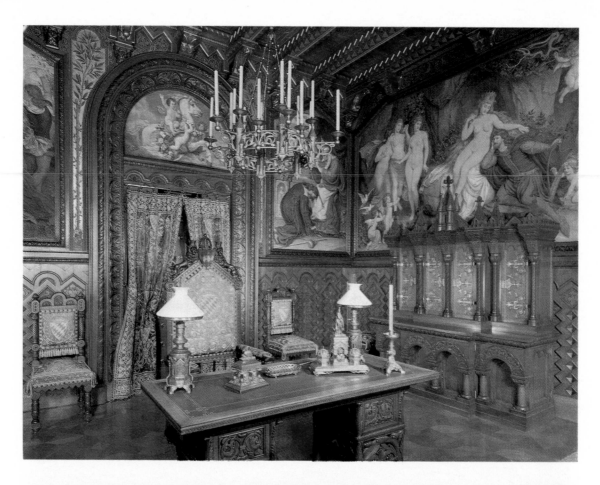

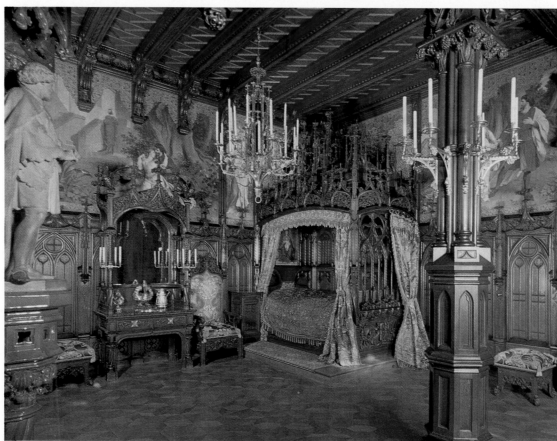

remarkable time. The original reason why there were tables and chairs in the world appeared to have been forgotten."

There were other rooms which were more available for everyday use, but, in spite of that, for our taste "as crowded as a furniture storehouse" and full of "medieval corners." These were rooms which had not formerly existed in middle-class homes and whose appearance demonstrates the increasing prosperity and rising social standing of this section of society. There was the billiard room, the smoking room, the music and dining rooms. The bedroom had lost its former social role as reception room, was generally relegated to the extreme back of the home and was often no more than a dark, poky tomb. The furniture in the man's room tended to be in styles borrowed from what were considered the manly forms of the Renaissance, while the lady's room contained furniture which leaned more towards the softer curves of the Rococo. However much pride they felt for the technological accomplishments of their time, people saw themselves as heirs and custodians of the intellectual and artistic achievements of their forefathers, and, just as in architecture, they took these as their models in the design of furniture. Furthermore, they were completely ready to recognize the achievements of foreign, particularly oriental, cultures in the realm of comfortable living and to integrate them into their own life style. One could find traces of practically every stylistic period in history and many foreign motifs in the homes of this age. Training in art history was the most important prerequisite for designing furniture.

We have become used to using names like Neo-Gothic, Neo-Renaissance and so on to describe the repertory of forms of this period. One could easily—and this has frequently been done—even construct a neo—art history out of it. That is, look for a particular sequence in the changing stylistic motifs, a particular order in which they follow one another, reflecting the historical sequence of their sty-

listic models. However, that entails the risk of becoming lost in the comparison of details and only considering the degree of dependence on the historical model and the quality of the "imitation," consequently overlooking the independent achievement of the period as a whole. What is more, this neo—art history could not be written without falsifying the facts involved. As a rule, every historical stylistic model could be used at any time throughout this period, and quite often—as mentioned earlier—several styles would be represented in one apartment or even one room. It was much like one of the exhibitions which were so popular at that time where one could wander past the treasures of one country after another, or the newly established museums of arts and crafts where it was possible to admire the progress of art history from the way the exhibits were arranged together and in sequence. The home of a private individual would generally offer a collection of articles of furniture and ornaments of the most varied stylistic origins.

Naturally, there were "stylistic fashions," and at one time one model would be more popular and then be replaced by some other. But these never completely excluded furniture designed according to a different pattern. When the fashions passed, their particular ideal would not disappear into oblivion. The most one could say is that the variety of decorative styles increased as the century proceeded.

One should not overlook the fact that in spite of all that they had in common, each country had its particular preferences. In particular, the return to their own national models was a general phenomenon. Of course, there were influences of one country on another. It was mostly the rich industrial nations which were also the centers of stylistic fashion. For example, the influence of England became predominant in the revival of Gothic forms which reached the Continent in the first half of the nineteenth century and lasted into the seventies and beyond. It was, however, not at all easy to adapt Gothic

Page 83: Garden hall of the house at 22 Schlesische Strasse, H. Licht, Berlin (above);
Parlor in the railroad parlor car of King Ludwig II of Bavaria, 1868, Nv (below)
Page 84: Ludwig II's workroom in Neuschwanstein Castle, paneling by Pössenbacher and Ehrengut,
murals (scenes from Tannhäuser by Richard Wagner) by J. Aigner, 1869—86 (above)
Ludwig II's bedroom in Neuschwanstein Castle (below)

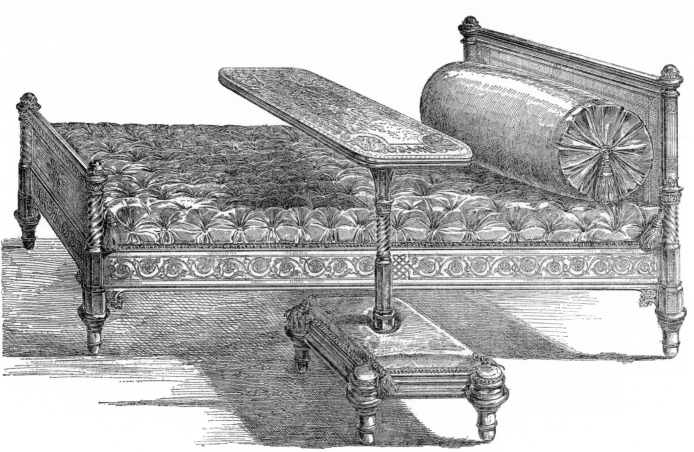

Above: Lounge with swivel table, Voit, 1851, Munich

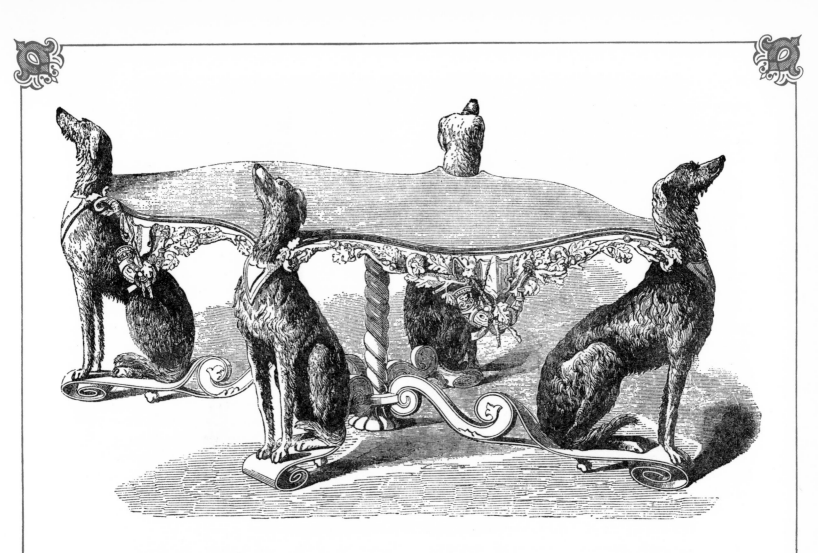

Above: Table of cast iron, design by John Bell, executed by Coalbrookdale Iron Company
(shown at the Paris World Exhibition of 1855)

forms, which are mostly derived from sacramental objects and are bristling with canopies and little spires, filigree and figurative carvings, to modern needs and the variety of new forms. For this reason, once the first romantic enthusiasm for medieval decoration had worn off, furniture in the Gothic style soon became an object of scorn to its contemporaries, not least because it was so uncomfortable.

Neo-Gothic furniture quickly found a "rival" in the revival of furniture design of the eighteenth century, the Second Rococo. This was accompanied by the rise of a powerful French influence, also beginning before mid-century, which was felt throughout Europe. A second center rose in Vienna. The comfortable design of Rococo furniture never completely disappeared from the living rooms of the nineteenth century. In its last quarter the Rococo fashion even enjoyed a revival when there was a return to other furniture styles of the eighteenth and early nineteenth centuries up to and including the Empire and Biedermeier. England during this time followed its own national styles of the eighteenth century: Chippendale and Adam Sheraton.

In the meantime, soon after the middle of the century, the forms of the Italian Renaissance had gained in influence as models. Through this, of course, Italy's national heritage became important. Northern Italy, in particular, distinguished itself by the production of richly carved furniture and by inlay work in marble, scagliola, and other materials. But the Renaissance fashion was international, propagated in particular by the theory and the writing of the German architect Gottfried Semper. This international fashion took on a distinctly chauvinistic flavor in Germany after the victory over France

when they wanted to demonstrate not just the superiority of German arms, but also the superiority of its art. The German Renaissance then became the dominant pattern for the middle-class German living room, and in the taprooms of inns it lasted far into the twentieth century as the expression of *"deutsche Gemütlichkeit."*

One should understand that this borrowing from a historical model was seldom based on purely formal grounds, on admiration for the beauty of the decoration and harmony of the proportions. Right from the beginning the return to past ages was meant to serve an idea, mostly of patriotic or religious virtues, which were considered to have flourished particulary in these earlier times. Therefore there is an allegorical aspect to all this furniture (just as in the architecture of the same time) in that they go beyond the form in referring to an abstract concept. This is just one example: at the same time that the newly constituted German Empire, Munich included, was placing such emphasis on everything Germanic, and in spite of the fact that Bavaria had taken part in the war against France along with the other German states and then joined with them in the formation of the empire, King Ludwig II of Bavaria tried to achieve the closest possible relationship with the styles and designs of the French monarchy, particularly of Louis XIV and Louis XV, in the architecture and furnishing of his new castles. The reason for this was that he saw their reigns as the realization of the ideal conception of monarchy, and to imitate this was his lifelong, though unfulfilled, dream.

Of course this particular choice was linked with an evolution of taste which was not restricted just to the King of Bavaria. Along with its increasing wealth there

Right: King Ludwig II's bedroom at Linderhof Castle, 1874—78

Page 90: Bed, metal frame with papier-mâché boards, about 1850, Birmingham, Lv (left);

Closet cabinet, Manguin, Dalou, Delaplanche, Meyer, about 1865, Pd (right)

Page 91: Closet cabinet, wood tarsias with bronze fittings and porcelain insets, design by Eugene Prignot,

execution by Jackson and Graham, London, for the Paris World Exhibition of 1855, Lv (left);

Closet cabinet, satinwood with tarsias, gilded bronze fittings and wedgewood insets, Wright and Mansfield, London,

for the Paris World Exhibition of 1867, Lv (right)

Page 92: Bed, painted and gilded wood, inlaid with mirrors and a painting showing the judgment of Paris,

VITA NOVA inscribed on the foot, WILLIAM BURGES ME FIERI FECIT and

ANNO DOMINI MDCCCLXXIX, designed for Tower House, Kensington, 1879, Lv

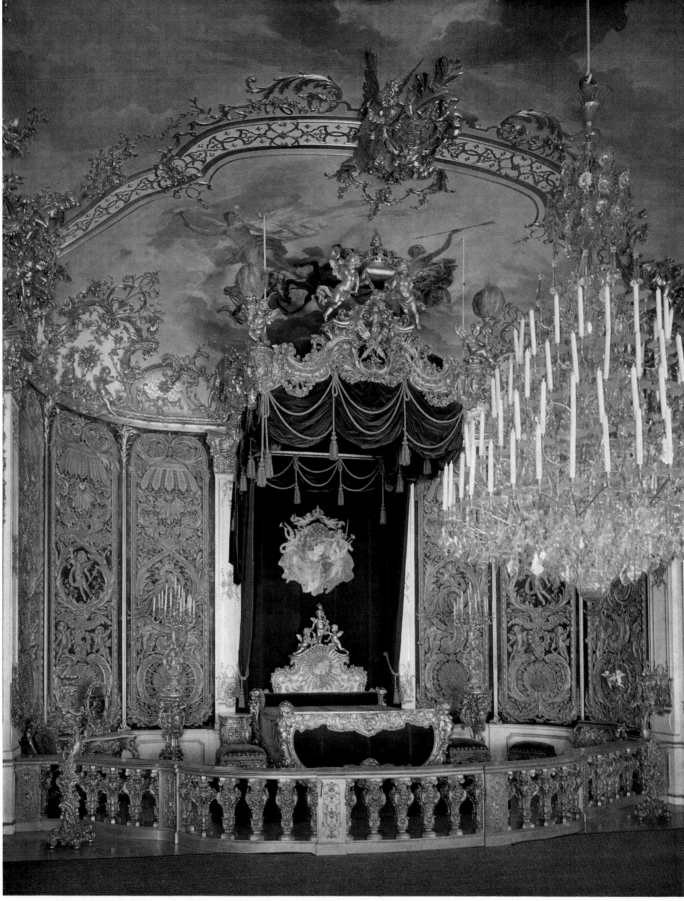

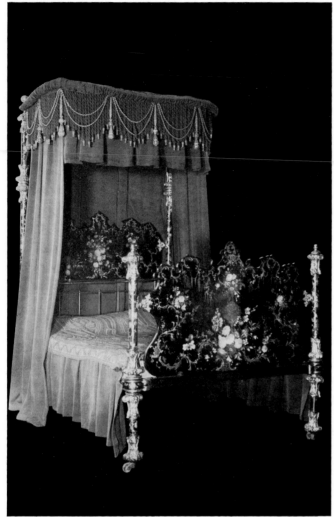

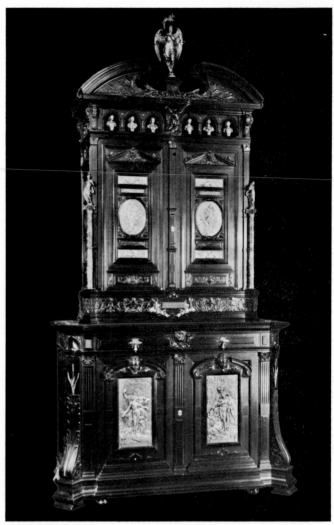

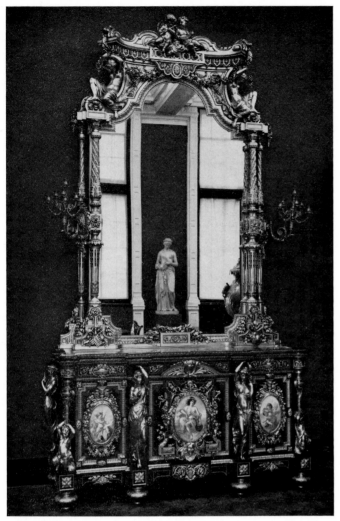
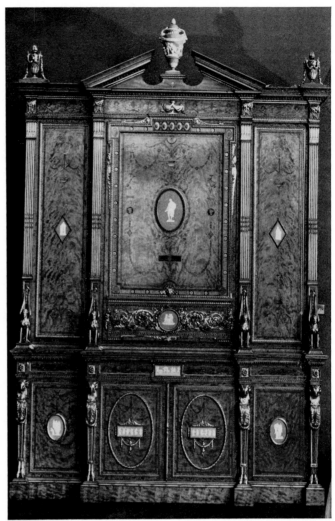

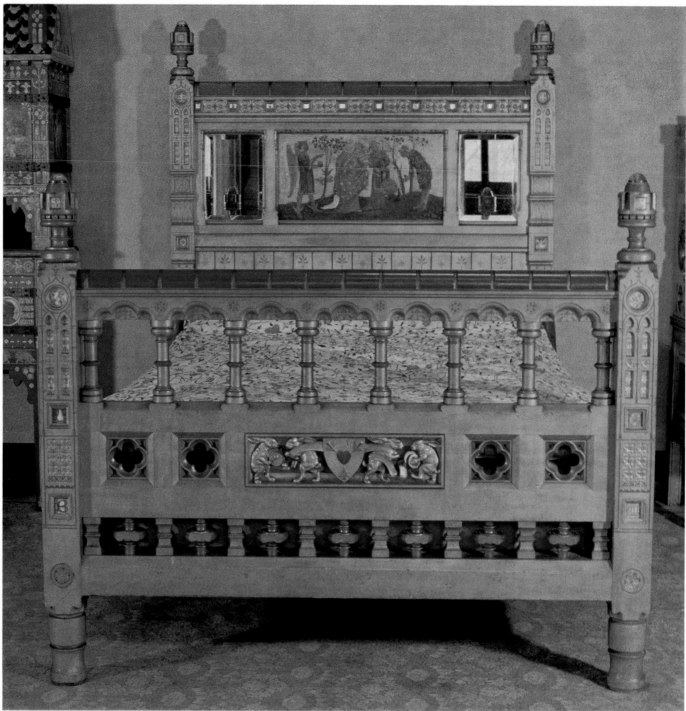

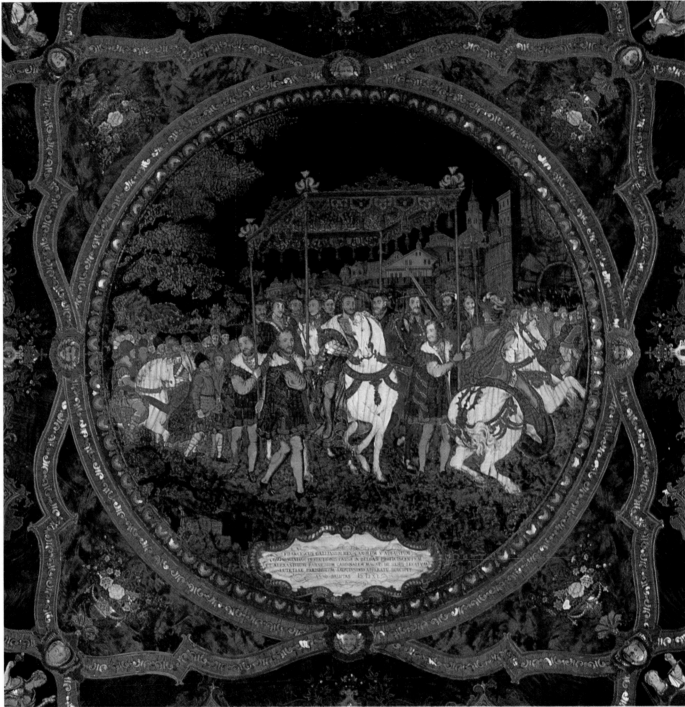

FRANCISCUS GALLIARUM REX CAROLUM V AUGUSTUM
LUGDUNENSIBUS DELECTIONIS CAUSA IN BELGAS PROFICISCENTEM
ET ALEXANDRUM FARNESIUM CARDINALEM RAVAE DE BLAIS LEGATUM
LUTETIAE PARISIORUM AMPLISSIMO APPARATU SUSCIPIT
ANNO SALUTIS 1 5 4 0

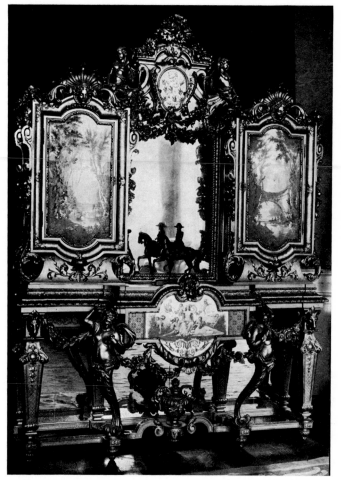

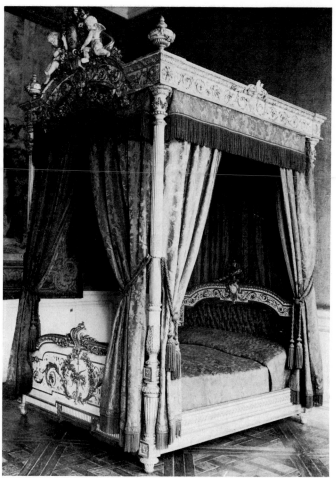

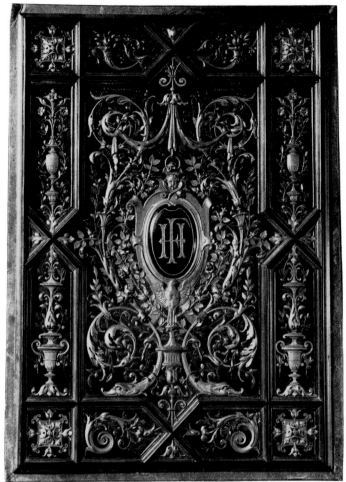

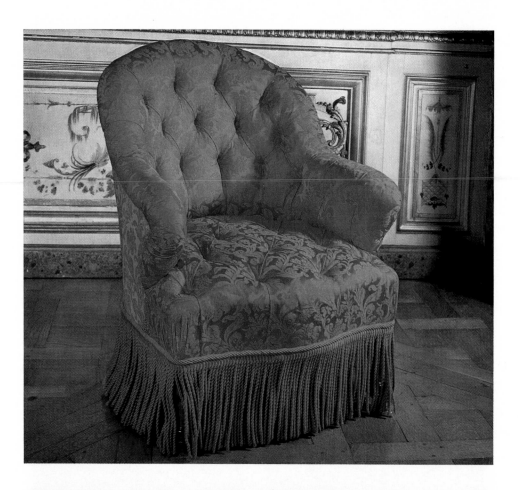
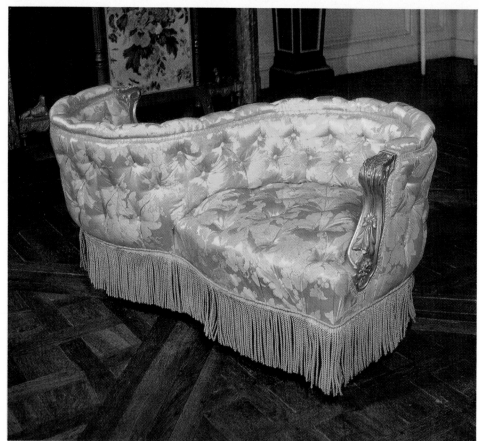

was a growing demand for pomp and ostentatious luxury in the houses of the uppermost levels of the German middle class too. The obvious thing—in spite of all patriotic feeling—was to choose the magnificent furnishings of the French monarchy as their model.

To present the idea it was enough just to make an allusion, so that as a rule there was no need for faithful copies of old furniture. Certainly there were copies, just as there was reuse of old furniture or parts. People would use reproductions of old furniture to decorate a room for the same kind of pleasure they took in the reproduction of an old painting. In her passionate enthusiasm for Marie-Antoinette, Eugénie, Empress of France, had her chambers in the Tuileries furnished entirely in the style of that queen by the architect Lefuel. This was in 1865, and it started a fashion for furniture in the style of Louis XVI. The furniture of these chambers consisted of in part exact copies of the eighteenth century originals. They were arranged together with new pieces which, though they followed the old forms very closely and were particularly precise in reproducing the ornamental details, were nevertheless the result of modern needs. Therefore not only should their total form be considered a new creation, but the relationship between the individual parts, their size, and their proportions, as well as the relationship to the purely decorative elements were all so different and newly defined in these cases that the piece is clearly an article of furniture of the nineteenth century.

This kind of original creation "in the spirit" of a historical style was very common. It was not simply a question of the pocketbook, for obviously the exact copies of old pieces cost considerably more than mass-produced furniture. Changing ways of life, new uses for furniture, new types, and not least mechanical techniques of manu-

facture had a much greater effect on design. This can perhaps be demonstrated in the changes which the forms of Louis XV furniture went through in the Second Rococo in Vienna (and in its spread from Vienna). The starting point was a close dependence on the French eighteenth-century model. But even at the very beginning some influences from the Neo-Gothic, which was very fashionable during the same time, were noticeable. The *rocaille* forms took on something of the feel of Neo-Gothic leaf designs, became more naturalistic and luxuriant, but at the same time somewhat more pointed and spiky. On top of that there were the influences of the stylistic forms which had changed the design of furniture since the Rococo. Bureaus and closets mostly kept the boxlike shape which they had acquired in the Neo-Classical age, up to the Biedermeier Period. Bowed or bulging surfaces were avoided, and the curve, as the typical distinguishing feature of the Rococo, was introduced only on margins and edges. A plain and very simple form of Second Rococo appeared, especially among the cheaper designs produced, which was definitely the result of Biedermeier influence, and this was very popular throughout the second half of the century in the houses of the middle class. It just borrowed the curved forms of the original pattern, using them particularly for chairs and also for decoration, as ornamental forms, on the edges of closets and chests such as the curved outline of closet headpieces and the tops of bureaus. There was almost no carving on them at all, and instead a rich profile would be milled on chairbacks and the borders and edges of closets and chests.

A more important and radical change affecting the form of chairs was brought about by the influence of a new technique for working wood. Michael Thonet, a Rhinelan-

Page 93: Inlay work, detail of the top of the table on page 106 (below), brass, mother-of-pearl, ivory, and lacquer pastes, pictures from the story of Charles V and Paul II. Hm

Page 94: Jewel cabinet, carved wood, gilded, with porcelain insets, Cn (left);

Four-poster bed, carved wood, painted and gilded, about 1865, Cn (right)

Page 95: Bookbinding, relief wood tarsia on an ebony base, Henri Fourdinois, 1872, Paris, made for the Vienna World Exhibition of 1873, Hm (left);

Wood tarsia on rosewood, detail of a closet door, around 1870, Paris, Pd (right)

Left: Armchair with red silk brocade upholstery, about 1870, Cc (above)

Seat, so-called vis-à-vis, with yellow silk brocade upholstery, about 1870, Cn (below)

der who had gone to live in Vienna, developed a process while working with the curved lines of Rococo furniture by which wood could be bent into the desired shape under the effect of damp heat. This new technique also led to a limitation of decorative details, especially in carving, which cannot be carried out so easily on bent wood as it can on wood cut with a bandsaw. The final result of this reduction was the bentwood chair in which decorative addition had disappeared and whose curves alone were still reminiscent of the eighteenth century. It enjoyed great popularity for a long time (and does again today) particularly as a cheap form of seating for restaurants and cafés.

New methods of manufacture and new requirements had the same or similar effects in the other decorative styles on the imitation of historical models. One can see how the forms of the ornaments on Neo-Renaissance furniture were changed by the precision of mechanical production. They became harder, more angular, and uniform; the fluidity of composition gave way to rows of repeated single forms, so that the string of pearls tended to replace the garland and, finally, those forms which could be easily produced by machines became more frequent at the expense of forms which still needed to be finished with a carving knife. The greatest modification of historical models, however, occurred where there were new forms and types of furniture which made even an approximate kind of imitation of an older type quite impossible. If one wanted a piano to go with his Neo-Gothic music room (and there were such pianos) then it was completely open to the designer's imagination how he would use Gothic decorative details to make the long, low form of the instrument fit in with the other furnishings.

This example shows how easily fashions in styles could slip into exaggeration and bad taste, and how close they often came to being ridiculous. The fact that practically every imaginable style was available for use in furniture design contributed to the confusion rather than the enrichment of a public which did not have the guiding influence of an aristocracy with sound judgment in matters of taste, as in past centuries. The changes in the models adopted by designers were a reflection both of the extensive art historical knowledge of this age and its uncertainty about how this should be used.

Even at the time there were voices raised in warning against the excesses and pressing for remedies. They tried to make themselves heard very early on when the nega-

tive consequences of mechanization and mass production in furniture making—as in the other arts and crafts—had only just become obvious. State and private institutions which were supposed to work for new principles and standards of artistic and craftsmanly quality arose, arts and crafts associations and schools dedicated themselves to the task of training craftsmen and designers, and many periodicals and publications tried to spread new ideas. Perhaps the oldest of these arts and crafts associations was the Munich Verein zur Ausbildung der Gewerke, founded in 1851.

Nevertheless, there was not complete agreement about the course to be adopted in order to raise the level of the industrial arts. Two main "schools" emerged. Their starting point was the same, but their goals and their methods were radically different.

One school accepted the mechanization of furniture production while regretting its negative consequences. It tried to improve artistic and craftsmanly quality by drawing attention to the roles of function and materials in determining the form of furniture, and to restore this as the basis of design even of mass-produced articles. Its main proponent and teacher was the German architect Gottfried Semper whose decades of teaching and numerous writings had a by no means minor influence on European arts and crafts. "Every product sold," he taught, "should be so made that it serves the broadest possible use; it should show no other feature than those necessitated by its purpose, the materials used and the way this has been handled." He demanded that people go back to an awareness of the "primal motif" or to "types" of functional form which are "the forms determined by the original needs, but which are modified according to the materials available for their production." These principles hold for every branch of the industrial arts. For the construction of furniture, the combination of purpose, material, and manner of working the material gives the tectonics of the simple box shape as the result of the structure of wood. For this reason Semper rejected the curving forms of the Rococo, for example. Semper did not preach a pure functionalism. In addition to the primal motif of the functional form conditioned by purpose and material, there was also the "symbolic form." This meant everything that is added to the purely practical form in the way of intellectual and spiritual content as a result of traditions, conventions, and the existing social order. It is only through this that a style can arise which can make an object for use into an object of art. He saw the Italian

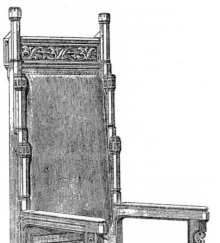
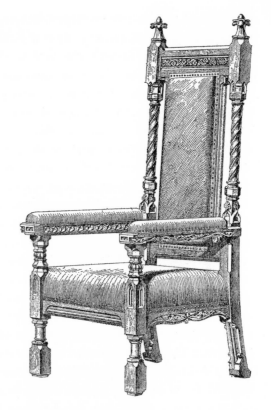

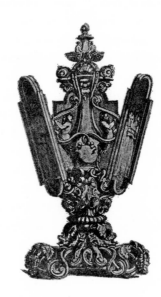

Above left and right: Two gothic chairs, G. G. Ungewitter, sketched by H. Riewel, 1851, Kassel
Middle: picture stand, design and execution by M. Thonet, Vienna

Renaissance as that style in which fidelity to purpose and material were ideally united with the principles of a secular middle-class social order, and he also took it as the model for his buildings. It was also part of his theory that the main guiding idea should be derived from architecture: "The decorative arts should evolve from architecture and maintain their relationship to it," because "in architecture...the various branches of industry and art are united into one total synthesis according to one guiding idea." (All quotes from the years 1853–54.)

It is true that Semper's theory at first only brought about a new variant of stylistic borrowing, yet his efforts to achieve a new order in arts and crafts under the guidance of architecture did begin to show some success after the seventies. In Germany especially an approach to interior decoration started to develop which no longer began with the individual piece of furniture, but regarded the room as a single entity and sought to design it as a single whole. The architecture, that is, the walls, was once again seen as the basic element in the conception of the room. The arrangement of the walls was the dominant motif, and the furniture had to be of a scale and style which conformed to it. Wainscotting replaced cloths and drapes as a wall covering and so introduced a structural, tectonic element into the design. The furniture, which harmonized with this wainscotting, was built in, in part, and could no longer be swapped around at will or increased in quantity. The furniture itself again emphasized its structure, to which the decorative details had to conform. In upholstered furniture the upholstery became smaller in size and was reduced to a secondary part, to just a cushion on the wooden structure.

These tendencies achieved public acceptance and general approval when in 1876 the first specialist exhibition, devoted solely to arts and crafts, took place in Munich. Even the "fine arts" had to conform to them.

Here, for the first time—in the first "official" manifestation of the new art of interior decoration—the products were no longer arranged in groups like furniture, ceramics, textiles, etc., but put together in rooms which in each case were furnished according to a unified approach where everything exhibited had to fit in harmoniously.

The other school, by contrast, regarded the Middle Ages, and especially the Gothic period, as the finest example to be followed. Its roots lay in the Romanticism of the first half of the century, and it was decidedly hostile to industry. It not only deplored the decline of arts and crafts but saw it as simply a result of the decay of the old ordering of society, the decline of mores and moral values caused to no small extent by the uprooting of the craftsman and his degradation to a servant of a machine. A reform of arts and crafts could therefore only be achieved as the result of a reform in the circumstances of production and the methods of manufacture, that is, by reintroducing the old practices of craftsmanship.

The most important supporter of this school on the theoretical side was the Englishman John Ruskin, whose ideas were put into practice by William Morris, but it also had a considerable following on the Continent. One of its prophets in France was the architect Viollet-le-Duc. He was less radical but for that reason had a more widespread influence. Morris had a house built for himself in 1859 by the architect Philip Webb, and this brought to his attention the tremendous lack of good quality furniture and decorative objects. He decided to design and produce all the furnishings for his house in his own workshop. Soon after, beginning with the architect Webb as his partner, he founded a firm, and after some successful exhibitions of its products a clientele of suitable customers was established.

In his works, Morris tried—and here he was in agreement with Semper—to achieve a harmonious combination

Right: Peacock Throne of King Ludwig II from the Moorish Kiosk at Linderhof, peacocks in enameled cast bronze and "fake precious stones" by Le-Blanc-Granger, 1877, Paris, throne by Anton Pössenbacher, Munich
Page 102: Sewing table, tarsias, about 1870, Pd (above left); easy chair, rosewood, about 1870, Pd (above right); Chair with pearl embroidery, end of the 19th century, Pd (below left); easy chair, so-called chauffeuse, about 1870, Pd (below right)
Page 103: Sofa from Compiègne Castle, about 1870, Pd (above); Chairs with lacquer pastes and mother-of-pearl, about 1870, Pd (below)

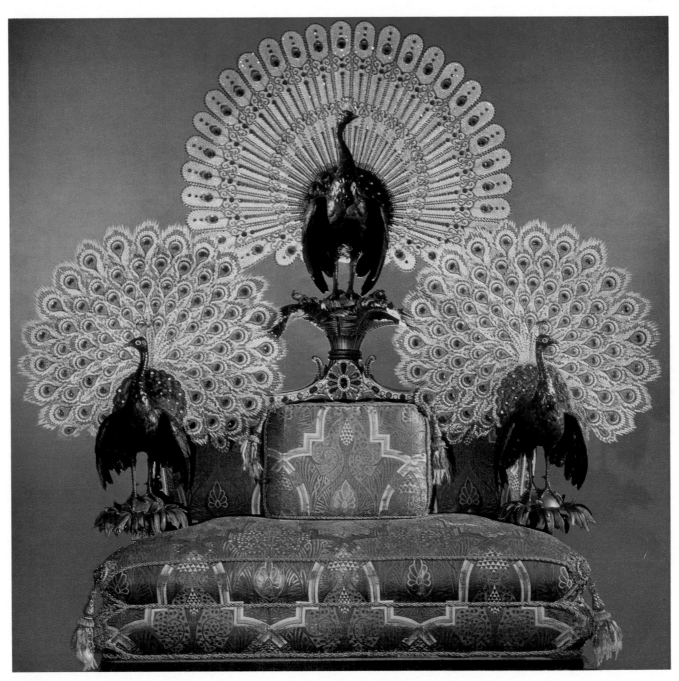

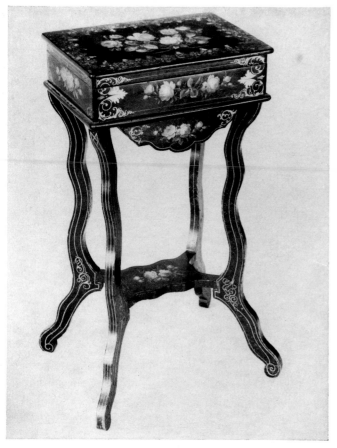
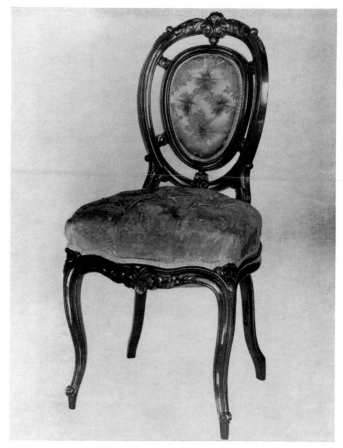
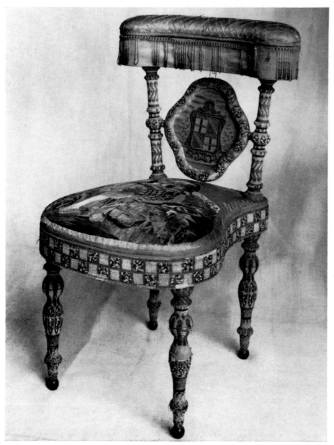
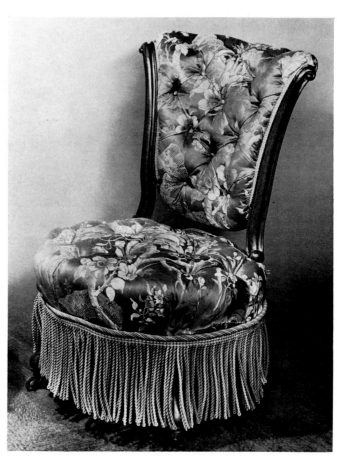

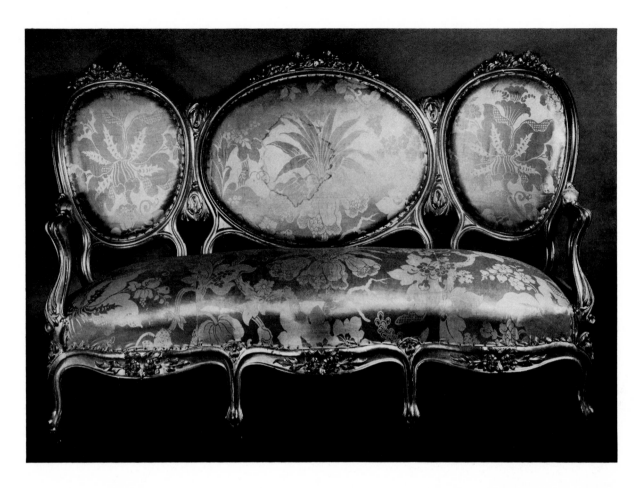
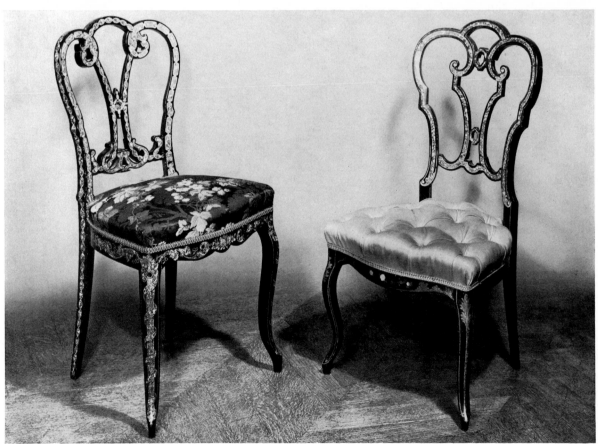

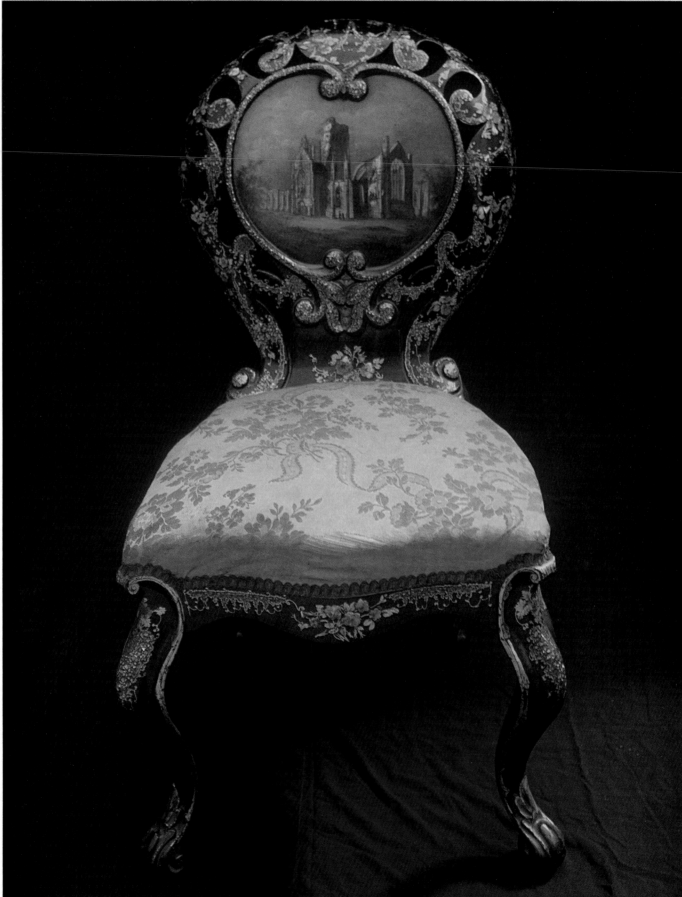

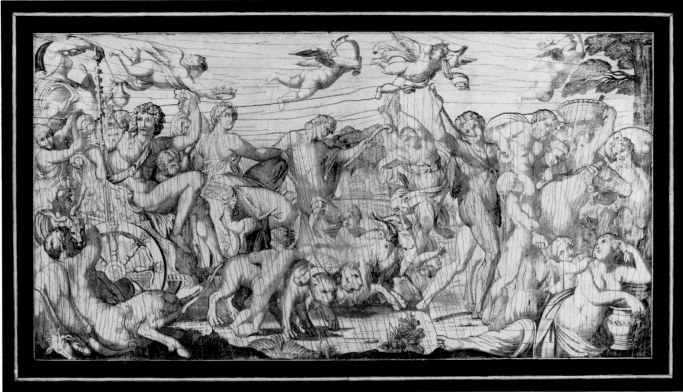
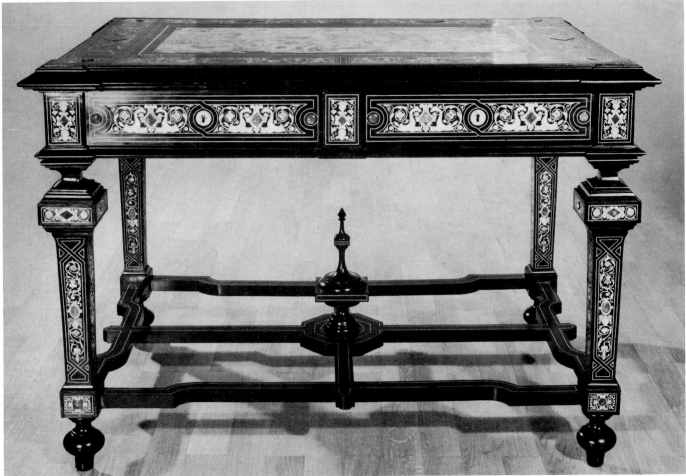

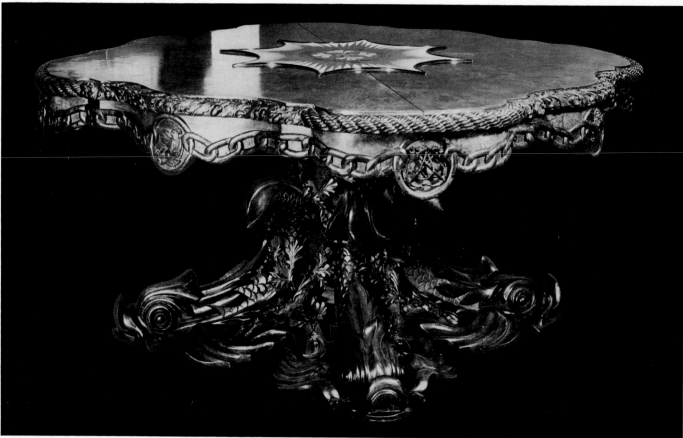
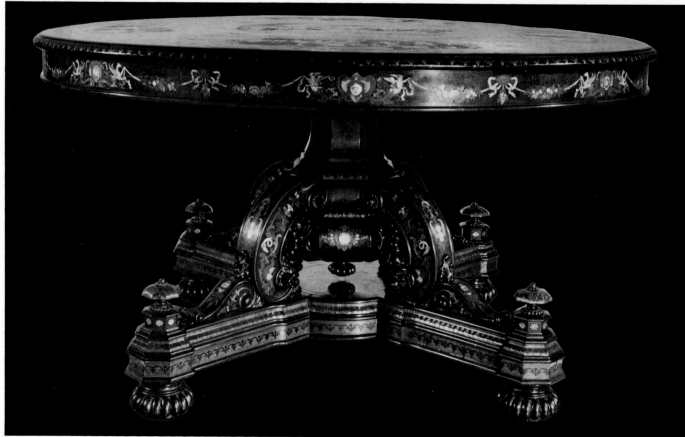

of the material and the function, and to avoid excessively rich forms and ornaments. His ideal was the clarity and simplicity of medieval furnishings. This was also the basis of his insistence on the genuineness of materials, that is, the rejection of surrogates that were widely used at that time, and on things being craftsman-made from the design right through to the final completion. Sometimes he tried to revive techniques which even craftsmen had already given up, such as when he mortised boards together with dowel pegs instead of gluing them. There was no imitation of Gothic forms in his designs. He was concerned, rather, to penetrate the spirit and the formal principles of the Middle Ages in order to breathe new life into them and so arrive at new forms for furniture and decorative art.

Though the things produced in Morris's workshop were of a high quality, the methods of production were an anachronism in an age where a mass demand had to be satisfied quickly and at low cost. His products could only be enjoyed by a small class of wealthy people. Nevertheless, a whole generation of architects and craftsmen were trained according to the principles of Ruskin and Morris, and in 1884 they joined together to form the Art Workers Guild and the Arts and Crafts Exhibition Society, which offered the public its first exhibition in 1888. Thus, William Morris's efforts finally bore fruit in the movements which strove for a radical renewal of art and craftsmanship toward the end of the century.

Perhaps the most important motive force and place for public judgment of the currents and developments in the making of furniture during the second half of the nineteenth century were the great trade fairs which were held all over Europe in quite rapid sequence. In these each country would exhibit the whole range of its products—from its industry, its craftsmen, and sometimes even its agriculture—thereby allowing an impression to be formed of its level of development and enabling comparisons to be made between them. The earliest of these was the Great Exhibition in London in 1851. As the first international exhibition of this kind, its importance for commerce and industry, business and trade can hardly be put high enough, and in the fields of furniture production and arts and crafts it opened up a new epoch.

Here, for the first time, all the possibilities and consequences of the industrial mode of production—that is, of mechanization, huge-scale mass production, and the introduction of new materials to replace wood—could be seen almost too clearly. What until then might have been regarded as an isolated phenomenon now emerged as a general, international direction of development which could not be considered just from the local aspect. Suddenly, coming almost like a shock, the exhibition made the crisis which had overtaken the industrial arts as a result of the replacement of craftsmen by factories quite obvious: while successful solutions had been found to the technical problems arising out of the enormously increased demand for cheap furniture, there had not been the same success in coping with the artistic aspect of the changing situation.

It became clear that the old interplay of client and producer was no longer effective in determining form and quality under the new conditions of production and marketing. New ways of controlling quality had to be found since it was no longer possible to leave furniture to depend on the manufacturer's judgment. Comparing products together on the basis of their country of origin made what had previously been the private concern of the purchaser now a matter of national prestige. At the same time it set up new criteria, an international stand-

Page 104: Chair, papier-mâché with mother-of-pearl inlays, back painted in color,
original damask upholstery, about 1850, England, Lv
Page 105: Table, ebony with tarsias of ivory, mother-of-pearl, and colored stones, about 1870, Florence, Hm (below);
top of the same table, ivory tarsia after the fresco by Annibale Caracci in the Palazzo Farnese, Rome,
showing the marriage of Bacchus and Ariadne (above)
Page 106: Table, walnut with carved decoration, a star in porcelain inlay on the top,
Henry Eyles, Bath, shown at the London World Exhibition in 1851, Lv (above); table, walnut and other woods,
C. F. H. Plambeck, Hamburg, made for the London World Exhibition of 1851, where it won a prize, Hm
(below — detail of the top on page 93)

ard, which was in fact not matched up to by any one of the exhibiting nations.

The country that came off best in this comparison was France. Here, in spite of the freedom won by the trades during the Revolution and the establishment of the middle class as the strongest force in the state, the standard of production was determined, just as it had always been, by the demands of an aristocratic upper stratum. French craftsmanship still looked for its models, its methods of production, and its standards of quality in the examples provided by the monarchy of the seventeenth and eighteenth centuries. This meant that the quality of French furniture was actually an anachronism, and its contemporaries were very well aware of that. Lothar Bucher, correspondent of a German newspaper, wrote from London at the time of the exhibition: "French industry is still the industry of the monarchy. In the French section we are forced to ask: What do poor people buy in France? Everything that you see, from the wonderful goldsmith's work, the fabrics from Lyons, the Gobelins and the porcelain right down to the cabinet making seems intended for the drawing room, for people with an income of at least 100,000 francs." And Bucher quotes the Frenchman Thiers: "Democratic France produces for the aristocracy, aristocratic England for the masses."

It was true that the process of industrialization and mass production had progressed farthest in England, and that the crisis in quality was most striking there. Nowhere was the shock so powerfully felt as in the host country itself. For this reason the reaction in England was the most energetic and purposeful. The question of artistic and craftsmanly quality in the industrial arts was left to private initiative alone no longer. The state, under the patronage of the Prince Regent Albert, began to play its part. Immediately after the exhibition, an institution for teaching arts and crafts was founded, and the basis and mainstay of this was a collection of outstanding examples of the arts and crafts—now the Victoria and Albert Museum. The best products of every nation and every age were arranged according to the material and technique of production, and could be studied in conjunction with the contents of the library, courses, and

lectures. These courses were not restricted only to London but found a response in other cities of the country, too.

Other countries followed England's example, especially after the first fruits of her efforts could be seen in the exhibition of 1862 in London. In 1863 what is now the Musée des Arts Décoratifs appeared in Paris, and in 1864 the Österreichische Museum für Kunst und Industrie was opened in Vienna. The Viennese museum was the inspiration for similar foundations in other states of the Germanic Confederation and later of the German Empire: the Bayerisches Nationalmuseum in Munich in 1867 and the Hamburgisches Museum für Kunst und Gewerbe in 1877, to name just two examples.

All these and similar institutes had the aim of raising the level of art and craftsmanship in the industrial arts and so improving the standards of the furniture industry. Together with private arts and crafts associations, efforts were made to set up courses for training designers and skilled artisans. Periodicals and other publications distributed patterns and designs, and attempts were made to spur the ambition of artists and craftsmen through competitions and exhibitions.

The chief "testing ground" and the sharpest stimulus to these efforts remained the international trade exhibitions. They set the standards and provided new inspiration. Not only did the neighboring European countries show their wares here, but the colonies and overseas nations were also represented by their products.

In a sense the exhibitions took over the role of the old aristocracy as arbiters of taste and patrons of the arts. Every country and every firm naturally took care to exhibit only the best of what they produced. Often enough the furniture shown was purely for display purposes, made for the exhibition only, and unsuitable for normal use because of its size and the way it was decked out. Though designed especially as objects to be exhibited, they were also in many cases included in the collections of the industrial arts and so came to exercise an influence as ideal examples for mass production.

In this way these exhibitions filled a double function. They took stock of what had been achieved and provided a new impulse for future efforts. One of these im-

Right: Design sketches of tassels, Rittmeister, 1851, Munich

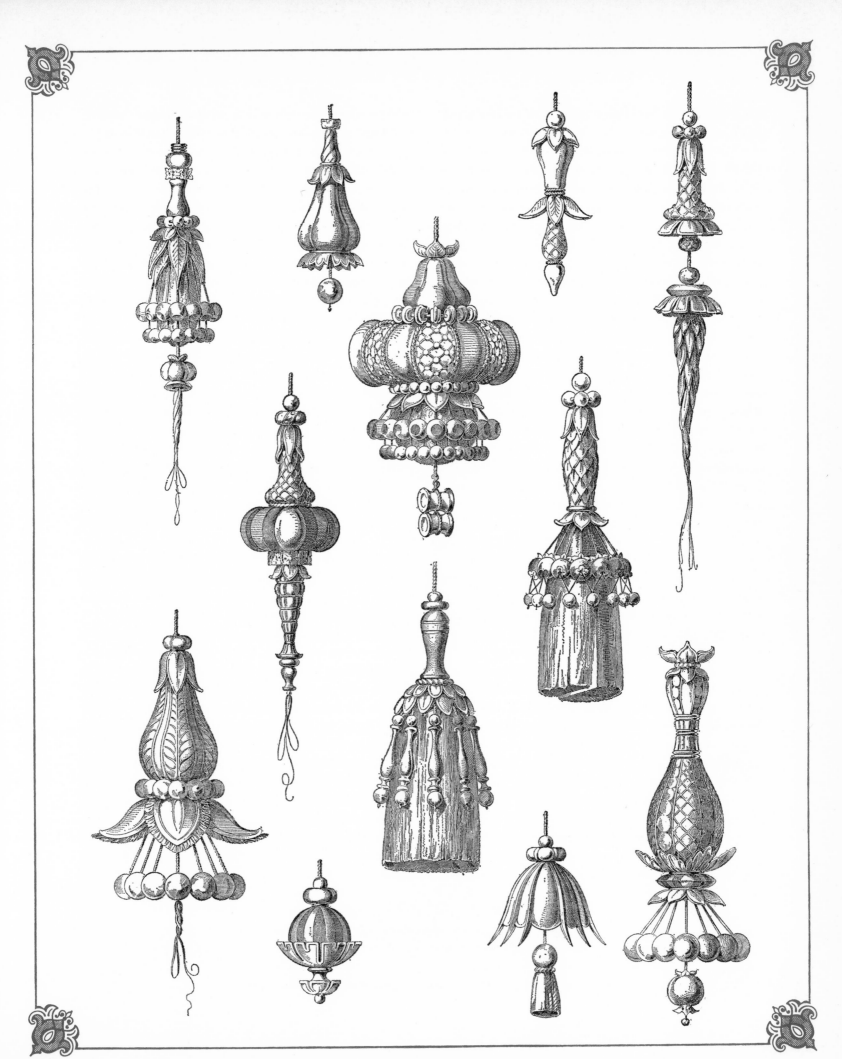

pulses was generated by the appearance of Japanese furniture. The earliest results of this stimulus from the Far East could be seen in about 1875, when the first furniture in the Japanese style appeared on the market. At first it seemed nothing more than a new stylistic fashion, just another exotic fad much like the passing enthusiasm for Moorish buildings and furnishings. Yet this fashion was to turn out to be far more effective, finally, in setting furniture making and handicrafts along a new line of development than all the efforts of Semper or William Morris, for example, had ever been. It was not really possible to imitate Japanese furniture or Japanese handicrafts in the same way as had been done with the European historical styles. The ways of life which were reflected in them were too foreign for that. It was difficult to adapt them to European conditions. It was therefore only possible to adopt the formal principles of Japanese handicrafts such as the lightness of the furniture or the quite different relationship between ornament and basic shape. In this way the foreign form and that endeavor produced an art which on the one hand was nothing more than a product of the period of stylistic imitation and yet on the other was something quite new—it was "art nouveau."

Page 111: *Studio of the Painter Hans Makart*, painting by Rudolf von Alt, 1885, Vienna, Wh (above); Mural from Ludwig II's winter garden in the Munich residence (below)

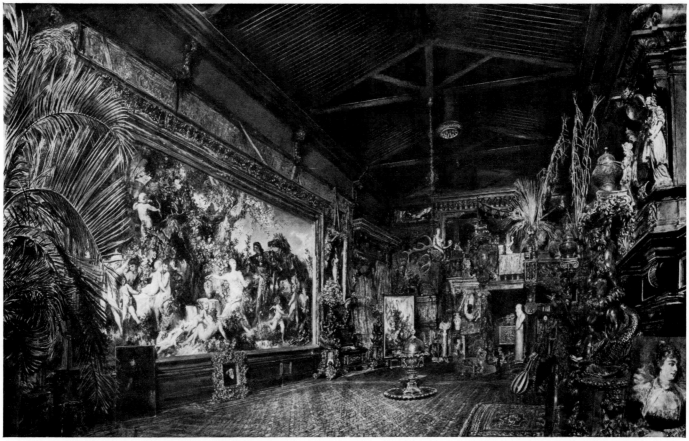
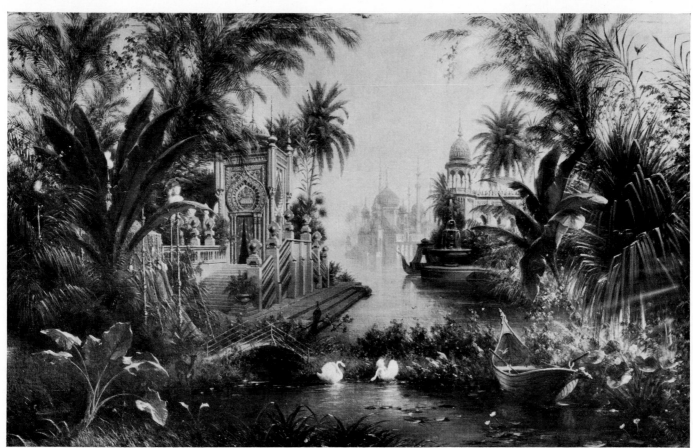

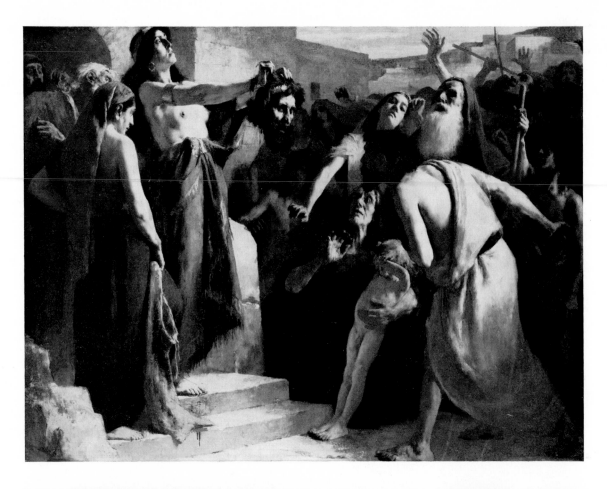
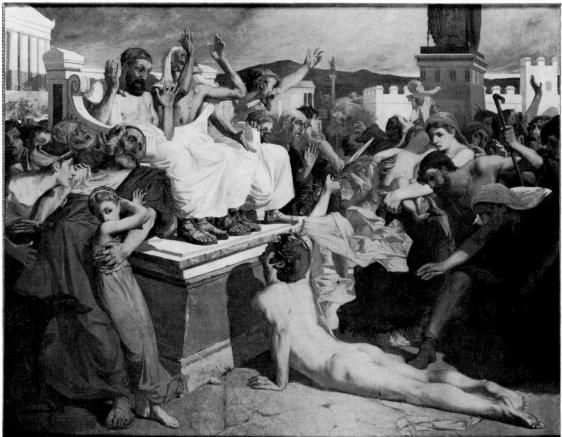

Painting

The history of painting and the graphic arts in the period between Biedermeier and Jugendstil is generally concerned with the stylistic ideas of Late Romanticism, Realism, Naturalism, Impressionism, and Post-Impressionism. While this sequence is correct from the standpoint of art history and is convincing in its organic development, it completely ignores those movements which outwardly dominated the contemporary art scene in the second half of the nineteenth century and which were the only part that the majority of people were aware of at the time. Until now there has been no overall term to cover them. Expressions like Stylism, Historicism, or Academic painting are very inadequate ways to describe the phenomenon of a plastic art which is decidedly eclectic and consists of idealistic and naturalistic elements often discordantly combined. Terms like Victorian, Wilhelmine, *Gründerzeit*, Second Empire, and *Fin de siècle* convey much more of the character and the atmosphere of the age which is being rediscovered and reevaluated today.

Right from the beginning of the nineteenth century a stylistic division, a "split," can be seen in it. Up until the end of Baroque and Rococo there had always been one single dominant style in Western art which governed every aspect of the plastic arts from the pattern of a doorknob to palace architecture, and from porcelain plates to ceiling paintings; but from then on a completely new situation of stylistic pluralism arose and deepened through the course of the century. Many often contradictory conceptions, all with the same degree of justification, existed side by side or even in conflict. Classicism and Romanticism were polar possibilities which developed parallel to one another. The seeds of the antagonism between Ingres and Delacroix were already present one hundred years earlier in the quarrel between Poussinists and Rubenists. There was a host of contrary

models available to the artist. Schinkel painted and built simultaneously in the Classical and Neo-Gothic style. During the decades between 1850 and 1890 the differences of form and style, of pictorial themes and techniques of painting became still more pronounced. No one comparing pictures by Ingres and Turner, or by Gérôme and Courbet, Rossetti and Renoir, Böcklin and Manet, Burne-Jones and Van Gogh would ever imagine that they were produced at the same time.

The stylistic pluralism of the nineteenth century did not come about without historical causes. The Enlightenment and the French Revolution had already created the conditions necessary and destroyed the old order. New ideas of freedom, society, humanity, and culture replaced the old hierarchical value system. "Dogmas were questioned, absolute standards replaced by relative ones," states Werner Hoffman in his book *The Earthly Paradise—Art in the Nineteenth Century*, "the fundamental supporting strength of religion was lost and the stability it had provided broke up. The capacity to create and sustain a style disappeared with it. The whole disbanded its parts so that they, having no common denominator, all demanded autonomy and equal rank. After the collapse of the vertical ordering of values all that was left was a horizontal plane on which the polarizing forces could carry on their dialogue. In other words, the hierarchical cosmic system was replaced by a dialectical one."

The new stylistic pluralism was manifested on two levels—the historicist and the modernist. On the one hand there was a recapitulation of artistic styles of the past which was quite unique in history. Styles from Ancient Egypt up to the Rococo all supplied material to be adapted and reappear idealistically transformed as part of an all-inclusive Historicism. Everything was looked at "historically," the ideas and forms of past ages taken over and attempts were made to recreate what was ir-

Page 112: *Judith Showing the Head of Holofernes*, painting by Leroux, awarded the Prix de Rome in 1894, Pe (above); *The Soldier of Marathon*, painting by Merson, awarded the Prix de Rome in 1869, Pe (below)

revocably lost, to resuscitate it as a beautiful utopia. The dream of the Golden Age, the earthly paradise, an immortalization of beauty in the spirit of classical antiquity and the Renaissance dominated the painters of the Pompous Age. On the other hand, by the mid-point of the century, the idea of "modernity" enters the scene as a new, sharpened consciousness of the present and the desire to express contemporary life directly through the medium of painting. Baudelaire, who lent all his support as a critic to Delacroix in particular, calls on the painter to "express what is modern." For Manet, painting is "a record of life, of reality," and even Courbet, a realist still caught up in tradition, was influenced by these currents. "No age can be depicted except by its own artists, that is, by those who have lived in it," he declared in 1861. There is no more definite rejection of historical painting, which at that time had reached its fullest flowering.

From that time on the division between the conservative and the revolutionary directions in art became more and more sharp. While the Impressionists after 1870 adopted an extreme Plein-airism in painting and preached a new, modern feeling for life which grew out of the pulsating big city and its atmosphere, the Academic Historicists, Stylists, and Literary painters in their sumptuous studios celebrated an imaginary past or a no less unreal earthly paradise in gross contrast to the social realities of early capitalism and rabid industrialization. "One wonders how this sordid century could have such dreams and realize them in art," remarked George Bernard Shaw before a painting entitled *The Ramparts of Heaven* by the imitator of Burne-Jones, John Strudwick.

While the practitioners of the generally backward-looking "official" salon art were enthusiastically received by the public and given adequate commissions of the right kind, the trail blazers of an *"avant-garde"* art for artists had to struggle hard for recognition. In their case, the gulf between painter and public became harder and harder to bridge. The artist was either honored by the mass as a demigod or forced into the role of a martyr. And he even saw himself the same way. One only has to put the almost simultaneously painted self-portraits of the celebrated Victorian Classicist Frederic Lord Leighton and the poor, tormented Vincent van Gogh side by side to see this difference.

In the almost all art-historical accounts of painting in the nineteenth century, the dominant aspect is his-

torical development. The pioneering tendencies which led to the "modern" occupy the center of attention. For a long time now the major lines of development from Constable and Delacroix down to the Impressionists and their followers have been studied and described over and over. On the other hand there has been little interest shown in the contrary movements of Historicism and Stylism, which extended right through this century, in which historical awareness was such a powerful element. And where they are dealt with, it is generally with playful mirth and indulgent irony, chiefly from the point of view of an often unconsciously Surrealist salon art.

Yet even within the limits of Stylist and Historicist painting, completely opposed to Realism and Impressionism, there are innovating achievements. The English Pre-Raphaelites had already, by the middle of the century, established the formal and aesthetic basis for the Art Nouveau and Jugendstil movements. To some extent they were precursors of Modern Design (William Morris). The significance of Ingres, Puvis de Chavannes, Moreau, and Odilon Redon for some pioneers of modern developments is undisputed. Even the triumvirate of Germano-Romans, Böcklin, Feuerbach, and Marées, functioned at a level which extends far beyond salon painting, and the forgotten gods of the *Victorian Olympus* (the title of a book by William Gaunt) include painters and paintings whose strange glacial beauty and surprising "mathematics of form" (as Richard Muther in 1903 said of Lord Leighton) are able to fascinate us once again for their elements of Surrealism and Constructivism. It is important to draw a clear distinction between the innovators and the imitators, the creative and the imitative talents. Art and kitsch are often very close, the dividing line between them appears fluid. Moreover, they cannot be normatively defined but only empirically determined—that is, determined from the experience of each individual work, and this will change according to the approach and the changing taste of different ages.

The term salon painting originated in Paris. Since 1737 the *Académie Royale de Peinture et Sculpture* regularly organized exhibitions open to the Parisian public in the Salon Carré du Louvre. These exhibitions were called simply "the Salon." And when, after 1848, they took place outside the Louvre in the Grand Palais and elsewhere, the name was kept. In the middle of the century it spread to all the art centers of Europe and eventually became a synonym for everything official, academic, pompous, perfumed, indeed *kitschig*, in painting.

Among the themes dealt with, historical, biblical, mythological, allegorical, literary, and poetic motifs were predominant in salons, along with genre and anecdote. The Impressionists and their followers wanted to reflect contemporary life and give expression to the modern world. They rejected all historical and literary content as nonartistic and based any emphasis of the theme on the techniques of painterly execution, which they gave a more and more absolute status. The salon painters and academic painters, on the other hand, worked in their hallowed temples of art to produce didactic and museum painting whose worth rested on the thematic content and perfection in the way it was carried out. The theme as such, its moral content, its gravity, and its sublimeness were direct indications of "quality." In the hierarchy of the many types of picture between which distinctions were drawn in the salons, the highest place was reserved for historical paintings. Every category had its subdivisions and its specialists, and among the various types there were peculiar mixtures, such as between history and genre which, in the terminology of the aesthetician Friedrich Theodor Vischer, combined as the *Sittengeschichtsbild*. *Romans in the Age of Decline* by Thomas Couture, a major work containing a large number of figures, which was shown in the Paris Salon of 1847, is the famous example of this type of painting. It was a new development at the time and later greatly increased in popularity.

The painting of the salons made great demands on the observer. Their content was by no means obvious or self-explanatory, and in fact they required considerable understanding and iconographic knowledge in the fields of biblical history, ancient myths, the Homeric sagas, historical events and legends, ballads, and the poetry of past ages. Since only a few of the visitors to the exhibitions possessed this kind of knowledge, and as the themes of the salon academics became more and more recondite and contrived, detailed explanations or quotations from the literary work on which they were based had to be provided to accompany the paintings. Often these would be absent, however, and in this case the title of the painting could only be deciphered completely if one had the relevant dictionary or history book with him. The more unfamiliar the theme, the greater the interest aroused among the public and above all among the critics. *Zenobia Is Found on the Banks of the Araxes* is the title of the painting with which Paul Baudry, who was later to become a famous French historical painter, first

appeared in the Salon of 1850 as a young man of twenty-two. *Marco Polo Before the Great Khan of the Tatars*, painted by Tranquillo Cremona in 1864, or *The Excommunication of Robert the Pious*, presented in the Paris Salon of 1875 by Jean-Paul Laurens, are two more typical examples from the vast quantity available of scenes from distant periods of history which, in these cases, acquired a new relevance from the religious or national point of view. J. L. David had begun working in this vein as early as 1784 with his *Oath of the Horatii*, and Ingres and Delacroix followed similar principles when, in antithetical form, they portrayed events like *The Vow of Louis XIII* (1824) or the *Death of Sardanapalus* (1827) in monumental paintings. Learning to discover historical events which had never been dealt with in paintings became part of an academic's training. This was often of the greatest importance for acquiring diplomas and medals. "All historians tell of things which have never existed except in the imagination." Nietzsche's *aperçu* strikes at a fundamental problem also affecting historical painting of the nineteenth century. The painter of the salon takes on the task of presenting his imaginary idea of "things which have never existed" as though they had really taken place. History becomes imagination, truth becomes poetic fantasy. Enormous pictures like *tableaux vivants* were produced which had a similar impact to a scene on a stage and all the splendor of a revue. Two famous examples of this are Piloty's *Thusnelda in the Triumphal Procession of Germanicus* (1873), almost twenty-three feet long, or Markart's *Charles V Entering Antwerp* (1878), a gigantic painting covering an area of more than 550 square feet with the dimensions 17' × 32' 7". Catastrophes and misfortunes in history were also popular as the subjects for monumental and dramatic genre scenes. The first of these came from the brush of Karl-Theodor von Piloty in the shape of his *Seni Beside the Corpse of Wallenstein*, presented before the Munich public in 1855. He followed this with *The Murder of Caesar* (1865) and the *Death of Alexander the Great* (1886). Anton von Werner glorified the German Empire in similarly monstrous works. *Command Billets in Paris 1871* and *Emperor Wilhelm I on His Deathbed*, each executed ten years after the event, are both illustrations of this. Paul Vogt is not far off the mark when he points out in his book on salon painting of the nineteenth century that such spectacular scenes are reminiscent of our own wide-screen film spectaculars. "Today the film has taken over the function of historical painting," Vogt ob-

serves. "It pillages stories from history and alters the life stories of great men to suit the taste of the public." The relationship between this and historical reality is generally no different from that ironically suggested by the comment of Nietzsche quoted.

These works contain two levels of Historicism, one thematic and one stylistic. The themes are taken from history, but the style in which they are portrayed is also derived from the art of the past. At times both of these are in harmonious agreement with one another, and there is a perfectly unified combination of the historical event, costume, and setting of the subject matter with the manner in which it is executed. More often, however, there is a peculiar contradiction between theme and style, between the historical subject and its dramatic conception. This contradiction is the result of the desire to recreate things from the distant past as vividly as possible. In the attempt to do this a return to old stylistic forms with a genre type of approach was combined with an almost panoptical naturalism, which evolved as a parallel to the triumphal progress of photography.

From the point of view of style, Classicism and Romanticism, Neo-Baroque and Realism remained the cornerstones of salon painting throughout the Pompous Age from 1850 until 1890—it made no difference whether the subject was an event in classical antiquity, from the Middle Ages, or from modern times, or whether it was taking place in Europe, in exotic lands, or in an imaginary dreamworld. The basis of what happened in the second half of the century was already established in the first. Raphael and Ingres, Rubens and Delacroix created the models which governed the work of the salon painters for decades. In addition there was also a recapitulation in painting of the styles of the past from the Egyptomania of the Empire under Napoléon I up to the Neo-Rococo of the Second Empire.

A return to the art of the past is always accompanied by the most exact possible imitation of nature. During the period between Biedermeier and Art Nouveau this generally resulted in an unresolved tension between naturalism and idealized stylization. If one compares the

models from the Renaissance and the Baroque, and also those of Ingres and Delacroix, with the relevant imitations or recreations from the second half of the nineteenth century, it is precisely this strangely stylized and yet seemingly photographic naturalism that is the most striking point of difference. It is often the cause of those unintentionally surreal effects which arise from the combination of dramatic gesture and panopticum.

The idea of blending a return to the art of the past with the imitation of nature has its roots back in the eighteenth century. It is connected with a historically new attitude and feeling for nature in the Age of Enlightenment and indicates a new reflective consciousness in the exploitation of artistic techniques and potentialities. Even Goya claimed, "My teachers were nature, Velázquez, and Rembrandt"; and Picasso—though, of course, with completely differing results—shows a similar idea still active in his work when he professes that his schools were "la Nature et le Louvre," nature and the museum. Unlike the work of the Pompous painters, however, the study of nature and the old masters which occupied Goya and Picasso and many other innovators between them remained simply the basis of creative syntheses and new formulations of pictorial concepts which keep the wheel of history turning and leave everything from the past far behind.

The academic Classicists, on the other hand, believed in an ideal world of art. The ideal conceptions of beauty evolved by classical antiquity and the Renaissance had to be preserved and kept alive in the present since they were equivalent in the field of aesthetics to the laws of nature. *"Vous apprendrez des antiques à voir la nature, parce qu'ils sont eux-mêmes la nature,"* urges Ingres to his pupils. In his opinion there is nothing left to be discovered in art after Phidias and Raphael, but, he says, there still remains enough to be done in propagating the cult of the Truth and in perpetuating the tradition of the Beautiful—*"pour maintenir le culte du vrai et perpétuer la tradition du beau."* Even Anselm Feuerbach believed in the accordance of truth and beauty. "Everything that is true is good, and, when seen more deeply, also beauti-

Right: *The Beloved*, painting by Dante Gabriel Rossetti, 1866—73, Lt
Pages 118—119: *Plato's Banquet*, painting by Anselm Feuerbach, Bn

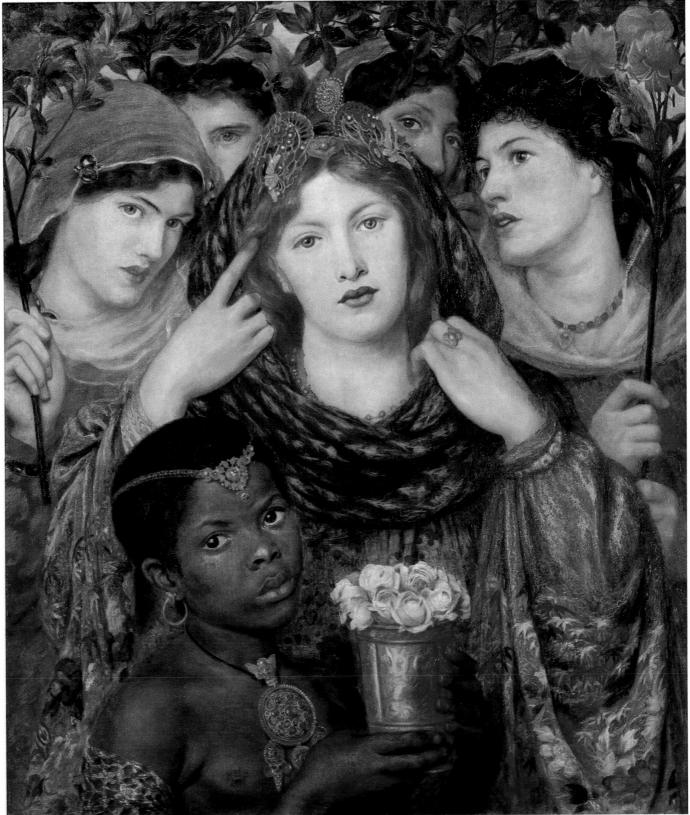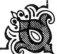

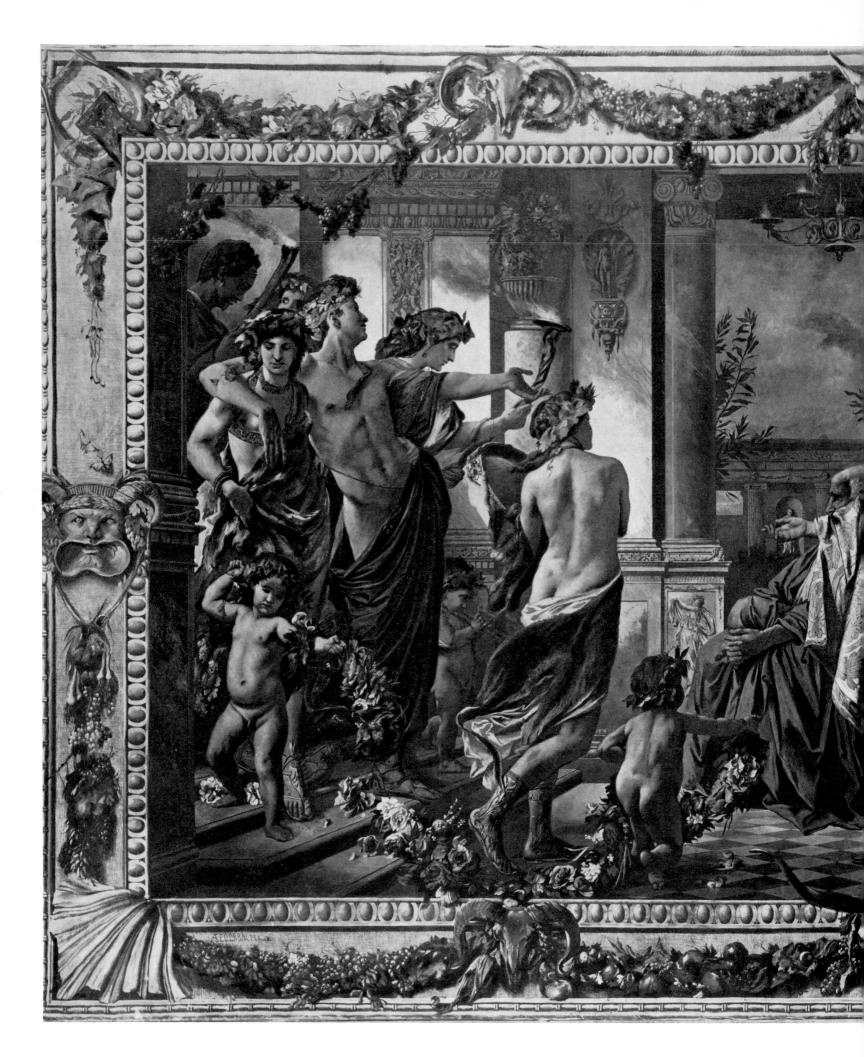

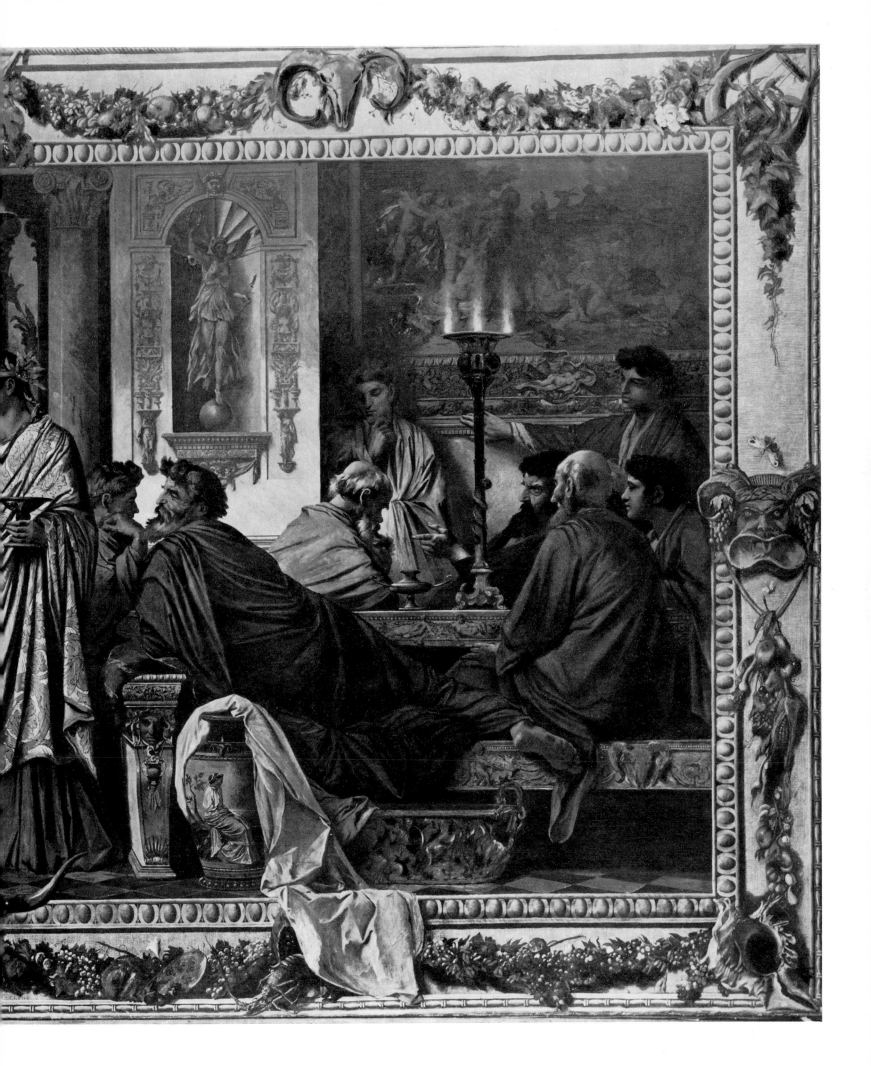

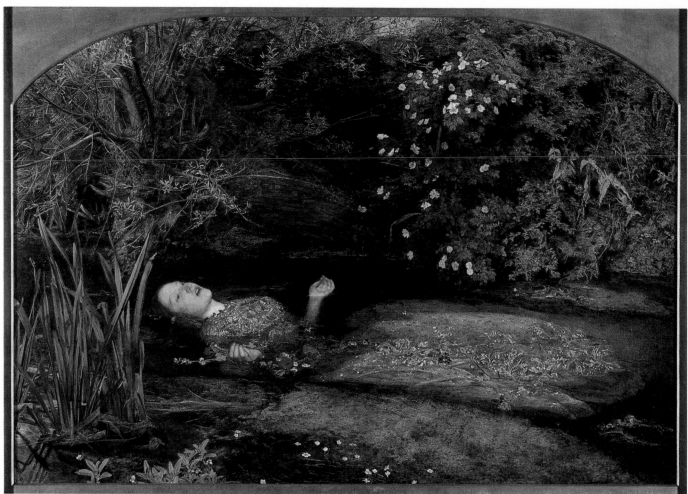

ful," he says. At the same time Feuerbach sees "the perpetual progress" of art as arising from a thorough study of nature. He described the conflict between idealism and naturalism which pervades all the paintings by the followers of Ingres as well as such important talents as Gérôme, Leighton, and even Feuerbach himself, with regard to the contemporary situation in Germany, as follows: "It is like this: the German artist begins with the intellect and a moderate amount of imagination when devising a subject for himself, and only uses nature as a means to the end of expressing his thought, which seems to him something of a higher order. Nature, infinitely beautiful, revenges herself for this by stamping such a work as untrue. The Greek and the Italian reverses this procedure. Knowing that reality alone is great poetry he goes to nature and looks her straight in the eye. As he fashions, creates, the miracle that we call a work of art happens—idealism becomes truth, and the truth is poetry."

As Feuerbach correctly observed, contemporary painting of the Pompous Age generally lacked that basic unity of nature and form, life and art, which ever since the Classical Period is constantly met with in the Mediterranean region. The lack of truthfulness he talks about is the result of such a failing. Yet even for him, the idealistic Germano-Roman, the realms of life and art remain separate. Painting was chiefly concerned with the portrayal of the world of the sublime, the ethical, and the ideal. Beauty, truth, and poetry are shown to be identical.

A credo of this kind is characteristic of the approach taken by virtually all Classicists, Neo-Romantics, and Academics during the *Gründerzeit* in Europe. Everywhere, art was set apart as something different, higher, solemn. It was the counterbalance to profane life which would raise mankind above the banality and sordidness of the everyday world into realms of the ideal. Art became a cult, the artist a priest, the museum a temple. Even to Goethe the museum was a shrine, and Hölderlin called it the "aesthetic church." The painter is the chosen one, inspired, often genius and prince in one. The shining aura of creativity and a glow of immortality surround

him. The self-portraits and life style of the Wilhelmine and Victorian painter-princes Lenbach and Makart, Leighton and Alma-Tadema clearly illustrate this.

Lord Leighton portrays himself as a masterful Olympian in the pose adopted in the high Renaissance; his noble, Zeus-like head is framed with curls and a full beard, and the background is occupied by the procession of horsemen from the Parthenon frieze, Phidias being his ideal. Holding back a little more because of his Neo-Romantic symbolic approach, but nevertheless with an essentially similar pathos, Arnold Böcklin shows himself about the same time as a painter with *Death the Fiddler* (1872), a heavily allusive blend of faith in genius and a *memento mori* painting. The English portrait painter and symbolist George Frederick Watts in a Titianesque late self-portrait looks like a monk in an idyllic monastery garden seated on a stone bench in a cowl and skullcap before a Florentine tondo relief from the Quattrocento. In his chapter on Watts, Richard Muther adopts a very critical position with regard to Whistler and the idea of *l'art pour l'art* of his time. "The question nevertheless remains," he wrote, "whether this battle cry *l'art pour l'art* was not also just a passing theory, whether the painter should really do no more than offer us color-combinations which are pleasant to the eye, whether he cannot be a priest and apostle, a molder of his age, the custodian of a philosophy." Watts certainly thought of himself, as his self-portraits and also the allegories he made up according to his own whims show, as a priest of art. He was not concerned only with painting beautiful pictures, but primarily with preaching morality and humanity.

Rudolf von Alt's painting *Markart's Studio* from the year 1885 shows with photographic accuracy the kind of luxury in which the successful painter-princes lived. The enormous room is crowded with opulently decorative furnishings consisting of bureaus, cabinets, showcases, screens, portieres, balustrades, figures, pictures in heavy gilt frames, oriental carpets, plush and brocade, wood paneling, timbered ceilings and crystal chandeliers, immortelles, palms, and parrots. These are the same refulgently sumptuous surroundings, completely obsessed

Left: *Ophelia*, painting by John Everett Millais, 1851—52, Lt

with a *horror vacui*, which we also find in his nude compositions such as *Summer* (1880—81)—pullulating with the sensual richness of the naked female form. While Makart surrounded himself in Vienna with Baroque ostentation, Alma-Tadema lived in London in the cool marble world of a completely artificial Hellenism amid Ionian columns, Roman mosaic floors, ancient reliefs, and wreathed urns. The artificial paradises of Victorian Classicists' marble-encrusted style survive for posterity in Alma-Tadema's work as a striking example of painterly illusionism. Apart from those mentioned above there were other painter-princes who created similar dreamworlds between ancient times and the Baroque—Moreau and Rossetti, Wiertz and Khnopff, Couture, Bouguereau and Burne-Jones, to name but a few. We also find grandiose attempts to realize artists' dreams in artificial paradises derived from the spirit of Historicism associated with Richard Wagner and King Ludwig II of Bavaria. The idea of the artist as a genius and priest of an aestheticist cult of beauty, which originated with Baudelaire, lived on past the dawn of the twentieth century in poets like Huysmans, Peladan, and Stefan George and his circle.

Delacroix had painted *Michelangelo in his Studio* as early as 1850. The master sits sunk in thought before his works, and there is a Michelangelesque quality about the brushwork of the painting. Inspiration and reflection are the pictorial themes, the creative process of art, its demands and its consequences are shown through the medium of a spirit which has shared these experiences. Daumier portrays his *Painter with His Work* (1863—66) less historically and as more concerned with the present. The artist is isolated, alone with his work, completely involved with himself and his task, thoughtful, dubious, critical and yet totally filled with the sense of his mission. Courbet, in the monumental picture *The Studio* (1855), which he himself described as an *allégorie réelle*, treats the subject in a puzzling, many-sided way, the image of artistic genius is coupled with a declaration of involvement in modern times.

In salon painting, artistic inspiration is generally represented allegorically. It takes the form of a woman and appears as a winged muse behind the artist's back or above his head. In Albert Maignan's Carpeux sketch of 1892 she is gratefully kissing the forehead of a sculptor, portrayed as a Michelangelo of his own time, who is dying in his studio. From *La Musique* by the historical painter Jean-Paul Laurens to Max Klinger's monument to Beethoven, the most amazing configurations have been used to represent musical genius. Among these is the lyrical picture of Richard Wagner and King Ludwig II at Neuschwanstein by Kurt von Razynski with the significant title *They Both Wander Through Mankind's Highest Realms.*

The motif of painter and model which Courbet included in his painting became a favorite theme of studio paintings in the Pompous Age. In an intensely prudish society it acquired the added spice of something forbidden and suggestive. The artist appears as a bohemian to whom women are eager to yield themselves, and the observer becomes a voyeur present at an intimate scene without himself being seen. The range of different levels on which this theme can be handled and varied extends from the studio painting of Albert Stevens, the Belgian, who was particularly noted for his pictures of the elegant Parisian women of the Second Empire, to the anecdotal scenes of the French salon painters Gaillac *(Dans l'Atelier)* or Dumas *(Le Modèle Frileux).* The Pygmalion motif also provided an opportunity to represent, in reversed roles so to speak, the relationship between artist and work, inspiration and life. In the eighties Burne-Jones tried to paint a cycle of four pictures illustrating this in his somewhat anemic manner influenced by Botticelli and Rossetti.

Closely linked with the theme of the painter and his model is the representation of the female nude. This is rooted, like everything in Historicism and Stylism, in the ancient Western tradition of painting, but differs from all the work that went before by its artificial idealization and, at the same time, its meticulous naturalism which are combined in a peculiar, conflicting way. Nudity in the nineteenth century was no longer taken as a matter of course and came to be considered provocative. To be nude in the age of civilization and industrialization meant to be unclothed. Instead of the natural nakedness which enlivened ancient and Renaissance art there was a feeling that a figure was "undressed," which caused either embarrassment or sensual arousal. There was also a glorification of the female body as something pure and ideal in response to the moral demands of the age, and no less to the new myth and cult of womanhood which was growing up at that time. On the one hand, we find the bloodless, flawless, frozen beauty of Classicism, and, on the other, contrived charades of disrobing in which there is a degree of suggestiveness hinted at, and erotic tension seethes beneath the surface. The latter can, in fact, be seen to apply in both cases to some extent.

In the work of Ingres sensuality is always crystalliz-ed in perfection of form. In his *Turkish Bath* (1863), which he began at the age of eighty, he portrays feminine animality in the context of a completely controlled com-position full of abstract elements and subtle distortions which, though a creation of pure artificiality, seems to be something occurring naturally, as a matter of course, and in the only way possible. In this late work Ingres drew on all his previously executed nudes and took over some of his earlier formal motifs almost unchanged. The rear view of the figure from his *Bathers of Valpinçon* (1808) reappears virtually unaltered as the figure in the center of the tondo. The other figures are also faultlessly interwoven variants of his earlier odalisques. The work is a strange allegory of feminine beauty and sensuality, a picture-poem without action, of cool tension and mild-toned balance, but also "ice and fire at the same time" (Gaëton Picon), like everything by this greatest Classicist of the age.

If one compares individual nude figures by Ingres, such as *The Spring* begun in Rome in 1820 and finished in 1856 in Paris, with the *Birth of Venus* (1879) by Bou-guereau, which was based on the same models by Raphael and similarly goes back to ancient sources, one notices not only the qualitative difference but also a changed conception of sensuousness in painting. Ingres tries to show the ideal of perfect beauty which he found in Raphael and the ancient "graces" through purely formal harmonies. Bouguereau, on the other hand, is attempting to blend idealized beauty with erotic attraction by bring-ing the traditional type to life as naturalistically as he can, and yet insisting on *glorifying* it. This gives the sense of a marblelike statuesqueness combined simultaneously with the awkward impression of the figure being "un-dressed," which makes the mythical motivation appear totally implausible. A discrepancy of this kind between idealization and unfree nakedness, mythological pretext and photographic naturalism, stands out even more clear-ly in the salon painting of the Victorian Classicists. Sir Edward Poynter's *Visit to Aesculapius* (1880) shows a group of naked women consulting the god of healing while he sits on his throne in a Raphaelesque pose in an idyllic park with fountains, fragments of pillars, and doves fluttering about. Their well-shaped bodies are copied from ancient statues, and yet they seem more Victorian than Greek. The motifs of *The Three Graces* and *The Judgment of Paris* have been arbitrarily com-bined and, through the refined illusionism, scrupulous

exactitude, and plasticity of modeling of the painterly technique, turned into a *tableau vivant* presented by graceful English ladies. Even where there is no mytho-logical disguise, a troubled attitude toward nudity can be felt. We can see this in Sir Hubert von Herkomer's un-clad girl, posed in front of blossoms, branches, and water. The title, *All Beautiful in Naked Purity*, is rather reveal-ing of the morality and erotic feelings of the age.

The motif of disrobing was a favorite theme of the period. Earlier on, legendary events like the stories of Phryne or Lady Godiva served as the excuse for titillating displays of exhibitionism. Later on, clothes were mostly shed without any visible motivation in a celebration of the "pure" beauty of the female body (Hans Makart: *The Summer*, 1880—81, Aime Morot: *Dryad*, 1884, Albert Moore: *A Summernight*, about 1880, the painting by von Herkomer already mentioned, etc., etc.). Phryne was an Athenian hetaira of the fourth century B. C. who is supposed to have posed as the model for Praxiteles' Aphrodite of Knidos. When one of her rejected lovers accused her of atheism, her eloquent defender, the rheto-rician Hyperides, secured her acquittal by stripping off her dress with a dramatic sweep before the very eyes of the court and exposing her charms to the judges and the witnesses. Jean-Léon Gérôme showed the scene in a famous painting of 1861, which now hangs in the Ham-burg Gallery of Art. Phryne's exposed nakedness is re-strained within a marblelike coolness, reflecting the con-tinued influence of Ingres, which shines with unblemished beauty. The dramatic gestures of the amazed or lustful old men of the Areopagus look as though they are carved out of stone and yet lose nothing of their intensity. Théo-phile Gautier praised Gérôme as master of the *genre néo-grec*, and in fact the painter did later on do some sculp-ture. What separates Gérôme's homage to womanly beauty from, for example, Couture and his *Romans in the Age of Decline* is the avoidance of flamboyant sensu-alism in his painting. His relieflike composition is strictly based on the Golden Section and effects a transformation of the disrobement motif into a form which is simul-taneously balanced and full of tension without any de-crease in its sensual charm. "It was not just nudity, but a woman's beauty laid bare that provided the impulse of painting in an age which was dominated by the power of the covering," declared Eberhard Roters in the catalogue of the important exhibition, *Le Salon Imaginaire*, which he organized (Berlin 1968). "Disrobing is an erotic ele-ment of yielding in which one thing conditions the other.

The textile charm of the clothing accentuates the tactile charm of the flesh, and conversely the smooth white skin of the body emphasizes the exquisiteness of the drapery surrounding it. The sensual magnificence of the naked female body is served up like the fascinating jewel of a living centerpiece at a banquet for gluttons. Makart's ripe, white-skinned dancing girls and the gliding rhythms of their movements swaying over the full curves of their hips, embody the erotic ideal of Salome in the age of Oriental fashions."

Culinary enticement is often paired with lustfully cruel coldness or unapproachableness. The woman appears as a seductive fairy without a heart, as a mysteriously fascinating creature whose repressed lustfulness seeks satisfaction as an undine, nymph, vampire, or herald of death who ensnares the man with a strangely captivating magic and brings about his destruction. From Ford Madox Brown's *Stages of Cruelty* to Makart's *Marmorherzen*, from Dante Gabriel Rossetti's *Pandora* or *Proserpine* to *The Depths of the Sea* by Sir Edward Burne-Jones or *Hylas and the Nymphs* by John William Waterhouse, there is a great variety of examples of this in the realms of legends and myths, fairy tales and poetry, psychology and moralistic painting. *La Belle Dame sans Merci* became a symbolic figure in Victorian England of the contrast between the enchanting beauty and the merciless cruelty of femininity. The romantic ballad by John Keats (1819) based on a French medieval legend provided the subject matter for a whole series of paintings. Waterhouse shows the meeting of the young knight with the touchingly delightful long-haired maiden who lures him into her grotto where the pale ghosts of her previous victims dwell. The central lines in Keats poem are as follows:

> I met a lady in the meads
> Full beautiful, a faery's child:
> Her hair was long, her foot was light,
> And her eyes were wild···
> She found me roots of relish sweet
> And honey wild, and manna dew;
> And sure in language strange she said:
> I love thee true...

And then in the darkness of the grotto, into which the knight is led:

> I saw pale kings, and princes too,
> Pale warriors, death-pale were they all;
> Who cry'd—"La belle Dame sans merci
> Hath thee in thrall!"

But the young man wakes up to find that the sinister scene was just a dream, and he is lying on the bleak hillside "and no birds are singing." Waterhouse restricts himself to their first meeting, which already contains hints of what is to follow. The tender maiden with silken hair and the knight in steel armor represent the contrast of gentleness and strength, innocence and enchantment which are later fatefully and cruelly reversed in the play of erotic enticement. The painting *Hylas and the Nymphs* (1896), which Waterhouse finished three years after, deals with a related theme from Greek mythology altered to fit in with the erotic outlook of the age. It shows beautiful, dreamlike girls who appear between water-lilies in order to draw the young Hylas into the pool and drown him with tender cruelty. They are young English girls of the Pre-Raphaelite type posing as Victorian nymphs. The scene is dominated by a flowing linearity such as is found in Art Nouveau, and the wide-eyed girls' faces, their softly waving hair, and the blooming water lilies produce a rhythmic decorative arabesque which is remarkably effective. A decade earlier Burne-Jones in his picture *The Depths of the Sea* had used the motif of an English undine carrying a sailor off in a deadly embrace to her home on the bottom of the sea. Elements of the Quattrocento and Mannerism are strangely interwoven with the truth to nature, fairy-tale imagination, and symbolism of the Victorian era.

Without any action or poetic story, the late half-length figures by Rossetti were really studies of this woman who bemuses men and prototypes in the manner of cult images of the "vamp." They include the *Pandora* of 1871, *Proserpina* of 1873, and the *Astarte Syriaca* of 1877, all of which are powerfully influenced by the dark beauty of Jane Morris whose Proserpina-like appearance came to define the "Rossetti type." The *Astarte Syriaca*,

Page 125: *The Tepidarium*, painting by Theodore Chasseriau, 1853, Pl (above);
Visit to Aesculapius, painting by Sir Edward Poynter, 1856, Lt (below)

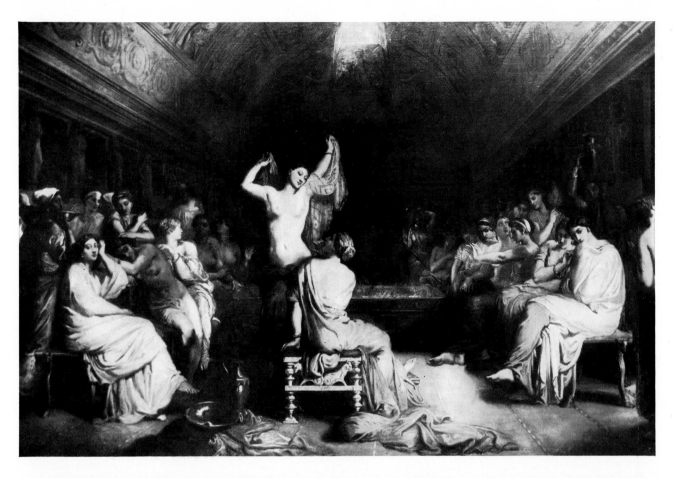
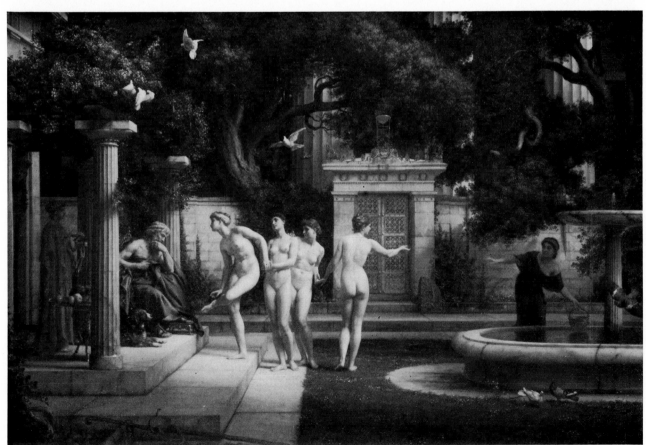

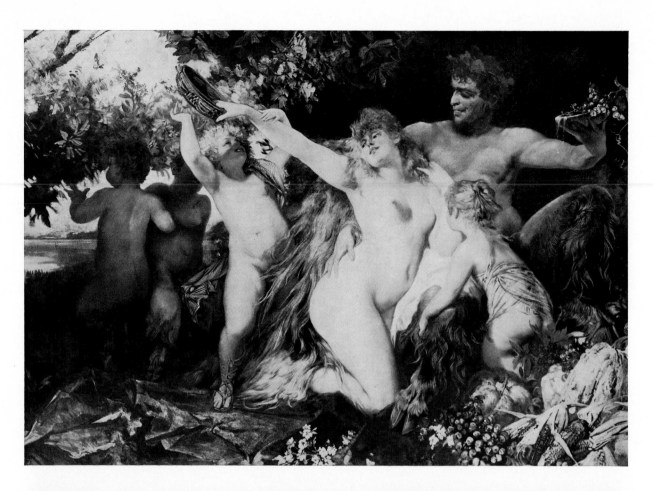
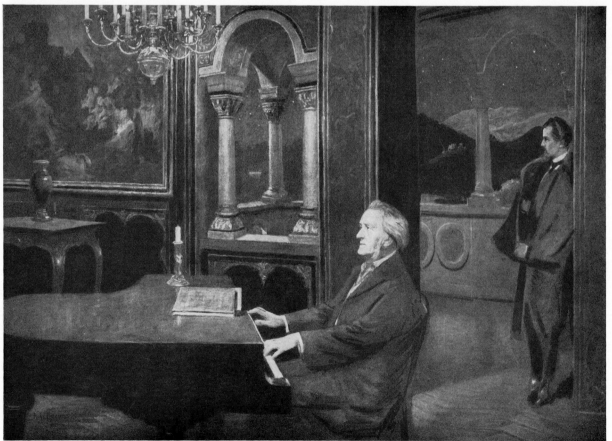

Rossetti's last work of importance, is a salon cult image of eros and feminine beauty as it was seen by the Victorian Age. The portrayal of the love goddess is Manneristic and has a Michelangelesque monumentality. She is facing straight forward, looking directly at the observer, half dreamily brooding, half staring into space, melancholic and mysterious at the same time. The breasts and abdomen, distinctly emphasized by the double silver belt, underline the essential motif of fertility and life force which can become a threat to men. The voluptuous hair fetishism that the picture expresses, the morbid twist to the "love-freighted" violet lips, the ceremonious pose of the two angelic maidens carrying ivy-wound torches with its ambiguous union of the spiritual and the sensual—all this finds a place in the sonnet of the same name that Rossetti wrote to his painting and had set in its frame:

> Mystery: lo! betwixt the sun and moon
> Astarte of the Syrians: Venus Queen
> Ere Aphrodite was. In silver sheen
> Her twofold girdle clasps the infinite boon
> Of bliss whereof the heaven and earth commune:
> And from her neck's inclining flower-stern lean
> Love-freighted lips and absolute eyes that wean
> The pulse of hearts to the sphere's dominant tune
> Torch-bearing, her sweet ministers compel
> All thrones beyond the sky and sea
> The witnesses of Beauty's face to be:
> That face, of Love's all-penetrative spell
> Amulet, talisman, and oracle,—
> Betwixt the sun and moon a mystery.

The picture is a hymn to feminine beauty and to "Love's all-penetrative spell" with a rapture of form reminiscent of Swinburne transposed into a plastic musicality. The parallelism of the gestures is like the alliteration of a litany. Rossetti develops a virtuoso's ear both from the point of view of the painterly and figurative aspect and of poetic symbolism. The elegiac and pessimistic quality of his later period is crystallized in the gloomy beauty of this goddess who is at once ideal, an inspiration, and a self-torment—the deified figure of Jane

Morris. Unrequited love is made the spur to artistic creation, a feast of suffering that brings joy. Long before he painted these monumental salon cult images, however, Rossetti had been one of the cofounders of the English Pre-Raphaelites in 1848. He produced many works which were innovative and created a new style, and these still attract considerable interest today.

There is less mythology or poetry than psychological reality in Ford Madox Brown's painting *Stages of Cruelty* (begun 1856, completed 1890), an allegory rich in allusions of the feminine psyche in the Victorian middle class. The almost surreal arrangement shows a little girl chastising her patient dog opposite a grown-up beauty torturing her languishing lover. With Pre-Raphaelite exactitude every detail is picked out as precisely as possible. Even the painting of the branch with which the dog is being beaten is botanically correct and has a symbolic meaning, as the red foxtail is also called "love-lies-bleeding" in England.

Makart shows the worldly woman of his time quite directly and with no attempt to dissemble in *Hearts of Marble*, an oil painting from about 1880, which has a soft Venetian brightness in the manner of Paolo Veronese. "Yes, that is how they look, these modern-day sirens whose lips can whisper words aflame with love and give hot kisses, and yet the heart that beats within their breasts is as hard and as cold as marble," says one contemporary commentary.

The extreme polar opposite to such *Hearts of Marble* is represented by portrayals of a heart-warming, selfless, true love that lives on after death. These are also counted among the nineteenth century's favorite themes, being used particularly by the English Pre-Raphaelites in subjects taken from poetry and legends. In contrast to the sumptuous display in nude painting from the salons, eroticism and even sex are raised in this case completely to the level of spirituality and the poetic, though without any sacrifice of sensual intensity. The object is not to reveal, but to inspire, the naked body becomes taboo, lustful desire is recast as devoted love and expressed only

Left: *Bacchante Family*, painting by Hans Makart (above);
Both Dwell on Mankind's Heights (King Ludwig II of Bavaria and Richard Wagner at Neuschwanstein Castle),
painting by Kurt von Razynski, 1886 (below)

in the clothing, the gestures, and above all in the face. In place of voluptuous odalisques there appeared a new ideal type of anemic beauty and nervous fragility. It was native to England, created by Rossetti and his friends at the beginning of the fifties, and by the end of the century it had spread over the whole of Europe.

The soul-stirring figures of Ophelia, Isabella, and the Lady of Shalott replaced the unworried odalisques and bayaderes. In 1851—52 John Everett Millais painted the ethereally beautiful Elizabeth Siddal, who had earlier been Rossetti's model and later became his wife, as Ophelia. With her copper-colored hair and her green eyes, she floats in the river amid dense blossoms, shoots, and greenery. A magical hothouse atmosphere fills the picture, every particular is picked out in sharply detailed realism as though with a magnifying glass, and yet the colorful scene as a whole seems strangely transfigured and weird. The model had to lie for hours in the bathtub wearing a long dress to enable the painter to convey the effect of Ophelia floating in the water as naturalistically as possible. The attempt to achieve the highest degree of naturalism is combined with stylization of gesture which anticipates elements of Art Nouveau. Although the fusion remains discordant, Millais has created in this picture one of the most original works of the middle of the century. In spite of the Shakespearean subject matter, it is no longer backward-looking or historical but an artistic innovation belonging entirely to its own time and its own experience.

All the magic of early Pre-Raphaelite figures of girls pulsates through Arthur Hughes' slightly later work, from the year 1856, *April Love*, just as it does in *Ophelia*. The melancholic charm of this picture echoes an epigram from Tennyson expressing the transience of, or rather the danger that threatens, a young love which is born in April and perhaps is dead and forgotten by harvest time, a favorite early Victorian theme. The picture is dominated by an unforgettably intense turquoise-violet tone which anticipates Art Nouveau.

The *Lady of Shalott* is a painting of similar quality. Elaine, "fair maid of Astolat," is confined to her bower by a mysterious spell. Day in, day out, she must weave a precious robe for King Arthur; and during this labor she may never look out of the window down into the valley of Camelot, observing life only in a concave mirror (a symbol of purity). As the innocently guilty victim of her sudden temptation by the figure of Sir Launcelot of the Lake riding by, she is a prototype for Pre-Raphaelite

images of the young maiden. William Holman Hunt drew her for the first time in 1850 and then again in 1857 for the Moxon edition of Tennyson's poems. He shows her at the moment where she becomes entangled in her weaving as in a magic net and the mirror shatters while the heedless knight's armor and helmet flash in the background. In the same volume Rossetti illustrates the end of the balladesque story when Launcelot leans over the boat in which the dead Elaine is carried down the river to Camelot to be with her knight, and says, with only mild regret: "She has a lovely face: God in his mercy grant her grace, The Lady of Shalott." It is a fate much like that of Ophelia which, toward the end of his life, Holman Hunt recreated once again in a famous picture in the Manchester Art Galleries.

Often the story behind a tragic unrequited love can hardly be understood from the pictures without some commentary. Looking at Hunt's *Isabella or the Pot of Basil* (1867), which shows a long-haired girl in a Victorian salon embracing a pot arranged like an altar with basil growing in it, no one would ever guess what gruesome events lie behind this scene much resembling a still life, unless they knew the balled by John Keats (1820). The theme for both the poet and the painter comes from a story out of Boccaccio's *Decameron*. Isabella found her lover in a wood murdered by her brothers, took his head home with her, and buried it in a flowerpot with basil growing in it, which she besprinkled with her tears every day. In Keats' poem, the lines which moved Hunt to paint the picture while he was in Florence read as follows:

Then in a silken scarf—sweet with the dews
 Of precious flowers pluck'd in Araby,
And divine liquids come with odorous ooze
 Through the cold serpent pipe refreshfully,—
She wrapped it up; and for its tomb did choose
 A garden pot, wherein she laid it by,
And cover'd it with mould, and o'er it set
 Sweet Basil, which her tears kept ever wet.
And she forgot the stars, the moon and sun,
 And she forgot the blue above the trees,
And she forgot the dells where waters run,
 And she forgot the chilly autumn breeze;
She had no knowledge when the day was done,
 And the new morn she saw not: but in peace
Hung over her sweet Basil evermore
 And moistened it with tears up to the core.
Holman Hunt took this incredibly macabre and dis-

mal theme and made rather prudish salon painting out of it. In fact, he was not only painting it with his usual painstaking care over details, but also with deep inner feelings and involvement. This was because he was still weighed down by the death of his young wife whom he had lost after one year of marriage when their son was born. The theme of love continuing beyond death was for him—as it had been for Rossetti before him—a very real thing at that time.

In this age, which espoused the crassest materialism in its daily life, the glorification of love into something poetic and sacred is a leitmotiv which occurs amazingly often in a continually changing variety of forms. Unlike the Historicists who took over ready-established models, the English Pre-Raphaelites in particular were enabled by this to develop ideas in their work which were iconographically new. Dante Gabriel Rossetti, for example, shows Paolo and Francesca in their sinful kiss before an oval window which shines about the lovers like a nimbus and exalts what is taking place into a holy act. Even the famous *Beata Beatrice* of 1863, the culminating achievement of some important work by the ethereally sensitive Elizabeth Siddal, which was painted shortly after her early death, expresses a glorification or even canonization of love. Rossetti identifies himself with Dante and Elizabeth Siddal with Beatrice. He portrays death, according to his own thorough discussion of the painting, now in the Tate Gallery, as a trancelike state or a kind of hypnotic sleep in which the passage from earthly life into the eternal can be made. Through her closed eyelids Beatrice is already able to perceive the new paradisical world in an ecstatic vision, and a blessed radiance begins to illuminate her features. The haloed bird brings a poppy, the flower of intoxication, sleep, and death. It reminds one of a dove, symbol of the Holy Ghost, or at least of peace. Dante and Cupid stand in the background on the deserted street opposite one another. Dante is on the right standing in shadow, and the god of love is on the left "in fire-colored mist," as it is described in the poem. He raises up Dante's heart with the words *"Vide cor tuum."* The sundial, set horizontally, conveys three-dimensional space and the distance of the figures placed in the background, in a composition which is linear, two-dimensional, and flooded with diffuse light. A Pre-Raphaelite copper-green-violet tone, which seems to anticipate the Art Nouveau color scale, lends the picture its decisive touch. The painting stands at the head of a long series of studies of an aesthetic-symbolic woman cult which Ros-

setti introduced into painting. The painter concludes his detailed description of what is shown in the picture with these words: "She, through her shut lids, is conscious of a new world, as expressed in the last words of the Vita Nuova—That blessed Beatrice who now gazeth continually on His countenance *qui est per omnia saecula benedictus.*" Love is canonized, the painting of the beloved is made a religious icon.

Rossetti's imitators moved the theme more and more into a vague and distant fairy-tale realm, so losing a great deal of its compelling sensuous force. Such escapism, in which the Pre-Raphaelites finally ended, can be seen particularly clearly in the later works of Burne-Jones, friend and pupil of the Anglo-Italian, yet so differently constituted from him. Just like the work of his contemporary and traveling companion, William Morris, Burne-Jones's legendary scenes have been transposed into an ornamental tapestrylike and hermetically artifical mode. They are pictures of a dreamtime which never existed and never will exist either. Stylistically they are derived from Rossetti's poetic early style, Botticelli, and the Florentines of the Quattrocento, and based on a pronounced feeling for the "Gothic"-decorative approach and brocaded symbolism of his own. The erotic tension always felt with Rossetti gives way to mild spiritualization and idealization. In his best-known picture, entitled *King Cophetua and the Beggar Maid* (1884), the fabulous king's spontaneous love for the unknown beggar girl becomes a metaphor for a humanity that overcomes class barriers, and yet it does not in any way come to grips with prosaic reality. The lines in which Tennyson with great artistic skill portrayed the scene almost like a folk song, three decades earlier in 1853, are filled with highly poetic wishful thinking.

> Her arms across her breast she laid;
>> She was more fair than words can say:
> Bare-footed came the beggar maid
>> Before the King Cophetua.
> In robe and crown the king stept down,
>> To meet and greet her on her way;
> "It is no wonder," said the lords,
>> "She is more beautiful than day."
> As shines the moon in clouded skies,
>> She in her poor attire was seen:
> One praised her ankles, one her eyes,
>> One her dark hair and lovesome mien.
> So sweet a face, such angel grace,
>> In all that land had never been:

Cophetua swore a royal oath:

"This beggar maid shall be my queen!"

Burne-Jones managed to find an adequate painterly equivalent for the fairly-tale tone of the poem, yet what, in his own words, was originally meant as a "symbolic expression of contempt for wealth" turned out as just a beautiful brocaded dream. Like the original Pre-Raphaelites, Burne-Jones was also obsessed with the idea that the times were "out of joint." But he felt himself, as he confessed, incapable of changing society. His answer lay in aestheticism. " I have learned to know beauty when I see it, and that's the best thing." With his painting of Cophetua he had created a model as early as the middle eighties which remained influential far into the period of Art Nouveau.

The English painters and draftsmen of the Victorian Period after the middle of the century, working on the threshold between Naturalism and Stylization, produced far more innovative work in the spirit of their own times than the Classicists, Neo-Romantics, Symbolists, and Historical painters in France, Belgium, Germany, Scandinavia, and Italy. English leadership at that time did not only cover the realms of industry, trade, and shipping; it was not only the showplace of the first World Exhibition (London, 1851) and the pioneering development of new, bold feats of engineering, new efficient housing projects, and new industrial arts with a proper understanding of materials. In painting and the graphic arts, too, it presented the backward-looking salon art of the Continent early on with new models which tried to overcome Historicism. In the course of decades, up to the beginning of Art Nouveau, it finally came to influence the whole of Europe. What links these iconographically important efforts with the predominating painting of the salons, however, and lessens their significance in art history, is the conviction that theme took precedence over form, the ethical or poetic content over their realization as paintings. We cannot discuss here the trail-blazing achievements of men such as Constable or Turner, whose

work became the foundation of French Impressionism, in the field of landscape painting. They belong rather to the first half of the century, and also they are part of the line of development leading to the modern sketched in earlier, which is not our concern here. But what was happening in England in those comparatively dull years, from the artistic point of view, between the dying away of Classicism and Romanticism and the beginning of Realism and Impressionism should be set out as it evolved historically in order to throw light on some characteristic ideas about pictorial art in the nineteenth century and to show how they influenced the painting of the Pompous Age. Some examples have already been dealt with above from the iconographical aspect.

As in France, the English salon, represented by the Royal Academy in London, was dominated by allegories, genre, and historical painting. In addition to these there were landscapes, topographical views, and hunting and riding subjects, which continued to play an important role in England from the beginning. The animal paintings by Sir Edwin Henry Landseer (1802—73) were especially popular. These consisted mainly of sometimes touching, sometimes comical genre-style anthropomorphized dogs with titles to match (for example, *The Old Shepherd's Chief Mourner* of 1837—a sheepdog mourns for his master; or *Dignity and Impudence* of 1859—a setter and terrier are shown together looking out of their kennels). As far as the style is concerned, in most of the pictures the traditions of the Dutch landscape and genre painters of the seventeenth century and the great Englishmen of the eighteenth century, especially Reynolds and Gainsborough, are perpetuated on a different level. In England, a tendency towards sugariness and sentimentality was already becoming much more strongly noticeable than in the Paris salon of the same time, where the dominant feelings were heroic pathos and cool elegance. The compositions of female nudes with a more or less mythological aura by William Etty (1787—1849), Joseph Severn (1793—1879), and William Mulready

Page 131: *Prometheus*, painting by Gustave Moreau, 1868, Pl (left);
The Bath of Psyche, painting by Lord Frederic Leighton, 1890, Lt (right)
Page 132: *Thusnelda in the Triumphal Procession of Germanicus*, painting by Karl Theodor von Piloty, 1873, Mn (above);
The Founding of the League, painting by Karl Theodor von Piloty (below)

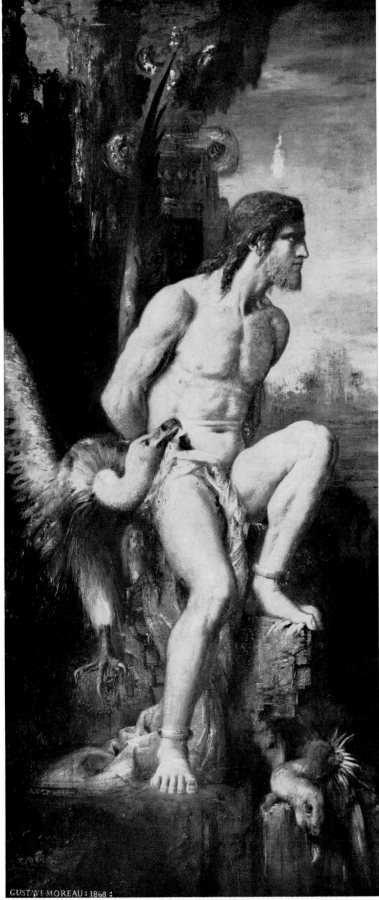

GUSTAVE·MOREAU·1868·

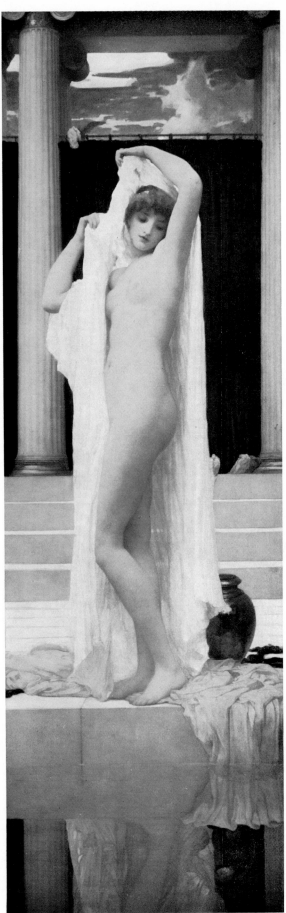

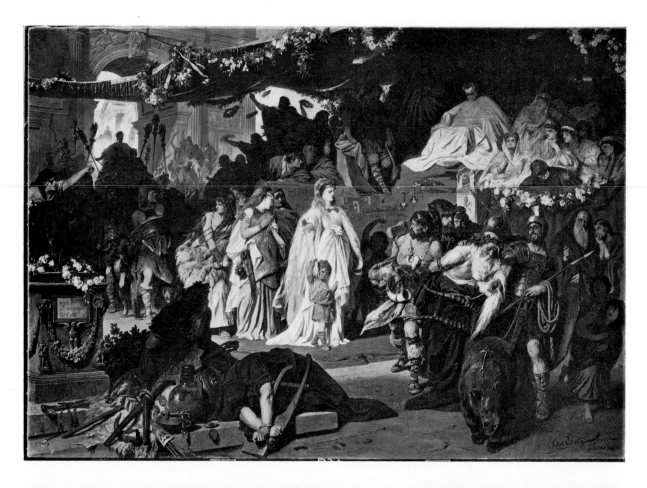
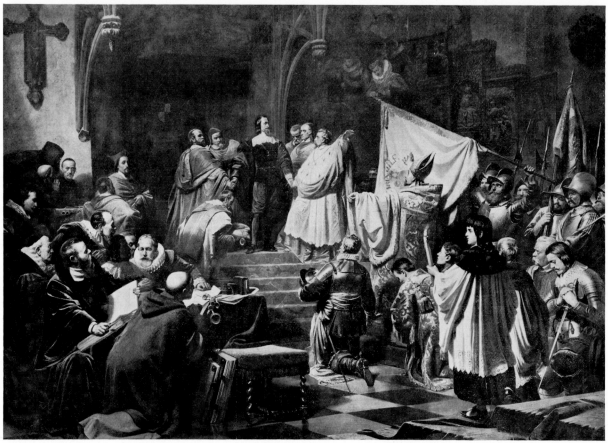

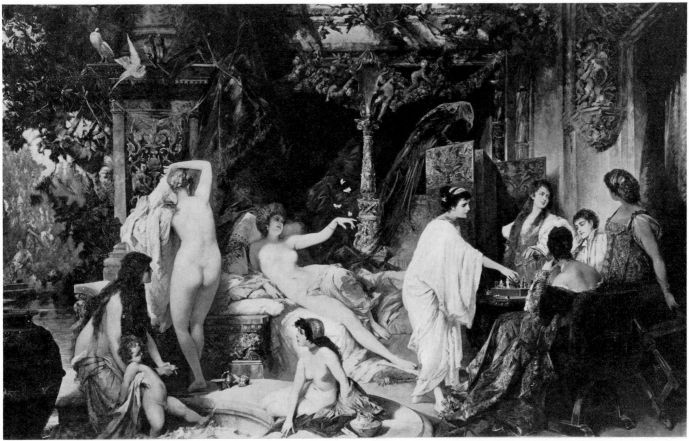
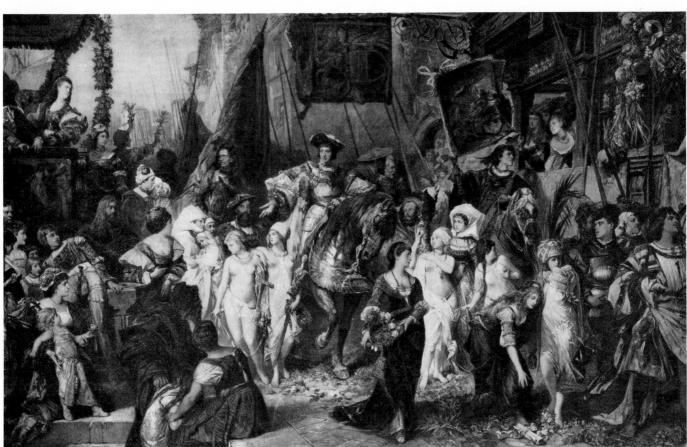

(1786—1863), as well as historical and genre paintings, provide many varied examples of this. In Mulready's nude group *Bathers Surprised* of 1849, the Classicism of work like Ingres's has been recast into something much closer to genre and, at the same time, oriented much more toward a naturalistic effect.

It was as this point in time that the young Pre-Raphaelites came on the scene. In the year 1848 three students from the Academy, hardly twenty years old, William Holman Hunt (1827—1910), Dante Gabriel Rossetti (1828—82), and John Everett Millais (1829—96), joined with four like-minded friends to form the "Pre-Raphaelite Brotherhood," an esoteric group of painters and poets. They were opposed to the dominant position of Academicism with its sugary allegories and its genre and historical painting, and strove for a renewal of art and life through a return to the masters of the period before Raphael, and, at the same time, by turning closer to nature. In their intention of reaching back to the early Renaissance, they shared some common ground with the German Nazarenes who had formed a somewhat more naive and pious brotherhood forty years earlier in Rome. In fact there were indirect links between the Pre-Raphaelites and the Nazarenes. Ford Madox Brown (1821—93) had met Overbeck and Cornelius during his visit to Rome in the years 1844—46, and the Scottish painter William Dyce (1806—64), whose naturalistic, polished, and minutely precise painting influenced the young Holman Hunt, had come into contact with them as early as 1825 during his years in Rome. His painting *Joas Shooting the Arrow of Deliverance* of 1844 and *Jacob and Rachel* of 1850—53 (both in the Hamburger Kunsthalle) are fascinating evidence of this.

In spite of connections of this kind the two movements are fundamentally different. The English Pre-Raphaelites were essentially modern men. They revived and poeticized the themes and forms they took from the past, but they also dealt with social problems of their own times, showing them in a way which was both na-

turalistic and, at the same time, symbolically heightened. These works took on a strange moralistic note and often had a balladlike character. Things of the present were always regarded from the irrational aspect of the timeless and eternal while things taken from the world of poetry and legend acquired an unusual sense of closeness to the present through the strongly pictorial intensity of expression. The twofold plan of the Pre-Raphaelites—return to the art of the past and imitation of nature—led to an often unresolved tension between Naturalism and Stylization. The distinguishing characteristic of their peculiar and unmistakable style in the fifties and sixties is a hitherto unknown poeticizing of reality which is at the same time observed as minutely as with a magnifying glass and yet, in the final analysis, is unreal—a hothouse atmosphere which has an almost magical effect in drawing the observer into the picture; a marked linearity and penchant for clear local coloring; an intensive eurhythmic parallelism of gesture, often reinforced by the subtle effect of slight distortions; a mysterious independent existence of things, which are handled with the most painstaking preciseness; the rhythmical breaking up of the surface both for decorative effect and to add to the intended meaning; a willingness to use strangely glowing, enamel-glossed, sometimes stridently bright color tones for a total effect which was both charged with tension and ornamental. Elements of the past and present, the intellectual and the visual, the moral and the aesthetic are remarkably intertwined. Although the P. R. B.—as the brotherhood abbreviated itself in its youthfully ironic rivalry with the Royal Academy (R. A.) —collapsed again after a few years, it bequeathed some far-reaching results. The special contribution of England to the art of the second half of the nineteenth century is due to them. The way was cleared for these young artists early on by the critic and social reformer John Ruskin (1819—1900).

Right from the start there were two different basic tendencies among the Pre-Raphaelites which are not

Page 133: *Summer*, painting by Hans Makart, 1880—81 (above);
The Entrance of Charles V into Antwerp, painting by Hans Makart, 1878, Hk (below)
Page 134: *Empress Eugénie with her Ladies-in-Waiting*, painting by Franz Xaver Winterhalter, Cn (above);
Consecration as a Priestess of Bacchus, painting (section) by Sir Lawrence Alma-Tadema, 1889, Hk (below)

usually distinguished from one another sufficiently. On the one hand, there was the direction, represented chiefly by Holman Hunt, of a heavily symbolic stylized realism which had its roots in historical painting, the Nazarenes and early Naturalism. In Hunt's case this was always in the service of a strict puritanical morality. Rossetti, on the other hand, founded a movement with the opposite goal of a poetic-symbolistic art which derived mainly from poetry and, in its later developments through the work of Burne-Jones and Morris, formed a transition to decoration and the industrial arts. In the beginning the two tendencies are delightfully interwoven. Holman Hunt was the dogmatist and puritan of the group who strove his whole life long to remain true to the Pre-Raphaelite ideals. His early works like *Claudio and Isabella* (1850) or *The Eve of St. Agnes* (1847–57), which use a motif from a scene from Shakespeare's *Measure for Measure* and the ballad of the same name by Keats, are characterized by pronounced Nazarene Stylistic features. Their rather dry and wooden literary historicism reminds one of Cornelius or Schnorr von Carolsfeld, but differs from both of them in the strangely sensual and, at the same time, psychic, intensity of expression and bearing which belongs only to the English Pre-Raphaelites and is expressed most purely in the medium of drawing. Among Hunt's most remarkable and original innovative paintings, however, are his religious and moralistic works, *The Hireling Shepherd* (1851), *The Awakening Conscience* (1853), *The Light of the World* (1853), and *The Scapegoat* (1854). Their symbolism, drawn with almost archaeological accuracy, is by no means directly comprehensible and can only be deciphered in its many-sided allusive richness by means of careful analyses and the painter's own commentary.

The Hireling Shepherd is connected with a quotation from Shakespeare's *King Lear* ("Sleepest or wakest thou, jolly shepherd: thy sheep be in the corn . . ."). The shepherd is dallying with a pretty young maiden and not watching over his flock which has strayed into a field of wheat. The sheep are eating the grain, which endangers their lives. Even the flirting beauty is behaving irresponsibly: she is foolishly feeding unripe apples to the charming little lamb nestling idyllically on her lap, though they could kill it. A tiny death's-head moth which the young man playfully holds in his hand symbolizes the danger that threatens. The picture, as Holman Hunt himself explained, is supposed to pillory the "sectarian vanities and perilous negligence of the day." It is supposed to point out and admonish the way the shepherds neglect their flocks, that is, the priests neglect their congregations, for the sake of vain things and fruitless discussions which are worthless to the human soul, and so bring it into the gravest danger. What at first sight seems to be a bucolic idyll of a pastoral scene turns out on closer inspection to be a moral allegory of stern social criticism. It was Hunt's opinion that lovers who were not involved with anything beyond themselves should not be shown in public ("lovers with only a personal interest should not be represented for public attention"). Yet neither the tiny moth with its death's-head, nor the unripe apples are able to diminish the extraordinary attractiveness which radiates from the flirting couple. The contradiction between the moral intention and the pictorial realization remains unresolved. The fact that it was the fascinating beauty of the girl which caused the first step away from the true path throws a revealing light on Hunt and betrays the painter's puritanical attitude. In accord with the bourgeois spirit of his time, he felt that a purely sensuous love was sinful and dangerous.

A similar theme is treated in the painting *The Awakening Conscience*, which Holman was inspired to paint by a scene from *David Copperfield*. This time a young girl, who a moment before had been sitting on the lap of her potential seducer in front of the piano, has just been gripped in time by the "awakening conscience." She jumps up in order to flee from the golden cage before it is too late. What at first seems to be a playful genre scene in a bourgeois Victorian home portrayed in great detail is finally revealed as a fundamentally moralistic comment on manners conveying a clear imperative on personal conduct for the observer to take to heart. Once again there are quotations added to make the meaning clear, this time from *Isaiah* and *Ecclesiastes*. Here again, there is the same discrepancy between moral intention and pictorial realization. The painter's two major religious works also show a similarly complex symbolism, such as only the nineteenth century could ever have invented. While *The Light of the World* can clearly be seen as a portrayal of Christ, no one who saw *The Scapegoat* without the commentary would ever suspect that he was looking at a scene taken from the Old Testament which is also a symbol of the passion of the Saviour. In the painting *The Light of the World* Jesus appears as a night watchman with a lantern, knocking on a door which is overgrown with weeds and thorns, and

nobody comes to open it. Callous humanity closes its heart to the bringer of salvation—this is the meaning of the religious allegory based on a quote from the Bible. John Ruskin described it as "one of the noblest works of sacred art ever produced in this or any age" in his criticism. *The Scapegoat* was painted in Palestine on the shore of the Dead Sea. Holman Hunt never spared himself any hardship in order to achieve the greatest possible authenticity of the *genius loci* for his strange pictorial ideas. A photograph taken at the time shows him in front of his easel, equipped with a Bedouin headdress and an enormous rifle, hard at work in the bare desert beneath the burning sun. Fidelity to nature was practiced as an ethic, and archeological accuracy elevated into an encoded symbolic system. The painter was not spared his disappointments. The critics misunderstood his profoundly meant work as a bleak landscape with a pitiful animal close to perishing of thirst. Only a few recognized the Christian content which Holman Hunt had tried to show in a completely new way with an assiduous intensity all his own. In the late religious allegories like *The Triumph of the Innocents* (1887), an arbitrary variation of the theme of the flight into Egypt, Hunt finally succumbed to the influence of cloyingly sweet salon painting resembling wax reliefs which he had so sharply condemned as a young painter.

The other Pre-Raphaelites also treated Christian and religious themes from a completely new aspect. In his early work *The Girlhood of Mary Virgin* (1849) Rossetti shows Mary's life while a young girl as a middle-class Victorian idyll. John Everett Millais takes this a decisive step further. In his *Christ in the House of His Parents* (1849–50), painted at almost the same time, a richly allusive Christian symbolism is concealed in a genre scene in a carpenter's workshop. The little boy Jesus has injured himself on a nail while working. On the palm of his hand which he shows to his mother as she kneels down to help him the tiny patch of blood is in the form of a cross. Like the death's-head on the moth in *The Hireling Shepherd*, a small detail becomes an important symbol indicating events that are yet to come. The picture stirred up strong controversy among the public and moved Charles Dickens in 1850 to write an outraged criticism which is very revealing of the temper of the times ("New Lamps for Old").

In his important early works like *Ophelia* (1852), *The Blind Girl* (1854), and above all *Autumn Leaves* (1856), Millais—just like Rossetti—created prototypes of

Pre-Raphaelite images of girls whose extremely youthful beauty combined, in a strangely fascinating mixture, intense longing and melancholy. Their expressions, their gestures, their long, flowing hair contain elements of style and expression which did not make their full breakthrough until four decades later, in Art Nouveau. The peculiarly English charm of these touching young girls is no less pronounced in the early works of Arthur Hughes (1830–1915), who was mentioned earlier, such as *April Love* (1856), *The Tryst* (1854), *The Long Engagement* (1859), and *Home from the Sea* (1862). His picture of the birth of Christ of 1858, with its eurhythmic pose and decorative linearity, seems to belong to the Art Nouveau as surely as if it had been painted in 1900.

Ford Madox Brown was never a member of the brotherhood, but he is connected with it stylistically. His great painting *Work* (begun in 1852)—much like Courbet's *Stonebreakers* (1849) and Jean-Francois Millet's *Gleaners* (1857)—constitutes an early example of a portrayal of a new ethos of labor. Other social themes topical at the time, such as emigration and illegitimate motherhood, are dealt with in his paintings *The Last of England* (1852–55) and *Take Your Son, Sir!* (1851–57). In this picture he took the type found in Quattrocento paintings of the Madonna as his model, in order to elevate the motif into something solemn and sacred. The unmarried mother holds out her new-born son like a Christchild, and the round concave mirror behind her head shines like a halo. The painful departure of a young emigrant couple with a baby is shown as a tondo illuminated with a lyrical density and intensity in which the traditional theme of the Holy Family is revived on a surprising new plane. Brown's late work seems rather dry by comparison, and in the frescoes of the Manchester Town Hall they remind one of late Nazarene historical painting.

The most gifted talent in the P. R. B. was the Anglo-Italian Dante Gabriel Rossetti, who was the creator of a new style. He derived his inspiration from poetry and legends (Poe, Keats, and Tennyson, but above all, Dante and Malory) and through his visual imagination was able to convey their own particular moods in the medium of painting. In this he was aided by his double-sided talent which included poetry and painting in equal measure. He was a poet who "painted" his poems and, at the same time, a painter who "wrote" his paintings. Furthermore, he painted pictures from his own and others' poems and composed sonnets to his own and

others' paintings. The poetic element in his pictures and the painterly element in his poems are distinguishing characteristics of his style. Through a manuscript he discovered William Blake while still a young man and, later on, together with his friend Swinburne, introduced him to a wider audience. Rossetti shares with Blake his leaning towards the mystical and sensual and the idea of a total work of art. His aquarelles and drawings of themes from the Arthurian legends and Dante's *Vita Nuova*, in which the earlier-mentioned Elizabeth Siddal with her copper hair and green eyes continually reappears as the model, are among the greatest achievements in the new style. This culminated, after her death, in *Beata Beatrice* (1863), which has already been discussed, and also the bridal painting influenced by Botticelli *The Beloved* (1866–73), a symphonic arrangement of girls' heads and flowers, magnificent clothes, and wonderful glittering jewelry. The central figure of the bride was inspired in Rossetti by the line from the Bible quoted on the picture frame, "My beloved is mine and I am his. . . ." Four young companions surround her like a garland of faces reminding one of an unfolded fan or the bright shimmering plumage of a peacock—"a sort of peacock's fan of women's heads," as Ford Madox Hueffer so aptly described it. Later on Rossetti moved completely into the realm of Victorian salon painting with his radiant, melancholic, or vampirelike half-length portraits of women, which were already being much talked about, so providing it with an important new stimulus.

Rossetti's pupil Edward Burne-Jones (1833–98) continued his early style of paintings from the Arthurian legends. The poetic-decorative picture of the sorceress *Sidonia von Borck* (1860) illustrates this. Later on he developed an independent kind of tapestrylike figure composition, like *The Golden Stairs* (1880), a row of long-robed young girls in white and gold, resembling a still life, which shows a purely imaginary Golden Age of beauty and harmony without any concrete content or

literary references. Burne-Jones's style influenced a third generation of Pre-Raphaelites, now working within the tradition of the salons, which included Walter Crane (1845–1915), John William Waterhouse (1849–1917), who has already been mentioned, and also Anthony Sandys (1832–1904), whose poetic picture of the enchantress Morgan-le-Fay (1864) is derived from the image of Sidonia.

The decorative tendencies of the new style bore lasting fruit in the work of William Morris (1834–96) who, together with Burne-Jone, was a pupil and friend of Rossetti's from 1856. Morris became opposed to the decline of craftsmanship caused by industrialization. Art and craftsmanship seemed to him inseparable. Through his reform of interior decoration, through the products of the Morris Company, founded by him in 1861, which he mostly designed himself—handmade furniture, wallpaper, tapestries, stained-glass windows, glasses, glazed tiles, and flat-patterned floral-printed textiles—he founded the modern industrial arts. As a typographer and printer (Kelmscott Press) he produced a new unity of type face, decoration, and illustration which was adopted by modern printing presses around the turn of the century and still serves as an example today. The illustration of Aubrey Beardsley (1872–98), who derived his first artistic inspiration from Burne-Jones, transformed the decorative tendencies set in motion by the Pre-Raphaelites finally into a refined decadent art of the *Fin de siècle*—of that period dominated by Oscar Wilde, Whistler, and Aestheticism.

In contrast to the Pre-Raphaelites and Aesthetes, the official painting of the Victorian Era was confined within the limits of an academic Classicism whose goal it was to create a "pure" and "exalted" didactic art in a supposedly Hellenistic spirit which was free of any contact with its own time. Among the gods on the Victorian Olympus, Lord Frederic Leighton (1830–96), president of the Royal Academy from 1878, occupied the highest

Right: *King Cophetua and the Beggar-Maiden*, painting by Sir Edward Burne-Jones, 1884, Lt
Page 140: *Surprised While Bathing*, painting by William Mulready, 1849, Dn (above left);
The Selection (the actress Ellen Terry), painting by George Frederick Watts, 1864, Lk (above right);
The Secret Reader, painting by Meissonier 1853 (below left); *Zenobia is Found on the Banks of the Araxes*,
painting by Paul Baudry, 1850 winner of the Prix de Rome, Pe (below right)

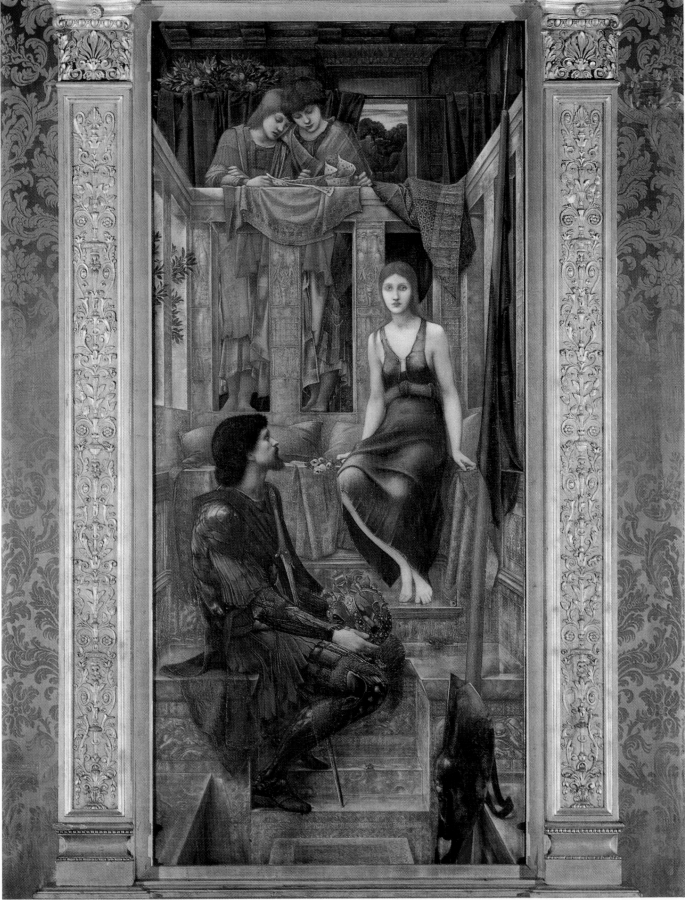

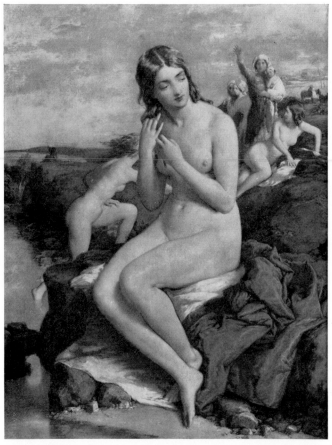
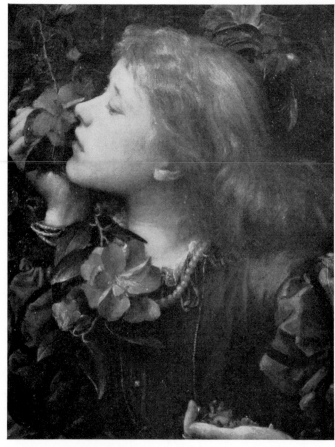
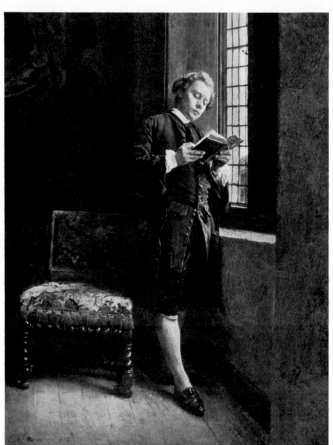
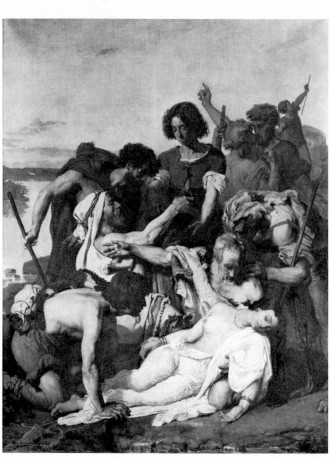

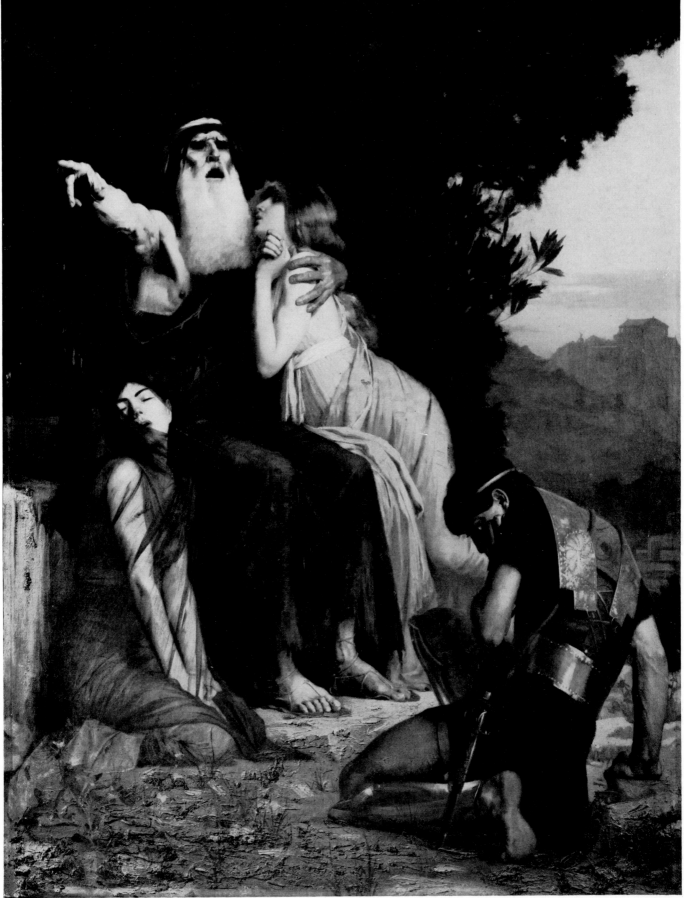

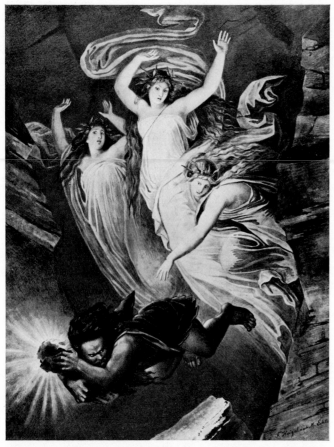
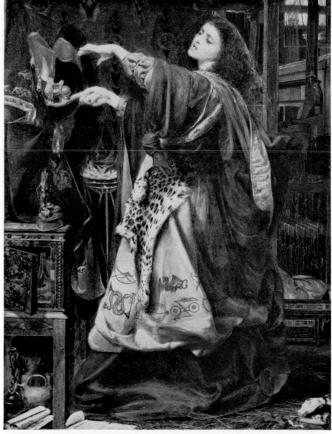
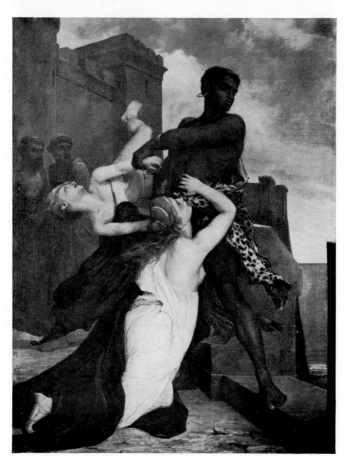
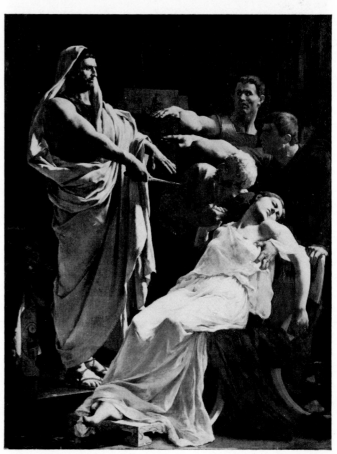

place. A restrained sensuousness combined with a cool mathematics of form appears in his historical-allegorical figure compositions, which are based on Polycleites and the Venus de Milo. In his *Garden of the Hesperides* there are three Victorian maidens grouped under a fruit-laden quince tree like the graces with picturesque rhythms of gesture and drapery, and his *Psyche's Bath* (1890), Leighton's most famous picture, shows a tall, picturesquely draped Englishwoman, three-quarters nude, between two Ionian columns moving gracefully as she performs her toilet in an imaginary ancient bathroom. Sir Edward Poynter (1836—1919), Sir Lawrence Alma-Tadema (1836—1912), and Albert Moore (1841—93), in their extraordinarily painstaking and elaborately painted pictures, portrayed an ancient world which never existed and which arose solely out of the wishful dreaming and ideals of beauty of Victorian salon painting. Poynter's already-mentioned *Visit to Aesculapius* (1880), Moore's *The Dreamers*, and Alma-Tadema's *Feast of the Wine-Harvest in Ancient Rome* (1879) and *Initiation of a Priestess of Bacchus* (1889) both now in the Hamburger Kunsthalle were much admired in their time as examples of a refined illusionism, amazing technical skill, and humanistic culture which is what was expected of an artist in that period. Alma-Tadema created a marble-encrusted style of great charm in his pseudoancient interiors. "He may paint what he will—it is always a five o'clock tea taken in a Greek thermal spring," Richard Muther comments with pertinent irony in a contemporary commentary.

An eccentric and original loner among Victorian painters was George Frederick Watts (1817—1904). His talent was trained in the tradition of ancient and, to an even greater extent, Venetian models and placed in the service of high moral ideals derived from puritanism. The allegory *Hope* (1885), presented at the 1889 Paris Exhibition, shows a girl huddled together with blind-folded eyes and holding a lyre with broken strings, crouching on the barren and bare terrestrial globe; it became the emblem of his painting and his outlook on life. In paintings from the same time like *The Minotaur*, Watts enters the realms of the fantastic and the surrealistic. He was a great inventor of frequently abstruse allegories which demonstrate considerable imagination and painterly skill. As a portrait painter, too, he had remarkable talents.

Many of the paintings by the three Belgians, Antoine Wiertz (1806—65), Felicien Rops (1833—98), and Fernand Khnopff (1858—1921), pulsating with pathos and erotic feeling, often seem to us today unintentionally surrealistic just like *The Minotaur* by Watts. Wiertz began with Baroque-inspired mythological scenes like *The Battle of the Greeks and the Trojans for the Corpse of Patrocles* in which, in his own words, he wanted "to match [himself] against Rubens and Michelangelo." In his *Beautiful Rosine*, a nude girl with a skeleton, he created a *memento mori* painting for his own time. Later he thundered against the evils of the age in panoptical monumental pictures, most of which are now in the pompous Musée Wiertz in Brussels. *The Civilization of the Nineteenth Century* is the title of a picture of an ancient battle in which a dehumanized soldiery is cutting down a young mother with her child. Another painting, directed against capital punishment, shows in three phases the *Thoughts and Visions of a Severed Head* in the first three minutes after its violent separation from the body. The meaning of the portrayed horror is described by the painter in a text which he has set into the frame. This states: "The executed man sees his corpse rot and wither away in a dark corner; and, the perception of which is given only to the spirits of another world, he sees the secrets of the processes by which matter is transformed. All the gases generated by his body, the sulphurous, earthy and ammoniac elements, he sees liberate themselves from his

decaying flesh and become used in the creation of other living creatures. . . . If that vile instrument the guillotine should really be destroyed one day, then let God be praised for it." The painting *Buried Alive*, in which someone who was apparently dead has revived and struggles desperately to raise the heavy coffin-lid, looks like a scene from a horror story. It reminds one of Friederike Kempner's poem *The Child That Seemed Dead* and its touching, unconscious humor ("Storms the house do shake / In his grave the child's awake / All his feeble power / He gathers in this hour . . ."). While Kempner in her gruesome ballad is making a dramatic appeal to her fellow men to prevent the burial of people who are only apparently dead, Wiertz is actually for the newly introduced practice of cremation in this piece of surrealistic salesmanship.

Rops, too, criticized his times, though almost never without including an erotically piquant element. His theme is the taboo placed on sex by society and the double standard that results from it. *Pornocrates* reigns over rows of people tormented by desire and pain—a voluptuous nude woman with a blindfold, black laced boots, knee-stockings, and elbow-length gloves who leads a pig on a leash. *Theft and Prostitution Rule the World*, title of another picture, could stand as the motto above all the work he distributed in the form of etchings and lithographs. In another picture, called *Sodom's Sense of Shame*, a naked woman is assiduously covering up the lower half of a heroic statue while on her exposed behind she wears a mask. The mask is a symbol of hypocrisy. Mostly, however, Rops only portrays the secret lusts and perversions of his fellow men in the form of suggestive genre scenes which appeal precisely to those people they are supposed to be exposing. The titles are for the most part an inseparable part of the action of the picture: *Eritis Similes Deo* (a pair of lovers sits naked in a tree), *At the End of the Furrow* (a peasant boy kisses a young girl in a field), *In Praise of Pan* (a girl who is stripping off her clothes embraces with longing the loins of the horned god), *The Rule of Whores* (a flagellatress rides on her masculine victim, whom she whips and controls with a bridle and bit). The same sensual fervor with which he fills *In Praise of Pan* is also found in a portrayal of Mary Magdalen with the significant title *Christ's Beloved*, in which a naked girl entwines herself in a passionate embrace of the foot of the cross. With engravings like *The Love-Fair, The Same Old Line*, or *The Woman with the Jumping-Jack* in which the attractive woman appears as

the temptation and ruin of the man), Felicien Rops has anticipated the basic themes and images of Max Klinger, Franz von Stuck, August Strindberg, and Edvard Munch.

The same thing is true of Fernand Khnopff and his hardly less richly symbolic portrayals of the seductive vamp. In his work the woman mostly appears in the form of a sphinx. One of the strangest, and, as it seems today, most surrealistic, of his major works shows a woman's head on a leopard's body which is gently nestling against a half-naked youth. It is titled *Art, Tendernesses or the Sphinx* (1896). Franz von Stuck (1863—1928) painted another *Sphinx* a few years later which was influenced by Khnopff. There are also marked similarities between those allegorical girls' heads strangely cut off at the upper edge of the picture such as *Medusa* or *Solitude* and von Stuck's female figures whose looks have the fascination of a yawning abyss—like *Sin* or *Sensuality*—and which mark the transition from Symbolism to Art Nouveau.

The painting of the French Symbolist Gustave Moreau (1826—98) glows with the shimmer of brocade and gold dust. Moreau created an iridescent world of peacocks, fairies, griffins, and sirens. The sphinx was a symbol of womanhood for him too. On the subject of his *Isle of the Chimerae* the painter wrote: "This island of fantastic dreams contains all the forms of passion, fantasy, and moods of a woman; Woman in her role as a reckless creature, besotted with the unknown, with secrets, in love with evil, with forms of perverse and diabolic seduction. Childish tears, deliberate tears, monstrous dreams, melancholy dreams . . . These are creatures whose souls are crippled, who wait by the roadside for the lustful goat, who are possessed by lasciviousness . . . Lonely creatures, sullen in their envious dreams, their unsatiated pride . . ."

In Moreau's work, Salome is the incarnation of the perverse powers of Woman. He shows her in his most famous painting, *The Apparition* (1876), when the severed head of John the Baptist appears to her in a vision with a shining halo. The picture inspired Oscar Wilde to write his poem in the French language. Joris Karl Huysmans, the Symbolist poet, describes the work in the chapter called The Picture Gallery in his novel *A Rebours* (Against the Grain) in a similar spirit:

In this hot air of the temple, heavy with sweet smells, stands Salome, her left arm raised imperiously, her right bent and holding a large lotus flower before her face. She approaches slowly on the tips of her toes in time with the strains of a guitar whose strings are plucked by a woman squatting on the floor. Her face is

reverent, solemn; she is almost majestic as she begins the voluptuous dance designed to stir the aged Herod's sleeping senses. Her bosom heaves, and, at the touch of her necklace as it whirls round in a circle, her breasts become firm and erect. On her damp skin, diamonds flash, her bracelets, her waistbands, her rings send gleaming sparks across her magnificent gold and silver embroidered costume covered in pearls. It is a soft armor of fine goldwork, every stitch of which is decorated with a precious stone whose fire becomes interwoven with serpentine movements on the smooth, rose-petal-soft skin like glittering insects with gleaming wing cases, marbled red, dotted with bright yellow, with steel-blue flecks, striped with peacock green. . . .

The refined fascination of the *fin de siècle* world of "sweet sin," where colors, perfumes, sounds, and spices formed a painterly poetic totality, could hardly be better described.

In the work of Arnold Böcklin (1827–1901), who belongs to the same period, we find similar dreamworlds blended from mythology and poetry, with naiads and sirens, tritons and centaurs, islands of the dead, and sacred groves. The *haut goût*, however, is missing. In its place there is pure ideality, sometimes petty-minded idylls, garden arbors with incense. The *memento mori* allegory *Vita somnium breve* of 1888 represents a well-known example of this. In the composition of *Odysseus and Calypso* (1883), however, Böcklin's symbolism attains a formal power which later became a pioneering influence in Chirico's *pittura metafisica*.

Max Klinger (1857–1920) produced a direct continuation of Böcklin's work, both from the formal and thematic point of view, in his murals in the Villa Albers. This can be seen in titles like *Tritons and Naiads*, *Ride on the Shark*, or *Sea-Gods in the Surf*. His monumental painting in Vienna *The Judgment of Paris* (1886–87), approximately 24 feet long by 10 feet high, has three relief busts supporting its predella and a decoratively flowing frame, setting it on the threshold between Symbolism and Art Nouveau. Klinger's relationship to Böcklin is like that of Khnopff to Rops or Burne-Jones to Rossetti.

If one compares Klinger's *Judgment of Paris* with the painting of the same title by Anselm Feuerbach (1829–80), dating from 1870, the changes from Classicist poetic linearity to Symbolistic decorative splendor are very noticeable. Yet even Feuerbach, who came to recognize the "ideal beauty of the line" in Rome ("Rome is my destiny") and brought it to the highest perfection in

his paintings of Medea and Iphigenia, was not completely unaffected by the Pompous Age. This is indicated by his *Plato's Banquet* painted in 1873 in Berlin, a second version of this theme. The painted border with its garlanded *putti* conflicts with the ancient subject and tends towards the sumptuous ornamentation of the Makart period.

Before Feuerbach, a pupil of Ingres, Théodore Chassériau (1819–56) had been working in France to attain an ideally glorified beauty and humanity in his figure compositions. He was a Creole born in the Antilles on Santo Domingo (Haiti) whom Gautier described as "an Indian swept onto the shores of Greece." He combined the cool, precise linear form of Ingres with the Romantic picturesque style of Delacroix. This difficult synthesis succeeded best in the painting *Esther's Toilette* of 1841 which, like Delacroix's *Women of Algiers*, became a prototype for the oriental fashion of the Pompous Age. His monumental *Tepidarium* of 1853, on the other hand, stands stylistically between Gérôme and Couture. The *Turkish Bath* by Ingres was not produced until ten years later, and in Makart's work the rhythmic grouping of female nudes in *The Summer* of 1880 has a sugary, overblown quality which is quite lacking in Chassériau's controlled form and clearly defined beauty. The short-lived Creole also expressed his delicately distorted linear magic learned from Ingres in the medium of etchings and lithographs *(Venus Anadyomene)*.

In the medium of mural painting Pierre Cecile Puvis de Chavannes (1824–98) portrayed a Golden Age of mythology and allegory, history and legend. His approach was similar to that of Hans von Marées (1837–87), who was only able to realize his great pictorial ideas in the Neapolitan frescoes of 1873, and he was not so much concerned with dealing with the theme as he was with the "problem of form," with achieving the "structured picture." There are several surprising parallels between the pictures of the seasons by Puvis de Chavannes such as *Autumn* from 1865 and paintings by Marées like *Rider Picking Oranges* (1869–70) or *Man Leading a Horse and Nymph* (1881–83) from the point of view of composition, color, and conception of the figures.

At the beginning of the nineties Richard Muther called the painters Böcklin, Burne-Jones, Puvis de Chavannes, and Gustave Moreau the "great four-leafed clover of modern Idealism." They were the stabilizing antipodes to the Impressionists, Post-Impressionists, and Pre-Ex-

pressionists who, by that time, were well-established on their triumphal progress. For them the artist continued to be "the priest" and art "the great mystery," as Peladan had declared in 1892 in his Rosicrucian Manifesto.

Moreau's brocaded Symbolism was developed and adapted by Odilon Redon (1840—1916), a contemporary of Monet and Renoir, right into the twentieth century. Visions and chimerae dominate Redon's early work. Edgar Allan Poe's *Mask of the Red Death* provided the subject for a charcoal drawing of 1883 which belongs to his series of "black pictures." Later on the fantasy becomes more and more sublimated in pure, pastel colors that iridesce like sea shells. The themes remain the same—*Aurora, Apollo's Sun-Chariot, Dante's Vision*—but the forms are different. A direct line of development can be traced from Böcklin's *Birth of Venus* of 1865 to Redon's *Birth of Venus* of 1912. However, the flutes and garlands are gone, Moreau's gold dust has disappeared, symbolism is displaced by painting, and the Pompous Age comes to an end. "The exalted enthusiasm of the artist survives the extinct piety of earlier days . . ." Peledan states in his Rosicrucian Manifesto, ". . . you can lock up the churches—but the museums? The Louvre will read the mass when Notre-Dame has been profaned. . . ."

Right: *Icarus' Lament*, painting by Herbert Draper, around 1898, Lt
Page 148: *Triton and Nereid*, painting by Arnold Böcklin, 1875, Bn (above);
Hylas and the Nymphs, painting by John William Waterhouse, Mc (below)
Page 149: *Phryne*, painting by Jean-Léon Gérôme, 1861, Hk

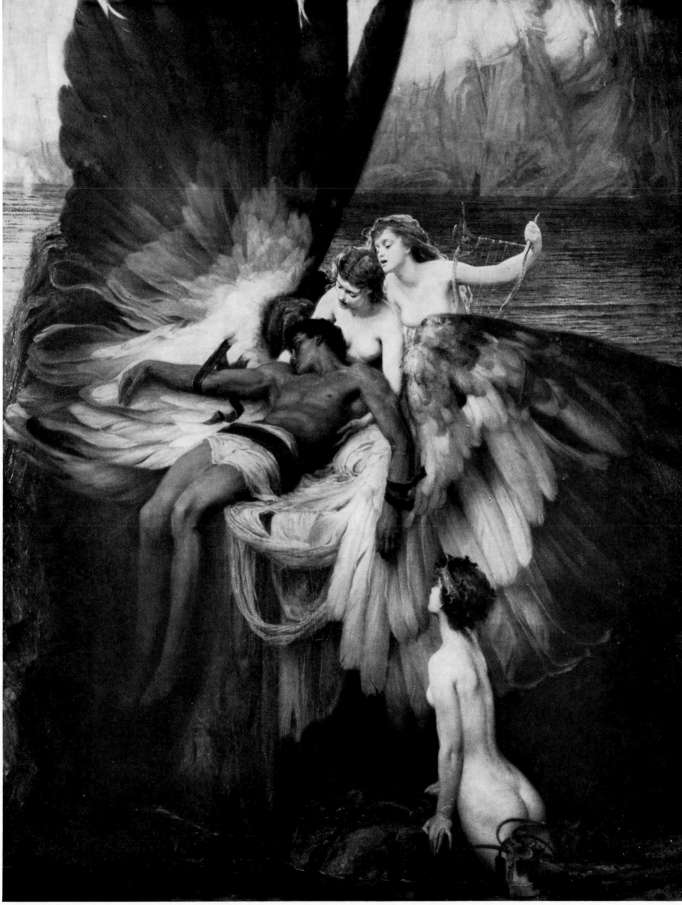

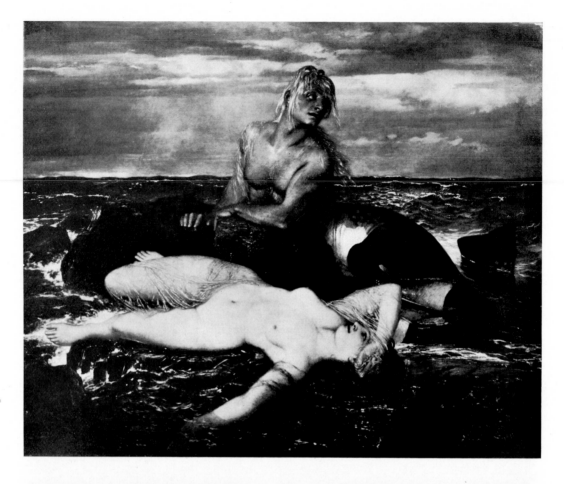

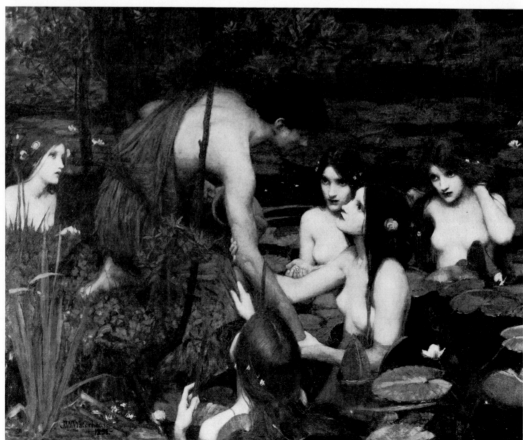

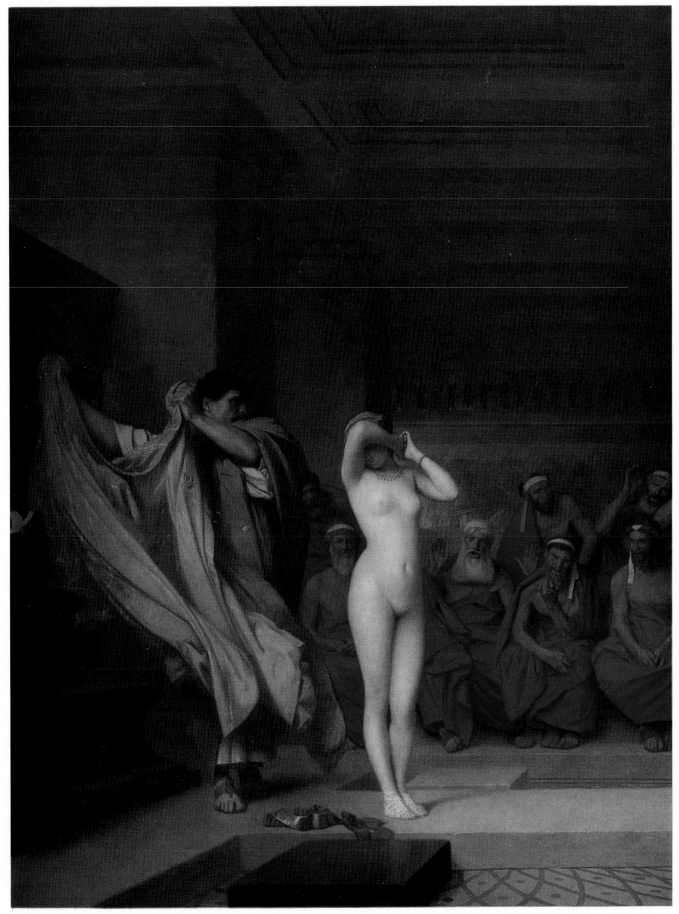

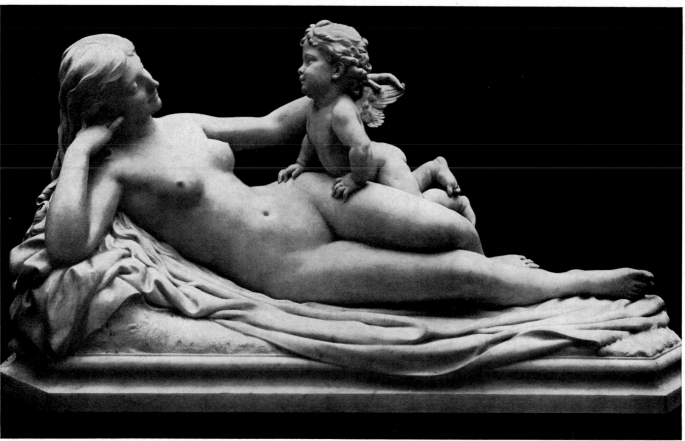
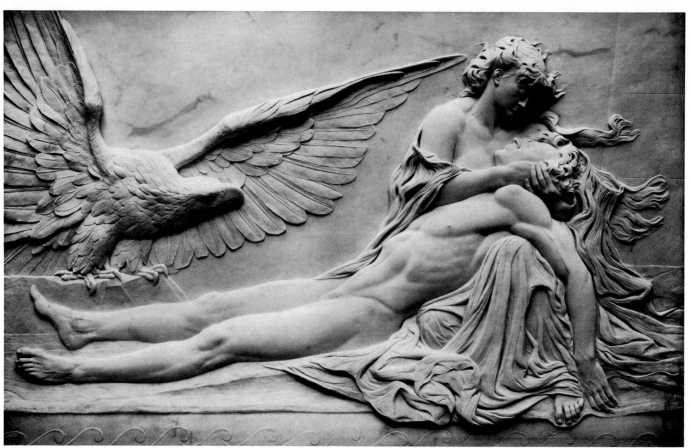

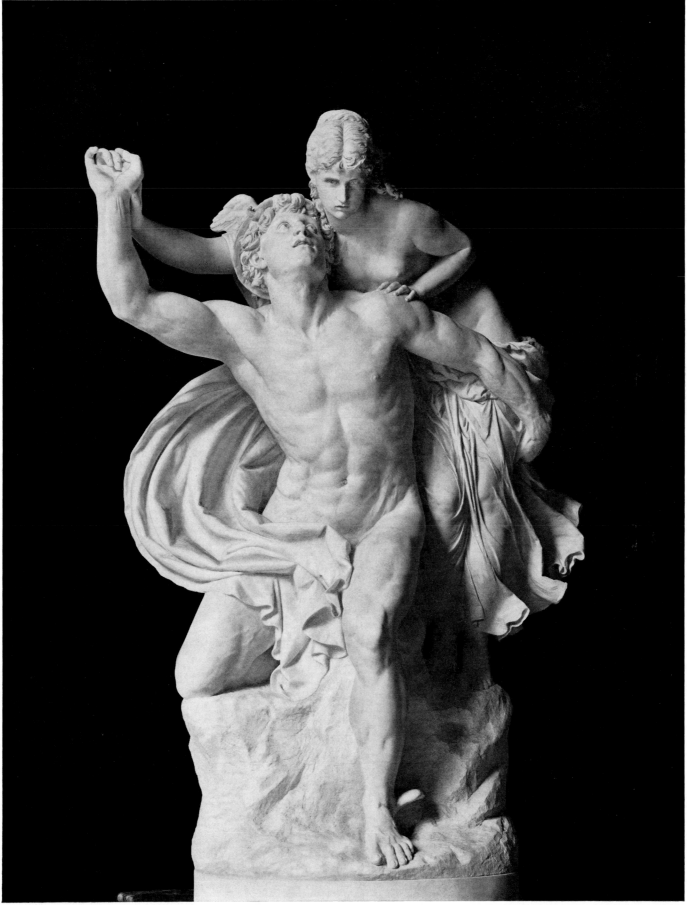

Sculpture

It is much more difficult to research "Pompous art" than the archaeology of a vanished culture, because the "Pompous Culture" (if one can call it that) has not only vanished but has also been hidden. While, for example, people tirelessly search for remains of the pre-Columbian or Mesopotamian cultures, carefully preserve them, and exhibit them in public, for some time now efforts have been made to remove from view those works of art which for fifty years represented the most famous achievements of their time. Nevertheless, it cannot be denied that at one time the products of this art did occupy a great deal of room in the museums, much to the disadvantage of misunderstood and despised artists whose importance was not recognized until later. Although sculpture, particularly the monumental statue, is not so easily hidden as paintings, it still requires considerable trouble to find those works which once graced the salons of the second half of the last century, received so much praise from the critics, and were rewarded with official prizes. Nowadays it is hard to discover in which museum they shun the light of day. Even exhibition as a monument in a public square or a park did not always offer protection if the authorities, conforming belatedly and regretfully to changing tastes, caused them to be "abducted." Many statues were removed from their pedestals under a great variety of pretexts, to say nothing of those which were carried off to the foundries in bronze-hungry times of war.

It is therefore necessary to undertake a wide-ranging search in order to determine where the sculptures ended up which were well known to the previous generation and—like most of those owned by the Paris Musée du Luxembourg, for example—became exiled to the provinces.

Even in London it takes a lengthy search to find the sculptures which not so long ago were housed in the Tate Gallery.

The bad conscience that is trying, one hundred years later, to correct an error of judgment or at least remove its consequences has not been able to get rid of a large number of monuments from this age which put them up with such enthusiasm. One comes across them with great frequency when passing through the great cities of the world. We shall mention a few examples, but first an attempt will be made to define the important characteristics of this style or else, perhaps, establish precisely the absence of any definable style. In pursuing the question of what sources and what circumstances favored its spread in a particular period we shall be analyzing all the forms of a sculptural art which has never been fairly judged either during the time of its popularity or the decades of its neglect.

The glorious epoch of the Pompous style reached its peak around 1880. Yet this style is not only representative of its own age. It also reflects an attitude which has manifested itself in completely different periods of art history, namely Ancient Rome and the Renaissance. The idea of the Pompous is in this respect rather like the Baroque, many of whose most important characteristics, it must be agreed, persisted beyond the period which long ago came to be termed the Rococo.

It is precisely the relationship with certain (the least original) aspects of ancient statuary and Renaissance sculpture which explains how such an aesthetic could evolve in the middle of the nineteenth century. The Pompous style drew on the Neo-Classical, which in its turn had is source in classical antiquity—or, to be more

Page 150: *Venus and Cupid*, marble, Gustave Crank (above);
The Death of Leander, Henry Hugh Armstead, 1875, Lt (below)
Page 151: *Mercury and Venus*, marble, Reinhold Begas
Page 152: *Hope*, painting by George Frederick Watts, 1885, Lt (left);
The Minotaur, painting by George Frederick Watts, Lt (right)

precise, in the imitation of this style which appeared in the plastic arts of the sixteenth century.

Such an aesthetic is characterized in particular by the sharp difference in each individual work between the extremely ambitious intention and the modest execution. The wider the gulf was, the stronger the ambition to equal the ancients in the production of "great art," to treat the themes "sublimely"—and the more miserable was the technique of the sculptural work and the more obviously ridiculous the whole business became. It was in this manner that so many works of art unintentionally acquired their truly comical effect.

One has to regard it as a real success that in this region on the borderline between Academicism and Mannerism, there were a few works conceived with considerable inventiveness and produced with interesting movement or genuine delicacy. These are the works to be dealt with if we are to elevate Pompous art to the level of a style.

Where the taste for the sublime could not be expressed, the sculptor would attempt to transpose literary or even poetic ideas into marble or bronze and so spiritualize the most banal themes. It became the role of sculpture to "lend wings" to an anecdote or, in other words, to ennoble silliness. To "lend wings" is not just meant figuratively either, for never before have so many wings unfolded on monuments and so many pedestals been occupied by an invasion of angels of glory, of triumph, and of fame.

The anecdote could be an everyday scene (*Peasant Woman Calming Her Child, Surprised While Bathing, Rest*) but could also be taken from history or mythology—the approach remained the same, and sometimes the model too. The woman shivering with pleasure or perhaps with cold as *The Bather* would reappear as the fearfully trembling *Iphigenia Captured*.

The sculptors of the nineteenth century had inherited this taste from antiquity—the rooms with Roman sculpture in the Louvre offered them more than just a model. The theme of mother and child, which provided innumerable versions of motherhood for the salons of the *Fin de siècle* after it had been through its period of spiritualized greatness in the medieval *Madonnas with Child*, originated in the first century A. D. in Rome, where it was represented by the marble statues *Messalina with Her Son Brittanicus*. It provided the opportunity to animate a mother with her child on her arm with overly graceful gestures and heavily theatrical poses. We

have a perfect example of the "pompousness" of the ancients in the *Roman Man and Wife As Mars and Venus*, where the woman is wearing the peplum and the man is naked apart from his helmet.

One may well ask what sculptors would have lived on if there had been no mythology. At the same time as it was providing the sculptors of the Renaissance with their main themes, it was also establishing the essence of Academicism, which is so well adapted to such themes. How many *Theseuses* and *Apollos* which appeared under Napoléon III are natural sons of Florentine heroes and gods, and how many *Psyches* would never have been raped if it had not been for Giambologna's *Rape of the Sabine Women!*

At times religion would push mythology aside, but it was never able to drive it out of the salons completely, though for long periods it did provide an excellent bait to attract official recognition. Here, too, the dreams of sculptors who wanted commissions from the clergy were not directed toward Michelangelo but to the precursors of the Baroque such as a certain Andrea Sansovino whose *Hope* in the Roman Church of Santa Maria del Popolo is surrounded with a rather more wordly than spiritual grace. Much later, around 1900, a great deal of religious work showed a distant relationship with Bernini's *Ecstasy of Saint Theresa*.

Yet between the Renaissance and the Second Empire there was one far more important stage in the progress of the statue towards Academicism than the Baroque, namely the Neo-Classicism of the beginning of the nineteenth century. This continued for a long time without ever completely abandoning the somewhat artificial charm of the eighteenth century. The later virtuosos of the realistic chisel could observe what immense care someone like Houdon would take over his busts, how he would carve the marble flowers in *Sophie Arnould*'s curls and trim *Madame Adelaide*'s neck with exquisite lace. His half-naked *Frileuse* in the Montpellier Museum showed them, in addition, how one can make a statue tell a little story.

Yet it was people like Canova, Thorvaldsen, their imitators, and their rivals who determined the direction of sculptural developments in an age when all eyes were fixed on classical antiquity as though bound by some spell. No one could imagine that anything acceptable could ever be achieved by turning away from these models which clearly possessed the secret of beauty. Through works like *Psyche, Awoken by Amor's Kisses*, Canova

long held his place as the fascinating example for emulation by the Academics.

Sculptors hit on the frightful idea of no longer depending on the pompous mythology for the themes of their work in marble, but instead using so-called "genre scenes," though of course without giving up anything of what they considered the "great art" of traditional sculpture. It should be particularly emphasized here that in the privileged field of official art there was much more concern with choice of subject matter than with the evolution of a new technique (and this involved the misunderstanding or neglect of attempts at originality such as those made with greater or lesser boldness and in greater or lesser secrecy by Daumier, and after him Carpeaux and Dalou). The story which was to be told, the scene which was to be portrayed, were considered far more important than the manner in which a work could be executed and the technical skill which would also express the artist's temperament.

The example of the painters who, as followers of Courbet, plunged into Realism was also followed in their own way by sculptors. They too looked for their subject matter in everyday things, though of course without abandoning the greatness of ancient sculpture. The art of the Pompous Age was therefore facing in two directions: its ideal should have been a *midinette* created by Phidias; unfortunately there was no Phidias among the sculptors of the age, and consequently all the more *midinettes* appeared as statues under the most varied kinds of pretext.

The Naturalism of the sculptors, eager to preserve the admiration of the middle-class salon public, was, moreover, just a mundane—that is, sugary and diluted—form of the literary Naturalism represented by Zola, Flaubert, and Maupassant, which seemed to most people a dangerously amoral, anarchistic, and harmful phenomenon. The sculptors were able to buy their way out of the business cheaply with such things as *Woman Selling Hay, Woodcutter,* or *Woman Carrying Bread.* Many, however, preferred to remain with the traditional themes and continued to obtain their inspiration from the Renaissance. In Paris there was the so-called "Neo-Florentine" group which adopted the sculpture of Tuscany. The founder of the movement was Paul Dubois (1827–1905) who established a considerable reputation with his *Florentine Singer* (Louvre) in the year 1865. Another artist, Antonin Mercié (1845–1916), a student of Jouffroy and Falguière, received the First Great Prize for Sculpture of

the École des Beaux-Arts in 1868 for his *Theseus Defeating the Minotaur;* he became famous in 1872 for a *David* inspired by Donatello. René de Saint-Marceaux (1845–1920) experienced a revelation of Florentinism. He is the creator of a *Spirit Watching Over the Secret of the Grave* and an extremely odd piece of work for which we cannot make Donatello responsible: the monument to *Alexander Dumas's Son* in the Place Malesherbes in Paris. This shows the writer surrounded by ethereal figures which allow the observer complete freedom to decide on the meaning of this metaphorical company himself.

In every age allegory has been the great reservoir for sculptors, their only means of expressing ideas. In this they are like dancers, who must translate every manifestation of sentiment and every ideological schema into a language of the body; yet they are in a more favorable position than sculptors since choreographers are able to exploit the element of movement. Nevertheless, the famous men who stood in frock-coated dignity upon the pedestals of public parks or over their own graves would be surrounded by very similar incarnations of the conventional ideas of glory—often in poses with the distinct lightness of dancers.

Many statues, the fruit of public commissions, were also designed as monumental decorations for the façades of public buildings. These would be erected either by the state or the city, such as city halls, theaters, exhibition buildings and so on. Others were to serve as reminders of some historical event or, even stranger, some sublime place such as politicians so eagerly choose for the sanctification of their speeches. Nowadays one would just as soon do without having to look at them as statues. The statues originated in a time when philosophy and sociology consisted of words with great but indistinct meanings and the stony contribution of allegory became greater than ever before. This would be mostly in the form of a female figure—sometimes robed and sometimes disrobed in imitation of the ancients—as Fame, Fortune, Posterity, Time, Immortality, Thought, Science, and the various arts. Examples of this are *Progress Vanquishing Error* (Falguière, 1831–1900), *Purity Above the Vices* (Marquet de Vasselot, 1840–1940), *Freedom Lights up the World* (Bartholdi, 1834–1904). It could hardly be overlooked that the sculptors were moralists—they created morality in stone.

Ernest Christophe (1827–92), producer of a forgotten work called *Destiny,* became better known through a

poem which Baudelaire dedicated to his *Woman with a Mask* and published in *Spleen et Idéal*. In the poem Baudelaire calls the work an "allegorical statue in the taste of the Renaissance":

> Observe the fullness of Florentine grace,
> In that muscular body's rhythm
> The heavenly sisters of elegance and strength.

But not every work had the good luck to be noticed by someone like Baudelaire, and how many names on the pedestals of *Hebe* and *Ganymede* had been forgotten before the signature in the marble had been worn away by the weather!

But still there was no lack of acclaim from contemporaries. The artists' careers would proceed from the Prix de Rome won at the age of twenty-three or twenty-five to their entry into the Institut de France often less than twenty years later. They would then be awarded a stream of official commissions, earn a reputation at the annual salon, and finally be rewarded with important posts and high honors. The career of Alexandre Falguière is a typical example. He was born the son of a mason in Toulouse, worked in Jouffroy's studio at the École des Beaux-Arts in Paris, and won the Premier Grand-Prix de Rome in 1859. Invited to join the Institut in 1882, he was made a Commander of the Legion of Honor in 1889—but who can recall a single one of his works off the cuff today! Parisians often mention his name, in fact, because there is a square, a street, a quarter in the city, an arcade, and a Métro station named after him, though few still remember that they have anything to do with a sculptor. No one today knows anything of the enormous success of his *Victor of the Cockfight* of 1864 (which after a long absence reappeared in the Louvre together with some other works in 1969) or his *Woman with a Peacock* (still in the Toulouse Museum) from the salon of 1890. Nobody realizes any longer that he is the creator of the statues of *Lamartine* and *Balzac* which one walks by without bothering to pause. Who ever inquires about the man whose inspiration produced *Heroic Poetry* and *Switzerland Acclaims the French Army?* It is true that one does not get to see his works very often; many of them still slumber on in the basement of the Petit Palais. Thus Falguière's fame, which lasted until the wave of Pompous art ebbed away, gradually faded out.

Much the same thing applies to the creator of the *Florentine Singer*, mentioned above, Paul Dubois, who also gave us an *Eve*, a *Pasteur*, the statue of the *Duc d'Aumale*, and the monument to *General Lamoricière* in Nantes. In 1873 he became curator of the Paris Musée du Luxembourg, in 1876 a member of the Institut de France, in 1878 head of the École des Beaux-Arts in Paris, in 1886 Commander of the Legion of Honor, and in 1889 Grand Officer of the order; he received the Grand Croix in 1896 and later on the Grand Cordon when the Parisians set up his *Jeanne d'Arc* in the Saint-Augustin Square.

England bestowed similar honors on its official artists. The painter and sculptor Frederic Leighton (1830–96), who produced *The Lazy Man* and the *Athlete Battling with the Python* (1877)—the Tate Gallery disposed of these when it brought its collection up to date, to the benefit of Leighton House Park in Kensington—was knighted in 1878, made a baronet in 1886, and became Baron Leighton of Stretton in 1896. From 1878 until his death he held the position of President of the Royal Academy, and he was given a magnificent burial in St. Paul's Cathedral. The transition of sculptors from the Neo-Classical style to an Academic Realism could not only be seen in the changing aesthetic, but it also brought about an entirely new category of monuments.

Right: Prince Albert Memorial, design by Sir George Gilbert Scott, execution by Henry Hugh Armstead,
J. B. Philip, Thomas Thorneycroft, and others, bronze figure of the prince by John Henry Foley,
Kensington Gardens, London
Page 158: *Queen Victoria*, marble, Sir George Martin Holloway, 1889, Lv (left);
King Ludwig II of Bavaria, marble, Caspar Zumbusch, 1864, Hl (right)
Page 159: *Jeanne d'Arc*, model of the mounted figure in the sculpture salon at the 1889 Paris World Exhibition
Emmanuel Frémiet
Page 160: Relief representing prosperity, brotherhood, and labor, 1889, on the Amsterdam central railway station

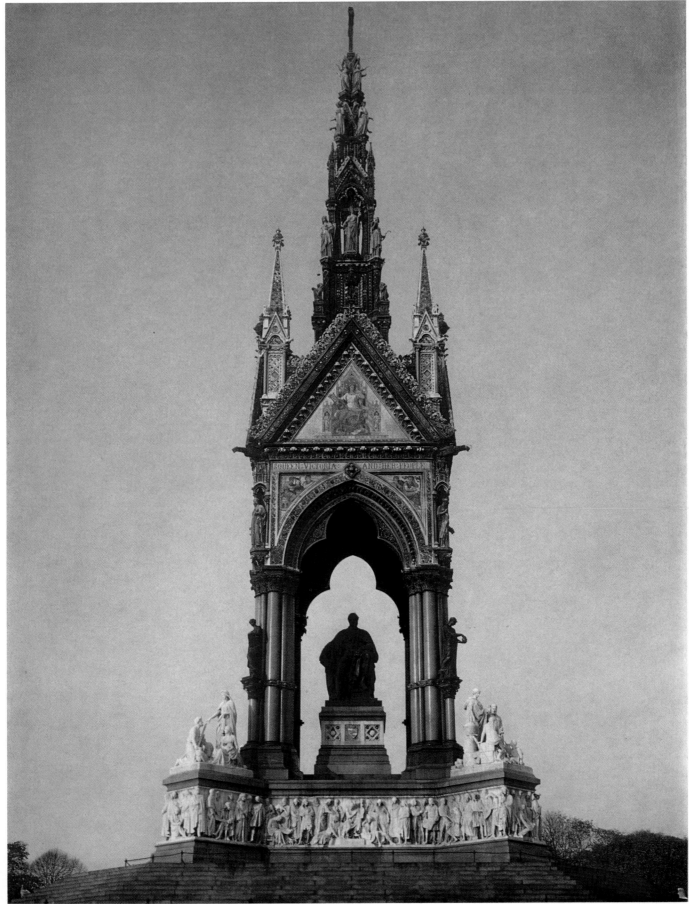

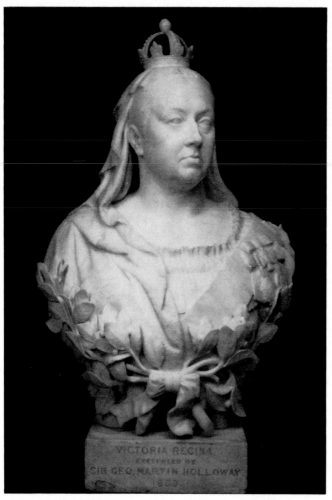

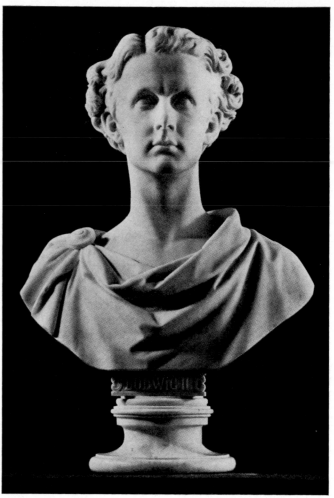

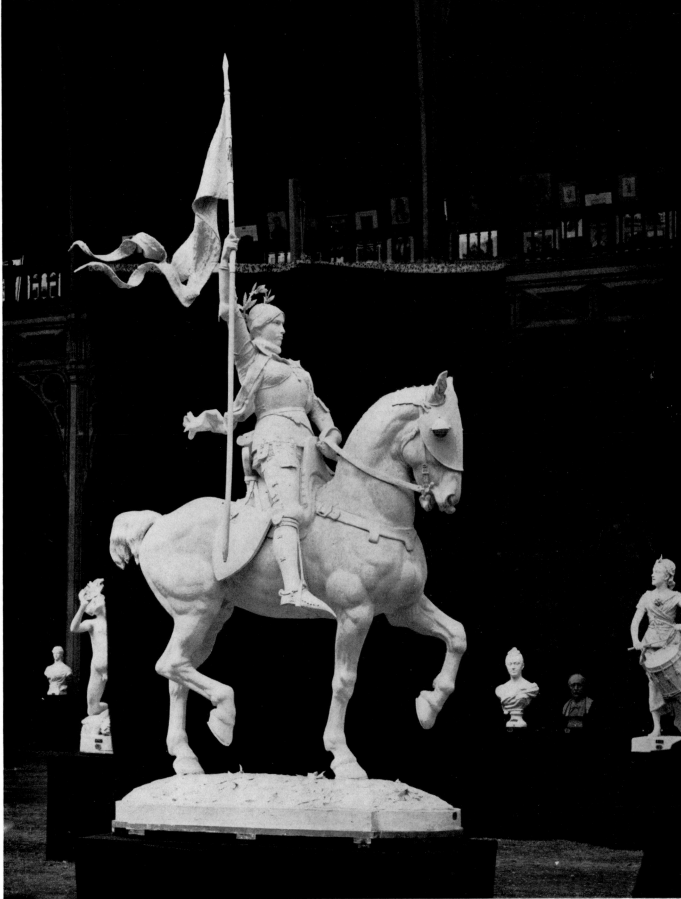

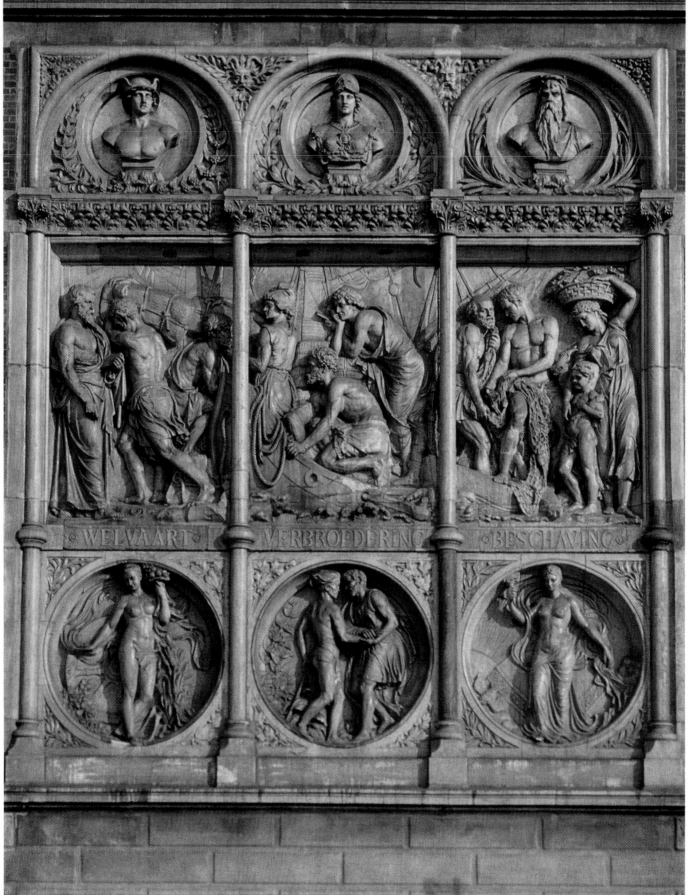

WELVAART · VERBROEDERING · BESCHAVING

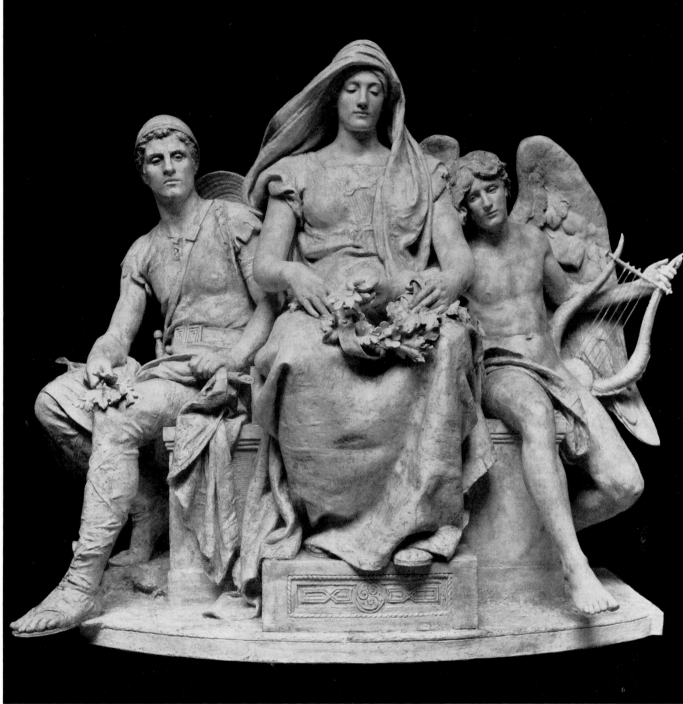

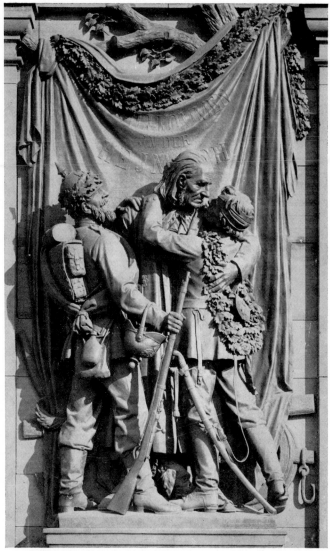
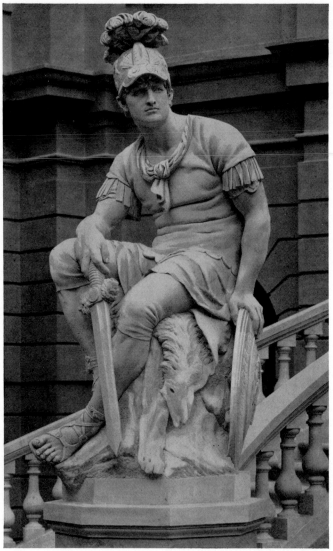

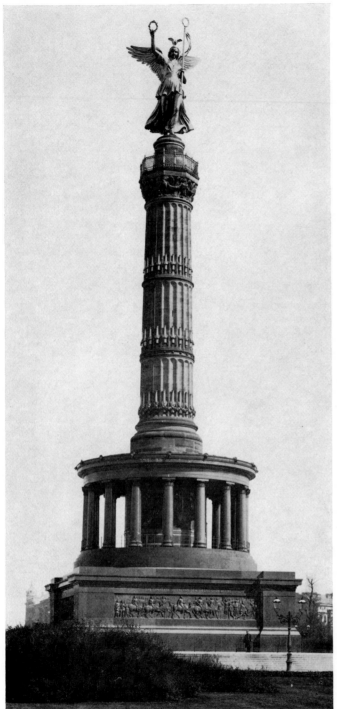

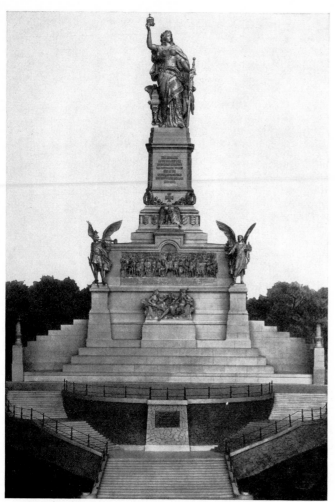
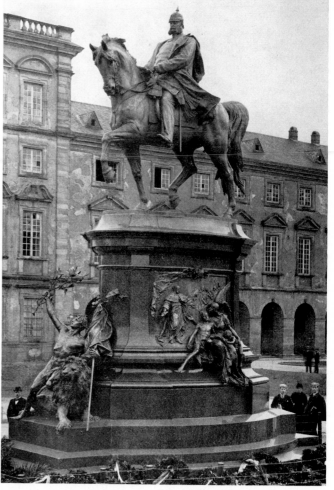

Many cities were overcome by a real passion for the cult of memorials, and every war brought stridently patriotic works in cake-frosting style honoring the fallen, even in small towns. The sculptors were never happy to allow the famous personage to appear without a train of allegorical figures, and the size of this escort was the precise expression of the importance of each particular immortalization in stone. Interestingly enough, we can also follow the social development which exerted such a profound influence on the nineteenth century through this cult of memorials. The "great men" upon whom the honor of a statue naturally descended were first of all the rulers, the statesmen, and the generals; then the men of learning were added to these; and later still came the heroes of the people. In a public park in Paris, the Montholon Gardens, a *Monument to the Workers of Paris* was even set up, a work by Julien Lorieux (1876—1915), who was a student of Falguière and Antonin Mercié.

The first category with whose style we are concerned here includes the most typical example of monumental glorification in London—the *Prince Albert Memorial*. The English have always had a strong interest in memorial statues, and I believe that there is no other city in the world where one can find such a fantastic quantity of statues as in London; the area round Westminster is a real Elysium in stone for the famous figures of the kingdom.

The *Prince Albert Memorial* in the Kensington Gardens is primarily a piece of architecture. The architect Sir George Gilbert Scott (1811—78) was commissioned by Queen Victoria to design a work worthy of her beloved consort's memory—inevitably in the Neo-Gothic style. Albert von Sachsen-Coburg-Gotha sits under a towerlike canopy 174 feet high lavishly decorated with colored stone, gilding, mosaics (by the Venetian Salviati), mar-

ble, and bronze. The simplicity of his pose forms something of a contrast to the massive ornamental elaborateness of the structure: the sculptor John Henry Foley (1818—74) shows him reading a catalogue of the Great Exhibition of 1851. Around the base there are 178 high-relief figures of famous artists from every age in marble, with large groups projecting above them at each corner symbolizing Agriculture, Industry, Trade, and Craftsmanship. Four more groups—Europe, Asia, Africa, and America—flank the steps, all the work of different celebrated artists like Henry Hugh Armstead, J.-B. Philip, Thomas Thorneycroft, and others.

The bronze statue of *Catherine II*, a work by Miketshin set up in St. Petersburg in 1873, is soberer, more modest, and reaches a height of only about nineteen feet standing on a base of red granite. All the same, instead of the simple exhibition catalogue befitting a prince-consort, the czarina is holding a sceptre in her right hand as an emblem of power, a crown in her left, and she wears the ermine-trimmed coronation cloak. Her favorites and a few famous figures of her time surround her: the princes Potemkin and Alexis Orlov, the poet Dershavin, and Marshal Suvarov—to whom a separate statue was also erected on the square named after him. The sculptor Koslovski portrayed him as *Mars*, which attracted the mocking attention of Alexandre Dumas in his book *Journey to Russia*. The Revolution left the monument to Catherine II unharmed; the czarina still sits on her throne above the gardens in the Ostrovski Square between the Nevski Parade and the Alexandrinka Theater, and on summer evenings the citizens of Leningrad stroll at her feet, sit on the benches, and can take a look at their former ruler.

Leningrad has also preserved the statue of *Peter the Great* and that of *Czar Nicholas I* by Klodt von Jüggens-

Page 161: Group from the Boyle O'Reilly Monument, Daniel Chester French, Boston, Massachusetts
Page 162: *Returning Home*, relief from the soldiers' memorial 1870—71, Siemering, 1881, Kassel (left);
Roman Warrior, Reinhold Begas, 1881, courtyard of the Hall of Fame in the Zeughaus, Berlin (right)
Page 163: *Victory Column*, Strack, 1873, Berlin (left);
Statue of Liberty, Frédéric-Auguste Bartholdi, New York (right)
Page 164: Niederwald Monument, model, figures by Johannes Schilling,
architectural base structure by Karl Weisbach, 1877, Niederwald am Rhein (left):
Monument to Kaiser Wilhelm I, G. Eberlein, Berlin (right)

burg, both on horseback. The enthusiasm for statues on horseback in the middle of the nineteenth century caused entire cavalcades of noble personages to ride out mounted high on their bronze steeds: in 1849 in Bern, Joseph Volmar's *Rudolf von Gerlach*; 1851 in Berlin, Christian Rauch's *Friedrich II*; 1855 in Orléans, Denis Foyatier's *Jeanne d'Arc*; 1859 in St. Petersburg, Klodt's *Nicholas I*, which is surrounded by statues of Justice, Power, Wisdom, and Faith. The statue of the *Duke of Genoa* on horseback by Alfonso Balzico was erected in Turin; *Friedrich Wilhelm III* by Karl Albert Wolff in Berlin; *Wellington* by Albert Stevens (later completed by Tweed) in London; the *Jeanne d'Arc* in Paris by Frémiet, to whom we also owe the *Pegasus* statues above the pylons of the Alexander III Bridge.

This *Jeanne* and the *Pegasus* figures are typical of the preference of the period—and of Frémiet in particular—for gilded bronze, which he also used for the execution of works of much smaller dimensions, for example the ornaments for Sarah Bernhardt's pseudo-Renaissance town mansion on Rue Fortuny where she lived until 1900. The works were split up in an auction in February, 1970. The pieces concerned were a *Pelican Eating Fish* (1890) and an *Ape Blowing Soap Bubbles with a Small Pipe* (1898), in which every bubble forms a lamp glass and snakes and snails crawl between the candles on a chandelier. However, Frémiet was more a specialist in horses than in snails and was the ideal choice to be relied on for the steeds of Carpeaux's *Fountain of the Four Corners of the Earth*.

Little by little the frenetic enthusiasm for portrayals of animals, which originally was intended to glorify moments in history, began to allow a little more room for less heroic subjects too. A country that had done enough for the glorification of its emperors and kings and the leaders of its slaughters conceived a desire to bestow the honor of a statue on its thinkers, its poets, and its musicians. Now each writer and each artist received his monument with the addition of one or more female figures signifying either the Muse, a source of inspiration, perhaps an admirer, or simply the embodiment of a life of sentimental rapture. So Charles Gounod received his monument in which, however, resting like the good Lord on a cloud, he seems not to notice the company Antonin Mercié has given him under the roof of foliage in the Parc Monceau. In the same park Chopin plays the piano for a lady whom waltzes and nocturnes have obviously reduced to a state of profound boredom—the sculptors

did not always show the most felicitous skill in the evocation of moods.

Whether the subject was a poet, a musician, or an admiral, the principles of composition were always the same. The type of monument had been established once and for all and perfectly adapted to the aesthetic outlook of the age: the "great man" was raised up on a pedestal where he would either stand or sit. (Politicians like Gambetta and Garibaldi generally stood in the pose of a tribune of the people or "poised for action," which was intended to be flattering to men who had primarily been speakers, while scholars as thoughtful men would be sitting in a chair, and nature-loving poets had to sit on a rock.) They were all berobed with the utmost care, often draped in a sort of peplum of such an indistinct style that it was impossible to associate the garment with any particular period. Presumably it was supposed to be taken as the clothing of eternity. The sculptor made the portrait of the immortalized figure as lifelike as possible and then made free with the addition of allegorical elements, juggling with veils and harps, with wings and laurel wreaths. The Pompous style was cheerful-spirited in these cases, preserving a melancholic mood for tombstones.

Strolling through graveyards is extremely instructive for our topic. Death offered a richly flowing source of inspiration for the theatrical statue of the eighties—the word theatrical here means that melodramatic tone which spiritualizes the subject and indicates the intention of striking a sensitive chord in our emotional life. In many cases, however, mourning does not appear to be the real theme of the composition, and our capacity for pity is clearly appealed to far less than an assumed feeling for the glorification of the person concerned. Sometimes the tombstone also had to portray a sort of biographical synthesis for the deceased, which would inevitably have to be of a laudatory nature. All the men lying there in their graves need have had no worry while they were alive that they would be presented to posterity with all the virtues.

One has to go to the large graveyards in order to gain an impression of what emerged at the end of the century and could be called the "art of the speaking grave" or even the "singing grave". They really do speak to us in a language of marble and bronze, sometimes whispering, sometimes shouting; occasionally they sing us arias of the great operas in voices of stone female singers among stelae, pyramids, fragments of Greek

temples and Gothic chapels, and other pieces of an architecture of eternity. The most monumental structures were by no means reserved only for celebrities. Many an unknown individual rests beneath an imposing mausoleum which guards the memory of a great fortune rather than a great spirit.

The Parisian Père Lachaise Graveyard is a veritable open-air museum which has material on view that one would have to search for with considerable effort in the regular museums. It contains works by all the sculptors who lived between 1860 and 1890. It is not always easy to identify them as their style hardly permits one to tell them apart, and the signature often cannot be found. Aimé Millet (1819–91) is represented by a statue erected in 1871 for a minister of public works. The success he achieved with an *Ariadne* in the salon of 1857 brought him a number of official commissions. These include, among others, a statue of Chateaubriand, a bust of George Sand, and the *Apollo* which we can see perched up on the roof of the Opéra. Étex (1808–88) contributed the *Monument to Théodore Géricault*. This artist, a pupil of Pradier, shows him on a couch with a palette in his hand. Étex's reputation was established with compositions like *Hercules Strangling Antaeus* and *The Genius of the Nineteenth Century*. As the creator of *Shipwrecked Men* (in Montsouris Park) he was given the commission for Géricault's monument and did not neglect to show his famous painting *The Medusa's Raft* in a relief on the base and find a place for the work *A Wounded Cuirassier Leaving the Battle* on another side.

In this way living sculptors provided dead painters with their accolade. But some of them also provided for their own tombstones, for example, Jean Carriès (1855 to 1894), a specialist in colored sandstone. He portrayed himself in a half-length figure with a statuette in his hand while next to him there is a touching evocation of his mother's face. Léopold Morice (1843–1920) composed the sculpture for the family grave where he also lies. It is in the graveyard of Montparnasse and shows the silhouette of a woman in long robes holding her hand in front of her tear-stained face. Morice is the creator of the gigantic *Republic* (in the Place de la République in Paris) and the more appealing *Water Sprites*—children listening to the horn of a sea shell and riding on a dolphin—on the Alexander III Bridge, to which we shall be returning later.

Finally, there are sculptors who have been glorified by sculptors at Père Lachaise—for example, Alexandre

Falguière by Laurent Marqueste (1850–1920). They were both masters of Pompous art. Marqueste secured his official career through the success of his *Perseus and the Gorgon* in the 1876 Salon. His statue of Étienne Marcel can still be seen at the Paris City Hall, and his monument to Waldeck-Rousseau is in the gardens of the Tuileries. Arrayed in front of the bust of the former prime minister, there are two naked workers and a woman with a crown of laurel beneath a Corinthian arch. Marqueste also carved a naked woman in high relief for Falguière's tomb.

The graveyards were actually populated by an astounding number of naked bodies. We are offered the show of a continous graveyard striptease with which the sculptors tempt us into these quiet places; their influence has transformed them into a land where men die and women take their clothes off. It is sometimes very helpful in cases like this when the inscription of a large bronze group prevents any misinterpretation: *Conscience Overcomes Vice and Injustice,* where oddly enough conscience is represented by a naked woman, vice by a naked man, and injustice once again by a naked woman.

Naked femininity also finds a place over the graves of the sculptor James Pradier and the painter Charles Chaplin. For an artist such academic freedom of association might seem justified, but one can hardly say the same for the finance minister of the Third Republic Auguste Burdeau; Alfred Boucher (1850–1934) produced a beautiful young naked woman obviously still lost in the dreams of her last sleep to decorate his tomb.

In the realm of graveyard sculpture French artists were completely under the influence of an anthropomorphic ideology. The aesthetic of the evocation of spirits would transform into physical but timeless figures (resembling the metaphorical figures of a dreamed-up mythology) anything that could in any way place the deceased in a flattering light for the memory of posterity. Their Italian contemporaries approached the design of tombs in quite a different way. Even they did not reject allusions to the dead person's virtues or representations of fate in the classical figure of Time, an old man with wings and a flowing beard, and they also emphasized the religious aspect of their works. But they were affected by the enthusiasm for realism which inspired them to produce great dramatic scenes of grief and family mourning. The grave was transformed into a little marble theater where one of those left behind—or even all of them together, wife, mother, father, children—had to play a role in the portrayal of mourning.

The graveyard of Genoa, the Camposanto of Staglieno, offers a panorama rich in examples of dramatic realism in Italian sculptural art. Many of the statues are not standing in the open but set out in rows in galleries which further accentuates the museumlike character of the display. The figures are mostly life-size. The tombs worthy of our interest date from between 1870 to 1890. There is no nudity here. The men and women grouped before the stele or surrounding the gravestone are dressed elegantly and completely in the fashion of their own times. The details of clothing, the hats, hair styles, embroidery and lace patterns are imitated so faithfully that experts in costume history are able to date accurately each figure from the way it is dressed.

The more or less famous sculptors—Augusto Rivalta, Giovanni Battista Cevasco, G. Scanzi, G. B. Villa, G. Benetti, Fabiani, Navone, Moreno, Saccomanno, Sclavi, and others—were skilled craftsmen and had an outstanding knowledge of how to work marble. But they wanted to make it "speak," rather in the same way as a few years later directors made the first silent films "speak"—with the eyes and the hands. I do not know who Mr. Raggio, who has a monument by Augusto Rivalta (1838–1925), was, but he was certainly very loved. His tombstone shows him lying on his death-bed surrounded by seven people, each stricken by grief in a different way. One woman is bending over the face with closed eyes as though she wanted to catch the last breath of life; another calls on heaven to witness the injustice of fate; a third—she is sitting in a chair decorated with trimmings and fringes, has her hair arranged prettily, tied up stylishly with curls in front of her ears, and is wearing a flounced dress in the fashion of 1875—is trying to drive out the shattering sight with her hands and her eyes as though it were just a horrible dream.

A common theme is the closed gate, the gate to the beyond, to heaven, to paradise. A massively constructed gate and the irrevocably closed door are a powerful expression of the division between the living and the dead. On the *Tombstone of Badaracco* by Cevasco a woman stands dressed in the clothing of 1885 holding a small crown in her hand. She has just knocked on the door with her finger—it is a portrait in the style of sentimental Mannerism, but nevertheless the image of this widow tormented by the longing to be united with the man who has left her forever is very gripping.

To conclude our examination of this specialized art form, which belongs to the burial customs of folklore, we should mention one of its strangest and least-known aspects: this is to be found in the graveyards for dogs. There is one of these in Asnières, near Paris, situated on a little island in the middle of the Seine where the dogs of Sybil Anderson and Sacha Guitry and the cat of Henri Rochefort lie buried—as well as a sheep and even a rabbit, all dearly loved animals as is clearly shown by the monuments dedicated to them and the sorrowful inscriptions in the stone.

On a rock which is supposed to represent the Great St. Bernard Mountain, a sculpture of the St. Bernard dog Barry, rescuer of many straying wanderers in the Alps, lies on his pedestal. A little girl sits astride his back with her arms around his neck, and the inscription reads: "He rescued forty people, the forty-first killed him!" Another monument shows a dog next to the bust of his master, a soldier whose "mascot" he had been in the army; there is a little female dog asleep on a cushion; a large dog sits like a sphinx on a pedestal decorated with mysterious ornaments. Frequently the inscription indicates what emotional intensity the love for animals is capable of: "Dear little Fanot—you were too good and too clever for this life!"

Strolling through towns, parks, and graveyards is most useful for collecting information on the sculpture of an age whose work has mainly survived where it is anchored to the ground by plant growth. But there are others, often no less impressive in size, which were part

Right: *Sorrowful Sleep and Joyful Dream* (detail), marble, Raffaele Monti, 1861, Lv
Page 170: *Reading*, marble, Emile Chatrouse, Pp (above left);
Velleda, marble, Hyppolyte Maindron, 1871, Pl (above right);
Woman Selling Hay, marble, Alfred Boucher, Pp (below left);
Spring, marble, Vincenzo Vela, 1857 (below right)

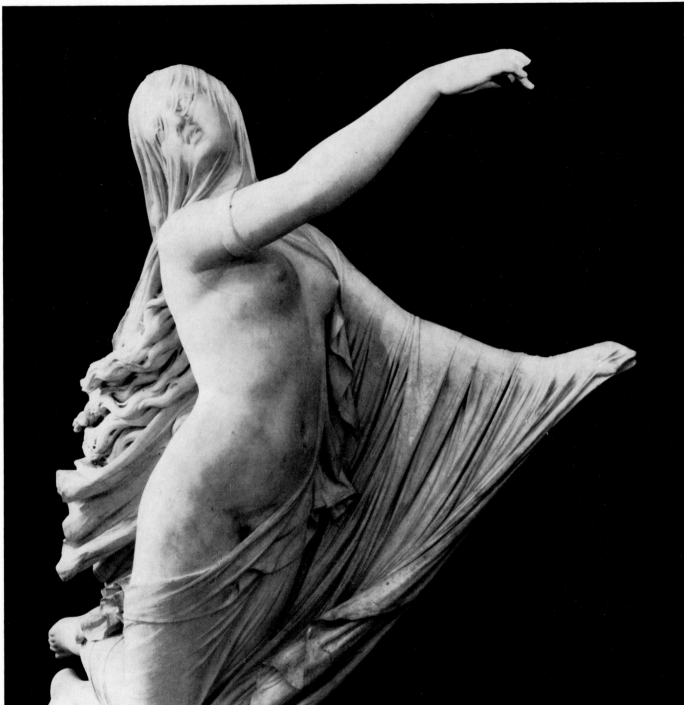

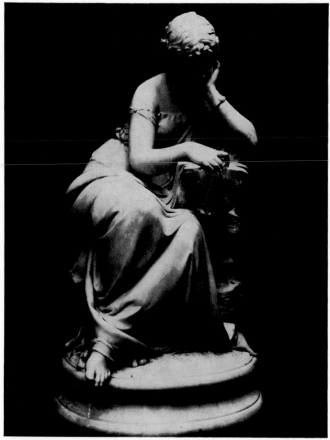

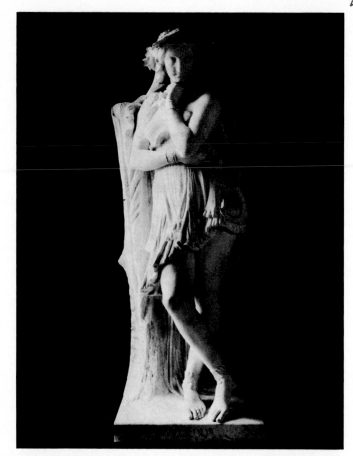

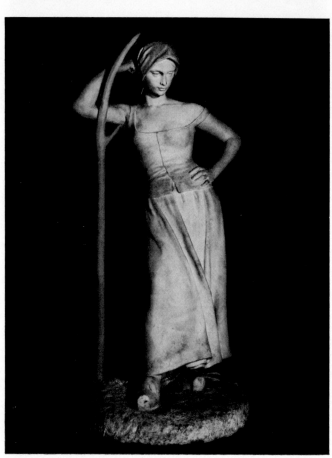

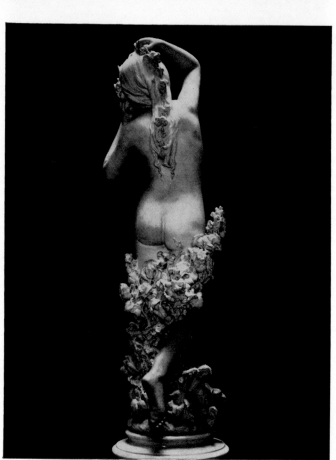

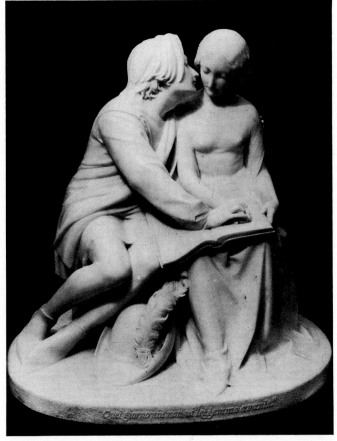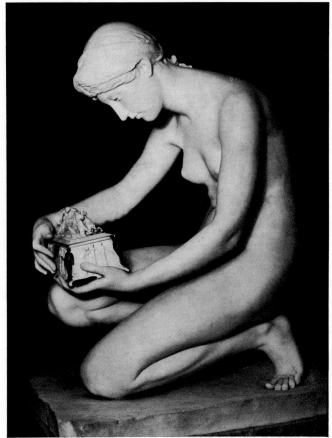

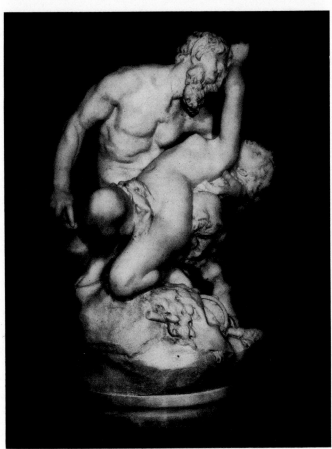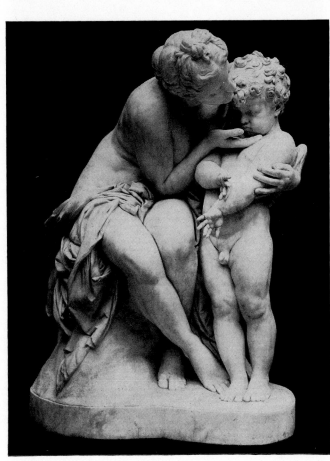

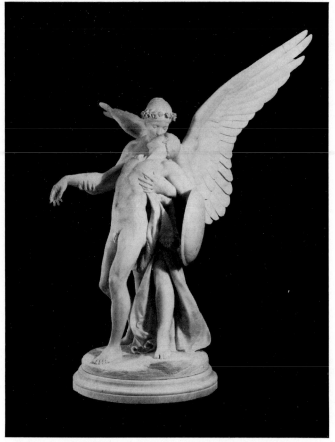
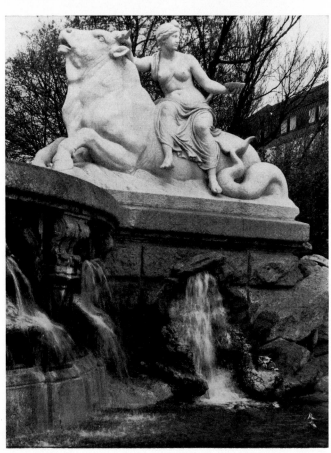
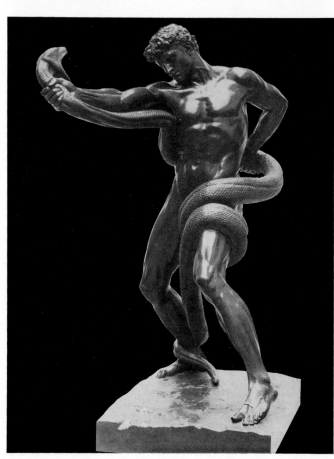

of the great ornamental development in the last part of the previous century. Sculptors were in great demand everywhere—especially those who were distinguished in the salons, of course—for the inner and outer decoration of public buildings, of theaters and town mansions, that form of luxury dwelling by which the wealthy middle class of the city attempted to assert itself against the castles of the nobility.

One should not mount the great stairway of the Paris Opéra without taking a look at the female lamp bearers at the approach which Albert Carrier-Belleuse (1824–87) had cast in bronze. They are typical of his constant striving for elegant and gracious forms. He was the father of Louis Carrier-Belleuse (1848–1913), to whom he taught his aesthetic principles so thoroughly that today there is more than one work which we cannot ascribe with certainty to either the father or the son. The "aesthetic principles" were actually based on business or, in other words, the desire to please the public. His particular preference was for little terracotta figures in the taste of the eighteenth century which earned him the reputation *ad nauseam* of a "second Clodion." His statuettes were especially suitable for mantelpieces and showcases, and it is understandable that he should be the creator of a group *Industry Brings Light and Peace to the World*—the industrialist class of the Second Empire was his best customer.

In 1875 he was made the artistic director of the porcelain factory in Sèvres. Many sculptors have him to thank for the reproduction of the works they exhibited in the Salon as little groups in Sèvres biscuit, such as *Caritas* by Paul Dubois, the *Diana Surprised* by Alfred Boucher, *Heroic Poetry* by Falguière, and *Fortuna* by Moreau-Vauthier. They are all in the collections of the Ceramics Museum at Sèvres, together with works of considerably more individual style designed by Carpeaux

and Dalou. Today it is difficult, if not impossible, to get to see any of them because all these fragile figurines are kept in the store rooms of museums out of the reach of the general public who are apparently no longer to be trusted with them.

Frémiet also produced his table centerpiece *Peacock* for Sèvres—many contemporary sculptors exploited the fact that a table centerpiece could be sold more easily than a statue. Raoul Larche (1860–1912) designed one of these with the *Birth of Venus* in the same somewhat Baroque style as his group of female figures surrounding the pool on the Champs-Élysées in front of the side entrance to the Grand Palais.

Only mediocre as creative artists, these sculptors often produced work which belongs more properly with the lesser forms of decorative art; their virtuoso technique is really comparable with that of chasers and goldsmiths. But they earned no lasting fame with it, any more than did those whose talents were used to provide decorations for the façades of buildings—for reliefs, caryatids, and medallions—or for the beautification of bridges: they remained or became unknown and are often unjustly neglected.

Among Paris's most popular statues is the *Zouave* of the Pont d'Alma who has occupied his place on a pillar between two arches since 1857 and is noticed by everyone whenever he is threatened by the water, which happens every time the Seine rises. But who has any idea that this is a work by Georges Diebolt (1816–1961)! And who could name the fourteen sculptors who worked together on the decorations of the Pont Alexandre III? Czar Nicholas II laid the foundation stone of this monument to Franco-Russian friendship in the Belle Époque together with Félix Faure. Frémiet's *Pegasus* figures in gilded bronze and Morice's little *Water Sprites* have already been mentioned. We should at least mention the

Page 171: *Paolo and Francesca*, marble, Alexander Munro, 1852, Bc (above left);
Pandora, marble, Harry Bates, around 1891, Lt (above right); *Faun and Bacchante*, marble,
Louis Carrier-Belleuse, Pp (below left); *Venus and Cupid*, marble, Reinhold Begas (below right)
Page 172: *The Kiss of Victory*, marble, Sir Alfred Gilbert, 1882 (above left);
Tomb of Carena, marble, G. Scanzi, 1882, Camposanto di Staglieno, Genoa (above right);
Europa, from the Wittelsbach Fountain, limestone, Lukas von Hildebrandt, 1892, Munich (below left);
Athlete Struggling with a Python, bronze, Lord Frederic Leighton, 1877, Ll (below right)

main motifs which make the total effect of this structure so spectacular: the four great stone figures at the foot of the pylons representing France at different stages in her history are by L. Marqueste, G. Michel, A. Lenoir, and Coutan. The *Children's Dance* in green bronze was designed by Henri Gauquié (1858—1927); some other *Water Sprites* bear the signature of A. Massoulle; the stone *Lions* of the left bank are by Dalou, those on the right by Gardet. And the bronze figures fixed on both sides of the drawbridge which hang over the waters of the Seine from the keystone are the *Nymphs of the Seine* on the downstream side and the *Nymphs of the Neva* on the upstream side, the creation of Georges Recipon, who specialized in acrobatic positions. He is also responsible for the great *Quadrigas* at the Grand Palais.

Looking back at these years where there was so much lively activity directed towards the development and "beautification" of cities one certainly has to recognize that it was almost exclusively the Pompous artists who profited from the wave of "beautification." The others, who made a name for themselves in the history of sculpture by the originality and importance of their work, experienced many difficulties in overcoming the hostile attitude of the public. Nevertheless, Carpeaux, Dalou, and Barye did obtain some public commissions, but, through some kind of strange contagion or distress at being misunderstood and rejected, these great sculptors sacrificed a lot of their personality when they carried out these commissions and sometimes did the same even when they were working for the salon, where the direction was set by the Académie des Beaux-Arts.

More than anyone else, Carpeaux could claim the title for one part of his *oeuvre* of the "Clodion of the Second Empire." Above all he wanted the approval of his contemporaries for those of his works showing the bold modeling of surfaces which mark his true and long unrecognized personal style. Finally he was no longer able to resist the temptation to please, and his charming busts and Floras with their somewhat decorative grace do come very close to Pompous art. The same could be said of Dalou, who possessed a thorough understanding of expressing his great sensitivity in plaster of Paris or clay, that is, in the works which stayed in his studios. Yet between the nervous, expressive, and powerful sketches and the execution in stone or marble it seems as though a quite different artist has interceded. But it was precisely in this stage of conventionalized perfection that his works were praised for their "convincing sincerity."

The monument to the automobile pioneer Émile Levassor which Dalou began in 1893 and which was finished by Camille Lefèvre (it stands at the Porte Maillot on the edge of Paris) is a good example of anecdotal sculpture which people claimed to see as the "living expression of the truth" (in the favored phrase of contemporary criticism). The relief, dominated by a winged wheel, shows Levassor hurtling forward in his machine with the gear lever grasped firmly in his hand, as calm and steady as the captain of a storm-tossed ship—though here the only storm is the applause of the crowd waving flowers and hats to cheer him on.

To be fair one should really add that Dalou died before the completion of the monument and that it does not bear his signature. He was also fully capable of producing a statue with a high degree of naturalism and giving it a very interesting turn. The bronze statue which he created in 1890 for the grave of Victor Noir in the Père Lachaise is a good example of this realistic aesthetic which avoids any of the genre's cheap desire to please. The journalist is shown stretched out on the ground, perhaps in the way that he fell when he was killed on January 10, 1870, by the pistol shot of Prince Pierre Bonaparte; his tall hat lies where it has rolled next to him. The work reminds one of Manet's beautiful painting *The Dead Torero*, which hangs in the National Gallery in Washington; the torero lies stretched out in the sand with his hat and his sword beside him.

And now we pass on to Rodin, the most revolutionary sculptor of his time, whose example eventually, albeit belatedly, totally swept away the Academic sculpture he had struggled against with all his creative energy—even Rodin, the great Rodin, had his fleeting but nevertheless perceptible hour of "pomposity." This is understandable when one realizes that in 1864, at the age of twenty-four, compelled by the need to earn his bread, he entered the studio of Carrier-Belleuse and worked for him for six years. No doubt Rodin's personality was too powerful to suffer any lasting harm from this influence, but he was unquestionably so struck by his master's approach that he nevertheless used the "technique of charm" himself, if only for a temporary solution to the problem of survival. In this period he produced some of his busts of patinized plaster of Paris such as the *Young Woman with Flowered Hat*, which can be dated from about 1865 and is a portrait of his mistress Rose Beuret (whom he married fifty-two years later, just before his death). These pieces belong to Rodin's complete work

as a sort of outing along the well-trodden paths of Pompous art.

Pompous art, in spite of its conformism, did develop different forms. All of them, however, without departing far from one another, fell between the Neo-Classical origins of Academicism and a more or less *mannered* Naturalism which actually had very little naturalness about it. Indeed it includes several aesthetic directions blended together which, when dealing with a few typical works, can still be distinguished from one another.

Some of these currents were so constant that they can be found in completely different artists from the middle of the century up to the end. What could, for example, be termed the "cool direction" was characteristic over a long period of that rigid austerity which tried to appear classical and only turned out boring. It is marked in the group *Paolo and Francesca,* produced in 1852 (now in the City Museum of Birmingham), which Alexander Munro (1825–71) made into a pair of awkward and shy lovers. (Quite different is the whirlwind of passion that has seized Paolo and Francesca in the group created by Rodin fifty-three years later.)

Elisabeth Ney also shows *Ludwig II of Bavaria* coolly and conscientiously in his beautiful embroidered cloak, and Caspar Zumbusch does the same thing in *Lohengrin with the Swan* in 1865. There is also no trace of warmth to be found in the *Kiss of Victory* which a winged spirit bestows on an obviously dying warrior. Sir Albert Gilbert, who created this group in 1882, loved winged spirits as did many of his colleagues; the best known of these that sprang from his imagination is the spirit which the English have christened Eros. It hovers high above the *Monument to the Earl of Shaftsbury* set up in 1893 in London's Piccadilly Circus, and it also has a brother, similarly bewinged and no less famous—the spirit of Freedom on the July Column standing in the Place de la Bastille. The artist is hardly known; his name is Augustin Dumont (1801–83).

Lyricism, a belated lingering-on of Romanticism, also had its proponents. In London's Victoria and Albert Museum there is a pure example of this under the title *Anxious Sleep and Joyful Dreams* by an Italian artist, Raffaele Monti (1818–81). Above a figure stretched out on the ground hovers the incarnation of its dream as a sublime being with a veiled face who is about to soar off again. The statue was made for the Duke of Devonshire in 1861. It by no means marks the end of a genre, either, for it continued to find determined supporters for many years.

A third direction can be distinguished by its frivolity. There was mythological frivolity, and there was historical frivolity. In each case it amounted to cautious eroticism disguised as goddesses and heroines. A few examples have already been mentioned; they could be multiplied indefinitely. Each year they became more openly offensive. There were also other subjects. For reasons explained by Freud, there are very definite lascivious ideas associated with the bite of a snake, and hence the death of Cleopatra was a subject taken up by the artists. This might be done in the way Giorgione used the subject—that is, to show a seductive bosom—or the artist might go as far as George Sand's son-in-law Auguste Clésinger (1814–83), who portrayed the beautiful naked body of Madame Sabatier as a *Woman Stung by a Serpent.* This woman, generally known as "la Présidente," was Baudelaire's mistress for a while, and, for similarly short periods, also on friendly terms with other famous men. She inspired Baudelaire to write parts of *Les Fleurs du Mal,* and Théophile Gautier wrote some highly enthusiastic lines on Clésinger's marble creation in the salon of 1847, which today has a place in the Louvre.

The *Velleda* by Hippolyte Maindron (1801–86) can also be seen in the Louvre. This is a perfect incarnation of heroic frivolity. Although she has been given a sickle for identification, one would hardly guess that this mini-skirted figure was the wild druidess and prophetess who was much like a Joan of Arc to the Batavians of Roman times.

Finally, we should mention one more particularly fruitful direction, whose supporters devoted themselves to achieving realism through painstakingly precise craftsmanship. Aside from those already mentioned we could name hundreds of these from all over the world. The main person in the U. S. A. was Saint-Gaudens (1848–1907); some of his pieces from around the year 1880, such as the bronze relief of *Louise Miller Howland at the Piano* (Howland Drake Collection, New York) are closely related to those of the Italian sculptors of the Camposanto of Staglieno. Realism was taken so far that some artists did not even stop short of making castings directly from nature. This was the method used in Barcelona by the Catalan Lorenzo Matamala (1856–1925) to produce the figures which Antonio Gaudi ordered for his extraordinary cathedral *La Sagrada Familia,* which was begun in 1884 and never completed. At the request of the architect, Matamala took castings of living people who were then supposed to figure as Christ, King Solomon, and as saints

and angels. He also produced animals, fruit, and other ornamental elements using this method.

Unbelievable as it may seem, I do not believe that this was an isolated or exceptional case, particularly because critics would repeatedly try to prove that artists had used this technique. As much as forty years earlier Gustave Planche had made the accusation to Clésinger that *Woman Stung by a Serpent* was not an original work but a casting. In the case of Rodin, of course, the charge against him was completely foolish when an attempt was made to discredit him at the 1877 Salon by suggesting that his *Brazen Age* was a casting. It is likely all the same that some sculptors made use of this method (it must have been extremely painful for the model who allowed himself to be used for the procedure). On the one hand it is unlikely that such accusations were made entirely out of the blue, and, on the other, I have discovered two pictures by the painter Edouard Dantan in the catalogues of the salons of 1887 and 1891 entitled *A Casting from Nature* and *Modeling Workshop;* both are pretexts for painting pretty naked girls upon whom preparations are being made for the application of plaster of Paris in the above-mentioned process. Dantan was far too much of a realist himself to have made up the scene shown in a painting.

To conclude this survey of the most important variants of the Pompous style in sculpture we must ask ourselves whether, in the course of those years in which the Pompous style manifested itself parallel to the creations of the great sculptors, we can find any development within the framework of its principles. In fact the definite rejection of any kind of development was one of the principles of this art, and if there should happen to be a change discernible in the *oeuvre* of an artist, it always involves his themes, not his technique. The technique remained the same for all of them. Any sign of an individual element in the completed design was avoided since the intention was to produce systematic and impersonally smooth surfaces. In the eyes of these sculptors the world, if it was to offer aesthetically worthy subject matter, had to be a smooth world.

If one thinks about it, it seems clear that there is without doubt a moral attitude expressed here—a longing for cheerfulness and serenity. A form with a rough surface (such as Rodin's bronzes) contains an element of uncertainty, perhaps even of alarm, which had to be avoided. The Pompous artist was duty-bound to a cheery banality.

It was only after the fundamental abandonment of these arbitrary standards that people understood that art, both painting and sculpture, is first and foremost a means for the artist to express himself and only after that a means of expressing his subject. Yet even today this truth is by no means universally accepted, so Pompous art still has a slight chance of survival.

Toward the end of the nineteenth century sculpture changed largely from Realism to the new baroque forms of Art Nouveau, which brought the various decorative tendencies of the time together in a new movement. This represented the triumph of a style which, with its themes and its feverish use of elements from plant forms in the portrayal of female figures, had to set sculptors free from the long subjection of their art to convention. Many were to discover that their dreams could be realized in a quite natural way and translated into a language which they themselves had never dared use.

Page 177: Lamppost on the Piazza Michelangelo, bronze, Florence (left);
Lamppost on the Alexander III Bridge, Emmanuel Fremiet, 1900, Paris (right)
Page 178: Centerpiece, silver with enamel, opals, and turquoises, St. Schwarz, 1883, Wa (above left);
Ceremonial vase, silver, St. Schwarz, 1889 (gift to the museum from its patron Archduke Rainer), Wa (above right);
Salver, electroplated, design by Alfred Stevens, executed by Bradbury & Sons, Sheffield, 1856, Lv (below)

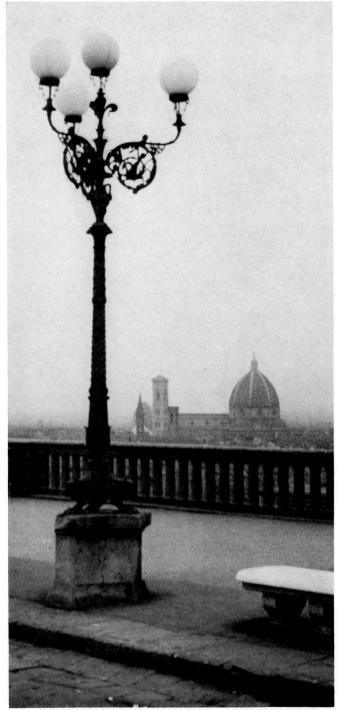
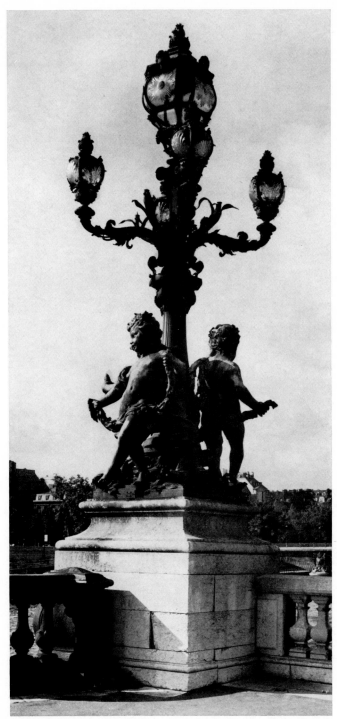

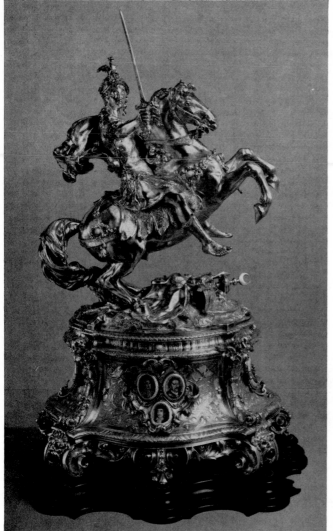

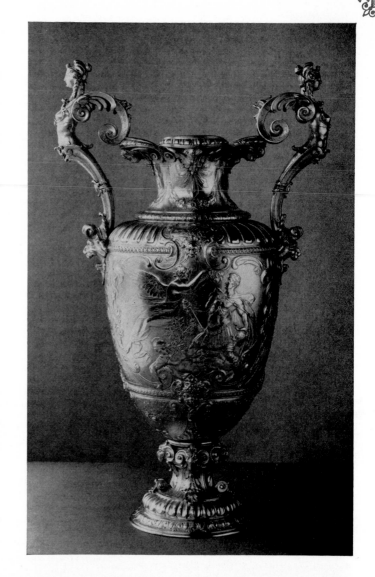

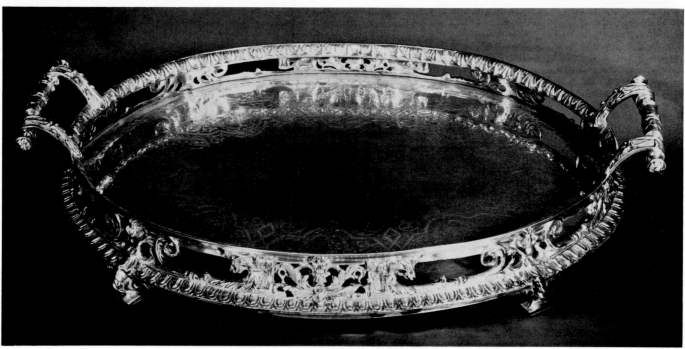

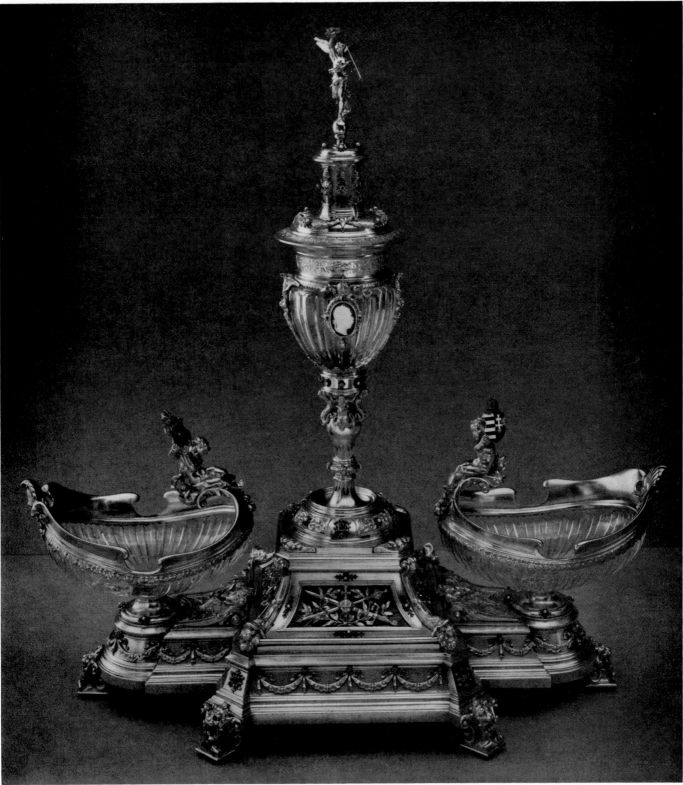

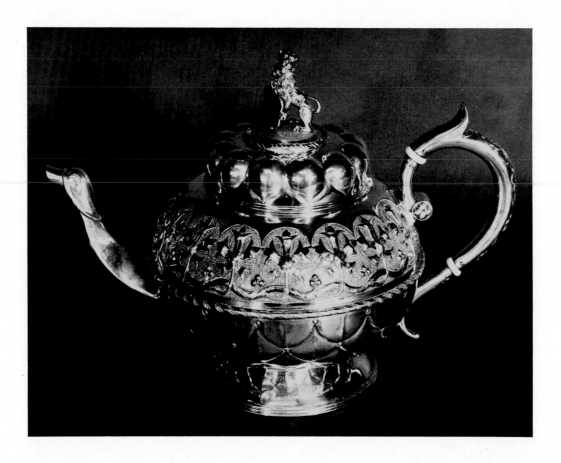

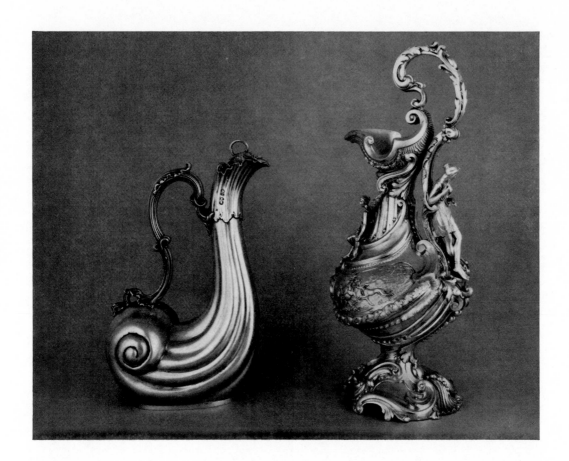

Goldsmith's Work

The extent of the Pompous Age both in terms of time and styles was not uniform in all the countries of Europe, and this is true also in the area of goldsmith's work. The term "Pompous" implies wealth, but, apart from England and—to some degree—France, Europe was poor in the first half of the nineteenth century. In Germany the Empire Period was followed by a Classicism which led without a break to the humble middle-class Biedermeier style. The main features of these periods were modesty and simplicity and finally even a tendency towards sentimentality; vine leaves and roses replaced laurels and meanders. Generally speaking, the only exceptions were a few things made for princely houses where they did not obtain their silver from foreign countries.

In France during the period of the Restoration and particularly under Louis Philippe there was both a return to the classical forms of the eighteenth century and the Rococo, and a certain amount of continued development of the Empire style. For a long time France also retained the first rank in the quality of its craftsmanship, which it had held since the eighteenth century.

Developments in England showed the greatest continuity. Many stylistic elements evolved as early as the Regency Period, between 1811 and 1820, which were still valid in the second half of the nineteenth century. Classicism was replaced by an idealized naturalism, but in addition to the greatest variety of natural forms there was also some use of very much earlier styles. Taste was largely determined by the nobility and upper middle class, with which the royal family also identified itself.

These differing courses of development—shown here from the examples of only three countries—reflect the political and economic conditions, and demonstrate the interrelationship of social structure and artistic forms, the dependence of craftsmen on their clients, and finally the influence of the techniques of production on artistic creativity. The development of these techniques will be dealt with at greater length later.

It is as hard to determine the date of the close of the Pompous Age as it is to find its beginning. Art Nouveau and Jugendstil had by no means been able to achieve complete dominance of the field by the turn of the century. Large sections of the middle class found this modernism obscure, so that naturalistic and historic pomp were "saved" right into the twentieth century. We should also mention at this point, however, that even in goldsmith's work there were movements early in the nineteenth century toward a predominantly functional approach which led directly into our own age.

The fundamental technical changes of the period under discussion did not take place suddenly. An accumulation of large and small inventions and modifications since the eighteenth century led in the end to something completely new; the guild craftsman became—in the ideal case—a manufacturer. It was not primarily the introduction of freedom in the practice of a trade, the dissolution of the guilds, which brought about this result, but rather the continuous changes in the structure of society in whose wake the corporative ties originating in the Middle Ages had to either collapse or go through a complete transformation. There were only a few areas in which the old type of craftsman could survive. Most of those who failed to make the step up to become "manufacturers"

Page 179: Centerpiece, silver, cast, embossed and gilded, with enamel, stones, and pearls, glass dishes, and cup
with portrait medallion of Emperor Franz Josef I to celebrate the fiftieth year of his reign, Vienna, 1897, Wa
Page 180: Teapot, silver, Hardman & Co., Birmingham, 1861, shown at the London World Exhibition of 1862, Lv (above);
Pitcher, gilded silver, Charles Edington, London, 1849, Ls (below left);
Pitcher, silver, gilded, with hunting scenes, standing Diana and Nymph, London, 1855, Ls (below right)

ended up in the class of wage-earners and became workers in someone else's business. The proletariat, which quickly became the largest section of the population in the cities, grew increasingly important as a consumer. Articles of industrial mass production are also part of the Pompous Age. It gave birth to kitsch.

This situation caused one of the conflicts of the age to develop—the desire to make something look more than it actually was. Mechanized techniques of manufacture which made rationalized mass production possible and could imitate hand craftsmanship, the use of substitute alloys in place of silver, and above all the employment of mechanical or electrolytic gold and silver plating came to play an increasingly important role.

Naturally there was still some high-quality craftsmanship as well, but the number of clients for it had declined considerably. With the new processes—particularly the electrolytic—it was possible to produce very convincing work. "Honesty" in the use of materials and the unity and realization of the design have become the criteria for judging them.

It is impossible to describe the style or even just the stylistic concept of the Pompous Age precisely and in a few words. The many-sidedness indicated in what has been said above shows quite plainly that we cannot expect to find a unified, clear-cut line of development.

In Germany, historical thought had already been directed toward the Middle Ages by the year 1800 due to the Romantics. This interest in the past did not reach its full formative influence on domestic styles and craftsmanship until the second half of the century. On the other hand, classical tendencies continued for a long time, even in Germany. Every field of craftsmanship received a powerful stimulus from architecture. Schinkel's generation was succeeded by that of Gottfried Semper, Classicism by Renaissancism—a word from that age!—while Neo-Gothic retained its stylistic influence throughout the century, and Neo-Romanesque tendencies became increasingly important towards its close.

Karl Friedrich Schinkel was not only an architect and a painter. He cooperated on and was the guiding influence over the *Vorbilder für Fabrikanten und Handwerker* (Designs for Industrialists and Craftsmen) which appeared in Berlin from 1830 to 1837. The designs reproduced in this folio are mostly in a classical vein, and some are suitable for execution in different materials. Such collections appeared in all European countries in growing numbers and increasingly splendid form. At the same time they developed from publications of new designs more and more into compendia of highly regarded models for imitation which were gathered together from every age. As well as folios and books there was also a series of periodicals such as the *Collection des meubles et objects de goûts* which appeared in France from 1802. These were widely distributed and contributed to a certain internationalizing of styles.

The word *Fabrikant* (industrialist) which appears in the title of Schinkel's folio suggests that he was aware of the need for him to provide guidance in the face of a new situation. Gottfried Semper tackled this task to a far greater degree from the middle of the century and contributed a great deal to its solution in the terms of that time.

From the middle of the nineteenth century on there were two institutions which determined the course of stylistic developments and strengthened the tendency towards internationalization of styles—the world exhibitions and the museums of industrial arts.

The Great Exhibition of 1851, put on in London's Hyde Park in the Crystal Palace, which was built specially for it, was the first international exhibition. There were precursors in the national industrial exhibitions held in France, first in 1798, then 1801, 1802, 1806, and then anually from 1819, and comparable schemes had been undertaken in England from 1847. Their initiators, the Prince Regent Albert and Henry Cole, were the driving force behind the organization of the Great Exhibition. Although the idea and the preparations for this show were regarded with skepticism by many critics, it turned out to be not only an enormous triumph of the imagination but also a material success. Through the initiative of Prince Albert a part of the profit was used to found a

Right: Monstrances, designed by H. Riewel, Vienna, about 1860

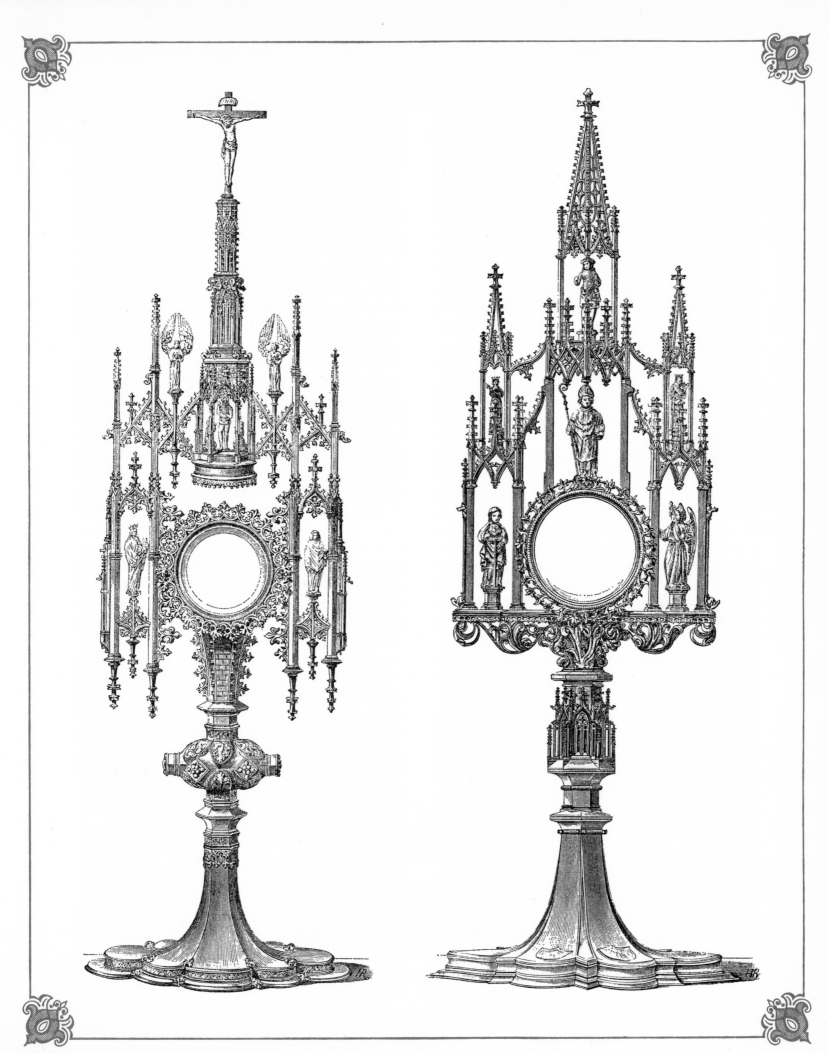

collection called the "Museum of Ornamental Art," which grew into the Victoria and Albert Museum. This institution was opened in 1852. The original collection included many objects which were purchased at the Great Exhibition. The museum was just one part of a center for culture and learning which also offered classes in design in a kind of art school. Among others, Gottfried Semper taught in these. Apart from making purchases for the museum and his activities as a teacher, Semper also contributed to the *First Report of the Department of Practical Art* (1853) and *First Report of the Department of Science and Art* (1854). In a *Bericht über die Waffensammlung in Windsor Castle* (1852) (Report on the Weapon Collection at Windsor Castle) he proposed that the collections should be enriched with colored drawings, plaster casts, and "galvanoplastic reproductions" of the most beautiful pieces, "as is done, for example, in Dresden." In his *Unterrichtsplan für die Abteilung für die Metall- und Möbeltechnik* (Instruction Program for the Department of Metalworking and Furniture-making) greater emphasis is put on the connection with practical work. Workshops and factories were to be visited as well as museums, and the students had to support "the studio's board of directors in their practical work." The tendency of all these efforts was to provide, in a very pragmatic way, designers for developing industry. In this way the separation of design and execution, of inventor and producer, became complete—a tendency which finally, despite all the efforts of Morris and others, led step by step to the situation of the present time.

The founding of the Victoria and Albert Museum was soon followed by the foundation of similar institutions in Vienna, Munich, Berlin, Hamburg, and other cities. In every case they were not intended just as museum collections, but rather as exhibitions of models and examples for the use of designers and manufacturers. Electrotype reproductions played an important part in these collections, as is suggested by the previous quote from Gottfried Semper's writings. Such copies were not only shown in the establishment's own exhibits—they were quite ready to set imitations of famous works from other collections among their own originals—but they also kept a large selection of electrotypes for sale and were aware that these were not primarily bought as works of art but as a stimulus and basis for new creations. Even in the second edition of Julius Lessing's *Gold und Silber*, which appeared in 1907 as one of the handbooks on the royal museums in Berlin, there is a list of the electrotype reproductions included in the appendix. The commentary states that "The reproductions are made with the greatest attention to details mainly by galvanoplastic techniques and finished by hand in the workshops of the court goldsmith D. Vollgold & Sohn and Sy & Wagner, and they may be obtained through the Museum of Arts and Crafts." The selection is divided into two sections. The first covers 27 pieces from the municipal silver treasury of the city of Lüneburg (which was purchased by the State of Prussia in 1871), and the second, under the heading "Pieces of Various Origins," contains copies of seven objects from Kassel, Erfurt, Warburg, Greifswald, Mölln, and Osnabrück. It is interesting that all these objects were available both in silver and copper and the differences in price were amazingly small, though the absolute prices were actually surprisingly high. There were goblets for 3000, 2500, 2000, and 1800 reichsmarks. In terms of today's money it would almost be possible to buy the originals for that amount.

The electrotyping process was not only used for the production of copies, but also for the realization of many elaborate and ambitious original designs. An example of this is the large cup by Paul Christofle and Henri Bouilhet (1881) which will be discussed later in greater detail. In this piece at least the figures and the relief were produced by the electrotyping process. A few des-

Page 185: *Comedy*, terracotta, Tony Noël, about 1900, Pp (above left);
Bust of Mademoiselle Massenet, Alexandre Falguière, plaster of paris, patinated, Pp (above right);
Bust of Madame K., glazed pottery, Jean Carriès, Pp (below left); *Fortune*, bronze, Jules Desbois, Pp (below right)
Page 186: Globe, cast silver, engraved and chased, Wilhelm Widmann, 1885, Sm (left); monstrance, bronze, fire-gilt,
with semiprecious stones and enamel, design by Herdtle, execution by Brix and Anders, Vienna 1893, Wa (right)

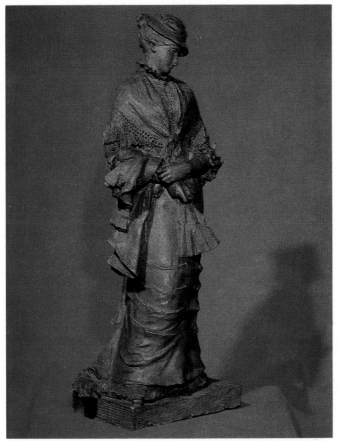
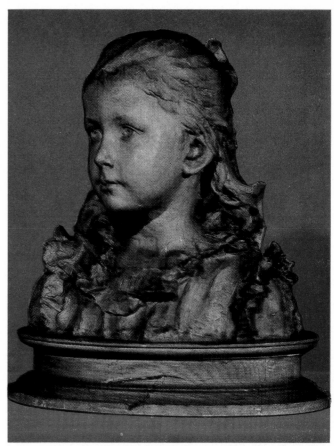
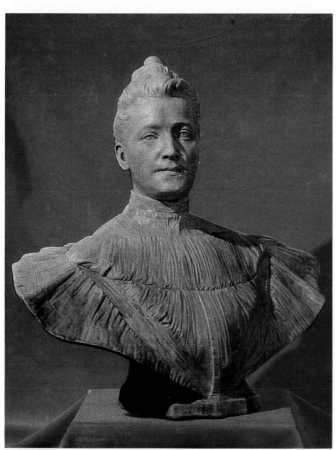
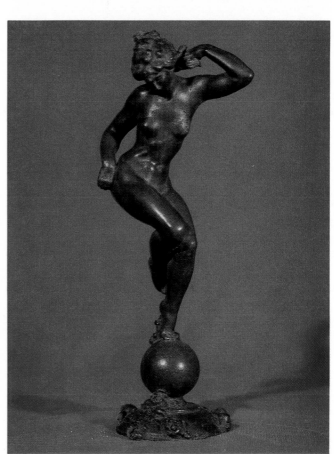

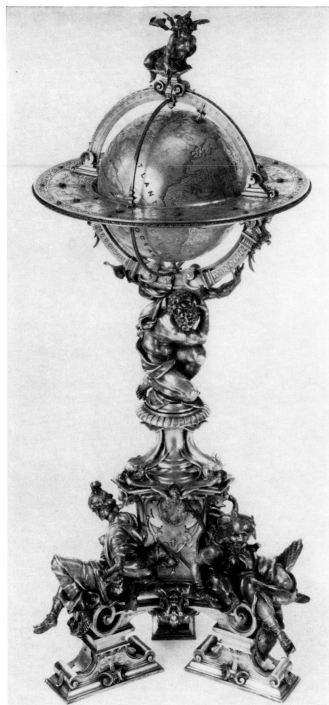
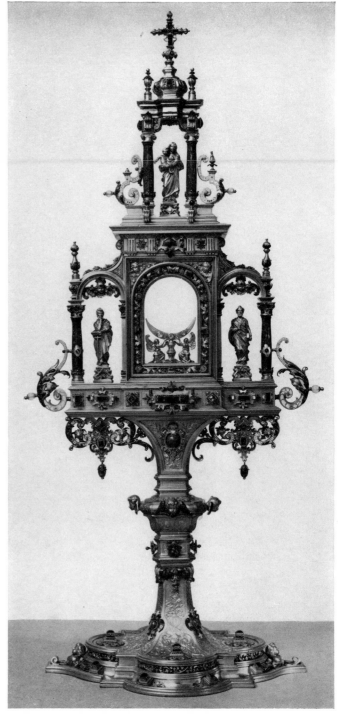

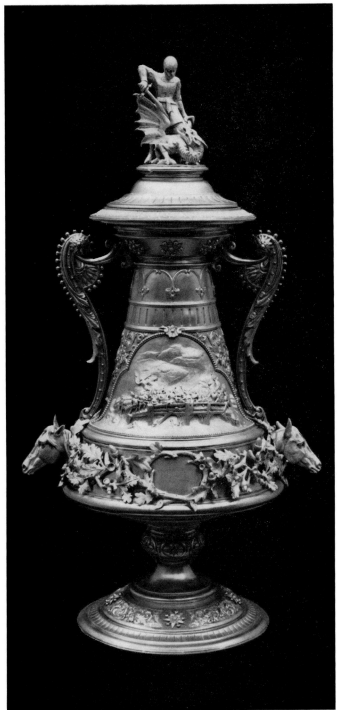
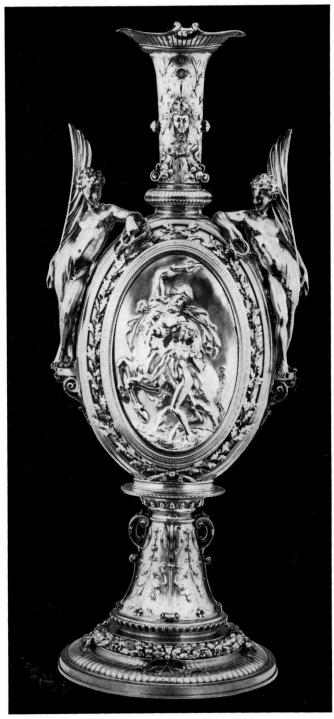

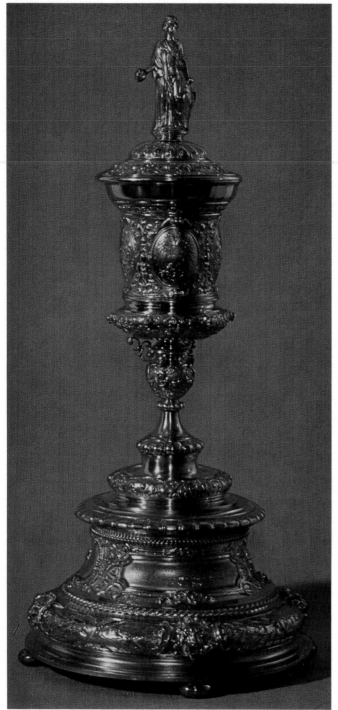
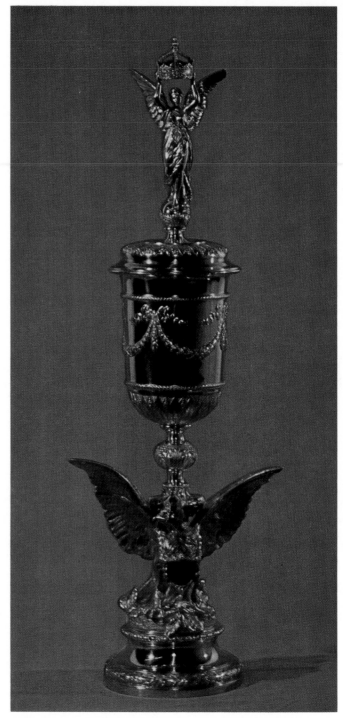

criptions from the catalogue of the London World Exhibition of 1851 will demonstrate how widely this method was used in manufacturing, and not only for reproductions. Concerning the copies of a group of large silver objects it reads: "A group of objects executed in *electrotype* by the firm of Elkington and Mason. Some of the objects which we selected for reproduction on this table are made from original designs and some are copied from antiques. The top of the table, which was made for his Royal Highness Prince Albert, is the galvanoplastic copy of a salver of exquisite workmanship kept in the Musée du Louvre."

The firm of Elkington & Mason mentioned here in the catalogue held a similar position in this specialized field to that which Charles Christofle of Paris occupied on the Continent. In England there was also Bradbury & Sons in Sheffield, which was responsible for the salver illustrated at the bottom of page 178. This was made from a design by Alfred Stevens and was first produced in 1856. In Berlin there were the court goldsmiths Sy & Wagner and Vollgold & Sohn who employed the electrotyping process with perfection for manufacturing, reproducing, and gold and silver plating. Toward the end of the century an industry specializing wholly in reproductions of this kind developed at Hanau. We have already become acquainted with the two Berlin firms as the manufacturers of the copies sold in the Museum of Arts and Crafts in Berlin. The firm of Sy & Wagner grew out of that of Johann George Hosshauer. There is only a small example of this man's work illustrated here, though this represents a self-made memorial to his life. He was born in Berlin in 1794, the son of a nailsmith. He went to the Jewish school, learned Hebrew, and after his confirmation he became an apprentice tinsmith in 1809. He was a soldier from 1813 to 1815, went to Paris, and there became acquainted with new methods of making metal goods. After a brief period of work in

Berlin he went back to Paris to continue his apprenticeship from 1817 to 1819 under the famous goldsmith de Ruolz and in the factory of Tourot. The beaker by Hosshauer illustrated here shows him, in a relief medallion on the side, as a goldsmith at the anvil doing embossed work. The vessels all around him are all formed in the Classical style. The inscriptions are "Souvenir à Paris Études 1817 bis 1819" and on the other side "Dedié comme marque de Reconnaissance Monsieur de Ruolz par George Hosshauer à Berlin." After his return to Berlin Hosshauer founded in 1819 a *"Fabrik für Waren aus Platina, Gold, Silber, Bronze und gold- und silberplattiertem Kupfer nach englischer Art"* (Factory for goods made of platinum, gold, silver, bronze, and gold- and silver-plated copper in the English style). In 1824 he produced goods from a new alloy called alfenide consisting of nickel and copper. He developed processes for stamping objects over a wooden core on a lathe which until then had had to be embossed. Ornamental stripes were made under presses between steel stamps. In 1826 he became royal goldsmith, and his workshop grew into a large concern; in 1844 he was employing 63 people there. Electrical reproductions were made from 1852. Hosshauer was a judge at the Paris World Exhibition of 1855. He died in 1874, a *Geheimer Commissionsrat* and highly respected figure, having transferred his business to Sy & Wagner in 1859. It is no accident that Hosshauer studied in Paris and stated in the description of his firm that he produced goods "in the English style." These countries were able to build up and maintain their leading positions in almost every branch of the industrial arts until after the middle of the nineteenth century.

If one studies the dates when the works illustrated were produced it will be noted that the English and French pieces were generally made earlier than the German and Austrian work. This phenomenon can also be explained by the political and economic conditions. Eng-

Page 187: Winner's cup for horse-racing, silver with cast figurative and ornamental additions, crowned by the figure of St. George, Stephen Smith, London, 1868—69, Lv (left); Vase, silver, electrotyped, made for a commission by Napoléon III by Paul Christofle, Paris, 1855, Ac (right)
Page 188: Cup, silver, gilt, gift from the senate of the Hanseatic City of Lübeck, 1890, Hm (left); Cup, silver, gilt, design by August Schleissner, 1898, Ha (right)

land and France were earlier in developing imperial forms of government in the nineteenth century. The commissions and the example of the courts had an encouraging and fertilizing effect on all the industrial arts.

In England, Prince Albert was not only active in stimulating and organizing others, but also in producing some extremely remarkable designs which occupy an important place among the works of Pompous goldsmithing of the nineteenth century. The Victoria and Albert Museum has on loan from the royal family two table centerpieces which the prince designed himself. In one there is an architectonically constructed base which supports a dish with a lively-shaped foot on a strong, square pedestal. All the parts are richly decorated with ornaments and heraldic devices. On the base around the pedestal there are four perfectly modeled images of four of Queen Victoria's favorite dogs whose names—Islay, Waldmann, Eos, and Cairnack—are also engraved on the base. The silver-gilt centerpiece was executed by the court goldsmiths R. & S. Garrard & Co. in London in 1842 and was exhibited at the Great Exhibition in 1851. The second one has, supported on a naturalistically formed pedestal, a domed Turkish pavilion with a spring inside it. Two Moors, a man and a boy, are watering three noble Arab horses while a dog walks beside them. In this case only the pedestal and parts of the pavilion are gilded. In combination with the white and silver or the animals and parts of the architecture, the gleaming black of the Moors and the glowing colors of the enamel give an added liveliness.

The eight examples of English silverware dating from 1842 to 1864 which follow are indicative of the wide range of stylistic possibilities in an age which is all too often denigrated for being eclectic. A return to the forms of the Renaissance and High Baroque and elements of the Rococo can be seen here and there, but all these elements are blended together into an organic and highly original whole.

The innovations, apart from the naturalistic ornamentation and impulses which also occurred in earlier ages, include elements from non-European cultures, such as in the partly gilt flask (p. 195, above left) with its wide body and slender neck from which a chain hangs down. The decoration of embossed foliage is exquisitely arranged. The teapot from Birmingham made in 1861 (p. 180, above) appears oriental in the overall impression it makes, although the form and all the individual points— the scale, pattern, bulbous shape, twining flowers, and

lion bearing a shield on the lid—are entirely European.

The three pitchers (p. 180, below left and right; p. 195, above right) are an interesting group. The earliest piece, the gilt jug made by Charles Edington in 1849, is reminiscent of a snail whose uplifted neck is ringed with lobed leaf forms. This body harmonizes perfectly with the equally lively appearance of the handle.

In the pitcher made in London in 1855 (p. 180, below right) the design is reminiscent of the still severe forms of the early French Rococo from about 1740, but the frieze of hunting scenes on the sides and the figures of Diana and a nymph, which are both Classical and wholly charming at the same time, have been incorporated into the composition magnificently. The third one, made in London in 1864, can be regarded as a final achievment of the Rococo (p. 195, above right). The *rocailles* are not added-on decorations, but grow out of the form of the body. On the widely flared neck they seem to dissolve into foam.

The cup and silverware (p. 195, below left and right) produced in 1842 at the workshop of Hohn Mortimer & John Samuel Hunt were christening presents. The extremely heavily worked and gilt objects are decorated with animals and putti which carry a deep symbolic meaning: the snake at the foot of the Tree of Life in whose crown there are children representing the innocence and purity of the beginning of life, and a lamb and a lion—gentleness and strength—on top of the lid.

The salver, basically round in shape and with its edge curved in the Baroque manner (p. 211, above), has a mirrorlike polished surface in which a mythological scene showing a triumphant Venus and other gods has been engraved. The style of the scene is reminiscent of Marcantonio Raimondi. The inner surfaces of all the figures and the foreground are gilded. The small medallions on the eight areas along the edge have also been handled with a similar technique. The delicacy of the work is extraordinary. The inner area is only loosely linked with the edge; it is beaten extremely thin and therefore taut, as the goldsmiths say, so that it is elastic and springy in holding its shape. This quality can only be achieved with silver by means of the greatest possible compression, which also causes the mirrorlike shine.

As was mentioned earlier, the developments in France followed the same course as in England. The Louis Philippe Period was marked above all by a return to the Rococo. The stylistic and technical advances were especially dependent on two goldsmiths or goldsmith

firms, François Désiré Froment-Meurice (1802–55) and the Christofle firm. We have shown just a few ornaments by Froment-Meurice, who was the main representative of France in the field of work in precious metal at the 1851 Great Exhibition, and the two works by Paul Christofle, the son of the founder of this firm which is still in existence today. The great differences they show give an indication of the range of possibilities and the quality and the imagination of these goldsmiths. Charles Christofle (1805–63), the founder of the firm, bought the process of electroplating silver and gold from the French chemist Count Ruolz and had it patented for his firm. The method of electrotype molding was developed from the silver-plating process, and was not used for copies only. The Musée Christofle, in St.-Denis near Paris, makes it possible to gain an overall impression of the achievements of this firm. For example, it has copies of every part of the Hildersheim silver find, which, toward the end of the century, were manufactured and sold in large numbers.

The reliefs and the figures, perhaps even all the parts of the large 28-inch-high vase (p. 187, right), were made by the electrotype process. The piece dates from 1855 or 1856 and was commissioned by Napoléon III. The back of its flat oval body bears his coat of arms. The medallion on the front shows Achilles' upbringing by the centaur Chiron modeled by the sculptor Mathurin Moreau after a painting by Jean-Baptiste Regnault (1754–1829) which is in the Louvre. The winged spirits which flank the body of the vase are by Auguste Madroux after the figures of the *Cheminée du Tribunal* in the Caryatid Room of the Louvre. The decorative forms on the neck and pedestal are drawn from the French Renaissance style. The goldsmith's own original contribution is the overall shape; the owner of the vase, court jeweler Roelof Citroen in Amsterdam, very kindly pointed out to me that the front view of the oval body and neck were inspired by a contemporary locomotive. This startling combination of form inspired by the modern technology of the time and figures and decorative elements derived from important works of French art from past ages is typical of many examples from the period of Napoléon III, who was exceptionally interested in technical innovations. The vase, which was shown in the 1867 Paris World Exhibition, is one of the magnificent silver utensils made by Christofle for the Tuileries Palace and is possibly the only one which survived the plunder and burning of the palace at the time of the Paris Commune in 1871.

The cigar tray in the Hamburg Museum für Kunst und Gewerbe (p. 194, below right) is completely different in style. A steep-sided tray with a profiled edge stands on a round plinth borne by four animal heads, and beneath it two lion masks hold ring-shaped handles in their fangs. A low swelling above the restrained foot of the tray is decorated with an openwork twining branch of leaves and flowers. The form of the plinth and the tray is Chinese influenced while the decoration is taken from Japanese motifs. The piece is made of bronze, the animals and the ornamentation are in gold of various colors which has been "encrusted" by the electrical process. Christofle showed objects of this kind at the Vienna World Exhibition of 1873; the work shown here as well as a bowl made by the same technique in the Austrian Museum für angewandte Kunst both come from that exhibition. The Japanese fashion was at its height in Paris at that time.

The seven pieces of goldsmith's work by which Austria's contribution to the art in precious metal of the Pompous Age is represented were all made between 1883 and 1897. These late dates—particularly by comparison with the English and French examples—are not the result of chance, but reflect the fact that in Austria the development did not reach its peak until this time.

The Austrian Museum für angewandte Kunst was set up in 1864 after the first enthusiasm for it had developed in conversations at the 1862 World Exhibition in London. Rudolf von Eitelberger, who later became the first director, was requested in July 1862, to "study the question of the foundation of a museum as an educational institution for industry, artists, and the public." The seven works shown here are not only part of the museum's collection, but can also be considered the fruits of its effectiveness. Parallel to the museum—as in London ten years before—there developed a school of the industrial arts. Many utensils and ornaments were executed, primarily from designs by Hofrat Josef Storck, the first director, and many of them have survived. This includes the magnificent great dish (p. 210, above), dating from the year 1880. The medallions in High Baroque style on the bottom and the broad rim of the dish are carved from ivory, mother-of-pearl, and coral; two workshops were employed on the project. The large central medallion is an allegorical image of the Danube with the heads on the rim representing the countries along that river.

The Renaissance, Baroque, and Rococo were godparents to the other magnificent pieces. Even the monstrance of fire-gilt bronze (p. 186, right) with enameled

pictures and precious stone trimmings follows models from the Late Renaissance and the period of Mannerism, while the chalice (p. 194, right) shows connections with the Italian Gothic in its basic shape, although the embossed and filigree work ornamentation actually consists of a strange mixture of oriental and classical elements.

Six examples of German goldsmith's work complete the selection. These pieces are also relatively late—from between 1885 and 1901. The first ones are some very representative works which served simply as showpieces, gifts from cities or groups.

During the *Gründerzeit* many cities whose municipal silver treasuries had been broken up and lost in the late eighteenth and early nineteenth centuries—or even during the Thirty Years War—began to acquire new municipal silver. The favored styles were Gothic and Renaissance. Frequently there was conscious use of quasi-allegorical figures to portray the occupations and history of the community. The men shown in "old German" costume wearing beards in the fashion of Kaiser Wilhelm II make rather a strange impression. A beautiful example of a new treasure of this kind is the Dortmund municipal silver of 1899, which was published in 1969. To give symbolic emphasis to the trades portrayed by figures, natural materials, such as coal, were also used. Dwarfs working in a cave of onyx represent different industries. The craftsmanship is uniformly of the highest quality and employs virtually every technique available to the goldsmith of the time. There is considerable use of precious stones and enamel painting.

In the year 1885 in Schwäbisch Gmünd, which during the nineteenth century had developed along with Pforzheim and Hanau into one of the most important centers for the manufacture of silver goods, a large globe (p. 186, left) was made as a present for a geographer. Its creator, Wilhelm Widemann (1856–1915), was known not only as a goldsmith and metalworker, but for years

had also executed compositions in the area of full-scale sculpture, including work for the Reichstag Building in Berlin, the cathedral there, and the city hall of Kassel. Widemann had lived in Italy for seven years, where no doubt Michelangelo's sculpture had left a deep impression on him. Three bases support the three-sided pedestal around which three female figures are arranged, and three dolphins lift up their tails to a round plinth where the figure of Atlas, crushed down by the weight, is holding a ring of metal in which the globe is set. On the horizontal ring running round it, the signs of the zodiac are engraved. It is topped with a winged putto holding a pair of calipers. All the parts are painstakingly cast, carved, and engraved.

A large table centerpiece and cup (p. 188, left) in the Hamburg Museum für Kunst und Gewerbe was—as the inscription on the pedestal states—given to the "Geh. Ober-Finanz-Rath Krieger on May 19, 1890, by the Senate of the Hanseatic City of Lübeck." The cup itself consists of modified Renaissance forms while the freer design of the pedestal, an addition invented by the nineteenth century, is full, rounded, and richly profiled. This reintroduction of the cup or goblet was characteristic of the Pompous Age. Aside from the area of guild paraphernalia, cups of this kind had practically disappeared from the repertoire of German goldsmiths since the early eighteenth century. The Lübeck centerpiece is completely gilded except for a few places on the base. It is crowned by a goddess of the city with a wreath and the Lübeck coat of arms who forms the handle of the lid.

The centerpiece made by the Munich goldsmith Weishaupt in 1890 (p. 202, above left) shows Late Gothic forms in every part—from the profiling on the smooth edge of the foot, the spiral keeled bosses on the pedestal, the broad spreading flat dish, and the slender stem rising up to the figure of St. George killing the dragon. If the settings of the semiprecious stones on the heavy ring ar-

Right: Queen Victoria of England and Prince Albert, miniature paintings, frame of foliage, gold, embossed, about 1850, Fa
Page 194: Beaker, vermeil, embossed, Johann George Hossauer, 1849, Bb (above left); Chalice, silver, cast, embossed, chased and gilded, with enamel, almandines, and turquoises, Wa (above right); Tea strainer, silver, partly gilt, with embossed foliage and mother-of-pearl handle, Schleswig-Holstein, 1853, Mh (below left); Cigar tray, bronze with gold, Christofle, Paris, about 1872, Hm (below right)

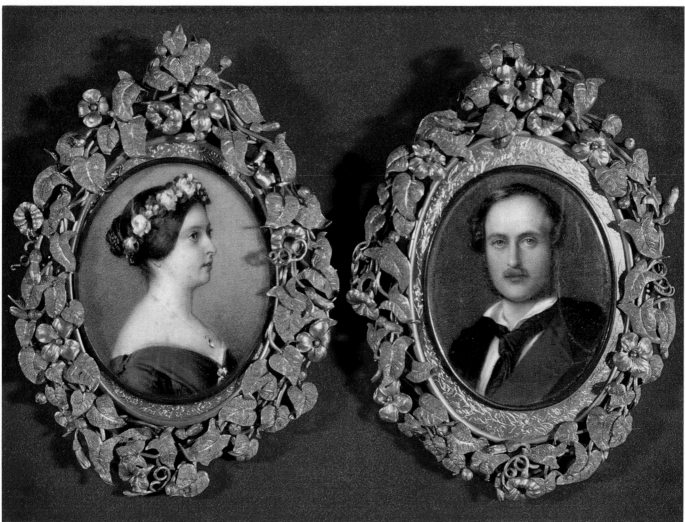

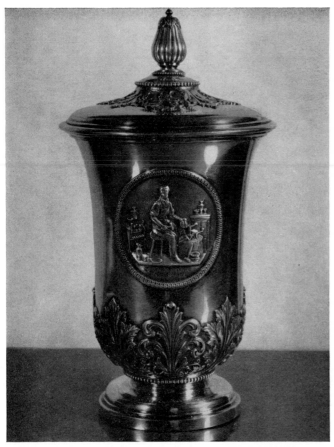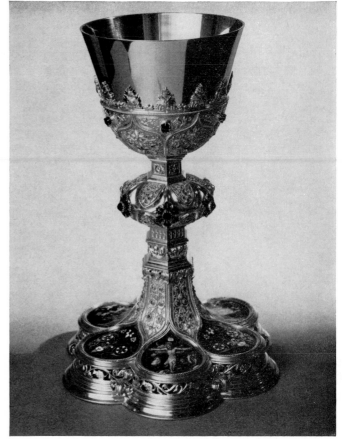

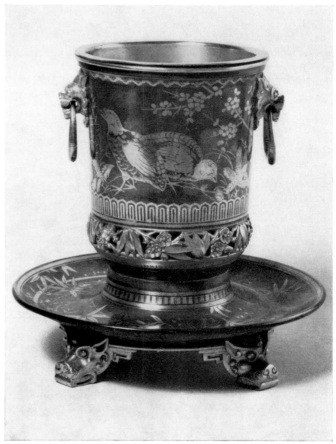

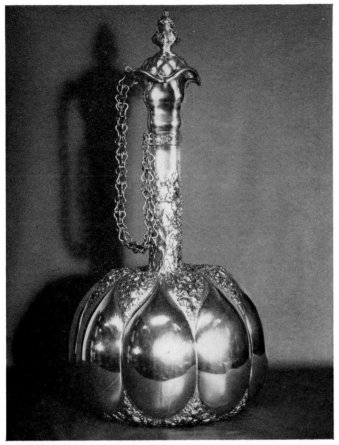

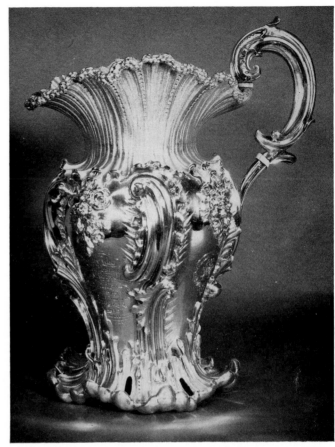

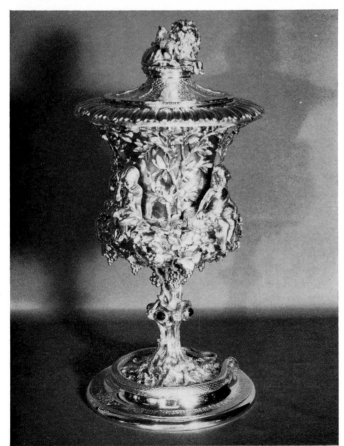

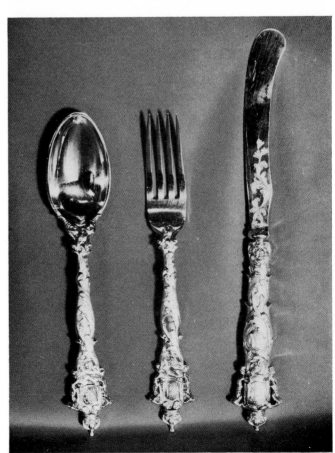

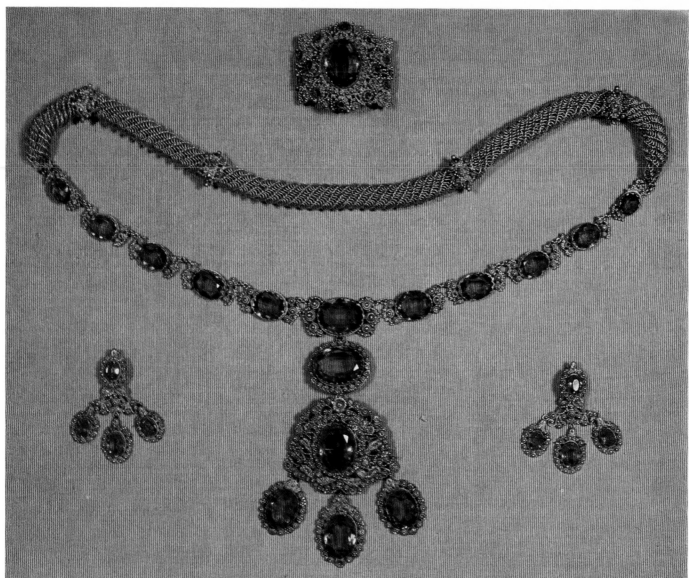

ranged between the dish and the stem to carry it by were not so completely different in style, it would take a second look before one realized that this was not an original from around the year 1500. Every part of this showpiece including the dragon is gilded.

The vase-shaped cup with a lid decorated with Brandenburg-Prussian gold and silver coins (p. 202, above right) was made at about the same time in the Berlin workshop of J. H. Werner. The round foot, the restrained stem, and the lower part of the powerfully modeled body rising out of it, which has low-set inward-curving handles, carry ornaments from the period around 1700, but some characteristics are reminiscent of the Louis XIV period. Above the rounded lower part, the sides of the cup are divided by vertical chamfers into twelve flat surfaces on each of which, underpinned by a garland, there is a coin. Set into the slightly convex surface of the lid around a large knob which bears a free miniature copy of the German imperial crown there are ten more coins. It is very indicative of the outlook of the age that the coins were not solidly brazed on, as had been done in earlier coin bowls, tankards, and cups, but were fixed so that they could be removed without damaging them. This was the reason why the sides were faceted and the lid made so slightly convex. The coins did not have to be bent to fit on to a curved surface. This concern for the coins as collectors' pieces is a reflection of the changed idea of history as compared to that of the seventeenth and eighteenth centuries.

The great gilt cup in the Altonaer Museum in Hamburg, which formerly belonged to the municipal silver collection of the town of Altona, was made to a design by the "silversmith, enchaser, and genre-painter"—as it says in Thieme-Becker's dictionary of artists—August Schleissner (1820–91). The foot, cup, and lid are simple and harmonious in form, the decoration is restrained, consisting of garlands in lively loops and wreaths in Classical style which are reminiscent of the ornamental forms of the late Louis XIV period. These, however, although essentially the most important parts of the cup, are in this case overshadowed by parts which are in themselves secondary—the stem in the form of a naturalistically modeled eagle on a pedestal overgrown with oak leaves and the beautiful winged female spirit who crowns the lid. The eagle, which supports the cup, is crowned as the heraldic animal of Prussia. Standing in front of it is a shield with the Prussian black eagle and the initials "FR" for Frederick I of Prussia, who was crowned king in 1701. The female spirit on the lid holds the crown of the new German Empire in her upraised hands. The cap of each crown—that of the eagle and that of the spirit—is covered with translucent red enamel. The cup was made in 1898 on the occasion of the unveiling of a monument to the Emperor Wilhelm I (p. 188, right).

In spite of many attempts at the introduction of independent formal innovations, the main tendency of the Pompous Age was always to borrow from the styles of past ages. Even though such sources of ideas were sometimes handled in so outstanding a manner that the results are equal to an original invention, totally new styles whose origins go back deep into the nineteenth century did finally establish themselves. Art Nouveau marked an important turning point, and yet even so, particularly in industrially produced household articles, traces of nineteenth century eclecticism have survived right up to our own times.

We have taken a coffee service (p. 203, below) made in Wiesbaden in 1898 as an example from the transition period. The edge of the oval tray, the handles, spouts, and the edges of the feet of the vessels show an influence from the Rococo, though just as a distant memory; the

Page 195: Bottle, silver, partly gilt, design by C. T. and G. Fox for Lambert Rawlings, London,
made for the London World Exhibition of 1851, Lv (above left); Silver pitcher, London, 1864, permanent loan from
Lord Dunboyne, Lv (above right); Cup (christening gift which also included the silverware next to it on the right),
silver, gilt, John Mortimer & John Samuel Hunt, London, 1842, Lv (below left); Silverware (belonging with the cup on the
left next to it), silver, gilt, John Mortimer & John Samuel Hunt, London, 1842, Lv (below right)
Left: Brooch, necklace, and earrings, gold with rubies, Lv

dominating elements are the poppy flowers and buds. These are not overdone on the sides, however, but arranged in a carefully balanced way to accord with the effect of the smooth surface. What at first glance appear to be *rocailles* on the handles and spouts are in fact leaf patterns. The flowers, stems, and leaves on the shoulders are arranged in a manner which is reminiscent of the faiences of the eighteenth century. This service, in which elements of the eighteenth century, the Pompous Age, and Art Nouveau are so harmoniously combined, concludes the selection of silver utensils.

Just as the individually operating craftsman had been forced by the silver goods industry to account for a tiny and dwindling proportion of the total production of silver utensils towards the end of the nineteenth century, so it went also with jewelry. The term jewelry industry is constantly met with at the end of this period. The independent goldsmith generally became the seller of articles which were mechanically made or even produced by machinery in large concerns and factories. Paste, plated metal, and surrogate materials dominated the market. Since the Biedermeier Period extraordinarily thin gold plate had been pressed out and backed with mastic to make it more durable. The production of valuable jewelry for the most fastidious tastes was concentrated in a few areas and workshops. France and Austria occupy the first rank, but England was also responsible for some important achievements. The names of the Parisian jewelers Froment-Meurice and Boucheron head the list, while in Austria noteworthy articles and sets of jewelry were made from designs by Josef Storck.

Two main approaches can be discerned. In some jewelry the carefully ground precious stone is what primarily makes the impact, and the setting, beautifully worked though it may be, plays only a subsidiary role, while in others figurative designs cut in stone or painted in enamel predominate in determining the total effect. Frequently complete sets would be made according to a single design; necklaces, earrings, brooches, and bracelets would all be made to harmonize together. This field was, like the silverwork of the time, dominated by stylistic pluralism. There were adaptations of every style, ranging from imitations of Ancient Egyptian and Roman jewelry through Renaissance, Baroque, and Rococo. For stone-cutting, apart from semiprecious stones, they made particular use of coral, lava, and colored sea shells. In Italy, the mastery practiced in this area since the Renaissance was revived.

Particular color combinations were especially favored. Amethysts, for example, were very important and were often used together with turquoise; rubies, emeralds, and sapphires appeared in combination with diamonds. Opals were also very popular, and new mines in Australia and South America were exploited. Predominant among this type of jewelry are those designs which can be called timeless and may be fitted into a continuous tradition which begins in the eighteenth century and lives on today.

Enamelwork underwent a new flowering, and not only in the enamel-painting of figurative designs on Historicist jewelry; it is frequently found on the settings of colored stones as well. A particularly charming example of this is provided by the set consisting of a chain and earrings (p. 218, below right). The amethysts are ground spherically to the shape of grapes and completed with green enameled gold leaves.

There are two types of jewelry in England for which there are virtually no equivalents on the Continent. In so-called mourning jewelry the colors black and white predominate. Contrast is supplied by severe ornamentation in black enamel fused into gold, and small oriental pearls joined with threads and set in gold or hanging down like tassels (p. 218, above right). The initials of the deceased engraved, set in small diamonds or in pearls are also an important element. The second type is influenced by oriental, and in particular Indian, jewelry. This is a reflection of the important part played by the overseas areas of the British Empire, especially India, in the nine-

The page on the right shows contemporary illustrations of exhibits at the London World Exhibition of 1851:
Gold and silver utensils, Ignaz Sazikoff, Russia (above left); Tea service, gold, Ball Tomkins & Co., U.S.A. (above right);
Church plate, sacred vessels, etc., design by Pugin, execution by Hardman & Co., Birmingham (below)

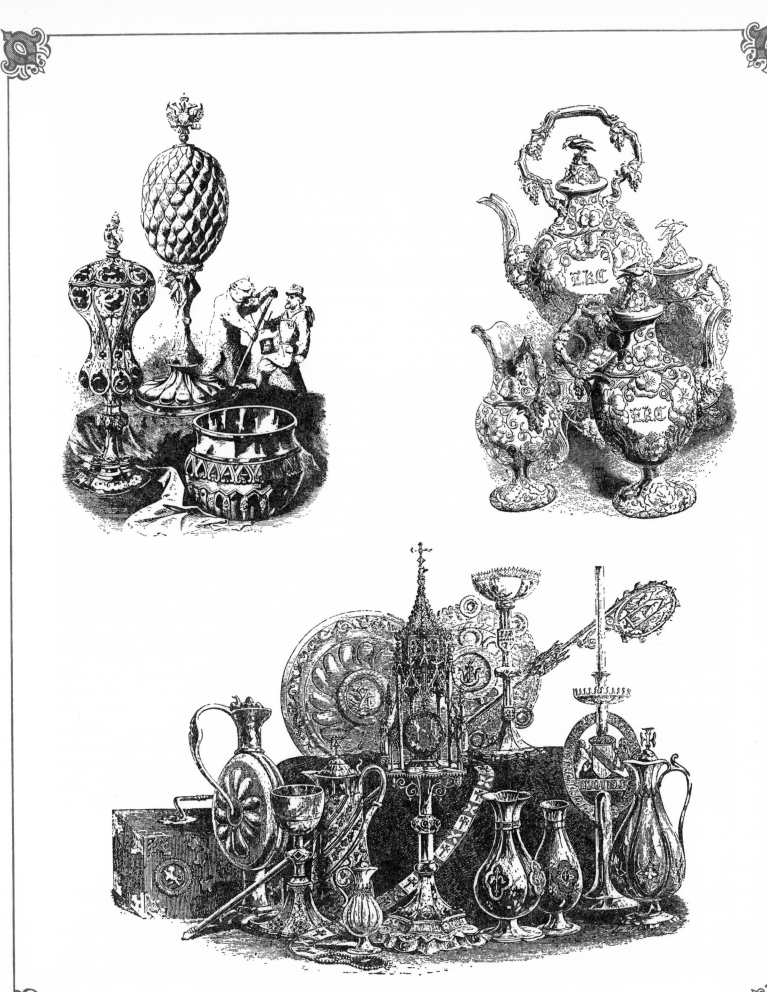

teenth century. Sets of jewelry consisting of diamonds and cut rubies, often held together with a delicate gold filigree mounting, came from India and influenced European goldsmiths. This type also includes the particularly unusual jewelry made from tiger claws, which is the finest among those kinds of jewelry made from hunting trophies. Magnificent pieces similar to those made in the Anglo-Indian world from tiger claws were produced from stag's teeth. The German Hunting Museum has an opulent necklace which was made for the last Empress of Germany using a number of gold stag's teeth with emeralds, diamonds, and enamel.

Single stag's teeth and also single tiger or lion claws are still worn by women today, but in those opulent sets of the end of the nineteenth century there was manifested a feeling for jewelry which disappeared with the Pompous Age.

Right: Majolica pitcher with stand, shown at the London World Exhibition of 1862, Minton, Stoke-on-Trent, Lv
Page 202: Centerpiece, silver, white dragon, everything else gilt, Weishaupt, Munich, about 1890, Hm (above left);
Cup with lid, with Brandenburg-Prussian gold and silver coins, cast, embossed, chased, J. H. Werner,
Berlin, about 1890 (above right);
Dessert service with changeable dishes, silver, partly gilt, with enamel and semiprecious stones,
design by William Burges, execution by Barkentin and Krall, 1880—81, London, Lv (below)

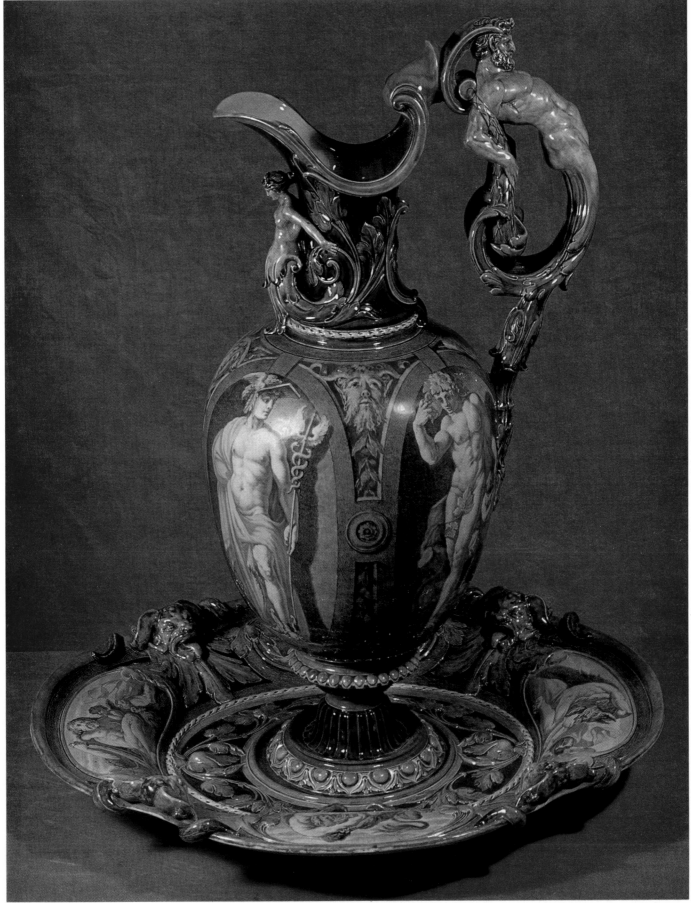

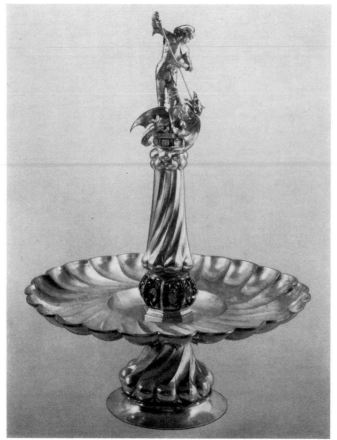
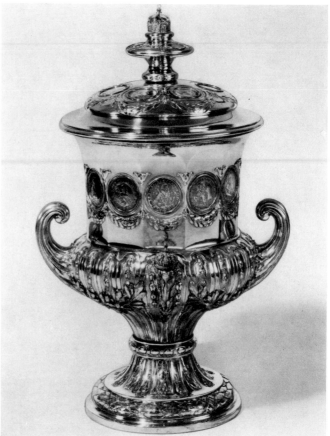
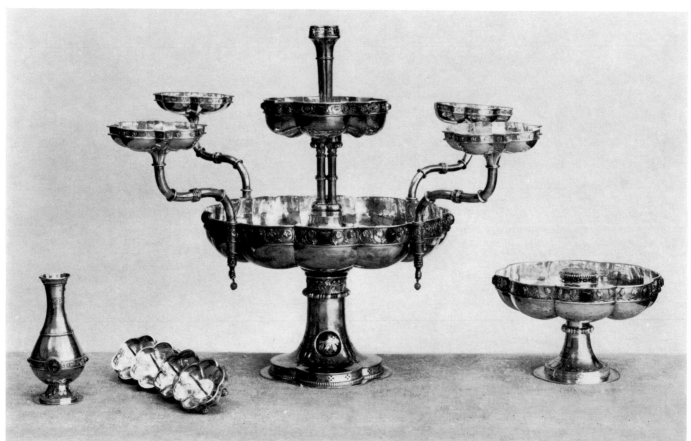

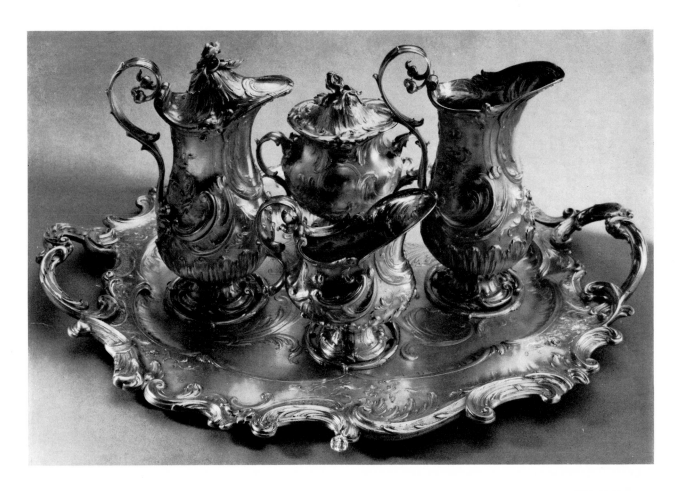
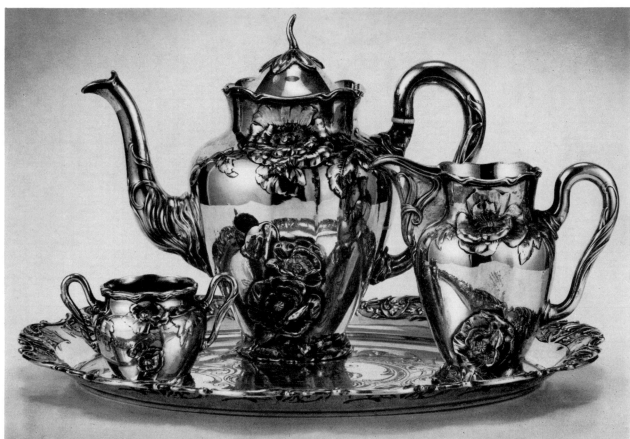

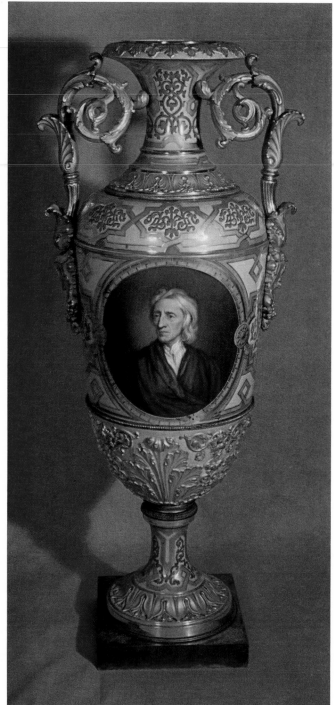
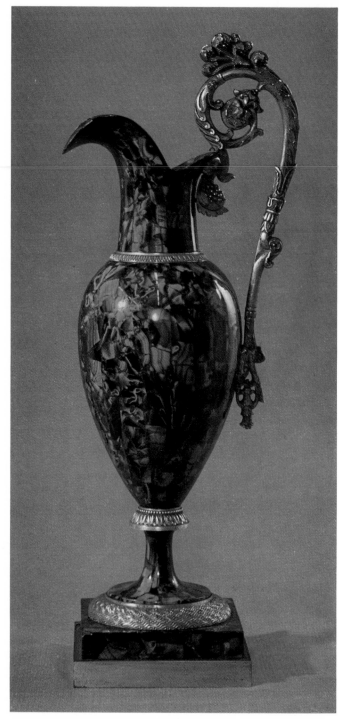

Ceramics

In assessing the ceramics of the later nineteenth century the main problem is to take proper account of a stylistic dichotomy which appeared at that time, and which in some sense continues even to today. Among the products of earlier periods we can often distinguish between different levels or qualities of taste; but only in the products of the second half of the nineteenth century are we made aware for the first time of wares made to suit an intellectual taste which does not belong specifically to the rich or the poor, to the educated or the uneducated. The success of the intellectual approach to ceramics has been ultimately so great that its manifestations have obscured the products intended for the majority taste of the time. The ideas of the intellectuals in the late nineteenth century formed the basis of the modern movement and very naturally attract our attention today, but it is necessary to realize that their works in ceramics, as in other media, are a minority expression and that the true spirit of the time is likely to be expressed in work made for those who were less conscious of their artistic motives.

In view of the intellectual reaction, which has so deeply colored our modern attitudes, it is important that we should examine in detail the characteristics of nineteenth-century ceramics which were, and are, considered unsatisfactory. The present difficulty in appreciating these characteristics is clearly revealed in the sequence of fashionable attention given to the styles of the recent past. In the third quarter of the twentieth century fashionable regard has moved in one leap from the Biedermeier or Early Victorian of the 1840s to the Art Nouveau of the end of the century, and thence to the 1920s and 1930s. Few have attempted to fill the intervening gap by assessing the general taste of the latter part of the nineteenth century. Much of the art admired by contemporaries at that time has been left behind in an almost unexplored backwater of taste.

The outlook of the period produced a style of artwork in which a superficial regard was paid to a variety of historic and exotic influences. This Eclectic art was inevitably complicated and rich in its effect. It was produced for the generality of the population, but it appears in its most complete and significant form in the objects made for the more opulent section. The adjective "Pompous" fits it well, for this was a style of artistic endeavor which accorded perfectly with the outlook of the industrially successful, with the new-rich of the later nineteenth century. Although its lesser manifestations were subscribed to by the great mass of the European and American populations, its extravagances were ideally suited to the expression of personal aggrandizement and self-confidence. Such work can best be described as "eclectic" or "pastiche," with the added implication that the stylistic borrowing is superficial and does not represent any deep understanding of the sources of inspiration.

It is symptomatic of our present lack of sympathy for this art that it is difficult to describe it in terms which do not appear derogatory. We are in effect describing the extreme form of an art against which our generation and its predecessors have reacted sharply. Yet we need have no doubt of its ultimate validity as an art form, expressive of its period and its context, and sufficiently capable of providing the means for the production of an occasional object of great beauty. In considering the Eclectic ceramics in particular, it is useless to look for the qualities which the later twentieth century is accustomed

Page 203: Coffee service, silver, cast, embossed, and chased, Hirsch and Smejda, Vienna, 1892, Wa (above);
Coffee service, silver, cast and embossed, Wiesbaden, 1898, Mh (below)
Page 204: Vase, porcelain, decorative painting with a portrait of John Locke, Imperial Porcelain Factory of
St. Petersburg, shown at the London World Exhibition of 1862, Lv (left);
Decorative piece in the form of a vase, malachite with gilded bronze mounting, Russia, about 1850, Hm (right)

to look for in a work of decorative art—an emphasis on form, simplicity, suitability for purpose—for these are precisely the qualities which almost by definition are lacking in any example of nineteenth-century Eclectic art. Rather we must look for imaginative qualities, complete technical control, richness of texture, and an admixture of motifs used with calculated and often charming effect. The modern style of eclecticism known as "pop art" gives an insight into the standard of evaluation to be adopted toward the Eclectic work of the nineteenth century. In the case of "pop" ceramics, as in the nineteenth-century work, an apparently capricious selection of motifs and styles, garnered from many distinct sources, is recognized as a valid medium in itself, to be used without any great regard for the proprieties of ceramic art.

The Eclectic art was near the end of a line which began with the industrial revolution. Modern industrial ceramics first appeared in England in the factories of Josiah Wedgwood and his contemporaries, and it is not surprising therefore that England was foremost in formulating the reaction through the Arts and Crafts movement, although strong signs of it had already appeared elsewhere, notably in the ceramics of France. The basic problem posed by the reaction concerned the subdivision of labor. In earlier times potters had worked by themselves or in small groups. Individual operatives had been largely responsible for individual pots. With the advent of quantity production, however, and the accompanying subdivision of labor, the individual operative played very little part in the final determination of the product, and the small part that he did play became excessively repetitive. Ill-informed design often took the place of an instinctive regard for the possibilities of the medium.

Besides divorcing the operative from the object made, the Industrial Revolution led to an embarrassing surfeit of technical knowledge. The use of industrial methods brought inevitably a rapid extension of deliberate experimentation. Relatively large potteries were in commercial competition with each other and improvements in materials and techniques were at a premium. The details of the many improvements are complicated and difficult to unravel, but their cumulative effect was to give to the nineteenth-century potters a peculiarly modern sense of confidence and superiority over their predecessors. They felt that they could do anything that had been done before, that they could in effect reproduce any technique which had been used in the past and, if necessary, improve on it.

With the technical means of reproducing the art of the past came a rapidly expanding interest in art history. By the middle of the nineteenth century the decorative arts of the past were being discussed increasingly not only in books but also in the periodicals of the day. Above all, this was the age which saw the foundation of museums of "industrial art" and of art schools in many of the great cities of Europe. A tendency toward Eclecticism thus came normally with the circumstances of the period. To us today, schooled in the reaction against "insincerity" in art, any sort of imitation seems automatically wrong. But in the middle of the nineteenth century this was not at all the case. Rising on the tide of technological efficiency, the direct use of admired ideas from the past seemed entirely commendable.

Used outside their original context, however, the borrowed ideas inevitably acquired a distinctively nineteenth-century character. Part of the validity of this Eclectic art was the fact that it did not fail to provide a vehicle for the expression of nineteenth-century attitudes and, as might be expected, the attitudes expressed were far more in accordance with the general spirit of the time than those of the Arts and Crafts movement. In particular it may be noticed that the new technical control was being used in the third quarter of the century for realistic effects with mildly erotic and even sadistic overtones. In the illustrated catalogues of the great exhibitions attractive female nudes, represented in various media, alternate surprisingly with scenes of savagery in the hunting field.

The direct use of motifs from the past was not in itself an invention of the mid-nineteenth century. Far Eastern wares had been imitated often enough, and the late eighteenth century had seen notable copies of Ancient Greek vases. The process of borrowing merely became in the nineteenth century more general at all levels of production and more indiscriminate. An important part in this development was played by the Second Rococo during the decades immediately before and shortly after the middle of the century. This style was especially common in England (where it may have had its origin in silverwork) and in Central Europe, notably in Meissen and in the factories of Bohemia. The style was characterized by an extravagant use of eighteenth-century *rocaille* motifs in heavy relief, which matched well with a revival of Romanticism and affectation. This was the style of the bourgeoisie, a style which did not lend itself to exclusive productions but which was undoubtedly ostentatious. In

England it was characterized especially by the liberal use of applied flowerwork, in a manner which was followed by many of the porcelain factories but is often referred to simply as "Coalbrookdale." In Bohemia the style was characterized most prominently by the production of porcelain figures in a sentimentalized version of mid-eighteenth-century costume with Rococo-scrolled bases.

The Second Rococo can be regarded as the first of the widely based imitative styles induced by the circumstances of the Industrial Revolution. It was certainly unique in the sense that its source of inspiration was European and less than a century away. As a style, however, it was a good deal less contrived than the work which was to follow. It seems in retrospect to represent a clearly defined fashion recalling a romantic pre-industrial past, and as such it differs markedly from the subsequent work which was eclectic in a less discriminating sense, drawing upon widely differing sources without reference to their essential qualities.

Around the middle of the century a naturalistic style was clearly discernible and was expressed at the Great Exhibition of 1851 where, for instance, wares incorporating vegetable forms were shown by the English firm of Grainger and by the Royal Porcelain Factory of Munich. A strain of this attractive naturalism continued into later decades, such as the sea-shell ornaments of the Belleek factory in Ireland, but in general the naturalistic forms made little progress in the current onrush of stylistic multiplicity. Following the examples set in the newly founded museums and in the art journals and spurred on by the incentive of the great exhibitions, the leading manufacturers were clearly casting about for new ideas and for new stylistic inspiration. The later 1840s had seen a fresh revival of Ancient Greek wares and a development of Gothic motifs in ceramics. The Greek wares by firms such as Copeland of Stoke-on-Trent were virtually exact imitations of Ancient Greek vases (although through a slight misunderstanding they were usually known as "Etruscan" wares). They appealed to a purist intellectual taste, but they were attractive also for their evocation of a distant past. At the 1851 exhibition the London decorating firm of Thomas Battam mounted a dramatic cave filled with pots to represent an Etruscan tomb. The Gothic taste of the 1840s, on the other hand, was a matter merely of motifs, of Gothic arcades or of niches filled with ecclesiastical figures, and not of the imitation of a historical ware. In England the most notable examples were slip-cast jugs such as the "Min-

ster" jug registered by Charles Meigh in 1842. In Germany the Gothic or medieval idea continued in the later part of the nineteenth century, as is instanced by a heavily molded dish of 1880 from Bichweiler of Hamburg, which is decorated with the figure of a charging knight on horseback.

More imitative were the wares which followed the style of porcelain made at Sèvres in the 1750s and 1760s. It is worth noticing in this context that whereas over most of the continent of Europe the standard nineteenth-century porcelain was of the hard-paste feldspar type, the English equivalent for tablewares and for most ornamental wares was the relatively soft bone china which had obvious affinities with the soft-paste porcelain originally made at Sèvres. Perhaps for this reason a number of English factories were especially involved in this continuing Sèvres tradition, notably Coalport, Minton, and Copeland in the 1850s and 1860s. Such work varied from near-forgeries to wares whose virtue lay largely in the imitation of the famous Sèvres grounds.

France was the source of other international styles involving imitation of either technique or overall effect. One of the most persistent was the so-called Limoges style, which originated not in ceramics at all but in the *grisaille* enamelwork on copper associated with Limoges in the sixteenth century. From this historical precedent emerged a nineteenth-century ceramic style of painting in white enamel on a dark colored, usually dark blue, ground. The possibilities of this technique were intriguing. If the white enamel was applied thickly it would appear opaque and white; but if it was applied thinly a degree of shadow would show through from the dark ground. This clearly held great possibilities for depicting the contours of human figures and draperies. By the 1840s these characteristics were being investigated in France in the Sèvres factory. In the two decades after the middle of the century Limoges ware was developed at the Worcester factory of Kerr & Binns (known as the Royal Worcester Porcelain Factory from 1862) principally by Thomas Bott working in the fashionable Renaissance style of the time. The Swedish factories of Rörstrand and Gustavsberg were similary involved with the Limoges technique in the latter part of the century, but surprisingly the medium used, in the case of Rörstrand at least, was earthenware rather than porcelain.

A parallel development which achieved a somewhat similar effect was that of *pâte-sur-pâte* decoration. Here again the decorative motif was painted in a light color

on a darker ground, but instead of using enamel the painting was carried out with successive applications of a porcelain slip, and detail on the raised areas was indicated by delicate carving and incising. To decorate porcelain in this way implied considerable technical experience, since it was difficult to estimate the translucency of the overlay until it was fired. But when successful, the effect of the translucency of the overlay was greatly enhanced by its relative thickness and the material affinity of the overlay and the ground. The *pâte-sur-pâte* technique was developed at Sèvres in the 1850s, and examples for instance by the artist Léonard Gély were shown at the Paris Exhibition of 1855. Among the other Sèvres artists working in the technique, Marc Louis Solon migrated to England after the Franco-Prussian War of 1870 and became a leading artist at the Minton factory until his retirement in 1904 (p. 209). It is interesting to notice that in England he used the parian porcelain body, which had been originally developed in England before the middle of the century for the production of marblelike statuettes. Although a relatively hard porcelain it was fired at a lower temperature than the feldspar porcelain used at Sèvres and offered in consequence a greater choice of colors for *pâte-sur-pâte* decoration.

The sixteenth century achievements of France were still further explored through a revival of interest in the wares of Saint-Porchaire and of the potter Bernard Palissy. The patterning on the original Saint-Porchaire wares was effected by deep-colored clay or clays on a white body. In the third quarter of the nineteenth century the type was known as "Henri Deux" or "Faience d'Oiron" and was the direct source of inspiration for wares made in French factories such as that at Choisy-le-Roi and in English factories such as Minton and Wedgwood. In this Henri Deux ware the technique seems of paramount importance, the style and form being imitative or else generally Renaissance in character. In the case of the imitations of the work of Bernard Palissy, on

the other hand, the style itself was of predominant interest, although the term "Palissy ware" soon came to acquire a wide connotation. Palissy's rustic style, involving the representation of lizards and snakes in high relief with colored glazes, was first revived in the nineteenth century by Charles Avisseau of Tours in the early 1840s, and he was followed by a number of potters and potteries in the 1850s, notably Landais (Avisseau's nephew), Barbizet, and Pull. At the 1862 exhibition in London the Palissy concept was taken to include a large Sèvres stand in naturalistic style. Among the English factories the style was followed extensively by Minton, and in Portugal it became for many years a speciality of the factory of Mafra & Son at Caldas da Rainha.

But the most important and far-reaching of all the imitative styles in the third quarter of the century came from Italy in the form of majolica. This earthenware with opaque tin glaze and painted decoration was revived in approximately its sixteenth-century style by many Italian factories, notably those of Ginori, Torquato Castellani, and Cantagalli. The style was also well represented in other countries: in England Minton commissioned some remarkable designs from the architect Alfred Stevens which were shown at the London exhibition of 1862, and the Berlin Royal Porcelain Factory showed some impressive examples at the Paris exhibition of 1867. In France, Italian maiolica was produced notably by Utzschneider at Sarreguemines, Ulysse at Blois, the factory at Gien, and Joseph Devers, an Italian working in Paris. The French were also producing work in the spirit of their own earlier faience, the Gien factory specializing in the old wares of Rouen, and Ulysse of Blois and Ristori of Nevers in the old wares of Nevers. In the same way a Spanish firm such as Escofet, Fortuny was producing imitations of old Hispano-Moresque ware at the end of the nineteenth century.

An unexpected corollary of the fashion for Italian maiolica was the emergence of the commercial majolica

Right: Pair of porcelain vases with *pâte-sur-pâte* decoration, Minton, Stoke-on-Trent, decoration by M. L. Solon, 1898, Lv
Page 210: Showpiece bowl, silver, embossed and gilded, with ivory, mother-of-pearl, and coral,
design by Storck and Karger, executed by Dörflinger and Gebrüder Frank, Vienna, 1889, Wa (above);
Cross, enamel on gold, set with pearls and diamonds, Boucheron, Paris, end of the 19th century,
donated by Bolckow, Lv (below)

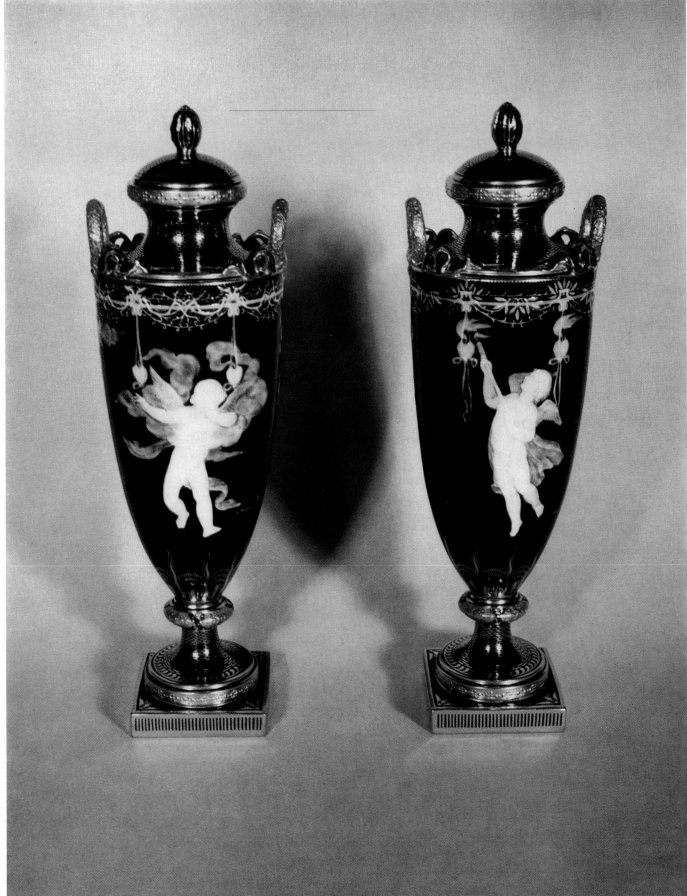

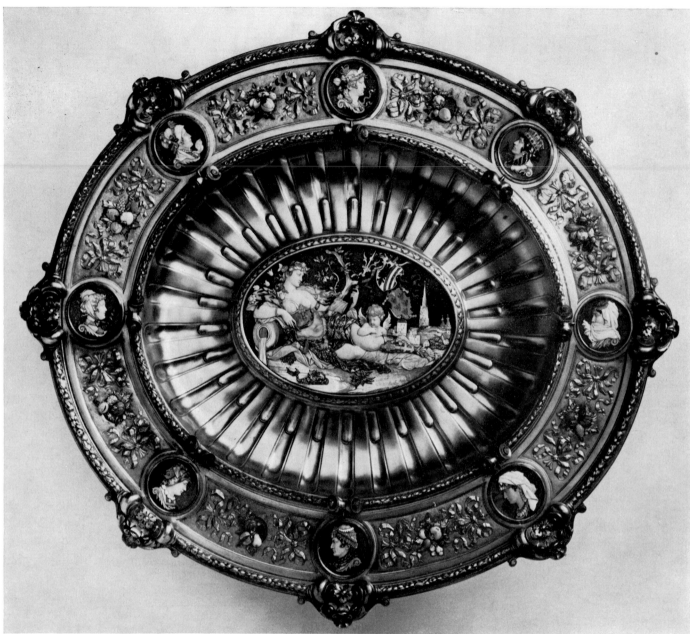

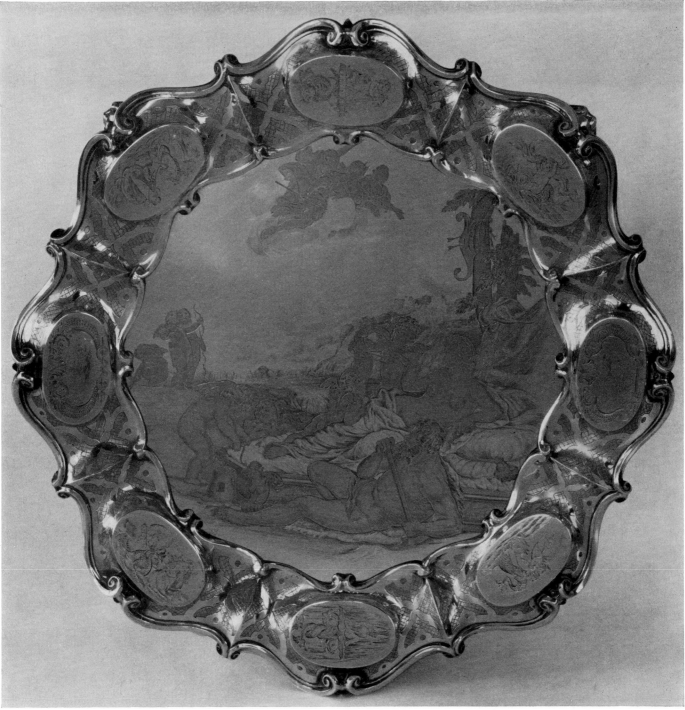

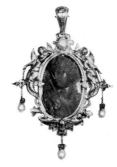

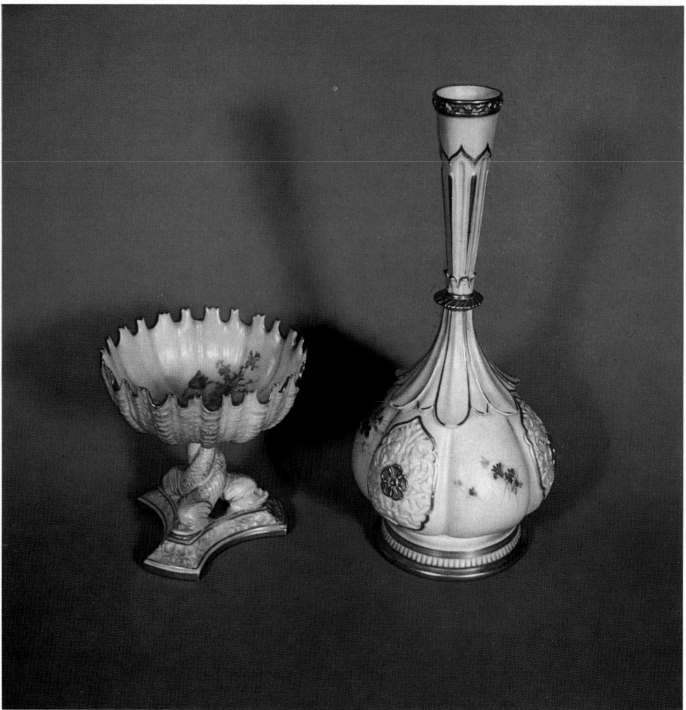

in the sense of earthenware with colored glazes. Usually decorated in heavy relief, this became the medium for innumerable late-nineteenth-century jardinières, umbrella stands, and other large domestic objects. There was little new in its technique of manufacture, and in some forms it was scarcely to be distinguished from Palissy ware. Commercially the style seems to have grown from the initiative of the English firm of Minton which first showed majolica of this sort at the London exhibition of 1851, but very similar work was to be seen shortly afterwards from many other factories. In the United States it was apparently made as early as 1853 by E. & W. Bennett of Baltimore, and it was later made extensively by the Phoenixville (Pennsylvania) Pottery of Griffin, Smith & Hill. In Germany and Austria it was made in the many factories which had previously made creamwares and printed wares in the earlier part of the century. In Sweden it was made impressively in the two leading factories of Rörstrand and Gustavsberg from the late 1860s onwards.

During its early years of development this style of majolica received considerable attention as an art form, often with painted as well as heavy relief decoration. In this sense majolica may be said to have reached its apogee at the London exhibition of 1862. A remarkable Minton jug and stand from that exhibition is illustrated here (p. 201). This was the exhibition in which the centerpiece consisted of a great majolica fountain made by Minton, which was 36 feet high and 39 feet in diameter. Later in the century majolica reached down to the simplest of dwellings, where it became the ideal medium for expressing the pompous manner of the late nineteenth century at its most popular level. It represented an attitude of grandeur which could be aspired to by all. Here was the proof that pomposity did not necessarily imply the possession of riches.

It will have been noticed that following on the Second Rococo the directly imitative styles of the third quarter of the nineteenth century were predominantly those of the Renaissance period. Sometimes copybook Renaissance motifs were used for their own sake (p. 220, below). This was in effect another period of Classicism which, besides the special manifestations of Renaissance origin, included all manner of Classically inspired shapes and motifs, many deriving ultimately from stonework or metal (p. 230, left). In some contexts, and particularly perhaps in the state factories from Sèvres and Berlin to St. Petersburg, the new Classicism had developed with little interruption from the Empire style of the earlier part of the century, but in spite of this apparent continuity a new spirit of interpretation was abroad. In the long run this nineteenth-century Classicism may have led to a certain sterility, but it remained none the less a basic ingredient in much of the industrial production of the later nineteenth century and beyond.

A fresh wave of influence was added in the last quarter of the century through the renewed influence of Eastern art, and especially of Japanese art which became widely fashionable in the 1870s and 1880s. In the mid-1850s Japan had been forcibly opened to world trade, and thereby Europe and America began to rediscover a half-forgotten oriental approach to the decorative arts. This implied the use of asymmetrical motifs and pattern arrangements, instead of the classical symmetry of Europe; and on ceramic tablewares it implied an important revolution in the possibility of dispensing with border patterns. If the intellectual influence of Japanese art was felt most keenly in France, it was in England that the Japanese style made its widest impact on industrial ceramics. In the later 1860s Eugène Rousseau in Paris commissioned from Félix Bracquemond a remarkable table service decorated with motifs from Hokusai prints, which was shown at the Paris exhibition of 1867. This was followed at a more commercial level by a considerable series of decorative and useful ceramics from such firms as the Worcester company and Minton (p. 234, below left). Some of the Worcester examples designed in the early 1870s attracted a great deal of attention. The vase illustrated here expresses very well the uninhibited approach to ceramic design. On each side of this porce-

Page 211: Salver, silver, partly gilded, London, 1851, Hb (above);
Pendant and two brooches, gold, set with coral cameos and pearls, F. D. Froment-Meurice, Paris, about 1855, Lv (below)
Left: Vase, 1892, and bowl, 1896, porcelain, Worcester Royal Porcelain Company, Lv

lain vase oriental figures engaged in pottery manufacture are represented in imitation of lacquer work inlaid with ivory. Here the Japanese style is unashamedly used for its picturesque effect, and the decoration on the vase involves the representation of no less than two materials other than porcelain. Here is an art medium, bound up with a sense of novelty, which could only be fully enjoyed by contemporaries involved in the rediscovery of Japan.

Alongside the fashion for Japanese art came renewed influences from China and from the Near East. The Chinese influence came still from the later periods of Chinese ceramics and was sometimes intermingled with that from Japan. The influence of the Near East, which had been present in some degree from the middle of the century, was derived variously from Moorish architectural details and from Persian, Syrian, and Turkish pottery and tilework, and many factories picked up at some point stylistic traits of this nature in form or decoration. The Islamic bottle form was an especial favorite, with decoration which might derive from the highly stylized motifs of Persian carpets or, more attractively, from the floral motifs of late Persian or Turkish pottery.

After the Classical and Renaissance phase of the 1850s and 1860s, the exotic styles, and particulary that of Japan, can be considered the principal element in the factory work of the later 1870s and 1880s. The final phase of the development, at least so far as concerns the nineteenth century, can be identified with the Third Rococo, which culminated in the 1880s and 1890s. This involved naturally a further revival of the asymmetrical scroll motifs. Frequently, as with the Second Rococo, these were used in heavy relief, sometimes to the detriment of painted decoration. But the Third Rococo was much more distinct than the Second from the original Rococo of the eighteenth century. In particular the use of applied flowerwork does not seem to have been picked up to any extent in the Third Rococo. It may be noticed, however, that the use of shading was particularly associated with this latter phase, that is, colors were deliberately shaded over an area from light to dark or from one color to another. Shading of this nature appeared not only in ceramics but also in other arts, such as in fancy glassware, and can be regarded as a characteristic of the last decade or so of the century. The Worcester factory, from which an example is illustrated here (p. 220, above), was a leading exponent of the Third Rococo style in England. On the Continent it was practiced in most factories from the great state factories of Berlin and

Sèvres downwards. In the United States also it appeared in the work of many factories, perhaps most characteristically among the so-called "Belleek" ware of Ott & Brewer and of the Willets Manufacturing Company, both of Trenton, New Jersey.

By the end of the century the intellectual reaction which was to lead to the modern movement in the decorative arts was well under way. In England it had been expressed in the salt-glazed stoneware of the Doulton artists and the Martin Brothers and in the figured-glaze earthenware of the "art potteries." In the United States the art potteries, such as that of Rookwood in Cincinnati, had made an important and original contribution with figured grounds and slip painting. On the Continent of Europe a somewhat separate movement led to the remarkable French development of stoneware and porcelain with Far Eastern style glazes by artists such as Ernest Chaplet, Auguste Delaherche, Jean Carriès, and Adrien Dalpayrat, and to the similar work by German artists such as Hermann Mutz, his son Richard Mutz, and Julius Scharvogel. On the Continent earthenware was also being used about the end of the century for work in the current "Art Nouveau" style by artists such as Max Läuger working in Germany and A. W. Finch in Finland. Above all, the movement towards modern industrial ceramics was gathering momentum in the years around the end of the century. Developing from the French interpretation of the Japanese spirit, and thence the new work of the Copenhagen factory, the first years of the twentieth century saw the purging effect of the Art Nouveau style and the uncannily advanced designs for German factories by artists such as Peter Behrens and Henri van de Velde.

In all this progressive work the artists were reacting against the relative indifference to ceramic qualities and the stylistic confusion displayed in the Eclectic ceramics of the nineteenth-century factories. The artists were seeking to exploit ceramic qualities for their own sake. This can be seen to apply in the case of the drab-colored, salt-glazed stoneware and in the cultivation of Far Eastern glazes. It can be seen also in some of the artists' more derivative work such as the study of Near Eastern colors and motifs by Théodore Deck in Paris and William De Morgan in London. On the other hand the movement towards modern industrial ceramics was a reaction in a quite different direction toward a greater control in the use of new simple shapes and original decoration appropriate to the immediate purpose of the ware. The out-

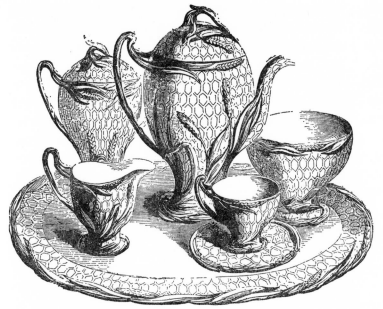

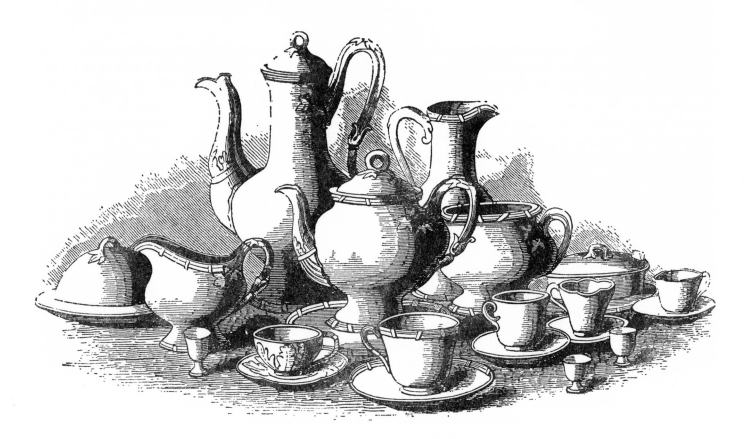

Above: Coffee service, porcelain, Graininger & Co. (left); Porcelain vase, J. Rose & Co. (right);
Tea and coffee service, porcelain, Ridgeway & Co. (below).
All the objects are exhibits from the London World Exhibition of 1851

come was a cleavage in modern intellectual ceramics, which has largely persisted to this day, between the studio potters on the one hand, who are inclined to cherish every chance accident of firing and who base much of their work on the inspiration of early Far Eastern ceramics, and, on the other hand, the industrial designers, who attempt to combine functional qualities with a sculptural simplicity of line. Meanwhile the nineteenth-century Eclectic approach to ceramics did not disappear with the turn of the century, but it has gradually diminished in validity to become less and less characteristic of its time. Ultimately its products have sunk to the level of kitsch, but as such it has still some part to play in the history of the least sophisticated popular arts.

Right: Venus and Cupid, fancy-ware figure of porcelain, probably Thuringia, about 1880, Mh
Page 218: Set of jewelry, gold, openwork with jade, English, third quarter of the 19th century, Wa (above left);
Set of jewelry, enamel on gold, set with pearls and diamonds, English, between 1840 and 1880, Lv (above right);
Set of jewelry, gold with turquoises, amethysts, and pearls, English, between 1830 and 1860 (below left);
Brooch, necklace, earrings (upper pieces), enamel on gold, French, about 1840; Bracelet, gold with semiprecious stones, English, about 1840; Brooch, English, about 1860 (lower pieces), Lv (below right)
Page 219: Necklace, gold with enamel and pearls, design by Josef Storck,
executed by Macht and Kleeberg, Vienna, 1890, Wa
Page 220: Dish with relief decorations, Worcester Royal Porcelain Company, probably 1890, Lv (above);
Pitcher with stand, earthenware, painted in imitation majolica, Royal Porcelain Factory, Berlin,
shown at the London World Exhibition of 1867, Lv (below)

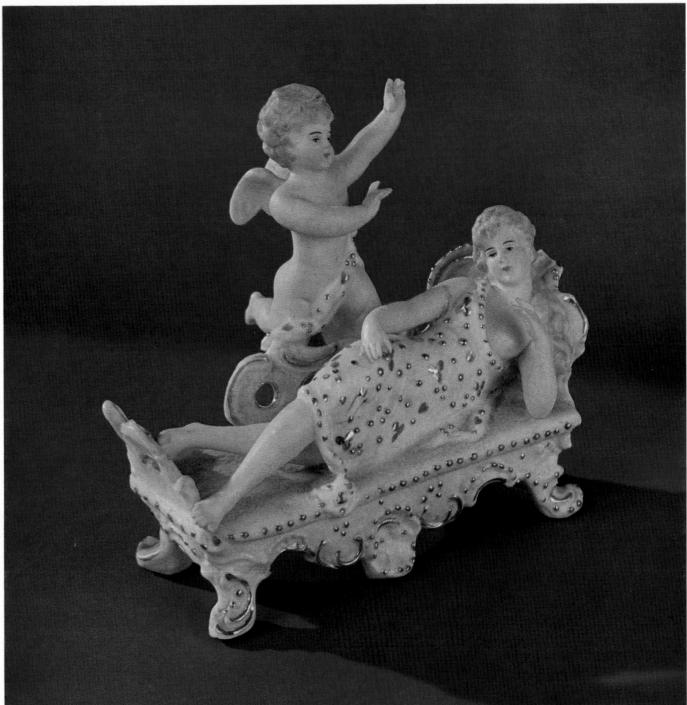

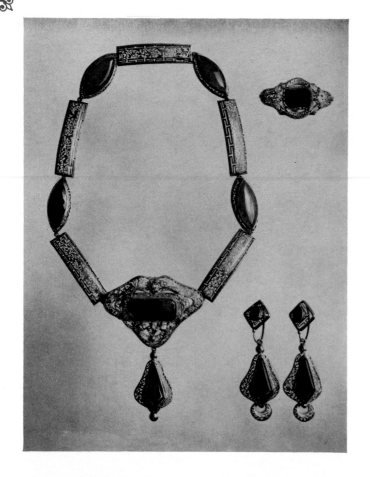
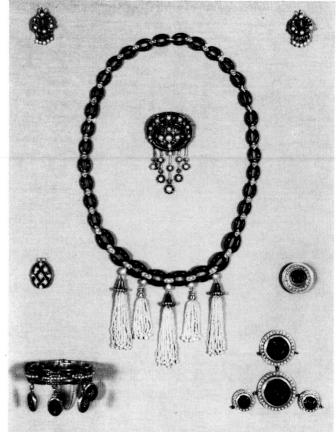
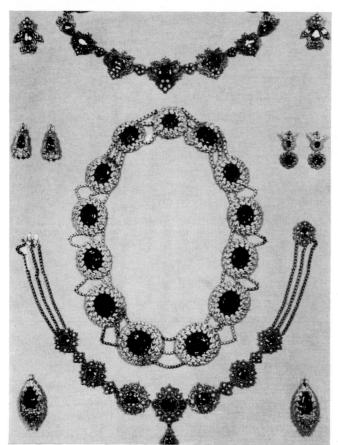
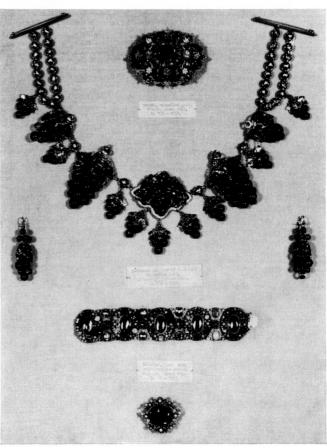

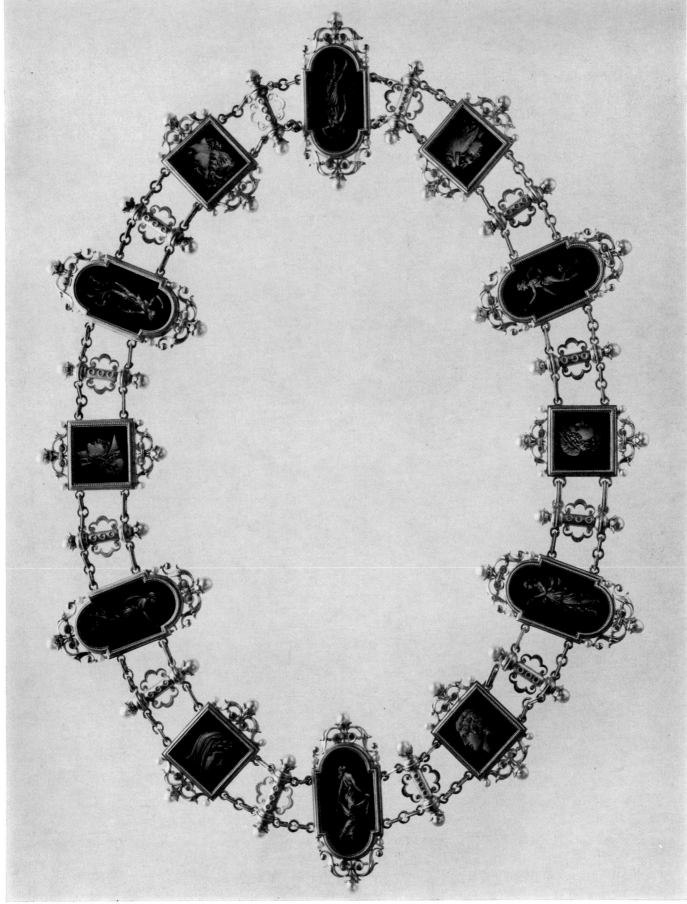

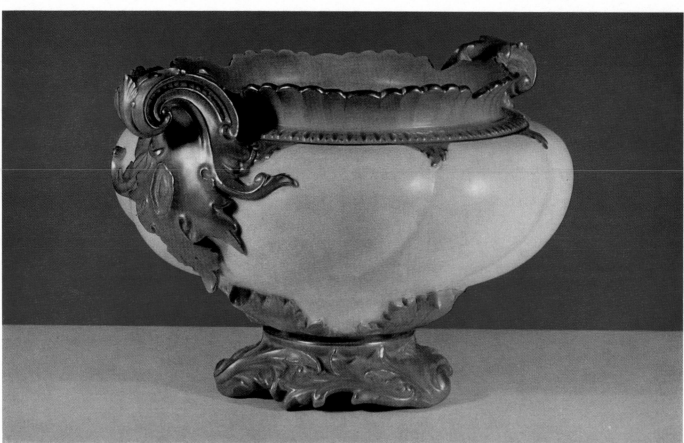

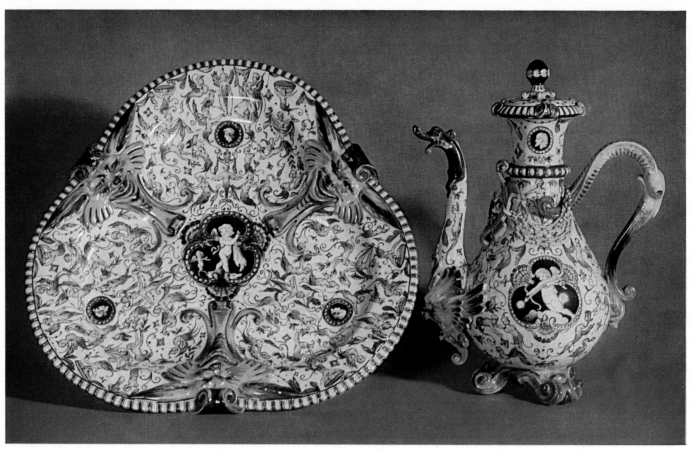

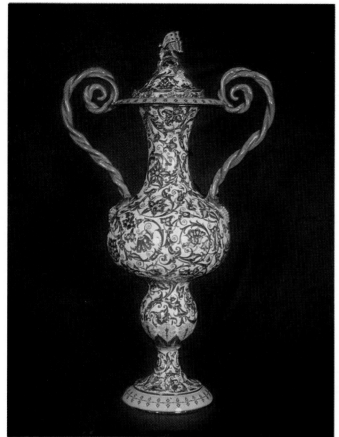
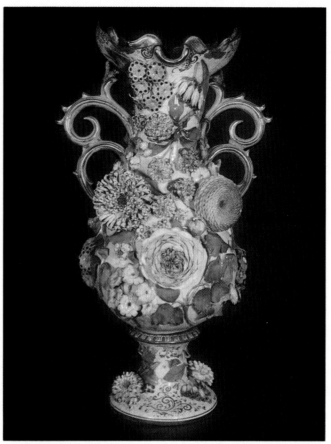

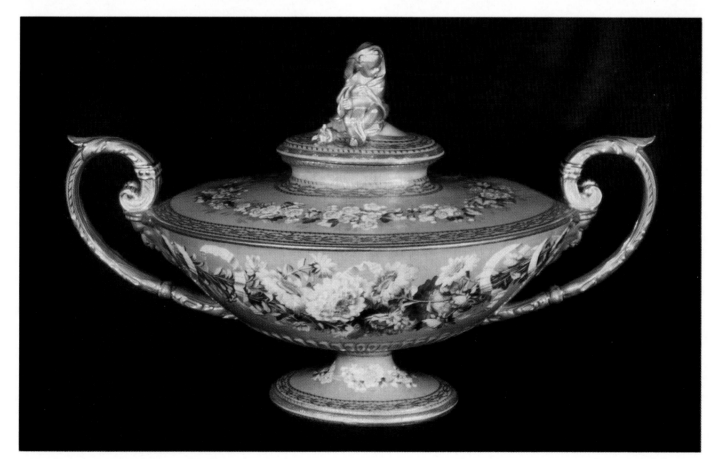

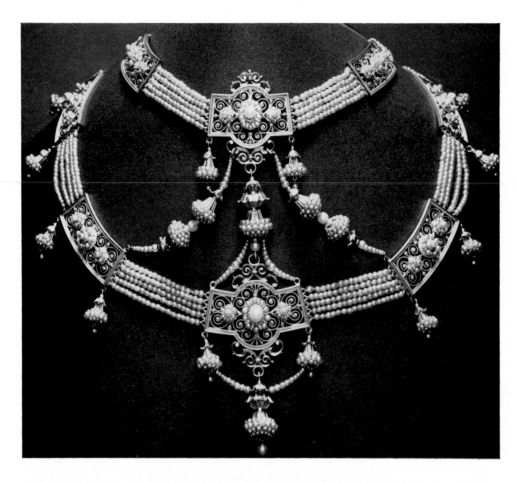
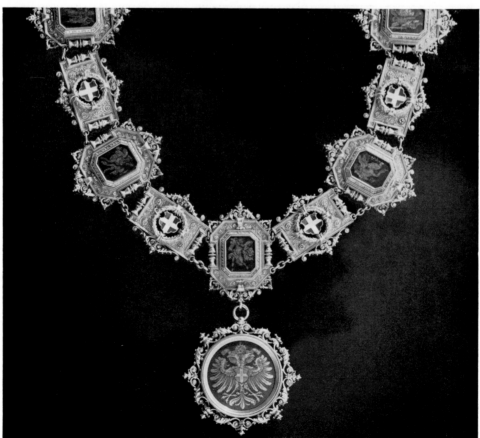

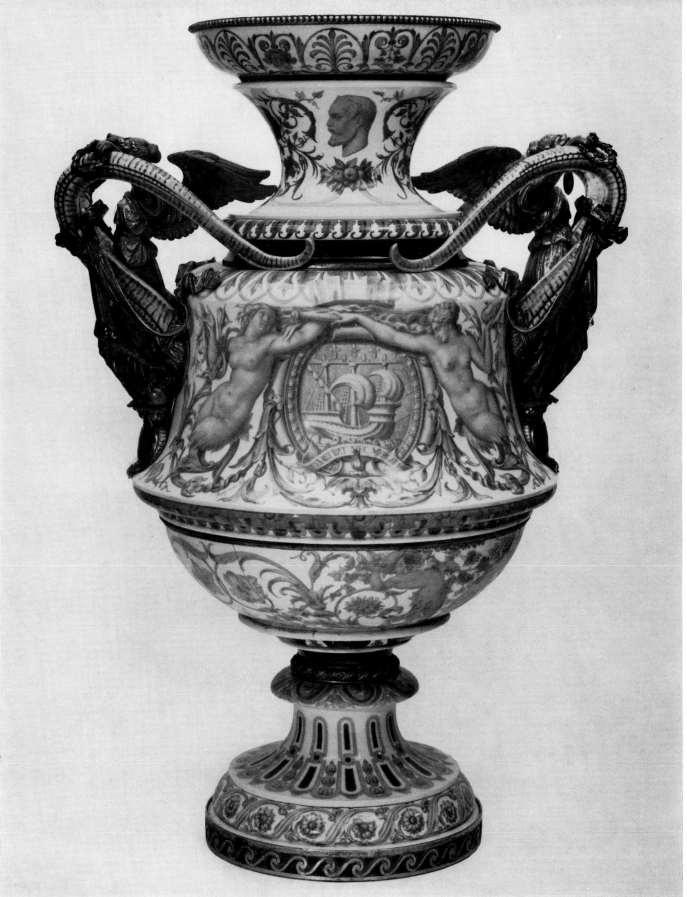

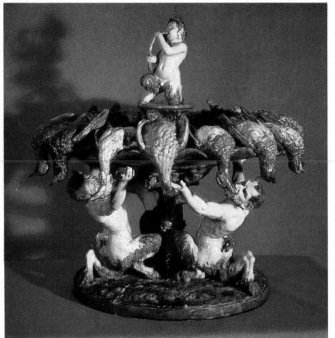
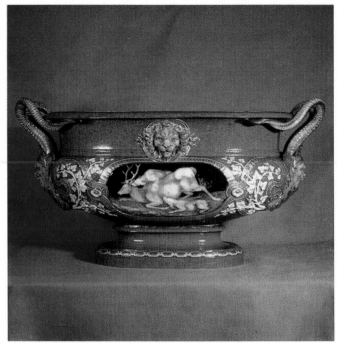
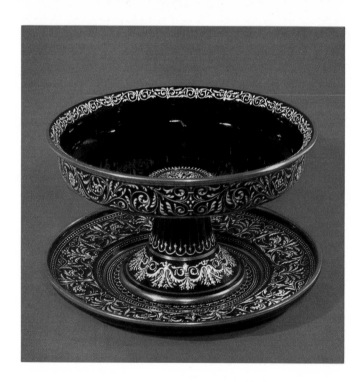
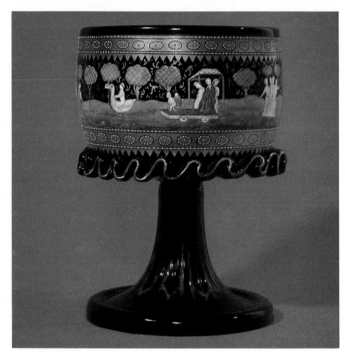

Glass

"There are three—we could call them principles—upon which the aesthetic quality of glass depends: form, color, and transparency. The last two combined give glass its artistic distinctiveness. Relief decorations are not suited to its nature as the transparency neutralizes the shadows cast by the relief. Relief is therefore not suitable for glass styles"

It was with these apodictic sentences that Jacob von Falke began the chapter on glass in his *Ästhetic des Kunstgewerbes* (Aesthetics of the Industrial Arts). He was one of the leading personalities of the then young Viennese Kunstgewerbe-Museum, and his book, which was completed in 1883, still seems progressive in some respects even today. Each one of the sentences describes the exact opposite of what the best artists in glass at the time were putting into practice in outstanding works. Only two techniques, cut crystalware and undecorated glass formed by blowing, satisfied Falke's requirements—all other processes, particularly those which were rediscovered, newly tried out, and in a variety of ways further developed after 1850, violated his maxims. The paradox in the judgment of contemporaries and succeeding generations regarding what was considered right or wrong, progressive or conservative, emerges at once on closer examination. It was precisely those techniques which took away transparency of glass—painting with opaque enamels, gilding, frosting, the use of untransparent masses, building up with several layers—which became important in the renewal of the artistic use of glass on the way towards its highest achievements later on in the Art Nouveau Period. Anyone who was not judging from a one-sided, didactic, or doctrinaire point of view saw the situation differently from Falke. In his *Führer durch das Hamburgische Museum für Kunst und Gewerbe, zugleich ein Handbuch der Geschichte des Kunstgewerbes* (Guide to the Hamburg Museum of Arts and Crafts, and also a Handbook on the History of the Industrial Arts) of 1894, Justus Brinckman states very succinctly: "Since the first World Exhibition in the year 1851 the European glass industry has received a new impetus."

The progress which Brinckman saw came as a result of Historicism, not hidden, but as its prerequisite and consummation. Historicism was the form which, to a positivistic age, mean tradition and progress, preservation of the past and preparation for the future. The processes used by artists in glass working with Historicist patterns made available to industrial production traditional techniques of craftsmanship in manufacturing concerns, some of which had been lost and had to be rediscovered. As the length of time since the *Gründerzeit* increased, so the importance of the historical models seems to us to grow less and the specific characteristics of the nineteenth century appear more obvious. These are the hardness and precision of form, the clarity of colors, the mathematical regularity of the ornamentation, and the slight range of variation within a series. These stylistic

Page 221: Vase, earthenware, Ristori, Nevers, shown at the Paris World Exhibition, 1855, Lv (above left); Vase with lid, English about 1830—40, Lv (above right); Tureen with lid, porcelain, Copeland, Stoke-on-Trent, shown at the London World Exhibition, 1862, Lv (below)
Page 222: Necklace, gold, filigree with pearls, designed by Josef Storck, made by Bacher and Son, Vienna, 1887, Wa (above); Mayoral chain of the city of Vienna, Vienna, 1883, Wa (below)
Page 223: Vase with lid, porcelain, Sèvres, 1854, Tr
Page 224: Centerpiece, earthenware, Sèvres, shown at the Paris World Exhibition of 1855, Lv (above left); Ice-pail, porcelain, Sèvres, 1874, Lv (above right); Bowl and foot bath, dark blue glass with white enamel and gold burnish, about 1880, Hm (below left); Imitation of a piece of Venetian glass of the 15th century, probably Italian, middle of the 19th century. Hm (below right)

criteria apply to the individual masterpiece, the manufactured object, and mass-produced articles. The large expenditure of time and materials needed for the production of particularly luxurious objects in most cases quickly worked to the advantage of mass production, and for this reason there is a close link between the luxury article and mass product.

What most glasses of the second half of the century have in common is the tendency towards virtuosity in deception. Designers, producers, and consumers in every area of interior decoration and industrial arts were fascinated by the imitation of different materials, and this was no less true in the area of work in glass. It had to compete not only with rock crystal, all kinds of semiprecious stones and even marble, but where possible with ceramics and goldsmith's work too. The deception could only be successful, however, even with mastery of every technical refinement, if the glass were wholly or partially deprived of its most characteristic quality, namely transparency. The glass of the Pompous Age is seen at its best in direct or oblique lighting rather than light which shines through it.

The violation of overly restrictive rules governing the correct use of materials had been established by precedent ever since the invention of the art of glasswork by the Egyptians and Mesopotamians. Every age that made an important contribution to the technical and aesthetic development of glass offended the principle that transparency should be the most desirable effect to achieve with it. It was the glass painted with opaque enamel of the Seljuks, Venetians, and Germans, the glass of the Chinese and Bohemians which looked like stone, and the glass made in the workshops of Roman Syria where burial in the soil had produced a heavily iridescent layer which particularly fascinated the nineteenth century. The results of this enthusiasm, achieved by methodical work, could be seen convincingly for the first time in great breadth at the Viennese World Exhibition of 1873.

The works which had won honors in previous world exhibitions were also on show in Vienna. In comparison with the new prizewinners, these pieces seemed strikingly conventional. Both French manufacturers such as Baccarat and Saint-Louis, and English such as W. H. B. & J. Richardson and Thomas Webb followed models from the first half of the century with their prismatic cut-crystal patterns. That they should have held on to tradition in this way is even more surprising considering that no other age ever invented so many decorative patterns only to

reject them again within a short space of time. Hugh Wakefield has established that the manufacturer Thomas Webb alone brought 25,000 different patterns onto the market between 1837 and 1900. Clearly the customers, though offered a wide choice, preferred those pieces which represented the traditional type of crystalware and showed only minor variations in its design. The same feeling for tradition is also reflected in the success of pressed glass, a cheaper imitation of cut-crystal glass.

The technique of pressing a mass of glass in metal molds was in fact already known in Europe during the late eighteenth century, but it was not developed further until the 1820s in America and was registered for a patent in England by Apsley Pellatt in 1831. Up until 1840 a number of English factories, some of them in Birmingham and Stourbridge, the center of English crystalware, took up the production of pressed glass, and yet only one of them showed its products at the London World Exhibition in 1851. Pressed glass was obviously considered artistically inferior until it found its own form, i. e., until it no longer imitated crystalware but took into account the possibilities available in pressing a viscous fluid mass into a plastically complex mold.

In Vienna in 1873 the most important achievement in the realm of conventional techniques was presented by the firm of J. & L. Lobmeyr. The success that their cut, ornamental, or figuratively decorated vessels of crystal glass met with can be compared to the successes of Émile Gallé and Louis Comfort Tiffany toward the end of the century Lobmeyr's work was so powerful and convincing that it was adopted as the critical yardstick by most people involved in the field until the twenties of our own century. The statements quoted earlier from Falke are only comprehensible in the context of Lobmeyr's achievement. Even in the one-sidedness of certain observations by so important an expert on the material as Gustav Pazaurek, a continuing respect for Lobmeyr can still be felt.

The founding of the firm can be dated from the first entry in the books, which was made on February, 1823. It developed steadily under its founder, Josef Lobmeyr, achieved its first succes in London in 1851, and then after the founder's death was able to extend these successes internationally under his son, Josef, Jr. Ludwig Lobmeyr's assumption of control of the business became a decisive factor for the world standing of the firm and also in the development of European glasswork. Together with his brother-in-law Wilhelm Kralik, he was able to set the great capabilities of Bohemian craftsmanship at the dis-

posal of the best Viennese designers available to him—the architect Teophil von Hansen, Josef von Storck, and Friedrich von Schmidt. The cooperation of these designers soon earned the firm considerable success at the Paris World Exhibition of 1867 and brought them equal standing with the traditional products of the manufacturer Baccarat, which at that time were still considered exemplary. Lobmeyr continuously extended the group of designers and craftsmen, had each of them specialize in particular technical and artistic aspects of the increasingly broad and varied range of production, and yet was able, through recognition and judicious promotion of craftsmen in each specialized area, to maintain a high standard.

Lobmeyr's success at the Vienna World Exhibition cannot be separated from the enthusiasm for the Renaissance. The models for his ground crystal glass were the sixteenth century rock crystal vessels belonging to the emperor which it had been possible to show publicly, for certain periods of time at least, since the founding of the Vienna Kunstgewerbe Museum. This revival of crystalware reflects the influence of the young Kunstgewerbe Museum on production. This can be observed even more clearly from the influence of glasswork from the Near and Far East on glass of the period between 1860 and 1890.

The oriental fashion, which had found expression variously in painting, architecture, and book design, was the starting point for important new possibilities in glasswork which Gallé brought to their highest level. The nineteenth century was chiefly interested in three groups of oriental glass: Chinese glass from the seventeenth to eighteenth century, Arabian enameled glass of the late Middle Ages, and the glass vessels of Roman Syria which burial in the soil had given a covering of shimmering iridescence. The most intense area of this interest was centered round the luxurious vessels decorated with enamel and gilding from the Seljuk period. These beakers and mosque lamps of the thirteenth century were much-sought-after objects by collectors and museums; the temptation to make a handsome profit with imitations and forgeries of Islamic glass was very great. The products manufactured by E. J. Brocard can largely be explained by this situation in the art market. Brocard was a sensitive artist, but even more competent technically. Forgeries and original artistic works exist side by side among the objects from his workshop. Technically, the only difference between them is that the former have been artificially dirtied and superficially damaged, where-

as the latter are in gleaming enamel colors and brilliantly burnished gold. The almost mechanical regularity of the ornamentation, however, makes the forgeries easily recognizable today even to the relatively untrained eye. Brocard's growing success at the Vienna World Exhibition, and five years later at the Paris exhibition of 1878, may have been what caused him to direct his talents and energies later on almost exclusively toward the invention of new patterns. An abstract floral ornamental pattern had already appeared on the best pieces shown at the Vienna exhibition, instead of the orientalized style of decoration. Brocard departed even further from the oriental model by more frequently using transparent enamel paints instead of opaque ones.

With the work done by his firm, Ludwig Lobmeyr was able to outdo all the other European manufacturers. This included even Dr. Antonio Salviati, who had worked in Murano to revive the forms of old Venetian glass and whose endeavors had reaped their success at the second Paris exhibition in 1867. Lobmeyr's catalogue for the Vienna exhibition also carried vessels with "Renaissance, Persian, Moorish, etc., ornamentation" in enamel painting as products of the Bohemian factory of Meyrs Neffe, which belonged to Lobmeyr's firm. While the first examples of the enameled line were being made, Lobmeyr and others were working on what was to become one of the most important studies published in the nineteenth century on glasswork: *Die Glasindustrie, ihre Geschichte, gegenwärtige Entwicklung und Statistik* (The Glass Industry, Its History, Present Development and Statistics; Stuttgart, 1874). Lobmeyr secured the cooperation of Dr. Albert Ilg, curator of the Vienna Kunstgewerbe Museum, as author of the historical section, and Wendelin Boeheim as the specialist on statistical questions. Lobmeyr's methodical approach was of particular benefit for the oriental tendencies of his products. Designers with scholarly knowledge, such as Girard, Rehländer-Knab, and Schmoranz, provided the decorative patterns and made sure that even the Kufic script was reproduced correctly. The Viennese firm, unlike Brocard, never misused its expertise to produce forgeries, however. The bottom of an amphora fashioned after Arabian models carries the translation of a quotation from the Koran written in Kufic on its side: "O Lord, thou art the best help." The experience gained from historical models placed Lobmeyr in a position to work more freely, always on the basis of the technical achievements of his Austrian and Bohemian factories. Opaque enamel was fused onto

heavily colored glasses, combined with rich burnished gold, set in contrast with frosted surfaces, even applied to chandeliers.

The world-wide success of Louis Comfort Tiffany's Favrile-Glass treated with metal salts has obscured the fact that the process for making glass iridescent artificially was not invented by the American at all. Individual glassworks from Bohemia and Hungary had brought glass vessels with a luster produced with metal salts to the Vienna World Exhibition, and Lobmeyr produced some in 1873 to make a contribution in this area with the soft shimmer of rainbow colors he used in the decoration of some Indian-flavored pieces. His enthusiasm for the natural iridescence of Roman Syrian glasswork could only find expression in his own products after his brother-in-law, Kralik, managed in 1875 to secure an invention made by Dr. L. O. Pantotsch in the glass factory of J. G. Zahn in Sladow near Losancs. Pantotsch had succeeded in producing a heavy luster by vaporizing salts (that is, metal salts) inside a tin drum filled with glassware. In 1878 Lobmeyr exhibited this innovation in Paris, but without subsequently extending this branch of production. The existence of any connection between Tiffany's early work and Lobmeyr's experience with Pantotsch's invention is still an open question.

Techniques which we know today chiefly as processes used by artists of the Art Nouveau Period were also first introduced in England in the nineteenth century, some of them so early that their first application appears to be isolated aesthetically and from the point of view of historical development. The "Portland Vase" of the British Museum was highly esteemed among famous examples of old glass by English artists. It was considered exemplary use of the "cameo" technique, in which a colored glass object is covered with a layer of white and a decoration is cut into this in such a way that the white design stands out against the darker background. The inventor of this process, John Northwood, was able to look for a more widespread growth of his idea when he was commissioned in 1864 to work with the Birmingham based firm of Stone, Fawdry & Stone.

During the seventies a copy of the Portland Vase as well as a number of other works in cameo glass were made. The high regard these pieces enjoyed is reflected in the names they were given by contemporaries. Gallé, who became acquainted with the Arts and Crafts Movement during his stay in England, may have experienced some inspiration from this special achievement of English glasswork, although his artistic purpose was directed toward different goals from those of the English. Shortly before the middle of the century glass vessels appeared in England which were astonishing for their unpretentiousness. This was before the experiments of the French and Austrians with enamel paints and contemporaneous with the transparent enameled glass of the late Biedermeier Period. They form a decided contrast to the overburdened works of the second half of the century. Their ornamentation is inspired by the study of nature.

Developments in Germany trailed behind those of Austria, France, Italy, and England for a long time. It was not until the late seventies that German firms could come forward with original work of their own. Among these the best known is the Rheinische Glashütten Aktiengesellschaft in Ehrenfeld bei Köln. The credit for the high standard of its products is due to Oscar Rauter, who founded a new branch of the business "for artistic products" in 1879–80. To begin with, older pieces from public and private collections in Köln and Düsseldorf were copied in this section; in later models, a stylistic approach emphasizing simplicity was introduced which began to replace the glass of the *Gründerzeit* and led via Art Nouveau into the twentieth century. This development grew primarily out of German glasswork. The vessels of the E. F. Rönneburg factory in Flensburg are just one example; these works date from about 1883, yet they could just as easily have been made in Murano around 1955.

Right: Flower vase, gilded, with vitreous enamel, F. A. Torstrup, Oslo, end of the 19th century, Hm

Page 230: So-called Nelson vase, biscuit porcelain, Alfred Crowquill, Burslem, Staffordshire, 1851, Lv (left);

Vase, porcelain set with gold and jewels, Worcester Royal Porcelain Company, about 1885, Ca (right)

Page 231: Two vases, porcelain, gold and silver decoration in low relief, Minton, Stoke-on-Trent, about 1880, Hm

Page 232: Foot bath, glass with enamel painting, M. Brocard, Paris, shown at the Vienna World Exhibition of 1873, Hm

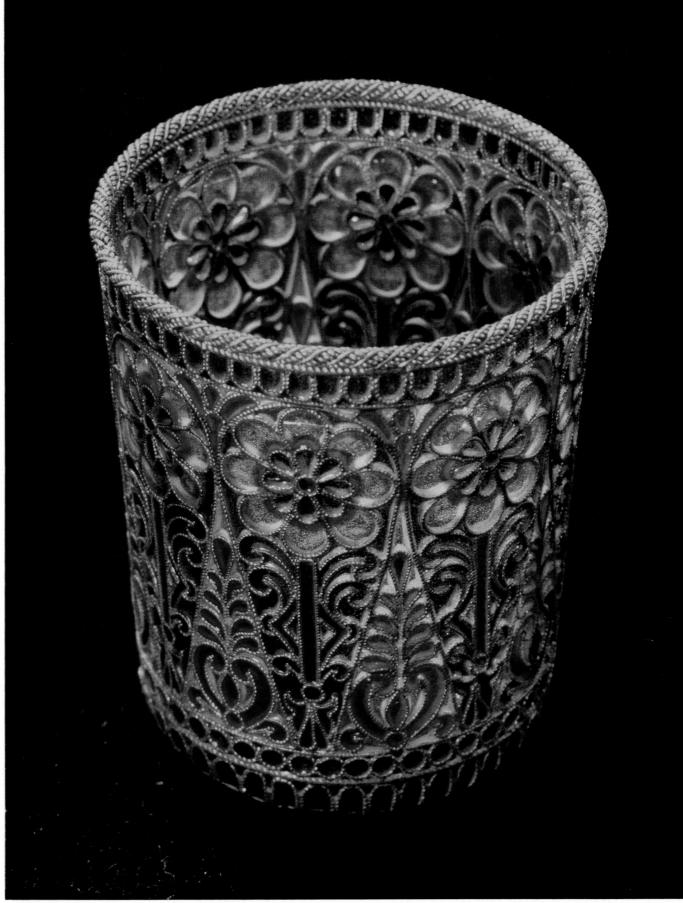

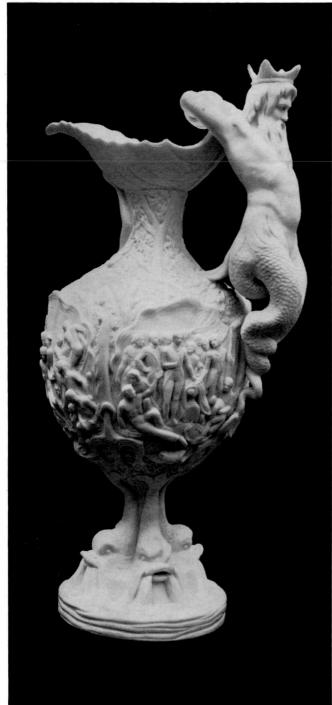
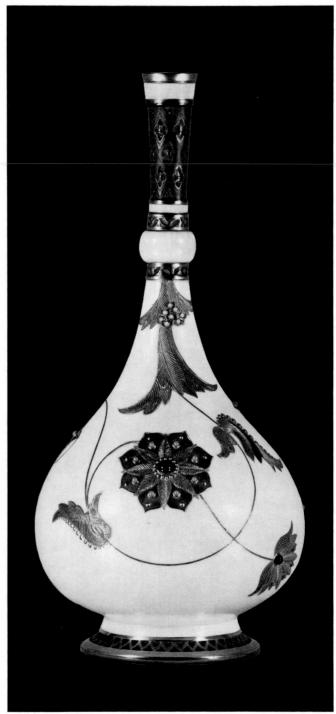

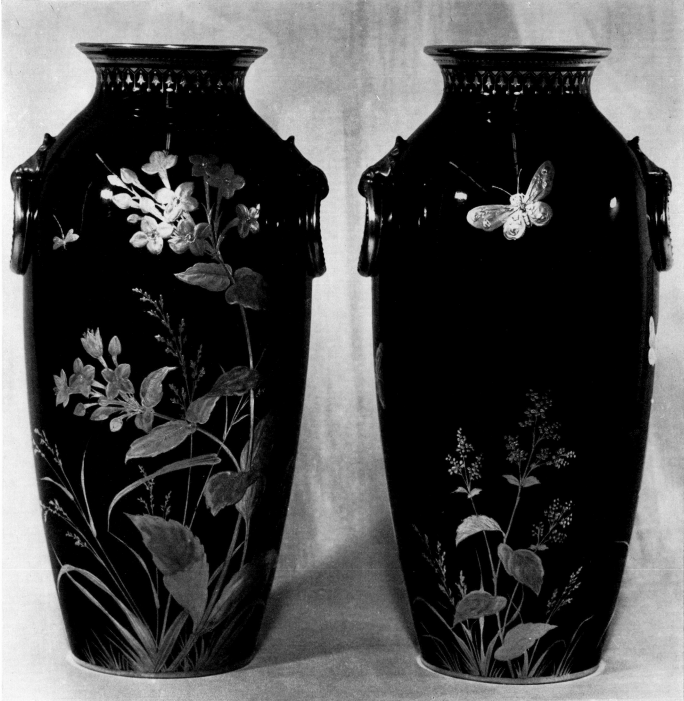

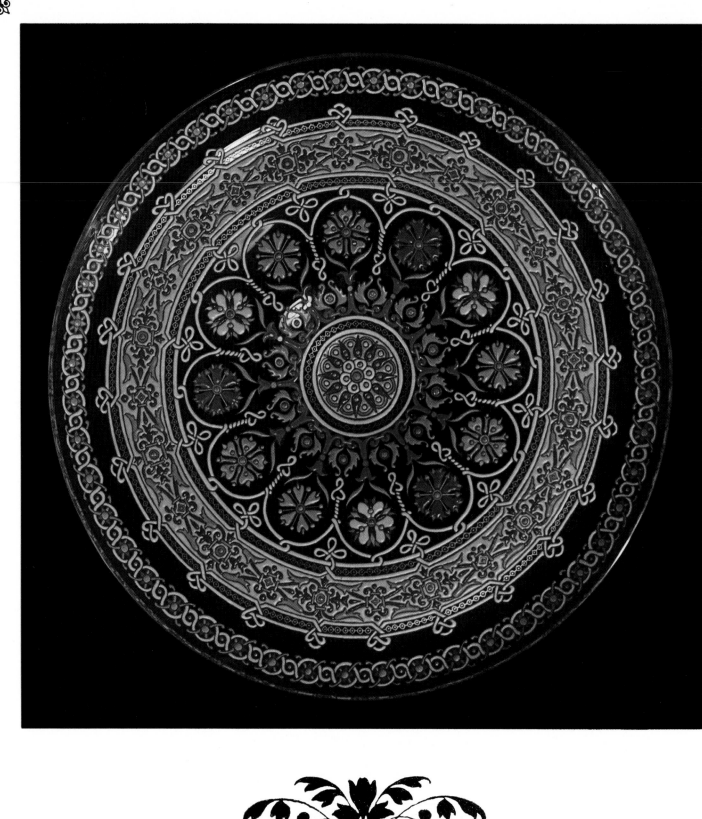

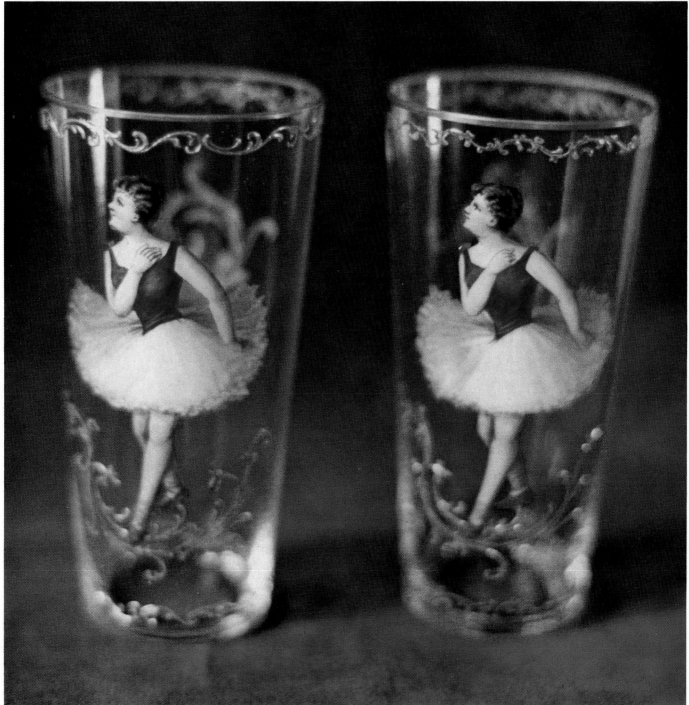

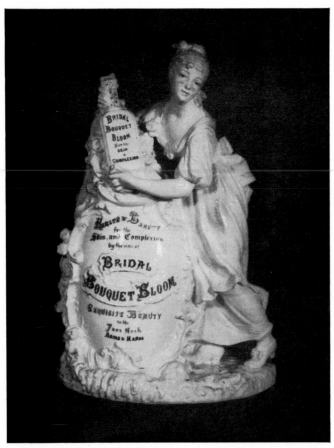
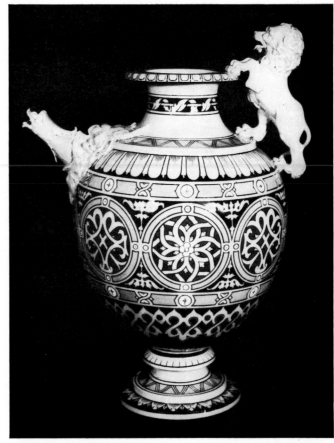
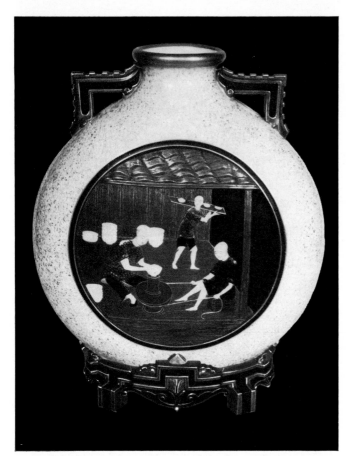
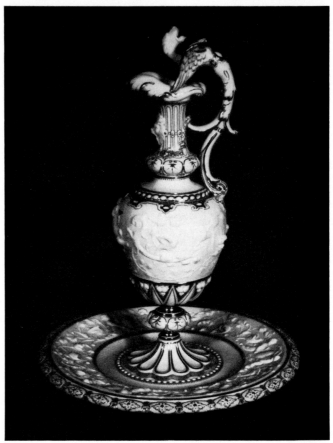

Textiles

The nineteenth century was above all an age of Eclecticism, and in no field was this more manifest than in the decorative arts. This Eclectic approach to design is admirably summed up in the introduction to *Hints for the Decoration and Furnishing of Dwellings*, published in the *Journal of Design* in London in 1849: "There is no general agreement in principles of taste. Every one elects his own style of art ... some few take refuge in a liking for pure 'Greek,' and are rigidly classical, others find safety in the 'antique,' others believe only in 'Pugin' (*i. e.*, the Gothic style), others lean upon imitations of modern German and some extol the *Renaissance*. We all agree only in being imitators."

It would be wrong, however, to dismiss the nineteenth-century designers as mere imitators, for while borrowing from every known historical style they imparted a new spirit to their designs, recreating something that was essentially of their own age, something that could have belonged to no other period. It is nearly always possible to trace the source of inspiration and to attach a current label to the style—"Gothic," "Moresque" or "Arabesque," "Elizabethan" or "François Premier," "Rococo" or "Louis Quatorze," to name but a few—but there is a certain affinity between all the styles in spite of essential differences in the choice of motif. A unifying feature was undoubtedly elaboration, which was equated with beauty, producing patterns that were pompous and pretentious but evincing great skill in their invention and technical execution.

The nineteenth century saw a great expansion of the textile industry, with new markets opening up and increasing competition for them. The perfection of the Jacquard loom, improvements in textile printing machinery, and the discovery of new chemical and aniline dyes enabled the most elaborate designs to be carried out, and designers were quick to seize upon the new possibilities with little restriction on their invention and ingenuity.

Although national differences exist, the Pompous or Eclectic style was essentially an international style, for the sources were available to all. The international exhibitions of art and industry that were held in all the major cities of Europe enabled manufacturers and designers to see and emulate the products of their competitors. It was also common for manufacturers to buy their designs in Paris, where the design industry was highly organized, thus contributing to this internationalism. Even more influential in this respect was the large volume of published sources of design. One of the most important published sources was the *Grammar of Ornament* by Owen Jones (1809—74), first published in 1856 and running to many editions and translations into foreign languages. The 112 plates cover the whole gamut of historical styles from ancient times to the Renaissance and also include Arabian, Moorish, Persian, Indian, and Chinese ornament together with the "ornament of savage tribes." Apart from ten plates at the end of leaves and flowers drawn from nature, most of the plates are of purely ornamental styles, the floral elements being highly stylized, and as such it was instrumental in the battle

Page 233: Two champagne glasses, glass with gold and enamel painting, Rhineland, about 1880, Mh
Page 234: Advertising figure, porcelain, 1880, Lv (above left);
Jug, Henry II, stoneware, Minton, Stoke-on-Trent, shown at the London World Exhibition of 1862, Lv (above right);
Vase in the Japanese style, porcelain, Worcester Royal Porcelain Company, 1872, Lv (below left);
Jug and base, porcelain, Minton, Stoke-on-Trent, shown at the London World Exhibition of 1851, Lv (below right)
Page 235: Carafe, glass, cut, with silvered bronze foot, design by F. W. Moody, made by Pellat & Co.,
London, about 1862, Lv
Left: Chenille carpet, English, mid 19th century, Lv

against the Naturalism that had pervaded the decorative arts in the mid-nineteenth century.

Another important source book for textile designers was Friedric Fischbach's *Ornamente des Gewebe* (Hanau, 1874–80) which reproduced historic textiles from the Byzantine, Medieval, and Renaissance periods from extant museum specimens. In Germany particularly many of these fabrics were reproduced, notably by the firm of E. Kopp & Co., both in their Berlin and Italian factories. Other designers drew inspiration from Fischbach's plates producing fabrics in Byzantine, Gothic, and Renaissance styles which were not copies but pastiches of the originals.

The Pompous style, which was above all an eclectic style, was rarely purely original but invariably drew its inspiration from historic precedent, adapting the source material so that the final design had a validity of its own.

The Gothic style was one that found favor in the 1830s and remained current throughout the next thirty years or so, becoming transformed into the Medieval in the 1870s. Patterns based on fifteenth- und sixteenth-century damasks and velvets were particularly suitable for ecclesiastical use and for rich, formal interiors, and such designs remained in favor throughout the century. Gothic architectural details such as tracery, crocketing, and cusping were introduced into the designs. Such architectural detail is rarely found in woven silks, but carpets in the Gothic taste, with the details reproduced as it were in full relief, were popular throughout the 1830s and 1840s. Contemporary critics, however, deplored the use of "shaded architectural ornament, often used very objectionably in carpets, and suggesting impediments or stumbling." Patterns of Gothic tracery were also much employed in Berlin woolworks particularly for the seats and backs of *prie-dieu* chairs. Another type of Gothic pattern consisted of floral designs, with exaggerated spiky leaves, thistles and other naturalistic details, reminiscent of Germanic or Flemish Late Gothic ornament.

Throughout the 1830s and 1840s the Classical style found expression in patterns of acanthuslike leaves, scrolls, and bosses, loosely based on Roman architectural detail or on Renaissance revivals. The "Raphael" brocatelle (p. 241, center) by Daniel Walters of Braintree, Essex, woven in 1862, is based on a selection of details from Raphael's decorations of the Loggia of the Vatican, based by Raphael on Roman ornament. These details are reproduced on Plate LXXXVI of Owen Jones's *Grammar of Ornament*, and some of the elements of the design of this silk seem to have been directly copied from this plate.

Pure Greek ornament of palmettes, rosettes, and anthemion motifs was employed by Owen Jones for a number of designs produced for Benjamin Warner and woven by Warner & Ramm of Spitalfields, London, between 1870 and 1875. The silk illustrated on page 244 (below left) is a fine example. These rich formal designs by Owen Jones can legitimately be called Pompous, especially the spectacular silk called "Etruscan" illustrated on the same page (above right). Owen Jones produced other sumptuous silks based on Egyptian, Indian, and Chinese ornament as well as a number of highly stylized floral designs that owed little to historic precedent. Owen Jones was one of the most influential designers of his day, and the silk by a Bavarian firm, acquired by the Victoria and Albert Museum in 1874 (p. 241, below right), has a distinct affinity with his work.

Another formal style current in the 1840s and 1850s was the Elizabethan, which first appears in England about 1834. Some of the designs, which appear in both woven and printed fabrics and in wallpaper, are purely abstract with bands of strapwork, cartouches, and bracket scrolls; in others the ornament is combined with flowers. Some designs are suggestive of Elizabethan carved woodwork in which, by means of shading, the strapwork is given a three-dimensional effect. The François Premier style, which is found not only in France but in England and elsewhere, was somewhat similar to the Elizabethan, but generally more elaborate and more curvilinear, with masks and human figures introduced into the designs.

The Alhambresque, Moorish and Arabian styles first appeared in the late 1830s, and were apparent at the Paris Exhibition of 1839. These styles received wider currency after the publication of Owen Jones's *Plans, Sections and Details of the Alhambra* in 1842, becoming a dominant style in textiles and wallpaper in the 1850s. An added impulse was provided by Owen Jones's Alhambra Court at the Great Exhibition of 1851 at the Crystal Palace in Hyde Park. Elaborate patterns of interlacing strapwork, scrolls, and leaf ornament covered the whole surface of the fabric. The large scale Alhambresque silk, woven by Keith & Company, London, about 1850–55 (p. 241, above left), is a particularly impressive example giving a rich and sumptuous effect. As in the Alhambra itself, primary colors were preferred for these Moresque designs. Diaper patterns and patterns based on Moorish tilework are also common. Less frequently, bands of Moorish ornament alternate with vertical stripes filled with flowers.

Elaborate interlaced ornament is also found on the brocatelle woven by A. & W. Saposnikoff of Moscow about 1870 (p. 245, below left). The textile is said to be copied from an old Russian towel illustrated in Boutoffsky's *History of Russian Ornament.*

The foregoing styles were "intellectual" styles, but the revived Rococo or Quatorze style, although capable of pretentiousness and pomposity, was more frivolous and elegant and eminently suited to the drawing room or boudoir. The Rococo scrolls and cartouches, filled with diapered ornament, combined admirably with curling leaves and sprays of flowers. The mid-nineteenth century French silk (p. 241, above right) with its brightly colored flowers and elaborate scrolls in shades of gold is a typical example. When disciplined and restrained, it is a charming style, but all too often the scrollwork was too coarse and the flowers too exuberant, giving a degenerate and vulgar appearance. The chenille carpet illustrated on page 236 is a fairly restrained example of the Louis Quatorze style applied to carpets.

In spite of the predilection for the eclectic use of historical ornament, purely floral designs remained popular throughout the period, but there is a wide variety of treatment and choice of flowers. The late nineteenth-century Italian velvet (p. 241, below left) has a much more subdued and heavy palette than its earlier Genoese prototype, and the flowers are treated much more naturalistically. The Rose, Thistle, and Shamrock silk (p. 241, center right) was woven by Daniel Walters for the new ballroom at Buckingham Palace in 1859 and shows a naturalistic spray of flowers combined with more formal laurel-leaf ornament to give it a suitably royal and pompous effect.

In the late 1840s a fashion for exotic plants arose, a style which reached its peak at the Great Exhibition of 1851. "Victoria Regia" lilies and huge tropical plants, with luxuriant leaves and trumpetlike flowers, often over life-size, sprawled over the fabric, the whole surface being covered with naturalistic detail. No doubt as a reaction against these excesses, in the late 1850s and 1860s, designs appear with motifs of a single flower, or detached sprigs of flowers and leaves, widely spaced on a plain ground. In the 1870s the floral designs were less naturalistic, with elaborate patterning on the leaves and petals as in the Bavarian silk shown on page 245 (below right).

The 1870s also saw a marked Japanese influence, which was an essential part of the Aesthetic movement and in England was exemplified by the textiles designed by the architect E. V. Godwin and Bruce J. Talbert, one of the most prolific designers of the Victorian period. Their textiles in the Japanese style were sophisticated and informed, but the 1880s saw a mass of inferior imitations which were often crude and ill-designed.

William Morris (1834–96) produced his first design for a printed fabric in 1873 and for a woven fabric in 1876. Most of his designs were based on direct studies of nature, preserving a feeling of living growth within a formal pattern structure based on historic precedent. His designs for woven fabrics were necessarily more rigid than those for printed fabrics and wallpapers. Some of his richest woven fabrics, such as the "Persian" brocatelle and his "Granada" velvet, derived from Persian and late medieval models, have the sumptuousness associated with the Pompous style. Most of his designs, however, fall outside the scope of this essay and with their scrolling leaves and swirling movement paved the way toward Art Nouveau.

For the richer fabrics, such as heavy silks and velvets, patterns based on Renaissance or seventeenth- and eighteenth-century styles were favored throughout the 1880s and 1890s. The silk by the architect T. W. Cutler (p. 245, above right) woven by Warner & Ramm in 1887 is a typical example as is their "Morton" silk (p. 248) produced in 1883. Both of these fabrics were eminently suitable for the Renaissance and Jacobean interiors of the 1880s with their dark wood paneling, elaborate plaster ceilings, and heavy carved fireplaces. The "Potsdam" velvet, enriched with gold thread (p. 245, above left), and the "Holyrood" silk and wool double cloth (p. 244, above left) woven by Alexander Morton and Company in 1891 testify to the remarkable technical skill of the weaving industry in the nineteenth century. They are both luxury fabrics and as such had a limited production, being purchased only by extremely wealthy customers.

Although the design of printed fabrics was often as eclectic, the designs were generally less pretentious and more ephemeral, catering to a more popular taste and for a cheaper market. Month by month new patterns were produced particularly by the Lancashire and Alsatian printworks. Floral patterns tended to dominate, although Rococo scrolls and other ornamental motifs were introduced into the designs. Many of the designs tended to be imitative, and in the 1850s *trompe l'oeil* effects of crumpled or draped silks appeared on the printed fabrics.

Eclectic designs combined paisley motifs with tartan patterns, and imitation jewels were printed on the fabrics. Pictorial fabrics with romantic scenes of crusaders, castles, or Eastern scenes were popular in the cheaper ranges throughout the mid-century. In the 1850s and 1860s a particular style in printed fabrics known as "Portuguese prints" was produced primarily for the Portuguese, Spanish, and South American markets. The distinguishing characteristic is exotic flowers and animals, often incongruously combined with figures without any sense of scale, printed in vivid colors on striped grounds. Between 1855 and 1860 there was a distinct fashion for delicate designs of ferns, a fashion which is also reflected in engraved table glass from 1860 onwards. From the mid-1840s onwards, furnishing chintzes were often printed on a worsted woolen fabric, known as challet, which gave a rich and lustrous effect, enhancing the brilliance of the dyes. In Alsace, in the 1860s and 1870s, these woolen fabrics were often printed with tropical flowers and exotic birds, set on a dark ground, producing fabrics that were luxurious enough to compete with the more expensive woven silks. The roses and hollyhocks of the earlier floral chintzes gave way to different flowers, such as daffodils, poppies, and orchids, the latter often printed in the new aniline Magenta dye, perfected in France in 1859. The panel of Hamburg woolwork (p. 253, below) with its poppies and magenta flowers is very close in spirit to the chintzes of the 1860s.

As in woven fabrics, the 1870s saw the emergence of the Japanese style in printed fabrics, and once again Bruce Talbert was one of the main innovators. The printed fabrics of William Morris in the 1880s and those of C. F. Voysey (1857—1941) had a profound influence not only in England but also on the Continent, particularly in Germany and Austria, with a beneficial effect on standards of design. Traditional floral chintzes and reproduction designs continued to be produced, but by 1900 the dominant style in both textiles and wallpapers throughout Europe was undoubtedly Art Nouveau.

Page 241: Silk brocade in the "Alhambra" style, Keith & Company, London, about 1855, Lw (above left);
Silk velvet, imitation Italian work of the late 16th century, Italian, end of the 19th century, Lv (below left);
So-called Raphael silk brocade, Daniel Walters & Sons, Braintree, Essex, 1862, Lv (center);
Silk textile with satin base and colored silk brocading, French, mid 19th century, Lv (above right);
Silk brocade, Daniel Walters & Sons, Braintree, Essex, made for the new ballroom of Buckingham Palace, 1859, Lv (center right); Silk damask, Bavaria, about 1874, Lv (below right)
Page 242: Fingerbowl and two glasses, Webb, England, about 1872, Hm (above);
Beaker and bottles, glass in Venetian style, C. F. Rönneberg, Flensburg, about 1882, Hm (below)
Page 243: Two bottles, glass, crystalware left, painted with gold burnish and opaque enamels right,
J. & L. Lobmeyr, Vienna, shown at the Viennese World Exhibition of 1873, Hm
Page 244: "Holyrood," silk and wool double cloth, Alexander Morton & Company, Darvel, 1891, Lv (above left);
"Etruscan," silk damask, design by Owen Jones, made by Warner & Ramm, 1883, Lw (above right);
"Athens," silk damask, design by Owen Jones, made by Warner & Ramm, Spitalfields, London, about 1870, Lv (below left);
Silk and wool textile, French, end of the 19th century, Lv (below right)

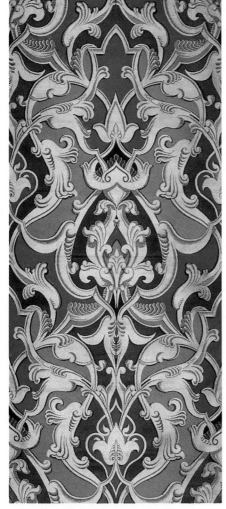

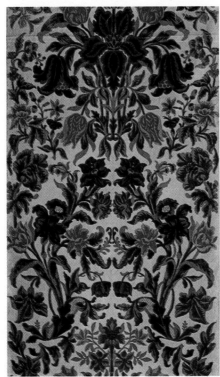

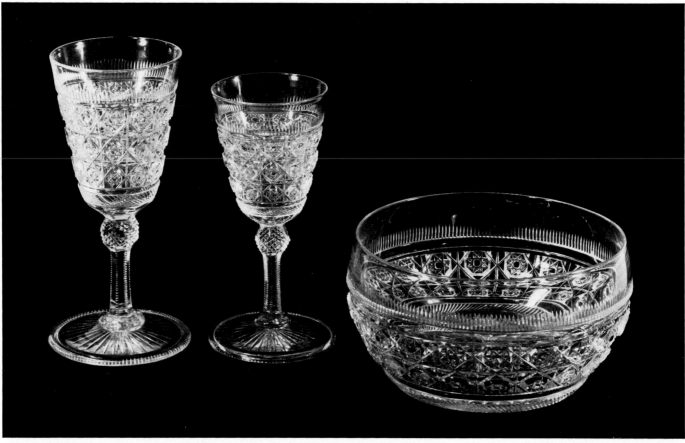
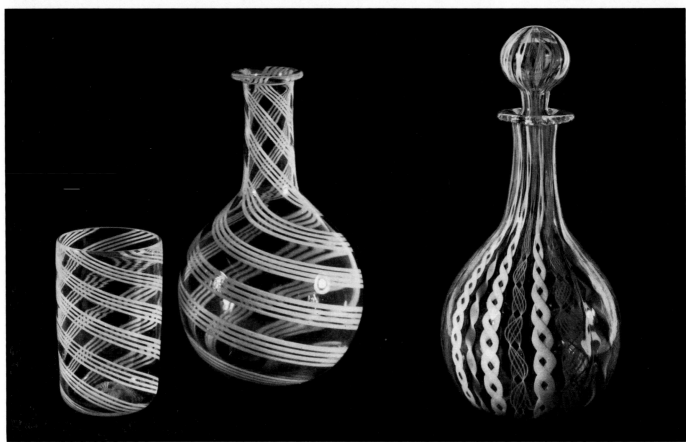

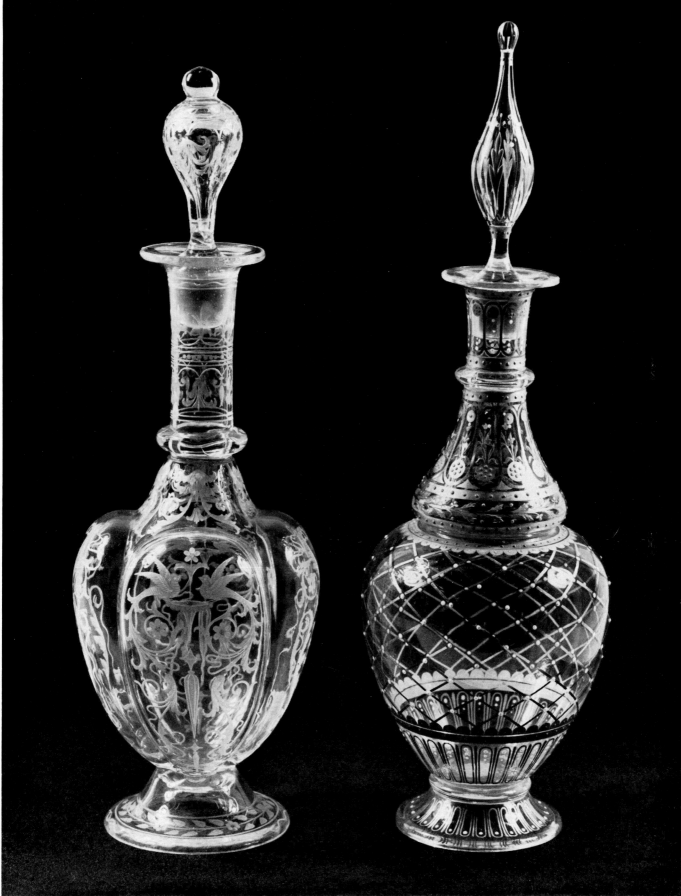

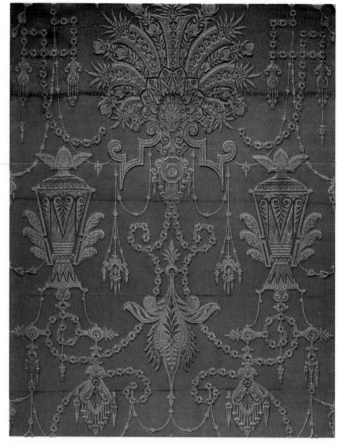
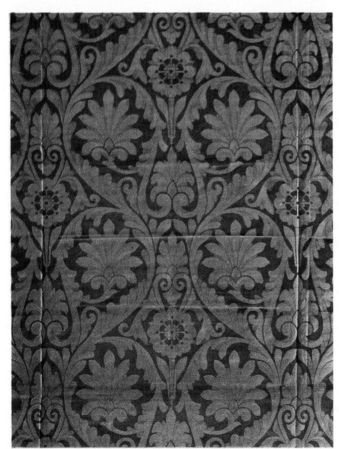
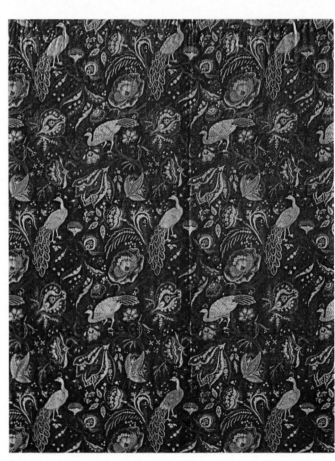

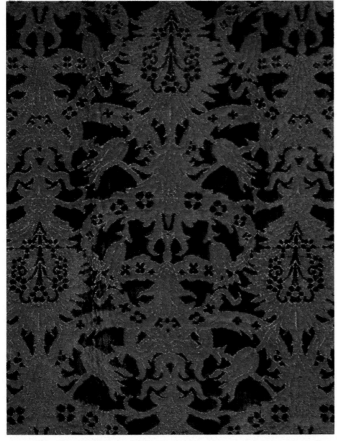

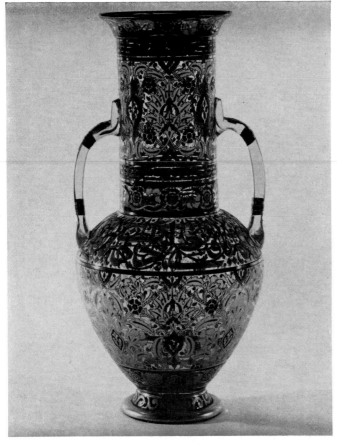
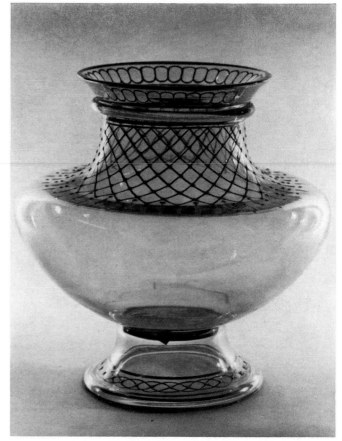
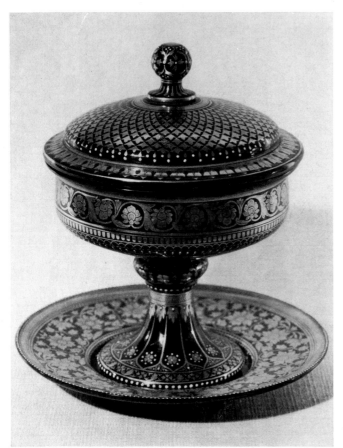
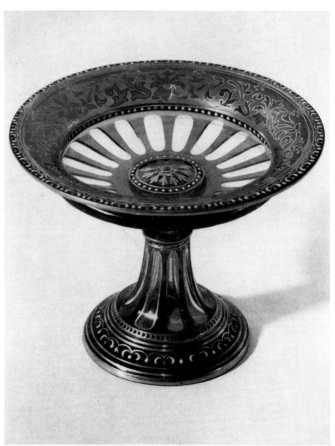

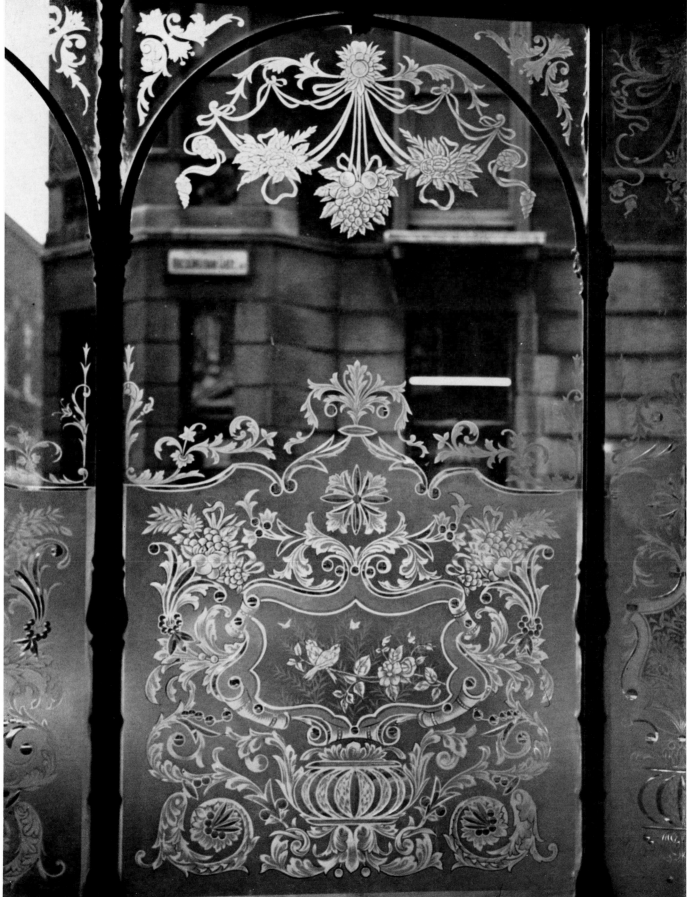

Key to the Illustrations

For technical reasons the illustration plates do not carry any page numbers or explanatory text. The purpose of this is to make for their most efficient possible use in the various language editions of the book. Instead, the numbers and captions appear on the pages of the text adjacent to them. They give, as far as is known for each object reproduced, the name of the artist, the architect, the person by whom the work was commissioned, the manufacturer, etc., the place and date of its origin, and its present location. Wherever any part of this information has been left out it was because it could not be found out. The abbreviations given below have been used for the present owners and locations. References to the illustrations in the text are given in parentheses; the numbers indicate the page, and the position on the page is shown by the words above, below, center, and left and right.

AMSTERDAM *Netherlands*
Ac Roelof Citroen Collection

BERLIN *Germany*
Bn Nationalgalerie

BIRMINGHAM *Great Britain*
Bc City Museum and Art Gallery

BRAUNSCHWEIG *Germany*
Bb Buchler Collection

CHANTILLY *France*
Cc Musée Condé

CINCINNATI *Ohio, USA*
Ca Cincinnati Art Museum

COMPIÈGNE *France*
Cn Musée National du Château de Compiègne

DUBLIN *Ireland*
Dn National Gallery of Ireland

HAMBURG *Germany*
Ha Altonaer Museum
Hk Hamburger Kunsthalle
Hb Kunsthandlung Edmund J. Kratz
Hm Museum für Kunst und Gewerbe

HERRENCHIEMSEE *Germany*
Hl Ludwig II Museum

LONDON *Great Britain*
Lk Collection of Kerrison Preston, Esq.

Page 245: "Potsdam," silk velvet shot with gold threads, Alexander Morton & Co., Darvel, 1891, Lv (above left);
Silk brocade, designed by T. W. Cutler, made by Warner & Sons, Braintree, Essex, 1887, Lv (above right);
Silk brocade, A. & W. Saposnikoff, Moscow, about 1870, Lv (below left); Silk brocade, Bavarian, about 1874, Lv (below right)
Page 246: Vase, glass with colored enamel painting and gold burnish, J. & L. Lobmeyr, Vienna,
shown at the Viennese World Exhibition of 1873, Hm (above left); Vase, glass with opaque enamel and gold burnish,
J. & L. Lobmeyr, shown at the Viennese World Exhibition of 1873, Hm (above right); Plate and jar with lid,
dark green glass decorated with gold burnish, shown at the Vienna World Exhibition of 1873, Hm (below left);
Foot bath, transparent glass, pale blue covering layer, ground and partly frosted, painted with opaque enamel
and gold burnish, shown at the Vienna World Exhibition, 1873, Hm (below right)
Page 247: Glass window with ground decoration, public bar, "The Albert," London, about 1880
Left: "Morton," silk damask, Warner & Ramm, 1883, Lw

Ll Leighton House
Ls Sotheby & Co.
Lt Tate Gallery
Lv Victoria and Albert Museum
Lw Warner & Sons, Ltd.

MANCHESTER *Great Britain*
Mc City Art Gallery

MUNICH *Germany*
Mh Hansen Collection
Mg Auktion Gerhard Hirsch
Mn Neue Pinakothek
Mr Residenz
Ms Stadtmuseum
Mw Kunstauktionshaus Weinmüller

NÜRNBERG *Germany*
Nv Verkehrsmuseum

PADUA *Italy*
Pc Museo Civico

PARIS *France*
Pe École des Beaux-Arts
Pd Musée des arts décoratifs
Pl Musée du Louvre
Pp Musée du Petit Palais

SCHWÄBISCH GMÜND *Germany*
Sm Museum Schwäbisch Gmünd

TORONTO *Canada*
Tr Royal Ontario Museum

VIENNA *Austria*
Wh Historisches Museum der Stadt Wien
Wa Österreichisches Museum für angewandte Kunst

Editorial Acknowledgments

The individual contributions to this book were written by the following: *Architecture* by Dr. Hans Lehmbruch, an art historian in Munich, and Dr. Nancy Halverson Schless, President of the Society of Architectural Historians in Philadelphia (dealing with American architecture); *Furniture and Fittings* by Dr. Hans Lembruch; *Painting* by Dr. Hanns Theodor Flemming, instructor in art history and president of the German section of the International Association of Art Critics in Hamburg; *Sculpture* by Jean Selz, an art historian in Paris; *Goldsmith's Work* by Dr. Manfred Meinz, chief curator of the Städtisches Museum in Osnabrück; *Ceramics* by Hugh Wakefield, keeper at the Victoria and Albert Museum in London; *Glass* by Dipl.-Ing. Dr. Heinz Spielmann, head of the Department of Art of the Late Nineteenth and Twentieth Centuries at the Museum für Kunst und Gewerbe in Hamburg; *Textiles* by Barbara J. Morris, assistant keeper at the Victoria and Albert Museum in London.

Photographs and other materials supplied for pictures reproduced were generously provided by the following people and institutions (wherever the source was a book it is also referred to with full details in the bibliography): Archiv für Kunst und Geschichte, Berlin (48, 49, 126 below); *Art Journal* (87); Elizabeth Aslin, London (79, 99 center); *Blätter für Architektur und Kunsthandwerk* (58 above left, above right, below right, 68 above right, below left, 82 below); Robert Braunmüller, Munich (202 above right); F. Bruckmann Verlag, Munich (51 above left, 57, 59, 68 above left, 68 below right, 74 below right, 101 below, 118—19, 126 above, 132 above, below, 133 above, below, 140 below left, 148 above, 150 above, 151, 159, 161, 162 left, right, 163 left, right, 164 left, right, 171 below right); Walter Buchler, Braunschweig (194 above left); Bulloz, Paris (131 left, 170 above left, above right, below left, 185 above left, above right, below left, below right); Cincinnati Art Museum, Cincinnati (230 right); City Art Gallery, Manchester (148 below); *Deutsche Bauzeitung* (63); City of Vienna Press Agency (10 above, below); Ludwig Eisenlohr and Carl Weigle, *Architektonische Rundschau* (15, 30 left, right, 39, 54, 55, 64 below); Margaret Henderson Floyd, Boston (58 below left); Giraudon, Paris (81, 96 above, below, 112 above, below, 134 below, 140 below left, 141, 142 below left,

below right); The Great Exhibition of 1851 (199 above left, above right, below, 215 above left, above right, below); Evelinde Hansen, Munich-Gräfelfing (194 below left, 233); Hans Jürgen Hansen, Munich-Gräfelfing (12, 20 below left, below right, 36 below, 172 below left, 177 left); R. Himpsel, Munich (254 above); Georg Hirth, *Das Deutsche Zimmer* (64 above); Historia Photo Charlotte Fremke, Bad Sachsa (7, 19 above); Historic American Buildings Survey, Washington (11, 19 below, 26, 27 above left, above right, below right, 34 above left, above right, below left, 65 below left); Henry-Russell Hitchcock, *Early Victorian Architecture in Britain* (23 left, 60 above); Howard-Tilton Library, Tulane University, New Orleans (27 below left, 82 above); Hutin, Compiègne (94 left, right); Wilhelm Kienberger, Lechbruck (28, 33, 84 above, below, 89); Ralph Kleinhempel, Hamburg (134 above); Lichino & Figlio, Genova (172 above right); H. Licht, *Die Architektur Berlin* (34 below right, 83 below) and *Architektur Deutschlands* (43, 65 above left, above right); Walter Lüden, Wyk auf Föhr (53 below right, 65 below right, 93, 95 left, 105 above, below, 188 left, right, 194 below right, 202 above left, 204 right, 224 below left, below right, 242 above, below, 243, 253 above, below, 254 below left, 255, 256); Wim Molenkamp, Amsterdam (187 right); Musée des arts décoratifs, Paris (76, 90 right, 95 right, 102 above left, above right, below left, below right, 103 above, below); Museo Civico, Padua (170 below left); Museum Schwäbisch Gmünd (186 left); Werner Neumeister, Munich (101, 158 right); Österreichisches Museum für angewandte Kunst, Vienna (178 above left, above right, 179, 186 right, 194 above right, 203 below, 210 above, 219, 222 above, below); Ursula Pfistermeister, Artelshofen (17, 18 above, below, 41, 42 above left, above right, below left, 50 above left, above right, below left, below right, 60 above, below, 67, 177 right); Wiebke Pleil, Hamburg-Blankenese (211 above); Preiss & Co., Munich-Ismaning (9, 20 above left, 25, 42 below right, 52 above, below, 75, 90 left, 91 right, 92, 104, 106 above, 117, 120, 139, 152 left, right, 157, 160, 169, 178 below, 180 above, 187 left, 193, 195 above left, above right, below left, below right, 196, 204 left, 209, 210 below, 211 below, 212, 218 above left, above right, below left, below right, 220 below, 221 above left, above right, below, 224

above left, above right, 230 left, 234 above left, above right, below left, below right, 236, 241 below left, center, above right, center right, below right, 244 above left, below left, below right, 245 above right, below left, below right, 246, 248); Prestel Verlag, Munich (66, 74 above right, below left, 83 above, 111 above, 125 above); Radio Times Hulton Picture Library, London (51 below left); Eberhard Ritter von Riewel, Munich (183 left, right); Hannes Rosenberg, Munich-Gräfelfing (203 above, 217); Royal Academy of Arts, London (140 above left, above right, 142 above right, 147, 150 below, 171 above left, above right, 172 above left, below right); Royal Ontario Museum, Toronto (223); Guy Lacy Schless, Philadelphia (20 above right, 36 above, 44); Gunter Schmidt, Munich (142 above left); Roger Seitz, Augsburg (47 left, right); Sotheby & Co., London (180 below); Stadtmuseum, Munich (73 below); Süddeutscher Verlag, Munich (51 above right, 73 above, 106 below); Betsy Swanson, New Orleans (35); Tate Gallery, London (125 below, 131 right); Moritz Thausing, *The Votive Church in Vienna* (23 right); G. G. Ungewitter, *Designs for Gothic Furniture* (99 left, right); Victoria and Albert Museum, London (91 left, 158 left, 201, 220 above, 241 above left, 244 above right, 245 above right); Watney, London (247); *Wiener Bauten Album* (74 above left); *Zeitschrift des Vereins für Ausbildung der Gewerke* (86, 109, 202 below).

Page 253: Cushion embroidery, flowers (below) and family of dogs (above), Renate Strelo, Hamburg, about 1800, Hm
Page 254: Gobelin, France, mid 19th century, Mw (above); Embroidered cover, appliqué and plain embroidery on velvet and silk, Studio for Embroidery-Work, Frau Dr. M. Meyer, Hamburg, about 1885—90, Hm (below left); Embroidered cover, silk and raw Linen, Studio for Embroidery-Work, Frau Dr. M. Meyer, Hamburg, about 1885—90, Hm (below right)

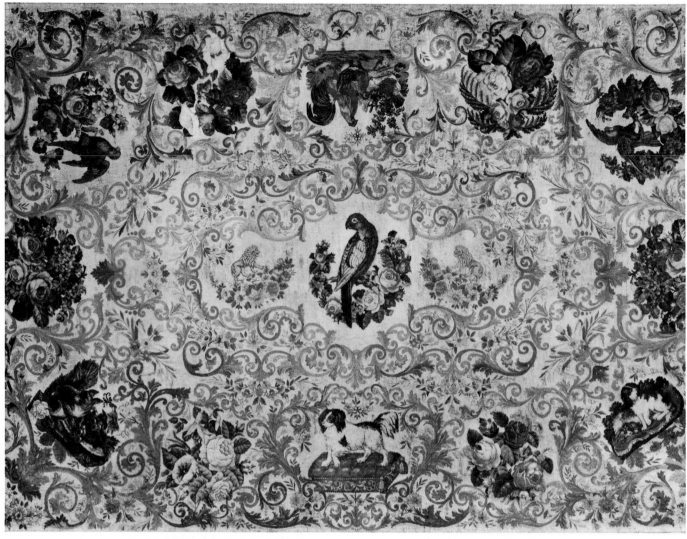
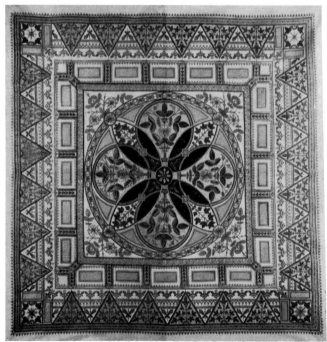

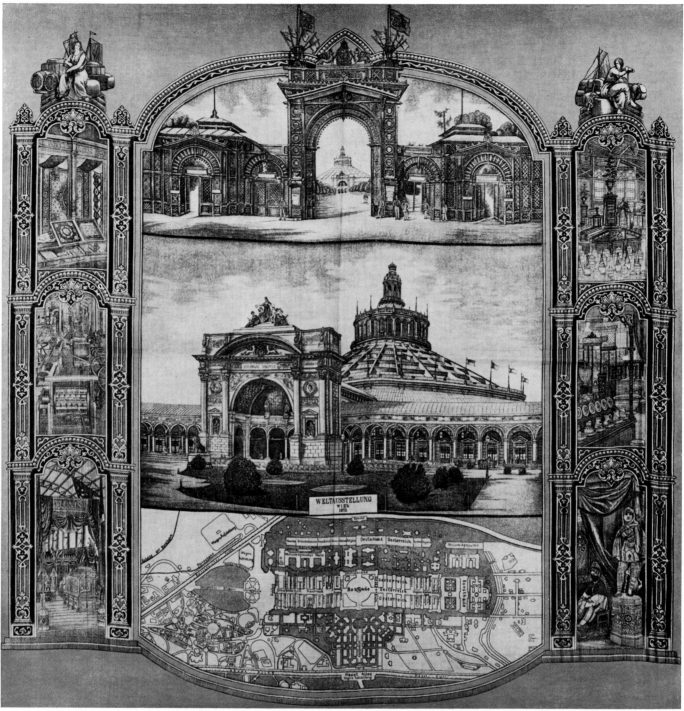

WELTAUSSTELLUNG
WIEN
1873

Die
Deutsche Flotte

Hurrah! Hurrah!

Bibliography

Allgemeine Bauzeitung, 1850 ff.

Angerholm, P., and Jahn, J.: Max Klinger. Zum 100. Geburtstag. Leipzig 1957

Appuhn, H.: Das Dortmunder Ratssilber 1898—1915. Dortmund 1969

Art Journal. London 1849—1912

Art Union. London 1839—1848

Aslin, Elizabeth: Nineteenth Century English Furniture, London 1962

Asúa, M. de: El mueble en la historia. Madrid 1930

Augst, E.: Das deutsche Möbel. Augsburg 1950

Baer, A., and Quensel, P., Editors: Bildersaal deutscher Geschichte. Stuttgart 1902

Baldry, Alfred Lys: Sir John Everett Millais. His Art and his Influence. London 1899

Baldry, Alfred Lys: Albert Moore. His Life and Works, London 1895

Barber, E. A.: The Pottery and Porcelain of the United States (3rd edition). New York 1909

Barié, O.: L'Italia nell'ottocento. Turin 1964

Barmann, L.: An Introduction to Railway Architecture. London 1950

Barqui, F.: L'Architecture moderne en France. Paris 1864

Barrington, Russell: Lord Leighton of Stretton. London 1897

Barzelet, James: La Verrerie en France de l'Epoque Gallo-Romain à nos Jours. Paris 1963

Beenken, Hermann: Das neunzehnte Jahrhundert in der deutschen Kunst. Munich 1944

Bell, Malcolm: Sir Edward Burne-Jones. London 1910

Benevolo, L.: Geschichte der Architektur des 19. und 20. Jahrhunderts. Munich 1964

Bennet, Mary: William Holman Hunt. Liverpool 1969

Berger, Klaus: Odilon Redon. Cologne 1964

Blätter für Architektur und Kunsthandwerk. Berlin 1895, 1896

Boarse, T. S. R.: English Art 1800—1870. Oxford 1959

Bodard, Roger: Antoine Wiertz. Antwerp 1949

Bott, G.: Kunstgewerbe. In: Propyläen-Kunstgeschichte, Bd. 11, Die Kunst des 19. Jahrhunderts. Berlin 1966

Brackett, O.: An Encyclopaedia of English Furniture. London 1927

Brackett, O.: Catalogue of English Furniture. London 1927

Braibant, Ch.: Histoire de la Tour Eiffel. Paris 1864

Briggs, A.: Victorian Cities. London 1963

Brinckmann, Justus: Führer durch das Hamburgische Museum für Kunst und Gewerbe, zugleich ein Handbuch der Geschichte des Kunstgewerbes. Hamburg 1894

Bucher, E.: Kulturhistorische Skizzen aus der Industrieausstellung aller Völker. Frankfurt 1851

Busch, Günter: Delacroix. Bremen 1964

Caisse Nationale des Monuments Historiques. Editor: Eugène Viollet-le-Duc, Exhibition Catalogue. Paris 1965

Cassou, Jean: Gustave Moreau. Baden-Baden 1964

Calliat, Victor: Parallèle des Maisons de Paris depuis 1830 jusqu'à nos Jours. Paris 1857

Casson, H.: An Introduction to Victorian Architecture. London 1948

Champury, E.: La Crise de l'Architecture et l'Avènement du Fer. In: L'Art 18, 1892

Chesterton, Gilbert Keith: G. F. Watts. London 1904

Christoffel, Ulrich: Malerei und Poesie. Die symbolische Kunst des 19. Jahrhunderts. Vienna 1948

Clark, K.: The Gothic Revival. London 1928

Clarke, B. F. L.: Churchbuilders of the 19th Century. London 1938

Clementi: L'Arte dell'arredamento. 1962

Contreras, J. de: Muebles españoles. Barcelona 1962

Daly, C.: L'Architecture privée au XIXe Siècle sous Napoléon III. Paris 1877

Page 255: *Vienna World Exhibition*, 1873, printed cloth, Vienna, 1873, Hm

Left: *The German Fleet*, printed cloth, German, about 1895, Hm

Degenhart, Bernhard: Hans von Marées. Die Fresken in Neapel. Vienna 1958

Delogu, G.: Italienische Baukunst. Zürich 1946

Dehio, Georg, Editor: Geschichte der deutschen Kunst. Berlin/Leipzig 1934

Deslandes, Yvonne: Delacroix. Munich 1964

Deutsche Bauzeitung. Current Years

Dibdin, E. Rimbault: George Frederick Watts. London 1923

Domenech, R.: Muebles antiguos españoles. Barcelona 1920

Doughty, Oswald: A Victorian Romantic — Dante Gabriele Rossetti. London 1949

Downing, A. J.: Cottage Residences. Boston 1842

Eastlake, Charles L.: The Gothic Revival. 1872

Eemans, Nestor: Fernand Khnopff. Antwerp 1950

Eiffel, Auguste G.: Travaux scientifiques executés à la Tour. Paris 1900

Eiffel, Auguste G.: La Tour de 300 mètres. Paris

Eisenlohr, Ludwig, and Weigle, Carl: Architektonische Rundschau. Stuttgart 1887 ff.

Ernould-Gandouet M.: La Céramique en France au XIXe Siècle. Paris 1969

Escholier, Raymond: Delacroix. Peintre, Graveur, Ecrivain. 3 Volumes. Paris 1926/29

Evans, J.: The Victorians. Cambridge 1966

Evers, H. G.: Tod, Macht und Raum. Munich 1939

Ferriday, P., Editor: Victorian Architecture. London 1963

Festschrift zum 50jährigen Jubiläum des Bayerischen Kunstgewerbevereins. Munich 1901

Feulner, A.: Kunstgeschichte des Möbels. Berlin 1927

Flemming, Hanns Theodor: Die stilistische Entwicklung der Malerei von Dante Gabriele Rossetti. Berlin 1954

Flemming, Hanns Theodor: Englische Kunst. In: Englandkunde. Frankfurt 1955 (5th edition 1965)

Friedlaender, Walter: Hauptströmungen der französischen Malerei von David bis Cézanne, Volume I. Bielefeld and Leipzig 1930

Gasparetto, Gastone: Il vetro di Murano delle origini ad oggi. Venice 1958

Gaunt, William: The Pre-Raphaelite Dream. London 1943

Gaunt, William: Victorian Olympus. London 1952

Gayanuño: L'arte del s. 19. In: Ars Hispaniae. Madrid 1966

Geist, Johann Friedrich: Passagen, ein Bautyp des 19. Jahrhunderts. Munich 1964

Geoffroy, G.: L'Œuvre de Gustave Moreau. Paris 1900

Giedion, S.: Bauen in Frankreich, Eisen und Eisenbeton. 1928

Giedion, S.: Space, Time and Architecture. 1941

Giedion, S.: Mechanization Takes Command. 1948

Gloag, J.: An History of English Furniture. 1952

Gloag, J.: A Social History of Furniture 1300—1960. London 1960

Gloag, J.: Victorian Comfort. London 1961

Gloag, J.: Victorian Taste. London 1962

Godden, G. A.: Victorian Porcelain. London 1961

Graul, R.: Great Interiors. London 1967

Griesebach, August: Die Baukunst im 19. und 20. Jahrhundert. In: Handbuch der Kunstwissenschaft. Berlin 1916

Hamann, Richard, and Hermand, Jost: Kunst und Kultur der Gründerzeit. Berlin 1965

Hahn, A.: Der Maximilianstil. Munich 1953

Hegemann, W.: Das steinerne Berlin. Berlin 1930

Hirth, Georg: Das deutsche Zimmer. Munich 1886

Hitchcock, Henry-Russell: Early Victorian Architecture in Britain. New Haven 1954

Hitchcock, Henry-Russell: Architecture of the XIX. and XX. Century. In: Pelican History of Art. 1958

Hofmann, Werner: Das irdische Paradies. Kunst im 19. Jahrhundert. Munich 1960

Hofstätter, Hans H.: Symbolismus und die Kunst der Jahrhundertwende. Cologne 1965

Hueffer, Ford Madox: Ford Madox Brown. London 1896

100 Jahre Österreichisches Museum für angewandte Kunst. Kunstgewerbe des Historismus. Exhibition Catalogue. Vienna 1964/65

Hunt, William Holman: Pre-Raphaelitism and the Pre-Raphaelite Brotherhood. 2 Volumes. London 1905

Huysmans, Joris Karl: A rebours. Paris 1884 (German: Berlin 1897)

Hymans, Henri: Belgische Kunst des 19. Jahrhunderts. Leipzig 1906

Ironside, Robin, and Gere, John: Pre-Raphaelite Painters. London 1948

Jarry, M.: Stilmöbel von Ludwig XIII. bis Napoleon III. Düsseldorf 1963

Jones, Owen: The Grammar of Ornament. London 1856

Jessen, Jarno: Rossetti. Bielefeld and Leipzig 1905

Joanne, A.: Paris illustré. Paris 1863

Joseph, Dagobert: Geschichte der Baukunst. Leipzig 1909

Joseph, Dagobert: Geschichte der Architektur Italiens. Leipzig 1907

Jourdin, Francis: L'Art officiel de Jules Grévy à Albert Lebrun. Mulhouse 1949

Journal of Design. London 1894—1951

Kahn, Gustave: Félicien Rops. Berlin

Kassner, Rudolf: Die Mystik, die Künstler und das Leben. Über englische Dichter und Maler im 19. Jahrhundert. Leipzig 1900

Kassner, Rudolf: Das neunzehnte Jahrhundert. Zürich 1947

Kidson, P., and Murray, P.: A History of English Architecture. London 1962

Köllmann, E.: Berliner Porzellan. Braunschweig 1966

König Ludwig II. und die Kunst. Exhibition Catalogue. Munich 1968

Kreisel, H.: Die Schlösser Ludwigs II. Munich 1968

Kühn, P.: Max Klinger. Leipzig 1907

Ledoux-Lebord, D.: Les Ebénistes parisiens du XIXe Siècle. Paris 1965

Lehnert, G.: Illustrierte Geschichte des Kunstgewerbes. Berlin 1908

Leixner, O.: Einführung in die Geschichte des Mobiliars. Berlin 1921

Le Second Empire, Exhibition Catalogue. Paris 1957

Lessing, J.: Gold und Silber. Berlin 1907

Licht, Hugo: Die Architektur Berlins. Berlin 1877

Licht, Hugo: Die Architektur Deutschlands. Berlin 1879

Lichtwark, Anton: Makartbouquet und Blumenstrauß. Berlin 1894

Link, E. M.: Ullsteins Silberbuch. Berlin/Frankfurt/Vienna 1968

Litchfield, F.: Illustrated History of Furniture. London 1892

Lochhead, M.: The Victorian Household. London 1964

Lundberg, E.: Arkitekturens Formspråk. 1961

Macdonald-Taylor, M.: English Furniture from the Middle Ages to Modern Times. London 1965

Magne, L.: L'Architecture française. Paris 1889

Macquoid, P.: English Furniture. London 1928

Major, M.: Geschichte der Architektur. Berlin 1960

Marangoni: Storia dell'arredamento. 1961

Maré, E. de: The Bridges of England. London 1954

Mauclair, Camille: Puvis de Chavannes. Paris 1928

Mauclair, Camille: Thomas Couture. Paris 1932

Meeks, C. L. van: The Railroad Station. New Haven 1956

Meier-Graefe, Julius: Hans von Marées. 3 Volumes. Munich 1909/10

Meier-Obrist, E.: Kulturgeschichte des Wohnens. Hamburg 1956

Meissner, Franz Hermann: Franz Stuck. Berlin 1899

Meissner, Franz Hermann: Max Klinger. Munich 1914

Melanie, A.: L'architettura nel secolo XIX. 1899

Meyer, August Georg: Tafeln zur Geschichte der Möbelformen. Leipzig 1902

Meyer, August Georg: Eisenbauten. Esslingen 1907

Meynell, Esther: Portrait of William Morris. London 1947

Monkhouse, Losmo: Sir Edward Poynter. London 1897

Moreau-Vauthier, Ch.: Gérôme, Peintre et Sculpteur. Paris 1906

Muther, Richard: Geschichte der englischen Malerei. Berlin 1903

Muther, Richard: Geschichte der Malerei, Volume III. Berlin 1912

Muthesius, Hermann: Englische Baukunst der Gegenwart. Leipzig 1900

Muthesius, Hermann: Neuere kirchliche Baukunst in England. Berlin 1902

Muthesius, Hermann: Stilarchitektur und Baukunst. Mülheim 1902

Muthesius, Hermann: Das englische Haus. Berlin 1904

Narjoux, E.: Monuments élévés par la Ville de Paris 1850 à 1880. Paris 1882

Odom, W. M.: A History of Italian Furniture. New York 1966

Oeser, Christian: Briefe an eine Jungfrau über die Hauptgegenstände der Ästhetik. 1874

Pariset, E.: Histoire de la Fabrique Lyonnaise. Lyon 1901

Parris, Leslie: The Pre-Raphaelites. Tate Gallery. London 1966

Pazaurek, Gustav: Moderne Gläser. Leipzig

Pecht, Friedrich: Geschichte der Kunst in München im 19. Jahrhundert. Munich 1888

Pevsner: Pioneers of Modern Design.

Pevsner: High Victorian Design. 1951

Picon, Gaëtan: Ingres. Geneva 1967

Pierrard, Louis: Félicien Rops. Antwerp 1949

Pirchan, Emil: Hans Makart. Vienna 1954

Poche, E.: Bohemian Porcelain. Prague 1955

Praz, Mario: Inneneinrichtungen. Munich 1965

Praz, Mario: An Illustrated History of Furniture. New York 1964

Prignot, Liénard et Coignet: L'Ameublement moderne. Paris 1876

Rathke, Ewald: Arnold Böcklin. Frankfurt 1964

Revue technique de l'Exposition Universelle. Paris 1889

Robson, W. D.: The Literary Background of the Gothic Revival in Germany. Oxford 1965

Roters, Eberhard: Le Salon Imaginaire. Berlin 1968

Rückwart, H.: Architektur der Neuzeit. 1889

Ruttenauer, B.: Maler-Poeten (Thoma, Böcklin, Klinger, Feuerbach, Puvis, Moreau). Strassburg 1899

Savage: A Concise History of Interior Decoration. London 1966

Schild, E.: Vom Glaspalast zum Palais des Illusions

Schleinitz, Otto von: Burne-Jones. Bielefeld and Leipzig 1901

Schleinitz, Otto von: Walter Crane. Bielefeld and Leipzig 1902

Schleinitz, Otto von: William Holman Hunt. Bielefeld and Leipzig 1907

Schmid, Heinrich Alfred: Arnold Böcklin. Munich 1903

Schmidt, Robert: 100 Jahre österreichische Glaskunst (Lobmeir 1823—1923). Vienna 1925

Semper, Gottfried: Der Stil in den technischen und tektonischen Künsten

Semper, Gottfried: Kleine Schriften

Standing, Percy Cross: Sir Lawrence Alma-Tadema. London 1905

Stengel, W.: Alte Wohnkultur in Berlin vom 16. zum 19. Jahrhundert. Berlin 1958

Stegmann, J.: Consort of Taste 1830—1870. London 1950

Straub, H.: Die Geschichte der Bauingenieurkunst. Stuttgart 1964

Süddeutsche Bauzeitung. Current Years

Symonds, R. W.: Victorian Furniture. London 1962

Talbert, B. J.: Gothic Forms Applied to Furniture, Metalwork etc. 1868

Talbert, B. J.: Examples of Ancient and Modern Furniture. London 1876

Tally: History and Description of the Crystal Palace. London 1851

Taylor, G.: Art in Silver and Gold. London 1964

Thausing, Moritz: Die Votivkirche in Wien. Vienna 1879

The Great Exhibition of 1851, Exhibition Catalogue. London 1851

The Great Exhibition of 1851, Exhibition Catalogue. Victoria and Albert Museum. London 1950

Thompson, Paul: The Work of William Morris. London 1967

Thonet, Michael: Exhibition Catalogue. Vienna 1969

Uhde-Bernays, Hermann: Feuerbach. Leipzig 1914

Uhde-Bernays, Hermann: Théodore Chassériau. Munich 1946

Ungewitter, G. G., and Riewel, H.: Entwürfe zu gothischen Möbeln. Leipzig 1851

Vacquier, J.: Le Style empire. Paris 1911

Vierendeel, A.: La Construction architecturale en Fer fonte et Acier. Louvain 1900

Vogt, Paul: Was sie liebten..., Salonmalerei im 19. Jahrhundert. Cologne 1969

Viollet-le-Duc, Eugène: Dictionnaire raisonné de l'Architecture française du XIe au XVIe Siècle. Paris 1867 ff.

Viollet-le-Duc, Eugène: Entretiens sur l'Architecture. Paris 1863—72

Viollet-le-Duc, Eugène: Habitations modernes. Paris 1877

Viollet-le-Duc, Eugène: Compositions et Dessins. Paris 1884

Vriend, J.: De Bouwkunst von ons Land. Amsterdam 1938

Wakefield, Hugh: Victorian Pottery. London 1962

Wakefield, Hugh: 19th Century British Glass. London 1961

Waring, J. B.: Masterpieces of Industrial Art and Sculpture at the International Exhibition 1862. London 1863

Warner, Sir Frank: The Silk Industry of the United Kingdom. London 1921

Wasmuth Verlag: Die preisgekrönten Entwürfe zu dem neuen Reichstaggebäude. Berlin 1882

Wheeler, Gervase: Rural Homes. 1851

Wiener Bauten-Album. Vienna 1883/85

Wilkens, H.: Das Silber und seine Bearbeitung im Kunstgewerbe. Bremen 1909

Windisch-Graetz, F.: Innendekoration und Mobiliar des Historismus. In: Alte und Moderne Kunst 1965

Yapp, G. W.: Art Industry. London 1877

Yarwood, D.: The Architecture of England. London 1963

Zapf, Hermann: William Morris. Scharbeutz 1950

Zeitschrift für Bauwesen. Current Years

Zeitschrift des Vereins zur Ausbildung der Gewerke. Munich 1851 ff.

Zweig, M.: Zweites Rokoko in Wien. Vienna 1924

Index